T0272542

Monumental Fury

The History of Iconoclasm and the Future of Our Past

Matthew Fraser

Prometheus Books

Essex, Connecticut

Prometheus Books

An imprint of Globe Pequot, the trade division of The Rowman & Littlefield Publishing Group, Inc.
4501 Forbes Blvd., Ste. 200
Lanham, MD 20706
www.rowman.com

Distributed by NATIONAL BOOK NETWORK

British Library Cataloguing in Publication Information Available

Library of Congress Cataloging-in-Publication Data Available

ISBN 978-1-63388-810-4 (cloth : alk. paper) | ISBN 978-1-63388-811-1 (ebook)

♾️™ The paper used in this publication meets the minimum requirements of American National Standard for Information Sciences—Permanence of Paper for Printed Library Materials, ANSI/NISO Z39.48-1992.

Factum abiit, monumenta manent.

"The event is past, the monument remains."—Ovid

Contents

Preface

This book was born unexpectedly and in exceptional circumstances. In the spring of 2020, my previous book, *In Truth: A History of Lies from Ancient Rome to Modern America*, was published in the middle of the first COVID-19 pandemic wave and lockdown. The timing was not auspicious for the release of a book, if only because bookstores everywhere were closed.

Only a few weeks later, the murder of George Floyd in Minneapolis provoked a furious outburst of statue-smashing across the United States that quickly spread to other countries. I followed these turbulent events like everyone else, but with particular interest, for portions of my just-published book examined the early history of iconoclastic violence. One section of the book was titled "Icons and Iconoclasts" and another "Twilight of the Icons." I had spent the previous three years immersed in historical research on the social dynamics behind the upheaval that the entire world was witnessing.

I set about writing this new book in response to those extraordinary events. My first task was to consult the existing body of scholarship on modern iconoclasm. I was fortunate as an academic living and working in France, a country with a long and tumultuous history of iconoclastic violence. French scholarly interest in the subject has a well-established tradition. A pioneering work in the field is Louis Réau's *Histoire du vandalisme: Les monuments détruits de l'art français,* published in 1959, followed in the 1990s by several notable works, including François Souchal's *Le Vandalisme de la Révolution*, and Alain Besançon's *L'Image interdite: Une histoire intellectuelle de l'iconoclasme*. In English, American scholar David Freedberg's seminal book, *The Power of Images: Studies in the History and Theory of Responses*, was published in 1989. Over the past couple of decades, several excellent books have added to this body of scholarship.

The examples of iconoclastic destruction in the chapters that follow represent a fairly wide range of historical experiences, though the book makes no claim on exhaustivity. Other scholarly works on the subject have focused on particular case studies that are either absent or only briefly evoked here.[1] My multi-disciplinary approach was not only useful but perhaps also even necessary given that scholarship in this field ranges across different academic fields. The fact that I am a political scientist on faculty in a university department of communication, media, and culture may reveal something about my particular perspective. I should stress that I did not embark on writing this book with any particular normative or ideological position. I do not argue that contested statues should, or should not, be toppled or removed. My analytical approach is dispassionately focused on historical events, the dynamics that animated them, the consequences they produced, and the questions they raise. In short, I focus on how we can understand and assess iconoclastic violence, past and present.

A word about semantics used in this book. There is considerable debate among scholars about distinctions between commonly used terms, notably *iconoclasm* and *vandalism*. The debate tends to focus on the suitability of the word *vandalism*, a term that can be interpreted as meaning "barbaric violence," compared with the more formal notion of *iconoclasm* describing destruction motivated by clear intentions based on beliefs or doctrine. *Vandalism* refers to Vandals, the Germanic tribes who sacked Rome and later migrated across western Europe and into northern Africa. In France, the term *vandalisme* was used to characterize the iconoclastic destruction committed during the French Revolution. Dario Gamboni, in his excellent book *The Destruction of Art: Iconoclasm and Vandalism since the French Revolution*, makes a distinction between *iconoclasm*, *vandalism*, and *destruction*—though he uses all three words in his book's title.[2] These distinctions usefully establish conceptual boundaries in scholarly discourse, though some have noted that they are based largely on connotations and remain open to interpretation. In this book, I use these various terms where I believe they are most appropriate when describing attacks on images, statues, monuments, idols, shrines, artworks, and so on. No judgments or connotations are implied when using any of these terms.

Finally, while this book was researched with rigorous academic methods and was peer-reviewed prior to publication, it is aimed at a general readership. A scholarly book taking a multidisciplinary approach for a wide audience runs inevitable risks. Scholars in a particular field may find that the book does not sufficiently explore particular issues, or insufficiently engages with specific questions. This book also eschews academic style and jargon in favor of an accessible and, I hope, engaging narrative. While it is my hope that teachers and scholars will find this book useful, it should be noted that it is intended for a broad audience.

To the academic colleagues who served as peer-review assessors of the book's merits, I wish to express gratitude for their critiques and suggestions. Thanks also to Adam Ostry, who read various drafts of the manuscript and gave useful advice before the book was submitted for peer review and publication. I also wish to thank my agent, Amanda Jain, and Jake Bonar at the Prometheus Books imprint of Rowman & Littlefield.

Introduction

In early March of 2001, a 31-year-old man wielding a sledgehammer marched into City Hall in San José, California. He headed straight for a life-sized statue of Christopher Columbus in the lobby and began smashing it repeatedly, shouting, "Murderer!"

The furious hammer blows broke off the marble statue's right arm and shattered both legs. Dozens of people in the lobby panicked and ran frantically from the scene. One woman, believing the loud noise was gunfire, fell and broke an arm while fleeing. The attacker stopped smashing the statue only when three uniformed police officers burst into the building with their guns drawn.

The assailant, a Native American activist, pointed at the statue and shouted, "This man murdered us!"[1] Arrested and charged with vandalism, he was sentenced in court to ten months in jail.

Two decades later, a frenzy of statue-smashing triggered by the murder of African American George Floyd stunned the world. The upheaval was the culmination of pent-up resentment that had been simmering for years in the United States. The video footage of George Floyd's agonizing death under the knee of a Minneapolis cop was the spark that ignited an explosion of rage against perceived symbols of authority, injustice, and racism.

The violence quickly spread around the world. In London, activists spray-painted "racist" on the pedestal of a Winston Churchill monument. In the English town of Bristol, a crowd pulled down the bronze statue of seventeenth-century slave trader Edward Colston. In Paris, protestors defaced statues of French colonial generals. A statue of Enlightenment philosopher Voltaire was splashed with red paint.

The outburst of rage against statues was wildly cheered by some, fiercely denounced by others. Many applauded as statues of hated Confederate generals and slave traders came crashing down across the American South. Others were

outraged at the sight of Abraham Lincoln and Winston Churchill statues being defaced and battered by angry crowds.

In the aftermath of the iconoclastic fury of 2020, we are looking at statues and monuments with different eyes. Statues of once-venerated figures have been knocked off their pedestals. Public monuments, many commemorating revered figures we believed could not possibly elicit controversy, have been pulled down from their commanding heights. Venerated icons have been defaced and mutilated as symbols of oppression. For the first time in generations, we are reflecting deeply on our relationship with the statues and monuments that stand in our public squares.

This book is about why we erect statues, why they elicit such strong emotional reactions, why we sometimes attack and destroy them, and why we often replace them with new monuments.

One way of understanding the status and fate of statues in our public spaces is to regard them as symbols of *power*. Throughout history, monuments have been commissioned and unveiled by ruling elites as symbolic expressions of authority. The presence of monuments in public squares sends powerful messages into the culture and shapes collective memory. They symbolize values that suggest how we are meant to understand the past. Public iconography—heroes glorified in marble and bronze, profiles etched on coins, monuments commemorating historic events, works of art adorning urban spaces—reminds us of what is worthy of respect, obedience, admiration, even veneration.

Violence against statues is frequently a revolt against power. Attacks on public monuments are attempts to destroy their symbolic authority. When people assail and mutilate public monuments, they are attacking symbols of a religion, a political regime, or a social order. Iconoclastic destruction is often an act of defiance that makes claims on social justice. The defacement of a statue is an expiatory ritual that purifies the corrupt and overthrows the oppressive.

For some, it is puzzling that people have such strong reactions to public monuments. They are, after all, merely objects, made of marble, bronze, or stone. Many statues in public squares are oddly invisible, largely unnoticed or completely ignored, gathering bird droppings. And yet, at certain moments in time, they suddenly come alive, as if resurrected, infused with life, and speak to us powerfully.

We react strongly to statues and images because we invest power in them as symbols. They occupy a higher ontological status in our imaginations. They symbolize values and elicit powerful feelings of identity and belonging—to clan, to race, to nation, to empire, to religion. Those who smash statues believe they are neutralizing their power in the hearts and minds of those who venerate them. When engaging in acts of destruction, iconoclasts are acknowledging the symbolic power of the objects they attack. Sometimes the statue is conflated with the

figure represented. In the mind of the assailants, there is no difference between bronze and flesh. They look upon the figures represented as if they are alive and their authority intact. The Native American activist who took a sledgehammer to the statue of Christopher Columbus shouted, "This man murdered us!" In his mind, the statue was Columbus himself.

Some regard violence against statues as irrational or fanatical acts. Attackers of statues are judged as deranged or mentally unstable. In 1972, a man in Rome took a hammer to Michelangelo's famous *Pietà* sculpture while declaring himself to be "Christ risen from the dead." He was arrested and committed to a psychiatric hospital. When not attributed to mental disorders, iconoclastic violence is frequently condemned as "medieval" vandalism. Following the defacement of statues in England, British prime minister Boris Johnson condemned "know-nothing cancel-culture iconoclasm." Describing statue-toppling as "barbaric," Johnson added, "I believe in putting statues up, not tearing them down."[2] Those who agree with him regard attacks on public monuments as senseless violence and public disorder. Not everyone shares this view. Others regard statue-toppling as a legitimate form of revolt against social injustice.

In truth, violence against statues can be attributed to a diverse range of motives—from individual psychosis and religious fanaticism to political ideology, social protest, acts of war, even financial gain. People gaze upon statues and images with intense and often-conflicted emotions—reverence, pride, gratitude, grief, fear, shame, contempt, hatred, even erotic desire. "People are sexually aroused by pictures and sculptures," observed art historian David Freedberg in his book, *The Power of Images.* "They break pictures and sculptures; they mutilate them, kiss them, cry before them, and go on journeys to them; they are calmed by them, stirred by them, and incited to revolt."[3]

Another important dynamic that can help us understand why we erect and destroy statues is *time.* It is frequently claimed that toppling statues is an "attack on history," or an attempt to "erase the past." The destruction of statues is violence that makes claims on how the past should be remembered. Collective memory is constructed around both the erection and destruction of statues. These acts, whatever their motives, introduce the notion of *time* into the fate of monuments.

Humans are mortal, occupying time only briefly, but monuments endure long after the generation that unveiled them has vanished. We are still gazing upon statues from ancient civilizations and contemplate them in our museums—for example, the Venus de Milo in the Louvre. The creation of a statue is an attempt to stop time, so to speak, to confer permanence on a symbol and, by doing so, to project the values it represents into the future. The philosopher Friedrich Nietzsche described monuments as a "protest against the change and decay of generations and transience."[4]

Nietzsche articulated a philosophy of history around this idea. How much those living in the present require the services of history, he argued, is a fundamental question for every generation. Nietzsche identified three types of history: *monumental, antiquarian,* and *critical.* Monumental history holds up heroic models to imitate—Moses, Pericles, Julius Caesar, Napoleon. It is the history of "mythic fiction" meant to inspire. Antiquarian history, on the other hand, is the scholarly process of preserving and venerating the past without any particular passion. Critical history is different. Its goal is to shatter and dissolve history by "bringing the past before a tribunal, painstakingly interrogating it, and finally condemning it." Proponents of critical history, observed Nietzsche, are "suffering and in need of emancipation." They are driven not by a desire for greatness, but by a compulsion to "sit in judgement and pass judgment."[5] These three models of history can help us understand our contemporary debates about statues. Conflicts over monuments today are, in many respects, pitched battles between *monumental* and *critical* values toward the past and their rival claims on collective memory.

These tensions also explain why statue-toppling is regarded not only as an assault on symbols of power but also, more widely, as a concerted attack on the past. Conflicts over statues are struggles to control narratives about the past. The past consequently becomes a battleground. The destruction of a statue asserts the primacy of present-day values over those of previous eras. As a result, history is constantly on trial. Rivalry over historical narratives is a dispute that is never entirely settled. As George Orwell observed: "Who controls the past controls the future; who controls the present controls the past."[6] It might be said, in the same spirit, that disputes about statues and monuments are power struggles to shape the future of our past.

Those who defend statue-toppling often remark that monuments don't represent "history." They are merely objects of propaganda from previous epochs. This is undoubtedly true, but violence inflicted on statues is no different. Iconoclasm, like the erection of statues, is a form of discourse. Those who smash statues are making their voices heard by performative violence motivated by religion, politics, and social revolt. Acts of iconoclasm are expressions of ideology and propaganda, though we sometimes use the more palatable term *values* to justify them. The motivation behind iconoclastic destruction is sometimes to assert dogmas and ideological certitudes, sometimes to inflict punishments on perceived moral sins of the past, sometimes to attract publicity for present-day causes. We witness this when protest groups such as Extinction Rebellion commit public acts of vandalism to sound apocalyptical alarm over the global environmental crisis. Their protests are similar to the iconoclastic violence of British suffragettes who, more than a century ago, mutilated famous paintings in London art galleries to bring attention to the cause of women's voting rights. If war is politics by other means, iconoclasm is speech by other means.

Sometimes iconoclastic violence marks a total rupture with the past. The Jacobins in revolutionary France, for example, were determined to obliterate every symbolic vestige of the past and construct a new social order with its own symbols. They even stopped the clock and invented a new French republican calendar beginning in Year I. Monuments can also be symbols of an imagined future: at world fairs bold futurist designs are displayed to be contemplated with marvel and awe. A famous illustration of this is the Eiffel Tower, erected for the Paris world's fair in 1889. Made of puddle iron, it was an architectural symbol that boldly announced the modern age. For those who gazed upon the Eiffel Tower in the 1890s, it represented the shock of the new. Parisians living in the Eiffel Tower's shadow were particularly shocked. Many hated it. A petition even circulated in Paris to have it torn down. Yet not only did the Eiffel Tower survive the revulsion of the Belle Époque, today it is universally regarded as an awe-inspiring icon that evokes romance, nostalgia, and an aura of everything quintessentially French. Monuments despised in one era are revered in the next, and vice versa.

Today's heated debates about contested statues, like the petition against the Eiffel Tower, are frequently framed as a what-to-do dilemma. Should they be *preserved, destroyed,* or *modified*? This question is normatively charged because, for those who contest statues, it suggests that "something must be done" with them. The assertion arrogates entitlement to the present generation as moral arbiters who judge and decide the fate of statues erected in the past. Questions raised by contested statues—domination, exploitation, injustice—are legitimate and need to be debated. It is important to keep in mind, however, that the judgments of the present day are filtered by the norms and values of only one moment in time. If Parisians in the 1890s had prevailed, the Eiffel Tower would not be standing today. It is worth asking: Does the verdict on a legacy of monuments belong to any one generation?

A related question is why attacks on statues have suddenly flared up today. Is there something unique about our own age that makes us more susceptible to rage against public monuments inherited from the past? Some argue that iconoclastic rage today is a symptom of our cultural obsession with collective memory and its claims on social justice. Memory today has been elevated to the status of a cult. Others claim that today's statue-smashing fever is an essentially American phenomenon, a resurgence of iconoclastic neo-puritanism that resonates and reflects contemporary "woke" values. That it has spread to other countries, it is claimed, is testimony to the global influence of American cultural ideology.

Yet statue-smashing is not unique to our own age, let alone to American culture. Iconoclastic violence is a long and turbulent saga stretching back to ancient civilizations. Widespread acts of iconoclasm tend to erupt at pivotal points in history, however, usually as symptoms of upheaval and dislocation. We are living

in one of these moments today. This book attempts to discover and examine the causes and consequences.

The book's thematic framework is structured around the following observation: iconoclastic eruptions are symptoms of religious, political, and social upheaval. The book is accordingly organized into three sections—"Religion," "Revolution," "Revolt"—examining these three categories of iconoclastic violence. Each section contains five chapters focused on specific illustrations of iconoclastic upheaval with a careful eye to identifying historical patterns that establish connections between the past and present. The term *iconoclasm* (from the Greek *eikon* and *klastes* for "image breaker") is used broadly, extending beyond icons and statues to include idols, relics, shrines, tombstones, sculptures, and paintings.

Religion

The book's first section examines violence against statues motivated primarily by *religion*. Religious iconoclasm is frequently commanded by faith to destroy idols and icons prohibited by scriptural doctrine. Iconoclasm is violence inflicted on false gods or proscribed images in the name of the one "true" religion. It is driven by an inflexible determination to smash, obliterate, and erase every trace of the symbols under assault. In many cases, religiously motivated violence is ritualized, sometimes accompanied by ecstatic emotions of exultation, chanting, and singing. It will be argued that we can witness the repercussions of religiously driven violence against statues in acts of political and social iconoclasm today.

The first chapter explores the religious origins of iconoclasm starting with the Taliban's destruction of the Bamiyan Buddhas. Chapter 2 focuses on early Christian destruction of pagan statues and religious idols in the Roman Empire. Chapter 3 begins in ancient Greece with Herostratus's destruction of the Temple of Artemis to achieve everlasting fame. His *damnatio memoriae* sentence—or memory erasure—is compared with the moral punishments in today's "cancel culture" and attacks on celebrity icons such as John Lennon. Chapter 4 explores the religious taboo of the "forbidden image," especially in Renaissance Italy where the charismatic monk Savonarola organized "bonfires of the vanities" whose flames consumed sinful works of art in public purification rituals. Chapter 5 examines the Conquistador invasion of Mexico and subjugation of native populations, resulting in the destruction of an entire civilization and its symbols in the name of the Christian faith.

Revolution

The second section addresses political violence against statues and images at turning points of *revolutionary* rupture when an existing order is forcibly overthrown—or regime change. The agents of revolution are motivated by an ideological program of political violence, iconoclastic destruction, and symbolic replacement. Iconoclastic violence entails systematic obliteration of the old order's symbols of authority.

The opening chapter on *revolution* examines iconoclastic violence in early modern England: firstly, Henry VIII's rupture with the Catholic Church; and secondly, Puritan statue-smashing during the Civil War. Chapter 7 shifts the focus to America, where revolution exploded in 1776 with a founding act of iconoclasm: patriots attacked an equestrian statue of king George III in lower Manhattan. Chapter 8 turns to the French Revolution, sparked by the destruction of the Bastille and followed by wholesale erasure of the Ancien Régime's statues and symbols. Chapter 9 examines the organized destruction of monuments under Marxist states in Russia and China, where revolutionaries destroyed religious symbols to construct a new system of iconography around communist ideology. The iconography of Nazi Germany is the focus of Chapter 10, which examines Adolf Hitler's visual propaganda and the post-war "de-Nazification" program aimed at purging every physical trace of the Third Reich.

Revolt

The third section examines iconoclasm as *revolt*, defined as spontaneous outbursts of violence against statues as symbols of social injustice and oppression. Protestors are animated by a spirit of revolt that makes claim on collective memory. These iconoclastic revolts generally lack a clearly articulated political program beyond claims of victimhood and calls for remedies for past injustices. More importantly, in contrast to revolutionary iconoclasm, statue-smashing revolts do not generally seek to overthrow and usurp power in the short term.

The first chapter in this final section begins with the sixteenth-century *Beeldenstorm* iconoclastic violence that swept through the Dutch provinces in a popular revolt against the Hapsburg monarchy and Catholic Church. Chapter 12 explores violence against works of art, starting with suffragette Mary Richardson's defacing of Velazquez's *Rokeby Venus* painting in 1914. Chapter 13 examines the "statue mania" era in the late nineteenth century and its legacy of heroic "great man" monuments that today are targeted by the Black Lives Matter movement. Chapter 14 traces the cultural shift in America from "statue mania" to "memorial mania" and its cultural obsession with collective memory

and monuments as expressions of public emotions. The book's final chapter examines new forms of iconoclastic protest—street art, graffiti, internet memes, holograms—and their implications for the future of public iconography.

It should be underscored that these three categories—*religion, revolution, revolt*—are not separated by impermeable boundaries, but overlap and interpenetrate. Iconoclastic violence that is religiously motivated can also have political implications, and vice versa. Similarly, statue-smashing as spontaneous revolt frequently is driven by a political agenda, and sometimes reveals characteristics associated with quasi-religious fervor. The book's structure is meant to establish a thematic framework that will help identify and assess recurrent patterns of iconoclastic violence across all three categories.

The dynamics of iconoclastic violence, as we shall see throughout the chapters that follow, vary according to different historical circumstances. In some instances, assaults on statues are organized, top-down forms of violence. This type of iconoclasm usually occurs when a political movement or religion overthrows an old order and sets about to erase its symbolic arsenal of authority. The Bolshevik destruction of Tsarist statues during the Russian revolution is an illustration of this type of top-down iconoclasm. Conversely, violence against monuments is sometimes spontaneous, bottom-up iconoclastic rage. Lacking structured organization, it erupts from below, often in sudden outbursts of protest. This is largely what happened during the wave of Black Lives Matter statue-smashing over several months in 2020. This type of belligerence usually does not entail total obliteration of a statuary legacy, but is random and partial in its targets and outcomes.

The book concludes with reflections on our relationship with statues, monuments, and public iconography. Some believe that contested statues, however controversial they may be, should remain intact. Others argue that each generation has the right to decide what kind of monuments they wish to see in public spaces—and to destroy those that they find objectionable. Another proposed solution is to put controversial statues in museums where they can be studied as historical artifacts. Still others argue for more creative approaches to public monuments by "reimagining" them to produce new layers of interpretation and meaning.

Meanwhile, we appear to be entering a post-monument era in which our relationship with statues and images is being radically transformed by their dematerialization. Digital technologies such as holograms present innovative ways of creating, venerating, and protesting public iconography—and even reviving symbols and images from the past to inspire new forms of idolatry. This latter point, as the chapters in this book illustrate, cannot be understated. Iconoclasm

is impossible without idolatry. At the same time, iconoclasm produces idolatry. While iconoclastic destruction is an attempt at erasure, the act of obliteration creates memory and, by doing so, keeps alive the symbolic power of the object attacked and destroyed. Toppled statues endure in the minds of those who venerated them. Their broken fragments become fetishized objects, like sacred relics. The striking blow of destruction is an act of creation. The saga of iconoclastic violence, in the final analysis, is inextricably tied to the history of idolatrous veneration.

The fate of contested statues presents difficult dilemmas about our moral obligations to previous generations. Those who live in the present understandably feel compelled to assert their right to decide what kind of monuments they wish to see in public spaces. Yet it could be argued that they also have a duty of care to preserve the legacy of monuments left by preceding generations. This was once their world; and we, like them, are merely fleeting tenants of the present, destined like them to occupy the historical past. This question invites us to reflect on the weight of memory in our relationship with the past and how it affects our attitudes toward monuments. While few would advocate collective amnesia about the past, obsessive fixation on the claims of collective memory can sometimes be just as harmful. There may be a point at which it is better to make peace with the past, to consign its incidents and upheavals to the status of history, and to take its lessons as the foundation for commitments we make in the present.

We should perhaps be encouraged to foster a culture that looks on the statues we have inherited, however contestable, with humility and forbearance. As noted above, we don't own this world any more than the ancient Romans or Victorians did in their time. It might be asked if any one generation should be entitled to sit in judgment of the entire past. We need to reflect on how much the past is responsible for the present, and how much the present is responsible for the past.

Resolving these questions will undoubtedly help us redefine our relationship with statues and monuments beyond the familiar "preserve-destroy-modify" dilemma. At the very least, it will encourage us to be mindful that, just as we judge previous generations for the monumental legacy they left behind, so will future generations judge our attitudes and actions toward the statues and monuments in our public spaces.

Part I
RELIGION

The Buddhas of Bamiyan

For fifteen centuries, two towering Buddha statues looked imperturbably across the Bamiyan valley in the Hindu Kash mountains of modern-day Afghanistan.

The giant Buddhas, one standing nearly two hundred feet tall, had been carved into the sandstone cliffs as elaborately ornamented cave temples painted in gold. Muslim tribes in the region had lived in the presence of the majestic Buddhas for centuries. Buddhist temples sometimes stood side-by-side with mosques.

After the radical Taliban took over the country in the 1990s, however, they turned against the Buddhas. The Taliban massacred thousands in the local Hazara population of Shia Muslims who had integrated the presence of the Buddhas into their legends. The ultra-fundamentalist Taliban leaders also ordered the destruction of all non-Muslim relics and statues in Afghanistan. Buddhist statues were condemned to be obliterated.

In early 2001, the Taliban attacked the Bamiyan Buddhas with tanks and anti-aircraft guns. But the giant Buddhas refused to fall. Finally, the Taliban drilled holes into the Buddhas and stuffed them with sticks of dynamite. The charges were detonated to shouts of "Allahu Akbar."[1] The first explosion blew off the leg of one Buddha. After daily explosions over three weeks, the majestic Buddhas crumbled into a pile of rubble. The vaulting caverns from which they had looked across the valley for centuries were now vacant.

Celebrating their iconoclastic triumph, Taliban fighters danced and fired their weapons into the air. The world looked on, horrified, at television images of the destruction of the cherished world heritage site.

Mullah Muhammad Omar, the Taliban's one-eyed spiritual leader, gave Islamic law as the reason for destroying the Bamiyan Buddhas. "These idols have been gods of the infidels," he declared.[2]

Engraving of the Buddhas of Bamiyan (1833), from Alexander Burnes's *Travels into Bokhara.*

The demolition of the Buddhas was also a victory ritual after the Taliban's occupation of Afghanistan following the Soviet Union's military withdrawal. During the Soviet-backed communist regime in Afghanistan, no heritage sites had been destroyed. After the Soviet Union collapsed in 1991, however, Afghanistan's communist regime fell, and the Taliban seized power. As Afghan *mujaheddin* factions despoiled the country, the Taliban unleashed a campaign of iconoclastic fury. At Hadda in the southeast, they smashed and plundered Buddhist sculptures. A mosque was constructed at the same location, where a nineteenth-century mullah had once called for jihad against British colonialists.

The wave of destruction sparked an international outcry against Taliban barbarity. In Paris, the Pompidou Center projected a massive image of a Bamiyan Buddha on its façade as a "protest against fanaticism." Many were perplexed by the utter senselessness of these acts of wanton destruction. Two years earlier, the Taliban had promised that the country's cultural heritage would not be molested and Mullah Omar issued a decree protecting non-Islamic antiquities in Afghanistan. In early 2001, however, he changed his mind. Mullah Omar issued a *fatwā* that allowed the destruction of the Buddhas. But why? There was no tactical military advantage in the obliteration of the Buddhas. Nor was the Taliban

vandalism an organized campaign of looting motivated by economic gain. Some interpreted the statue destruction as defiant belligerence against Western values of preserving cultural heritage. Observers in the international media put it down to the Taliban's "medieval" religious fanaticism.

"With their ultra-conservative Islamic ideology, they believe a depiction of any human being is blasphemous," observed a BBC reporter in Afghanistan. "They also think, mistakenly, that Buddhists worship the Buddha and that the statues are therefore idols."[3]

The destruction of the Buddhas was not a reckless act perpetrated by barbarous vandals. The destruction of the Buddhas was motivated by a combination of religious dogma and political defiance.[4]

Politically, the international context surrounding Afghanistan in the 1990s helps explain the Taliban's motivations. The country had just been through a long civil war. The Taliban leadership had provided safe haven in Afghanistan to Osama bin Laden. He was commanding his international network of Islamist terrorists from Jalalabad. Afghanistan's isolationist Taliban regime was consequently under tremendous international scrutiny and pressure. Bin Laden had even issued a fatwā calling on all Muslims to kill Americans. In 1998, the United Nations voted to impose international sanctions on the country.

By destroying the Bamiyan Buddhas, the Taliban were sending a defiant message to the West. The demolition of the Buddhas was carefully stage-managed for the global media so the entire world would witness the destruction.[5] The Taliban even took the trouble of flying in journalists, including a television crew from Al Jazeera, to film the giant Buddhas being blown up with dynamite.[6]

The Taliban's religious fanaticism was considered the primary reason for their actions. When reminded that Islamic tenets condemn destroying places of worship of other religions, the Taliban countered that there were no longer any Buddhists in Afghanistan. The Bamiyan site consequently did not constitute a place of worship.

"We do not understand why everybody is so worried," declared Mullah Omar. "All we are breaking are stones."[7]

These public declarations were specious. If the Bamiyan Buddhas were merely objects, the Taliban would have left them unmolested. As art historian David Freedberg observed,

> These statements reveal a central paradox not only of the Taliban's actions, but of iconoclasm throughout history: If paintings and sculptures are simply pieces of wood and stone, inert and insignificant, why bother to destroy them? The very act of iconoclasm testifies to the mysterious—and often threatening—power images can hold over us. In ravaging their country's artistic heritage in the name of fundamentalist Islam, the Taliban rulers reveal not their strength, but their

fear. In this, they take their place in a long line of despots and others who have trembled in the sight of creations they did not understand, creations that seemed somehow to embody a life and to emanate an inexplicable and ominous force of their own.[8]

In truth, the destruction of the Bamiyan Buddhas scrupulously followed an Islamic script. It was an orchestrated act of violence against infidel idols guided by the religious notion of *Al-wala' wa-l-bara*—"loyalty and enmity"—or purity and cleansing of the impure. Mullah Omar made this explicit when he declared, "How could we justify, at the time of the Last Judgement, having left these impurities on Afghan soil?"[9] The stain of the Buddhas had to be eradicated in a purifying rite of destruction.

The timing offered another clue that much of the Western media missed. Mullah Omar ordered the destruction of the Buddhas five days before the start of the *Hajj* pilgrimage, and eight days before *Eid al-adha* when Muslims sacrifice animals to honor prophet Abraham. In the Quran, Abraham is prepared to sacrifice his son as a sign of obedience to Allah and rejects the idolatry of his father, Azar. It is for this reason that Mullah Omar ordered an expiatory ritual following the destruction of the Buddhas. One hundred cows were sacrificed, including twelve animals in the former Afghan presidential palace. A double sacrifice therefore was observed: a purifying sacrifice of statue destruction, and an expiatory ritual of animal sacrifice.[10] The Taliban were symbolically casting themselves as heirs to Abraham by reenacting, through idol destruction and animal sacrifices, Islamic traditions in line with the *Hijri* calendar.

Still, voices of indignation around the world denounced the barbarity of these acts. The religious dogmas that inspired the Taliban vandalism, they claimed, had no place in the modern world. The blowing up of the Buddhas was an assault on civilization. Yet there was nothing "medieval" in the Taliban's action. It was coherent with religious iconoclasm that stretched back long before the Middle Ages. Iconoclastic violence has been commanded by religious dogma for thousands of years. It is driven by an inflexible determination to smash, obliterate, and erase every trace of the symbols targeted for destruction. In many instances, the violence is ritualized and accompanied by ecstatic emotions of exultation—like the Taliban dancing and firing guns into the air. The impulse to destroy venerated idols and icons finds its origins in the birth of the world's great religions—Islam, Christianity, and Judaism.

The words *idol* and *icon* are religious terms designating sacred statues and images that inspire veneration. In Christianity, veneration of the figure of Christ on the crucifix is an iconic illustration of religious idolatry. We have even borrowed these terms in our popular culture to designate the famous—teen "idols" and pop "icons"—whose fame incites fanatical devotion and even worship. Like the word *icon*, from the Greek *eikon* for "image," *idol* is from the Greek *eidolon*.

Idolatry is from *eidolon latreia* ("idol adoration"). The word *eidolon* also signifies a ghost or phantom, thus suggesting that statues can possess a spirit. This is a recurrent theme in the history of iconoclasm: statues are more than representation; they are regarded as possessing a life force.

Most ancient religions—in Mesopotamia, Egypt, Greece, Rome, Asia—were polytheistic and "iconic." In other words, they used statues and images to visually represent their diverse deities. In the Western tradition, statues of ancient Greek and Roman gods and goddesses come readily to mind, though polytheistic religions including Buddhism and Hinduism visually represented multiple deities. The emergence of monotheistic religions marked a rupture with idolatry. Monotheistic religions recognized the existence of only one God. The idea of a single God was metaphysical. God was invisible, no longer visualized, and consequently impossible to represent.

This abstracted concept of an invisible God is common to Judaism, Christianity, and Islam. All three are considered "aniconic," or against images. There are exceptions and contradictions to this schema, of course. In Christianity, the Bible prohibited graven images yet the Church eventually embraced idols and images to help propagate the faith. Religious attitudes toward sacred images were complex and often the object of competing doctrines and theological disputes. Generally speaking, however, religious iconoclasm finds its origins in monotheistic religions based on faith in a single God who cannot be visually represented and, consequently, idol and icon worship is prohibited.

This metaphysical concept of the divine was aligned with ancient Greek philosophy. As in Egypt and Mesopotamia, the Greeks gave form to their deities in plastic manifestations. But Greek philosophers such as Plato were also reflecting on the nature of representation and its relation to the divine. The Greeks held the spiritual above the material, the abstract above the particular, the universal above the finite. Images appealed to the senses, not to the soul. They were inferior copies of true existence. In *The Republic*, Plato condemned images because he distrusted their powers of enchantment. These philosophical reservations about images had powerful repercussions for Christian theology. The question of images, and iconoclastic reactions to them, would be the source of fractious disputes within the Church for many centuries.[11]

Religions that made a transition from polytheism to monotheism provide an illustration of iconoclasm at work. In ancient Egypt, the supernatural was represented by a plurality of gods. In the fourteenth century BCE, however, the pharaoh Akhenaten rejected traditional gods in favor of worshipping a single god: the sun disc Aten.[12] Akhenaten, often referred to as the first monotheist, instigated a violent campaign of iconoclastic destruction to disfigure all rival gods. Akhenaten proclaimed that Aten was "sole god, without another beside him." The pharaoh, whose official name was Amenhotep IV, even changed his own name to Akhenaten, which means "servant of Aten."

In the Judeo-Christian tradition, the Bible contains inconsistent passages about images and idols. In the Book of Exodus, for example, God commands that two gold cherubim be made to adorn his throne. Elsewhere in the Old Testament, God tells Moses to make a brass serpent and hang it on a pole among the Israelites so that anyone who looks upon it will be cured of snake bite. The same brass serpent is destroyed by the king of Judea, Hezekiah, in an iconoclastic campaign to purge the Temple of Jerusalem of idols and reunify Israel.[13] These Biblical stories reveal some ambiguity about the status of idols. There are, at the same time, numerous interdictions of idol worship. The Book of Exodus contains the famous commandment: "Thou shalt have no other gods before me. Thou shalt not make unto thee any graven image, or any likeness of anything that is in heaven above, or that is in the earth beneath, or that is in the water under the earth."[14]

The figure of Moses embodies the shift from polytheism to the worship of a single God, especially through the famous Biblical story of the golden calf. In the Old Testament, the Hebrews worship a golden calf while waiting for Moses to come down from Mount Sinai. Aaron, the brother of Moses, takes the golden earrings of Israelite women to make the idol. The calf is undoubtedly the Egyptian god Apis, a bull deity associated with fertility. Worshipping the golden calf signifies a relapse into polytheism. Idolatry is a rejection of the only true God. When Moses sees the children of Israel corrupting themselves before the altar of the golden calf, he burns the idol, grinds it to powder, and has 3,000 of the idolaters put to the sword before returning to the Lord to atone for the sins of his people.[15]

The theme of idolatry appears again in the Book of Deuteronomy, where the Lord commands his people to massacre the idol-worshipping Canaanites: "And you shall destroy their altars, break their sacred pillars, and burn their wooden images with fire; you shall cut down the carved images of their gods and destroy their names from that place."[16] The Book of Samuel includes the story of the pagan god Dagon, worshipped by the Philistines. After the Philistines defeated the Israelites, they captured the ark and placed it at the feet of Dagon in a pagan temple. The following day, however, the idol of Dagon had fallen over and was lying, its head and hands broken off, prostrate at the feet of the ark of God. Following the fall of Dagon, a plague descended on the Philistines.[17]

The same iconoclastic traditions were carried forward into Islam. The Quran recounts the golden calf story found in the Old Testament, portraying Israelite idolatry as a breaking of the Abrahamic covenant with God. In both the Bible and the Quran, Abraham is the proto-monotheist who rejects the idolatry of his forebearers. The Quran is explicit about polytheistic idolatry, or *shirk*. Those who commit *shirk*, called *mushrikun*, are enemies of Islam. Verse 22:30 of the Quran reads: "*So shun* the impurity of idolatry, and *shun* words of false-

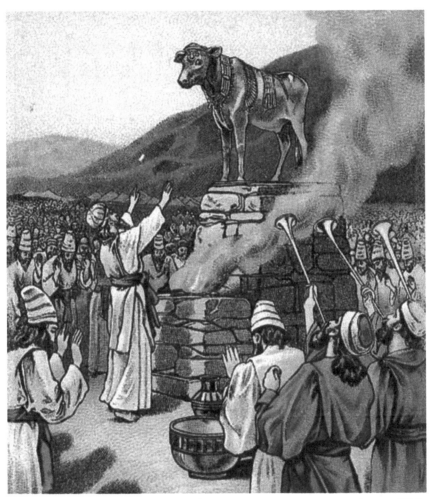

In the Book of Exodus, worshipping the golden calf. Illustration from a Bible card published in 1901 by the Providence Lithograph Company. *Wikimedia Creative Commons.*

hood." There is no mention, however, of the obligation to destroy idols. That tradition comes from accounts of Muhammad's words and deeds within the Hadith, where it is mentioned that the Prophet purified the Ka'ba in Mecca by driving out the old idols.

Both the Judeo-Christian and Islamic traditions, as we have seen from the scripture cited above, established a deep connection between monotheism and iconoclasm. In all three religions—Judaism, Christianity, Islam—there was only

one true God, who, being invisible, could not be represented visually. Truth was revealed in the word. According to the Gospel of John: "In the beginning there was the Word, and the Word was with God, and the Word was God."[18] God could be known through the word alone. Images and idols of the divine must therefore be destroyed.

The smashers of idols and icons in early Christianity and Islam were not only obeying religious dogma; they were also inflicting belligerence on foreign cults that thrived on material visuality of diverse deities. The early Christians who toppled Greek and Roman idols and vandalized pagan shrines were behaving not unlike the Taliban zealots who dynamited the Buddhas of Bamiyan. The Taliban were acutely aware that violence inflicted on the Buddha statues was reconnecting with historical Muslim forms of iconoclasm, which frequently included the defacement and beheading of statues and trampling on icons. During Muslim conquests in South Asia throughout the medieval period, trampling on icons was a ritualized feature of victory celebrations to demonstrate that Muslims did not revere icons.[19]

Grasping this fundamental connection to religious dogma is essential to understanding the impulses that have driven iconoclastic violence throughout history. The destruction of icons and idols, in ancient and modern times, share discernible patterns of motivation and action.

Violence inflicted on statues and monuments is rarely a psychotic outburst or random act of vandalism. While precise motives vary across different circumstances, attacks on images and statues are performative acts commanded by scripture, dogma, and ideology.

It is remarkable that the Bamiyan Buddhas survived so many centuries until their destruction by the Taliban in 2001.

The history of the two Buddha statues is a story of constant exposure to threats from invaders. It is a richly complex saga of vicissitudes over more than a thousand years as the Bamiyan Valley came under the influence of different cultures—Greek, Persian, Turkic, Indian, Mongol, Mughal, and Chinese.

Once the ancient Kushan capital, the Bamiyan Valley occupied a strategic position on the Silk Road between China and Rome. The Kushan Empire, stretching across modern-day Pakistan, Afghanistan, and northern India, was instrumental in the spreading of Buddhism throughout the region. In the fourth century AD, before the Islamic period, the Kushan Empire fragmented under pressures from foreign invasions, though it continued to flourish as a monastic center of Buddhist learning. It was during this period, in the sixth and seventh centuries, that the colossal Buddha statues were carved into the valley's sandstone cliffs.[20]

Iconoclastic damage to the Buddhist temples dates to the sixth century, when the Hephthalites—or "White Huns"—destroyed the monastic settlement at Bamiyan. A century later, Kabul and Kandahar succumbed to Muslim invasions, but the Bamiyan Valley remained Buddhist. The Chinese Buddhist monk Xuanzang, who was visiting the valley circa 630 AD, recorded that the giant Buddhas were decorated with gold and jewels.[21] The region capitulated to Muslim invaders in the eighth century, when the local elites converted to Islam under the Abbasid Caliphate.

Muslims were hostile to religious idols and looted Buddhist temples, but iconoclastic destruction was not unique to Islamic culture. In the ninth century, Tang dynasty emperor Wuzong unleashed a furious anti-Buddhist campaign that consisted of persecutions and destruction of temples to purge China of "foreign" cultural influences. The Chinese iconoclastic fury was religiously motivated, for Wuzong was a follower of Taoism. The campaign against Buddhism was also economic. Wuzong's treasury was on the verge of bankruptcy. His confiscation of tax-exempt Buddhist temples was a land grab. Buddhist shrines and temples met with even greater threats following the collapse of the Tang dynasty in the early tenth century, when the region splintered under the control of regional powers. In China, this anarchic period was called "Five Dynasties and Ten Kingdoms." The resulting instability opened an opportunity for Muslim powers, especially the Turks, to invade from the west.

There is evidence that Muslim invaders were fascinated by Buddhist statues. Buddhist visual culture had a significant impact on Muslim practices in the region. Islam shifted away from religious abstraction to embrace visual representations in mosques and on tapestries, silks, and ceramics. When iconoclastic violence against Buddhist monasteries occurred, it was sometimes economically motivated. In the ninth century, the Persian Saffarid ruler Ya'qub ibn Layth raided the region and seized precious metal icons and destroyed a temple. It was probably at this time that the faces of the Bamiyan Buddhas were first vandalized, in keeping with a practice of defacing pre-Islamic images.

In 870, the region returned to Buddhism but finally capitulated to Islam at the end of the tenth century when it fell under the control of the Turkic Ghaznavids. The sultan Mahmud of Ghazni, known as the "idol breaker," was infamous for his marauding raids into northern India and looting of Buddhist temples. In 1025 AD, he assailed the city of Somnath and sacked its Shiva shrine. When the local priests offered him a ransom for the main Shiva icon, he replied that he was a "smasher of idols, not a seller of them." Mahmud left the Bamiyan Buddhas unmolested, however. Two centuries later, when the Mongol emperor Genghis Khan invaded the valley and laid siege to Bamiyan, he massacred the local population though spared the giant Buddhas. He was less benignly predisposed to Muslim shrines, undoubtedly because his westward expansion put the

Mongols in military conflict with Islamic empires, culminating in the Mongol sack of Baghdad in 1258. In Afghanistan, Genghis Kahn's armies destroyed the mosque in Mazar-i-Sharif built by the Seljuk sultan Ahmed Sanjar. In an ironic twist of history, the descendants of the Mongols who remained behind in the Bamiyan Valley ended up worshipping the Buddhas.[22]

In the early sixteenth century, Babur—the Muslim founder of the Mughal empire—passed through the Bamiyan Valley, though made no mention of the Buddhas. In 1528, Babur left a written account of his encounter with Jain *tirthankaras* cave monuments in the Urvahi valley of northern India. The rock-cut Jain monuments depicted naked *tirthankaras* in the "*kayotsarga*" standing posture, showing genitalia in keeping with Jain iconography. Babur had them demolished. "On the southern side is a large idol, approximately 20 yards tall, they are shown stark naked with all their private parts exposed," wrote Babur. "Urvahi is not a bad place. In fact, it is rather nice. Its one drawback was the idols, so I ordered them destroyed."[23] It is likely that Babur, a Sunni Muslim, was offended by the nudity of the Jain images. The destruction did not involve the total obliteration, however, for the images survived without their heads, later replaced with stucco.

The ambiguity toward Buddhist temples during this period can be explained by two different movements in Islam during Moghul rule: Sufi mysticism and politicized shariaism. Sufi mysticism was relatively neutral toward Buddhism. It was the latter movement of politicized Islam that instigated jihad holy wars against Buddhists. As infidels, Buddhists were persecuted and expelled from Moghul territories.[24]

In the seventeenth century, the Mughal emperor Aurangzeb made an unsuccessful attempt to destroy the giant Bamiyan Buddhas with artillery. Another attempt was made a century later, when the Persian king Nader Afshar took his turn with cannon fire, but managed only to deface the statues. At the end of the nineteenth century, the Afghan emir Abdur Rahman—known as the "Iron Emir"—further damaged the faces of the Buddhas during a brutal repression of the local Hazara population. But the Bamiyan Buddhas, though battered, stubbornly remained standing.

Buddhist shrines were targets of belligerence in other parts of Asia, though not always for purely religious motives. In Japan, the wealth and power of Buddhists became an object of envy in a feudal society that was consolidating politically. Unlike the Bamiyan Valley at the crossroads of rival powers, Japan was an island and had no history of being traversed by insurgent and declining empires. Buddhism was integrated into the Japanese political system and became a powerful institution with its own warrior class. Buddhist shrines grew increasingly corrupted by power, however, and consequently the religion lost its transcendent authority.

The power of Buddhist shrines was the political backdrop to the turbulent period of Japanese unification in the sixteenth century. The leader of that movement was the feudal *daimyo*, Oda Nobunaga. Nobunaga was infamous for his merciless iconoclastic violence against religious statues as he secularized the country. Iconoclastic destruction of Buddhist religious symbols in Japan was not religiously motivated; it was politically driven in a secular project against religion. A contemporary Jesuit missionary in Japan reported that Nobunaga scorned all religions and claimed, "There is no Creator, no immortality of the soul, and no life after death."[25] Nobunaga was more interested in the cult of himself. He wanted to be the object of veneration as the supreme ruler of a unified Japan.

A familiar anecdote about Nobunaga's character reinforces his image as a man capable of psychopathic violence. In 1569, when inspecting *shōgun* Yoshiaki's palace, Nobunaga caught sight of a guard who was distracted from his duties by a young woman, flirtatiously lifting her veil to get a better look at her face. Infuriated, Nobunaga marched over, drew his sword, and decapitated the man with a single stroke. It was also said that Nobunaga had his enemies decapitated, their heads cleaned of flesh, and the skulls lacquered in silver so he could use them as cups to drink *saké*.

Politically, Nobunaga's "unification" policy was a massive land grab to bring the country under his authority. Since Buddhist monasteries in Japan were a formidable power base, Nobunaga targeted them for destruction. In 1569, he made his move on the Tendai monastery on Mount Hiei. He started by confiscating surrounding estates in the area near Kyoto, then led 30,000 troops against the monastery. The Buddhist priests panicked and offered gold and silver to placate him. Nobunaga refused. He claimed that he had not come to be bribed, but to punish the Buddhist priests. Realizing there was no escape, the priests abandoned their temples and scrambled to the top of the mountain for safety.

Nobunaga led his troops up the mountain and destroyed everything in his path, massacring four thousand people—priests and ordinary laymen. His soldiers chased down women and children and, despite their desperate pleas, decapitated them with swords. Every building and temple was burned to the ground. It was said that, when the slaughter was over, nothing remained alive on the mountain except foxes and badgers. This was iconoclasm as total war. It earned Nobunaga the unenviable name of Demon Daimyo—or "Devil King."

After Nobunaga successfully unified Japan, the Buddhist clergy was eradicated and thousands of their temples destroyed. Nobunaga effectively smashed and usurped Buddhism's political and economic power throughout the country. Buddhism consequently lost its status as the religious foundation of the Japanese state.

Nobunaga, for his part, died at his own hand in 1582. Betrayed by one of his own samurai generals, who had come to assassinate him during a tea

ceremony, Nobunaga chose to die with honor. Escaping into his inner rooms, he committed *seppuku* by plunging a dagger into his stomach and disemboweling himself.

After Nobunaga's death, many Buddhist priests believed his violent end had been "the Buddha's punishment" in revenge for the iconoclastic destruction of the temples on Mount Hiei.[26]

There can be no doubt that Mullah Omar was aware that his destruction of the Bamiyan Buddhas was inscribed in a long history of Islamic iconoclasm. He also knew that the Taliban's obliteration of the Buddhas in early 2001 was the completion of many other attempts over the centuries.

When the Metropolitan Museum of Art offered to pay for the removal of artifacts on the Bamiyan Buddha site, Mullah Omar repeated the words of sultan Mahmud of Ghazni a thousand years earlier to the Buddhist priests who offered him a ransom for a looted Shiva icon. He was a smasher of idols, he said, not a seller of them.

Only six months later, on September 11, the world witnessed an even more horrifying act of iconoclastic violence. Al Qaeda terrorists hijacked planes and crashed them into the twin towers in New York and Pentagon headquarters in Washington, DC. From his hideout in Afghanistan, Osama bin Laden had meticulously planned an attack on the West that would be watched on television and provoke shock and horror worldwide.

The 9/11 terrorist attacks were by far the most dramatic act of iconoclastic destruction in history. The twin towers and Pentagon were not merely buildings; they were architectural symbols of American financial and military power. The terrorist attacks were a gesture of political defiance to the West—vengeance for perceived crimes committed by the West against Muslims.

Fundamentally, the motivation for the 9/11 attacks, like the destruction of the Bamiyan Buddhas, was religious ideology. Bin Laden had declared a jihad against the United States and issued a fatwā in 1998 on behalf of a "World Islamic Front Against Jews and Crusaders." In that fatwā, Bin Laden stated,

> In compliance with Allah's order, we issue the following fatwā to all Muslims: The ruling to kill the Americans and their allies—civilians and military—is an individual duty for every Muslim who can do it in any country in which it is possible to do it, in order to liberate the al-Aqsa Mosque and the holy mosque [Mecca] from their grip, and in order for their armies to move out of all the lands of Islam, defeated and unable to threaten any Muslim. This is in accordance with the words of Almighty Allah: "and fight the pagans all together as they fight you all together," and "fight them until there is no more tumult or oppression, and there prevail justice and faith in Allah."[27]

The timing of the 9/11 attacks, within months of the Bamiyan Buddha destruction, cannot be regarded as a coincidence. Both were part of an Islamist holy war orchestrated from Afghanistan. As scholar Andreas Huyssen observed the following year:

> It is as if the dynamiting and collapse of the two statues was a carefully staged prologue to the attack on New York, symbolic actions both, intended to whip up support in the Muslim world for Bin Laden's apocalyptic Islamism. The parallels are obvious: in each, two figures, one taller than the other, like brothers, both invested in the aesthetic of the sublime, but not the terrorizing sublime that makes the spectator feel small and overwhelmed, for each allowed a view from the top—from the observation deck in the case of the World Trade Center, and from the top of the Buddha's cave at Bamiyan. In both cases, the aesthetics of the sublime represented, in the paranoid aggressive world of the Taliban and Al Qaeda, only the demonic power of the other—the other religion, the other way of life, the infidel.[28]

Another parallel between the Buddhas and twin towers was the immediate plans to resurrect them. If iconoclasm cannot exist without idolatry, the opposite also holds true. Iconoclasm inspires new forms of idolatry. The urge to restore the smashed object is just as powerful as the impulse to destroy it.

The twin towers in lower Manhattan were rebuilt on Ground Zero, not as replicas of the former structure but as a gleaming new structure, One World Trade Center. Also known as the "Freedom Tower" with the symbolic height of 1,776 feet—the year of American independence—the new structure finally opened in 2014. The site includes a 9/11 Memorial Museum, surrounded by oak trees and cubic waterfalls.[29]

In the Bamiyan Valley, many different plans were discussed to restore the giant Buddhas, including one to reconstruct them from their crumbled fragments. Finally, in 2015 a wealthy Chinese couple, Janson Yu and Liyan Hu, spent $120,000 to finance the resurrection of the Bamiyan Buddhas via hologram technology. The two giant Buddhas were projected as 3D laser images on the sandstone cliffs.[30]

If only fleetingly, the lost Buddhas were reborn, glowing brilliantly where they had stood for fifteen centuries. Their spirit had not been extinguished.

CHAPTER 2

The City of God

In the year 385 AD, hordes of black-robed religious zealots were a terrifying sight in the Roman province of Syria as they marauded from town to town. Sometimes they traveled in groups of five hundred or more, armed with iron bars as they cut a path of destruction throughout the region.

These bearded fanatics were Christians. Their targets were the "pagan" temples that had stood for centuries during the high flowering of Greek and Roman civilization.

One group of Christian militants stopped in the town of Palmyra, where they came upon the classical temple of Athena. It was a place of worship of the goddess Al-Lāt, whose cult was merged with the Greek goddess Athena. The Christian shock troops attacked the temple with furious violence. They mutilated the statue of the goddess, then decapitated Athena with a single blow. When the head hit the temple floor, her fine Grecian nose broke off. The Christians fell upon the toppled goddess and smashed the statue to pieces, chopping off the arms.

A modern-day reader cannot be indifferent to this account of shocking violence against a sacred temple in Palmyra. It evokes images of recent events in the same Syrian town: fanatical religious vandalism committed not by Christian zealots, but by Islamist fanatics. In 2015, as Syria and Iraq fell into chaos and violence, bearded ISIS soldiers rampaged through the ancient heritage site of Palmyra and used dynamite to blow up the Temple of Bel. They severely damaged the ancient statue of the Lion of Al-Lāt. They also destroyed the Roman monumental arch, constructed during the rule of emperor Septimius Severus in the early third century.

This alarming juxtaposition—ancient Christian and modern Islamist statue-smashing at the very same location—undoubtedly explains why author Catherine Nixey chose to recount the destruction of Palmyra's Temple of Athena

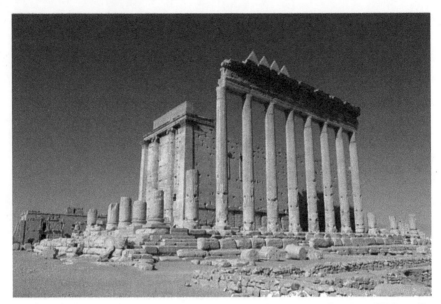

Ancient Temple of Bel, Palmyra, Syria. *Photo by James Gordon, Wikimedia* *Creative Commons.*

in the opening pages of her book, *The Darkening Age: The Christian Destruction of the Classical World.* The title succinctly states the book's main argument: many early Christians were fanatical iconoclasts determined to destroy the legacy of Greek and Roman paganism and build their own City of God on its ruins. For three centuries after the crucifixion of Christ, Christians living in the Roman Empire had been marginalized and regarded as deranged zealots. After emperor Constantine converted to Christianity in the early fourth century, however, Christians were officially empowered. Emboldened by their new status, they unleashed a campaign of furious destruction to eradicate the symbolic power of pagan temples, shrines, idols, and icons.

Some of the mutilated Greco-Roman statues we admire in museums today were disfigured by these early Christian zealots. A notable example is the Elgin Marbles in the British Museum. The famous friezes were taken from the Parthenon in the early nineteenth century. It is believed that damage to the Parthenon was the result of wars and the ravages of time, but there is strong evidence that Christians attacked and mutilated the Greek temple statues before it was converted to a church.[1] Another cherished artifact in the British Museum is a bust of the Roman general Germanicus Caesar, who was the father of the emperor Caligula. It shows clear evidence of mutilation by Christians. The nose of Germanicus is hacked off, and a Christian cross is etched on his forehead.

Catherine Nixey observes,

> During the fourth and fifth centuries, the Christian Church demolished, vandalized and melted down a simply staggering quantity of art. Classical statues were knocked from their plinths, defaced, defiled, and torn limb from limb. Temples were razed to their foundations and burned to the ground. A temple widely considered to be the most magnificent in the entire empire was levelled. Many of the Parthenon sculptures were attacked, faces were mutilated, hands and limbs were hacked off and gods were decapitated.[2]

Converting destroyed pagan shrines to Christian places of worship was common. In Monte Cassino, Italy, the founder of Christian monasticism, Benedict of Nursia, toppled a shrine to Apollo and built in its place a chapel dedicated to Saint John the Baptist. Christian fanatics plundered Greek and Roman libraries and burned "forbidden" non-Christian books in purifying bonfires.[3] The works of Roman philosopher Seneca were out; the writings of Christian theologian Saint Augustine were in. While book burnings today evoke dark images of Nazi bonfires, they would not have been controversial in the early Christian period. The practice of book burning was validated by the New Testament. In the Book of Acts, new converts to Christianity in Ephesus burned their books of sorcery.

Accounts of reckless Christian violence against the classical world revive similar views in Edward Gibbon's monumental eighteenth-century work, *The Decline and Fall of the Roman Empire*.[4] Gibbon, a product of the Enlightenment, regarded the classical world as a great civilization whose paramount virtue was reason. The fall of Rome, he argued, was hastened by the rise of Christianity and its religious culture of superstition. There was something unstoppable about this new monotheistic cult. It was, observed Gibbon, driven by an "exclusive zeal for the truth of religion." The new faith of Christianity was also fueled by sacred violence through the destruction of temples and all forms of pagan idolatry. For Gibbon, Christian iconoclastic attacks against the glorious legacy of Rome were the "destructive rage of fanaticism."[5]

It might be argued that Christian destruction of pagan shrines was long-simmering vengeance after three centuries of persecution in the Roman Empire. The narrative of Roman persecution of early Christians is a familiar legend, usually associated with the emperor Nero. In the time of Nero, a few decades after the crucifixion, disciples of Christ had arrived in Rome and were passionately proclaiming the Last Judgment. When fire destroyed Rome in 64 AD, many blamed Nero, though some believed it was the work of fanatical Christian arsonists. Roman authorities arrested Christians suspected of setting the blaze. Some even confessed. This is where the Nero persecution legend germinated. According to ancient historians, Romans rounded up Christians, whipped and tortured

them, then threw them to wild dogs. The historian Tacitus recounted how the torture of Christians was so horrific that Romans took pity on them.[6]

Today it might be tempting to describe early Christians in Rome as an oppressed minority. That is not how most Romans saw them, however. They regarded Christians as a bizarre religious sect. The ancient Roman writer Suetonius described them as "a class of men given to a new and mischievous superstition."[7] Tacitus, for his part, called Christians "notoriously depraved." Tacitus made a direct reference to Jesus Christ when describing the new cult: "The originator, Christ, had been executed in Tiberius' reign by the governor of Judea, Pontius Pilate. But despite this temporary setback, the pernicious superstition had broken out afresh, not only in Judea, where the evil had started, but even in Rome where all degraded and shameful practices collect and flourish."[8] Tacitus claimed that Nero had no particular malice against the Christians and did not have them tortured for burning Rome. The Christians were persecuted, observed Tacitus, because of their "hatred of the human race" (*odium humani generis*). This makes it clear that Christians were punished for their religious fanaticism.[9]

The irreconcilable differences between Romans and Christians were religious dogma and practices. Official Roman religion was polytheistic. A constellation of deities—Jupiter, Apollo, Mars, Minerva—was integrated into the Roman political system to serve the interests of the state. Christians were a tiny sect who had faith only in Jesus Christ, a Jewish preacher from Judea who they believed had been sent by God. Christianity was monotheistic, aniconic, and ultimately iconoclastic. Monotheism creates inflexible certitudes about the nature of the divine. There is only one God, and there can be no others. As one historian of early Christianity puts it: "The Christians asserted openly either that the pagan gods did not exist at all or that they were malevolent demons. Not only did they themselves refuse to take part in pagan religious rites: they would not even recognize that others ought to do."[10] Rejection of pagan polytheism put Christ's zealous followers on a religious collision course with Roman civilization.

In 112 AD, Pliny the Younger was a Roman governor in modern-day Turkey. He wrote to emperor Trajan of his difficulties with the local Christians who were proclaiming the end of time. The Christians also declared their hatred of Rome, which they referred to as "Babylon."[11] This could not have endeared them to ordinary Romans, much less to high-ranking officials like Pliny. Many Christians were tried and punished for adherence to their new and suspect religion. Their crime was professing faith in Jesus Christ and rejecting Roman gods and worship of the emperor. This is likely why Pliny was facing a dilemma before the Christians who had been arrested and brought to him for judgment and punishment. Overwhelmed by the task of managing the Christian nuisance, Pliny reported to Trajan that Roman citizens were converting in increasing numbers to the "depraved and fanatical" cult of Christianity.

"The infection of this superstition has spread, not only through the towns but also through the villages and countryside," he wrote to Trajan, adding that local temples had been emptied, for many had abandoned Roman religion to worship Christ. Pliny observed that Christians were singing hymns to Christ as if he were a god. He reassured the emperor, however, that "this disease can be checked and remedied."[12]

In their exchange of letters, Trajan judiciously advised Pliny that he should pardon any suspected Christians who could prove they were worshipping Roman gods.[13] Following the emperor's advice, Pliny submitted suspected Christians to an idol- and icon-veneration test. He had idols of Roman deities and a statue of the emperor brought before them. If they cursed the name of Christ and venerated the emperor's image and statues of Roman gods, they were spared. If they refused to curse Christ, they were executed.

Roman authorities were perplexed when Christians at trial refused to say anything except declaring, "I am a Christian" (in Latin: "*Christianus sum*"). Many of the accused embraced execution as martyrdom. Some were so-called "voluntary martyrs" who deliberately provoked the Romans so they would be put to death. Ignatius of Antioch was one of these Christian martyrs who, in 110 AD, was taken to Rome for his execution. Some claim Ignatius was thrown to beasts in the Coliseum for the entertainment of Romans. Ignatius wrote to his fellow Christians: "I give injunction to everyone, that I am dying willingly for God's favor. . . . Let there come upon me fire, and the cross, and struggle with wild beasts, cutting and tearing apart, racking of bones, mangling of limbs, crushing of my whole body . . . may I but attain to Jesus Christ."[14] These acts of religious self-sacrifice, which later inspired Christian martyrology, were widespread in many Roman provinces.

There can be no doubt that many Christians in the Roman Empire behaved like illuminated fanatics prepared to die to enter the kingdom of heaven. But did they commit crimes against Roman temples and shrines? Scholars have long debated whether early Christians were merely iconophobic or genuinely iconoclastic.[15] Followers of Christ were definitely hostile to idols and icons, if only because Biblical scripture explicitly prohibited them. In the New Testament, John 5:21 warns, "Keep yourselves from idols." In the Book of Acts, Saint Paul preached against idols in Ephesus where craftsmen were making silver figures of Artemis at the temple. Paul's presence among the Ephesian idol-makers provoked a riot among locals who insisted on worshipping the Greek goddess.

Debates about when exactly early Christians first turned to iconoclastic attacks on pagan statues are fascinating. So are questions about the extent of anti-pagan iconoclasm in different regions of the Roman Empire. The evidence is clear, however, that early Christians attacked and mutilated pagan statues and shrines. It is known, for example, that Christian iconoclasts were hostile to

nudity in pagan iconography. They hacked off genitalia on pagan statues and carved crosses on temple walls and targeted images.[16] By the fourth century, Christians were engaged in widespread iconoclastic assaults on pagan temples and statues. As one theological scholar put it: "In the latter part of the fourth century the destruction of pagan idols was for many Christians a virtuous act or even a duty."[17]

Christian belief in demons is important to underscore in understanding their motives. Christians saw the presence of Satan everywhere, including in statues of pagan gods. They were convinced that pagan temples were inhabited by demonic spirits. The temptation to attack and destroy these statues must have been great. Smashing pagan idols was a way of disempowering and neutralizing the demons inside them. Christian iconoclasm was, in a word, a form of deconsecration. Their iconoclastic violence was ritualized in ceremonies of religious exultation. Christians used various sacred methods—from chanting hymns to pouring holy water on pagan statues—in their attempts to expel demons from Roman temples.

This impulse to drive living spirits from statues is a recurrent theme in the history of iconoclasm. Iconoclasts fear statues because they believe they are inhabited by a life force. Violence inflicted on a statue is an attack on a living thing, as if the figure represented were still alive and in this world. The act of destruction is a symbolic form of exorcism or assassination. As art historian David Freedberg observes: "The iconoclast aims to make sure that what is dead has no chance of revival, whether in body or in spirit, and to show that in the end the image does not have the kinds of powers that transcend its material and that lead to seduction, desire, and worship."[18]

This is precisely what motivated early Christian hostility toward Roman shrines. The iconoclasm was commanded by dogmatic hostility to pagan idols and images, which in their minds were inhabited by demonic forces. Romans, needless to say, regarded Christian iconoclasm as unhinged violence committed by religious fanatics who did not fear death—and in fact embraced it. While it's true that Roman authorities had followers of Christ executed, these persecutions were more sporadic than suggested by later legends. The narrative of Roman persecutions served the purposes of Christian martyrology. It provided the new Christian cult with a heavenly pantheon of martyrs and saints who died for the cross.

Some early Christian writers doubtless exploited, and perhaps exaggerated, tales of pagan temple destruction for the same purposes of hagiography. Christian theologians of this period were aware that their tales were useful in promoting the new faith throughout the Roman world. Contemporary accounts of sacred violence against pagan temples helped forge Christian identity around the flourishing faith in Jesus Christ. The propaganda tales even followed established

literary structures. Most accounts of temple destruction ended with sudden conversions to Christ by those who witnessed the event.

While these early Christian narratives were undoubtedly literary exaggerations, there is significant written and archeological evidence to verify that acts of Christian vandalism occurred.[19] The Greek sophist Libanius, for example, addressed one of his orations, *Pro Templis* (For the Temples), to the Roman emperor Theodisius I, who was a Christian. Libanius pleaded with the emperor to protect Roman temples from the predatory violence of marauding Christian monks, who were often encouraged by their bishops.[20] Christians had been attacking not only pagan shrines but also synagogues. In 388, a band of Christian monks burned down a synagogue in the Roman town of Callinicum, or modern-day Raqqa in Syria. Libanius was not charitable in his description of the monks accused of smashing temples throughout the countryside: "Those black-garbed people, who eat more than elephants, and demand a large quantity of liquor from the people who send them drink for their chantings."[21]

Some historians claim Libanius was a polemicist whose accounts of Christian violence against pagan temples were exaggerated. This is very likely, but Christian violence against pagan statues was a clear pattern of conduct in this period. Saint Augustine was particularly fervent in his hostility toward pagan idols. In 401 AD, Augustine traveled to Carthage, where local Christians were in a state of agitation over a pagan statue of Hercules. Some had defaced the statue by hacking off the beard; others wanted to decapitate Hercules. In his sermon to a congregation in Carthage, Augustine encouraged Christians to smash tangible symbols of paganism. "That all superstitions of the pagans and heathens should be annihilated is what God wants, God commands, God proclaims!" he exclaimed.[22]

Besides reinforcing Christian identity, the destruction of pagan temples legitimized the rising power of the new religion. This, too, was consistent with the function of iconoclastic violence more generally. It marks a reconfiguration of power relations by overwriting old narratives with new forms of symbolic domination. In ancient Rome, as we have seen, demolished pagan temples were converted to Christian churches. The destruction of pagan shrines not only was designed to erase the authority of another religion but also provided sacred spaces for the new monotheistic faith. The result was a hybrid between old and new, polytheism and monotheism, pagan and Christian.

The wider context of Rome's decline cannot be neglected in understanding the acceleration of Christian triumphalism. Rome's fall in the fourth and fifth centuries was caused by a convergence of factors. Besides invasions of "barbarian" Goths, chronic war and pestilence had crippled much of the Roman world. A smallpox pandemic from 165 to 180 AD had eradicated about a third of the empire's population. Another epidemic struck a century later, adding the blight

of plague to the ravages of economic depression. At a time of widespread misery and suffering, the overstretched empire lurched slowly toward collapse. The new religion of Christianity offered an appealing counter-narrative that promised salvation and eternal life.[23]

Following the conversion of Roman emperors to Christianity in the fourth century, the once-marginal religion emerged triumphant as the pagan order collapsed. Christians were now securely in control of the narrative.

One of the most magnificent architectural achievements in the ancient world was the Serapeum in Alexandria.

A colossal marble temple dedicated to the bearded Greco-Egyptian deity Serapis, the Serapeum was built by the pharaoh Ptolemy III in the third century BC. Constructed on a plateau atop a hundred marble steps, the Serapeum rose majestically above the city and could be seen from sea as ships arrived in the Egyptian port.

At the end of the fourth century, Egypt was a target of Christian anti-pagan violence, largely because of the Greek and Hebrew cultures thriving there. In Alexandria, the local Christian patriarch was Theophilus, whose exalted title was Pope of Alexandria. Theophilus was known for his statue-smashing zeal. In 391 AD, a deadly riot erupted after local Christians plundered pagan temples and dragged their sacred objects into the streets to be ridiculed. When clashes erupted, many Christians were killed. Theophilus appealed to Roman emperor Theodisius, who responded by declaring the killed Christians as martyrs. A decade earlier Theodisius had officialized Christianity as the official state religion in 380 AD and outlawed pagan gods. Pagan sacrifices were henceforth banned. In the Roman Forum, the eternal fire in the Temple of Vesta was extinguished. Imperial decrees prohibiting pagan religion triggered a furious campaign of Christian intolerance against pagan temples, including in Alexandria.

The local non-Christians in Alexandria, fearing retribution after the deadly clashes, took refuge in the Serapeum and fortified themselves to protect its altars. Theophilus sought permission from the Roman emperor to destroy the Serapeum. Theodisius consented. Edward Gibbon tells us in his history of ancient Rome: "When a sentence of destruction against the idols of Alexandria was pronounced, the Christians sent up a shout of joy and exultation, whilst the unfortunate Pagans, whose fury had given way to consternation, retired with hasty and silent steps, and eluded, by their flight or obscurity, the resentment of their enemies."[24]

Led by Theophilus, a militia of Christian monks set about demolishing the Serapeum and its colonnaded court. At first they were hesitant to molest the enormous, bearded statue of the Serapis, believing that touching the pagan god

would provoke an earthquake. The Christians detested the pagan idol, but they also feared its power. The mood changed, however, after a Roman soldier struck the deity on the jaw with no consequences. When mice scurried out of a hole in the god's head, the sky did not fall. The Christian monks now felt emboldened in their resolve to destroy the idol. They attacked the statue, ripping the head from the torso and chopping off the feet with axes. They hauled the mutilated statue into the amphitheater and burned it to ashes in a purification ritual—a reenactment of Moses burning the golden calf before grinding it into powder. On the site of the Serapeum, a Christian church was built with a tomb for the bones of Saint John the Baptist. Conquering Christ had triumphed over pagan idols. Alexandria was now a Christ-loving city.[25]

In the same city, the woman philosopher Hypatia became a target of fanatical Christian shock troops a generation later. Daughter of the great mathematician Theon, Hypatia was head of the Platonist school in Alexandria. In the early fifth century, Christian fanatics, known as *parabalani,* were all-purpose members of a Christian brotherhood. They sometimes performed good works, such as caring for the sick and burying the dead. But they also performed terrible deeds. They served as bodyguards and operated as death squads. The fate of Hypatia revealed how gruesome their business could be.

Christians had already destroyed the Serapeum and demolished the pagan shrines and busts of Serapis. The Great Library was also gone, and many of the city's intellectuals had fled. Hypatia, now sixty years old, was a celebrated philosopher who had remained in Alexandria. Christians, however, regarded her as a vestige of the pagan culture that needed to be purged. The new bishop in Alexandria was Cyril, a nephew of Theophilus, who had ordered the destruction of the Serapeum. Cyril had already orchestrated a violent attack against the city's Jews, expropriating their synagogues and turning them into churches. His next target was Hypatia. The pretext was a rumor that she was using mathematical instruments—tools of the Devil—to advance her ideas.

During Lent in March of 415 AD, a gang of *parabalani* confronted Hypatia in the city. They ordered her out of her chariot and dragged her through the streets to a church. Inside the place of Christian worship, they ripped the clothes from her body, flayed her skin with the sharp ends of broken tiles, and tore off her limbs. Her remains were burned in a mock pagan sacrifice.[26]

For many, Hypatia's gruesome assassination marked the death of the ancient world. The violent events in Alexandria rivaled in their far-reaching consequences the Visigoth sack of Rome five years earlier in 410 AD. The radiant civilization of the Greeks and Romans was now sliding into the Dark Ages.[27]

Christian "triumphalism" can be overstated. Historians stress that the transition from paganism to a Christian civilization was a gradual process, not a dramatic rupture.[28] The status of Christianity often depended on the emperor

in Rome. Anti-pagan laws had begun under Constantine, who destroyed the temple of Aphrodite built by emperor Hadrian on the Golgotha site where Christ had been crucified. Yet even Constantine, who famously "converted" to Christianity, was almost certainly a pagan. He identified with the god Apollo (coinage depicted him as *Sol Invictus*, or the "unconquered sun"). The emperor Julian, who ruled from 361 to 363 AD, rejected Christianity and brought back Hellenistic culture. Julian is remembered as the last pagan emperor of Rome. The Catholic Church referred to him unflatteringly as Julian "the Apostate" to emphasize his rejection of Christian beliefs.

By the end of the fourth century, however, Christians were officially empowered by imperial decrees and laws. The slogan "one God and his Christ" was pervasive. This period, known as the "persecution of the pagans," turned the tables on the more enduring myth of the Roman persecution of Christians. Violent attacks on pagan temples were often enflamed by the overheated rhetoric of monks and Church leaders. Roman praetorian prefects also supported the new religion. One was Maternus Cynegius, infamous for his iconoclastic campaigns in Syria and Egypt, including the destruction of the Zeus Belos in Apamea. It was Cynegius who ordered the attack on the temple in Palmyra dedicated to the goddesses Athena and Al-Lāt.

As Christians established themselves in the Roman world, they disseminated their own iconography despite Biblical prohibitions. In the New Testament, Christ says to his disciples, "He that hath seen me hath seen the Father."[29] Images of Christ were rare in the early period, but by the fourth century they were circulating. The Christian theologian Eusebius—who was also emperor Constantine's biographer—refused to oblige a request from the emperor's sister asking for an image of Christ. Eusebius cited the Second Commandment prohibiting graven images and asked, "Are not such things excluded and banished from churches all over the world?"[30] This clearly suggests that, despite Eusebius's stern reminder, images of Christ were in demand, even at the highest levels of the imperial court.

Christian iconography in Late Antiquity, not surprisingly, took inspiration from Greek and Roman themes. The image of Christ as a shepherd tending to his flock, for example, was borrowed from Greek and Roman mythology. Christ was also represented as the god Apollo, which followed the Roman tradition of emperors venerating the sun god, including Augustus, Nero, and Constantine. When Constantine consented to the destruction of pagan idols, he insisted on one self-serving exception: images of himself. The emperor cult would be maintained. "Christian art was slowly developing," observes Alain Besançon in *The Forbidden Image*. "Immediately after Constantine's conversion, the Christian image, which had originated in the age of graffiti, proliferated and entered into constant dialogue with the imperial image."[31] Depictions of Christ were based on

monumental models of the Roman emperor—or so-called "Emperor Mystique" iconography.[32]

Christian destruction of pagan statues continued after the fifth century, but very little new statuary was produced. This was partly due to the decline in technical skills and lack of raw materials in Late Antiquity. There was also an abrupt decline in imperial statuary, probably because of the growing preference for iconography and mosaics, but also because statues of emperors were becoming targets of violence.[33] Christians were now attacking statues of Greek deities and Roman emperors, often disfiguring them before tossing them into wells and drains. The hallmark of Christian violence inflicted on these statues was a hacked-off nose and a cross carved into the face. A statue of emperor Augustus discovered in Ephesus was "Christianized" with a cross cut into the forehead. A basanite bust of Roman general Germanicus, today on display at the British museum, suffered a similar fate.[34] In Athens, Christians mutilated and inscribed crosses on temples and shrines before turning the structures into churches. Reactions to pagan temples and statues ranged from Christianizing and reinterpreting to total destruction.[35]

Once the Christian faith was spreading throughout the Roman Empire, church leaders realized that idols were useful tools to convert pagans. In Rome, the popes used images, idols, frescoes, stained glass, and tapestries as marketing tools for religious propaganda. Icons and idols gave illiterate worshippers a visible connection to the Christian narrative. In churches, scenes from the New Testament such as the Resurrection were transformed into stained-glass narratives. The growing Christian fixation on contact relics also enhanced the value of images, objects, and idols. Christian veneration of images, and the belief that they possessed miraculous powers, created a lucrative market for sacred relics. Church defenders of images claimed that they evoked powerful emotional responses and intensified piety in the faithful.

In the eight century, however, an iconoclastic countermovement resurfaced in Byzantium. It was led by Byzantine emperor Leo III in Constantinople. It may seem ironic that a Byzantine emperor was so hostile to images, given the rich visual legacy associated with Byzantium. But the Byzantine court adopted an official, unified policy against religious icons and idols.

Some claimed Leo III's iconoclasm was due to superstition. In 726 AD, he had been terrified by a volcanic eruption in the Aegean Sea with a plume of smoke and ash that extinguished sunlight over the entire region. Leo believed the tent of darkness was a sign of God's wrath at Christian image veneration. More likely, the Byzantine emperor was becoming increasingly anxious about aggressions from invading Muslim armies. Since the death of the prophet Mohammad in 632 AD, Muslims had conquered roughly two-thirds of Byzantine territory.

The invaders, in keeping with Islamic practices, were stridently opposed to all forms of idolatry. Yazid II, the Muslim caliph from 720 to 724, had ordered the destruction of all icons in Christian churches across the Caliphate.

In Byzantium, the veneration of images was widespread although opposed by the Church hierarchy. The masses of faithful saw and felt divine presence in sacred icons. Icon veneration offered everyone communion with Christ, the Virgin, and saints. The educated clergy and literate elites, on the other hand, tended to be against icons. The proscription of images reinforced their hierarchical power based on the written word in the Bible, the spoken word in church, and the sacrament of the Eucharist.[36]

In the early eighth century, opposition to icons began to build in Byzantine's ruling class and at ecumenical councils. In 726, the year of the volcanic eruption in the Aegean Sea, Leo III banned all icons and idols, decreeing that images of saints, martyrs, and angels were accursed. Christians found guilty of icon veneration were persecuted, tortured, and killed. Monks, who generally supported icons, were arrested and forced to break their monastic vows. Many went into exile in the Western empire, where the Church in Rome was more sympathetic to icons.

Pope Gregory II was the Byzantine emperor's main adversary in the schism over icons—or Iconoclasm Controversy. The Pope was an ardent advocate of sacred icons. The conflicting positions on icons could be explained by the different perspectives on the question in Byzantium and Rome. Whereas the official Byzantine position was shaped by a metaphysical view of images, the popes tended to regard images more pragmatically as a form of rhetoric. Or to put it another way, images were helpful in propagating the faith. The pope grasped that the power of images inspired awe and wonder in the hearts of the faithful. For the Church, images were the "books of the unlearned."[37]

Relations between Leo and Gregory became strained when the Pope refused to comply with the Byzantine emperor's decree against icons. The Pope moreover convened a synod to condemn iconoclasm. He dispatched letters to Leo III reminding him that the Byzantine emperor had no authority over Church dogma. Enraged, Leo organized a plot to assassinate Gregory, but it was foiled.

Pope Gregory's view on icons ultimately prevailed. In 787 AD, icon veneration was official reestablished at an ecumenical council at Nicaea. It was later reaffirmed after a second Church schism over icons in the early ninth century. Despite Biblical interdictions, the Church was officially idolatrous and iconophile. Certain points of theology had to be observed, however. Christ could be only depicted in his humanity. Also, icons could be venerated but not "adored." Adoration was due to God alone. Thanks to these subtle theological distinctions, from 843 AD icons enjoyed pride of place in the official Church narrative—until they were challenged yet again during the Reformation.

The portrayal of early Christians as iconoclastic destroyers of temples and icons continues to be contentious today. There is a tendency to underplay the destructiveness of early Christian iconoclasm, or to justify it by framing the violence in a noncritical way. "Modern scholarship, influenced by a Judeo-Christian cultural bias, has sometimes sought to present Christian desecration in a positive light," observes art historian John Pollini. One argument is that Christians were not destroying, but preserving, pagan monuments by converting them into churches.[38]

In 2009, the Greek movie director Costa Gavras learned firsthand about these sensitivities. Gavras produced a short film for the Acropolis Museum about the history of the Parthenon. The film featured a scene in which black-cloaked Christians are climbing up the famous Athenian temple to destroy the frieze. When the film was completed, the Greek Orthodox Church protested the film's depictions of Christians as violent smashers of idols. The Acropolis Museum at first agreed to cut the offending scene from the film. But Costa Gavras protested, calling the museum's decision "Soviet-style censorship."

"What the clergy did back then, smashing the marbles, they are doing today (to this film)," Gavras said. "If they want to show it this way . . . my name can't be on the film."[39]

The Acropolis Museum finally agreed to show the film uncut. Gavras reassured the Orthodox Church that the black-cloaked figures attacking the Parthenon were not presented as priests, but as ordinary Christians.

In the early morning hours on April 7, 2021, seven women armed with hammers and chisels showed up at Barclays' bank headquarters in London's Canary Wharf. With mechanical gestures, they began attacking the building's façade, hammering their chisels into the bank's glass doors. One of the protestors plastered a message on the entrance: "In case of a climate emergency, smash glass." One of the chisels was inscribed with the words, "For my grandson."

The well-dressed women hardly looked like violent fringe radicals. But the hourglass logo on their masks—warning that time was running out for the survival of the planet—left no doubt that they were Extinction Rebellion activists. They also wore patches emblazed with the slogan, "Better broken windows than broken promises." The seven women were attacking the Barclays headquarters to protest against the bank's investment in fossil fuels.

When their window-smashing protest was over, the seven women sat quietly in front of the building's entrance, legs crossed in a yoga-like position, and waited for the police to come.

"You may dislike our action today but I ask you to compare a crack in a window to funding wildfires and flooded homes," said one of the protestors,

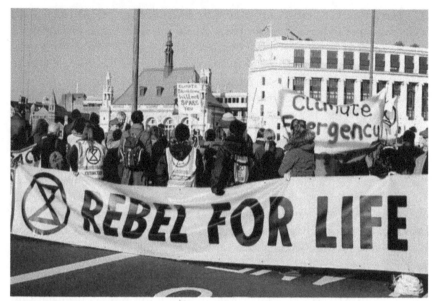

An Extinction Rebellion protest. *Photo by Julia Hawkins, Wikimedia Creative Commons.*

thirty-year-old Sophie Cowne. "We took action today because someone needs to raise the alarm, because broken windows are better than broken futures."[40]

Extinction Rebellion's performative protests have attracted media attention around the world, and they are exceptionally skilled at attracting publicity. This carefully stage-managed act of iconoclasm was no different. The attack on Barclays' bank glass doors was filmed at close range and posted on social media for maximum effect.

Today many are sympathetic toward Extinction Rebellion's theatrical acts of vandalism that bring attention to the responsibility of global corporations in the destruction of the environment. Others regard the movement's actions with exasperation, dismissing them as fanatics. Extinction Rebellion critics often describe the movement using terminology normally associated with religions. The term *cult* is frequently used. The movement is called a "doomsday cult," a "millennial cult," even a "death cult."[41]

Extinction Rebellion—known as "XR"— has no official links to any organized religion, and proclaims no belief in the supernatural. Given their interest in climate change, it could even be argued that XR activists are intensely focused on the here-and-now of the planet's material survival. One would expect them to be closer to Marx than to metaphysics. And yet the movement possesses many traits of zealous religious sects.

It could even be argued that Extinction Rebellion bears an uncanny resemblance to the early Christian iconoclasts in the Roman Empire. Like the Christians who revolted against pagan Rome, Extinction Rebellion activists strike against power structures that they regard as corrupt and evil. Like Rome as Babylon in the eyes of early Christians, for Extinction Rebellion adepts the empire of evil is global capitalism. Also, like Christians in Late Antiquity, the Extinction Rebellion movement is fueled by an apocalyptical vision—not the coming of the Lord, but the imminent destruction of the planet. And its adherents are driven by a cult-like devotion to their system of beliefs and a fearless culture of defiance against authority. Early Christians actively sought martyrdom under the Romans. Extinction Rebellion adherents similarly commit acts of vandalism for which they know they will be arrested and punished. More significantly, followers of Extinction Rebellion use vandalism as a form of protest against the power system they despise. Breaking the glass doors of a global bank is akin to smashing a pagan temple.

If this analogy seems overreaching, firsthand accounts of Extinction Rebellion protests underscore the quasi-religious dimension of the movement. At a protest in London's Oxford Circus in 2019, one XR member named Sarah Zaltash was preaching in the unmistakable language of spirituality. "There is nothing greater than oneness," she proclaimed. "There is no God, no H&M, no Piccadilly, none of that is greater than oneness. . . . *Hayya 'ala I-falah*. Come to sanctuary. Come to success. Cause that's how important it is to stay safe. . . . *Hayya 'ala s-salah*. Which means come celebrate. Come worship. Come pray." When the police showed up, Zaltash shouted at them, "We're in the middle of prayer!"[42] Other Extinction Rebellion rituals have made a connection to Christianity explicit. On the day of the Last Supper, commemorating Christ's washing the feet of his disciples, Extinction Rebellion organized a ceremonial foot-washing for protestors to "serve, nurture and bless activists."

Stefan Skrimshire, a professor of theology, made the following observation about Extinction Rebellion:

> It is no wonder that alongside the movement's political objectives is the nurturing of the "skill" of broken heartedness. This requires forms of protest that can also facilitate a kind of witness for which acts of liturgy and prayer could appear, to some, the most appropriate vehicles. This goes not only for grief but also for joy, since the protests are also exuberant acts of celebration through music, dance and theatre, providing a chance to reconnect with others and express gratitude for creation.[43]

Another scholar, Cullan Joyce at the Catholic Theological College in Melbourne, highlights the connection between Extinction Rebellion and early Christianity

around the theme of an apocalypse: "Elements of New Testament Christianity provide a context for understanding XR as a response to an apocalypse."[44]

Extinction Rebellion even enjoys official support from some religions and has a Christian wing called "Christian Climate Action." In Britain, some Anglican bishops have urged Christians to support the XR movement. Other church leaders are more skeptical, however. In an article titled "Extinction Rebellion—the New Religion with Greta as Its Saint," Church of Scotland minister W. C. Campbell-Jack observes:

> In this quasi-religion, science is overshadowed by the spiritual fervor of the well-meaning middle class who at last have found a fashionable cause they can follow. . . . Not having faith in the God of the Bible, they have substituted a fundamental belief in the morality of their cause which gainsays rational discussion. The Extinction elect who are so blindly assured of the righteousness of their faith even have a secular saint whom they idolize, one upon whose every word they hang, whose condemnations are received as blessings.

The "saint" is teenaged activist Greta Thunberg, who attracted global media attention for a speech at the United Nations where she warned, "Time is running out, but it's not too late."[45]

The attraction of quasi-religious ideology is not exclusive to left-wing climate activism. On the far right, conspiracy movements such as QAnon are frequently described as religious cults. On January 6, 2021, the mob of right-wing protestors who stormed the U.S. Capitol were not much different from the early Christians assaulting Roman temples. Protestors stormed the building, smashed through its doors, and vandalized the interior of the Congress—not unlike the fanatical Christians who demolished the interior of the Serapeum in Alexandria.

It is not coincidental that the QAnon conspiracy movement in America has attracted a large number of evangelical Christians. QAnon followers believe in "prophecies," regard Donald Trump as their "savior," and describe their adversaries as "Satanists." They see themselves as rising up against a power structure, sometimes called "Deep State," sometimes described as a "New World Order." In May 2021, a headline in the *New York Times* reported on a poll: "QAnon Now as Popular in U.S. as Some Major Religions."[46] When protestors stormed the U.S. Capitol, one of the rioters on the Senate floor shouted from the dais, "Jesus Christ, we invoke your name!" Nearby, a rioter calling himself "QAnon Shaman"—wearing a fur hat and bull horns—prayed into his megaphone:

> Thank you, heavenly Father, for being the inspiration needed to these police officers to allow us into the building, to allow us to exercise our rights, to allow us to send a message to all the tyrants, the Com-

munists, and the globalists, that this is our nation, not theirs, that we will not allow the America, the American way of the United States of America, to go down. Thank you, divine, omniscient, omnipotent, and omnipresent creator God for filling this chamber with your white light and love, your white light of harmony. Thank you for filling this chamber with patriots that love you and love Christ.[47]

The feverish behavior of modern-day culture warriors—on both radical left and far right—follows the same pattern as fanaticism of early Christian zealots. They start with claims of victimhood under a larger power structure, then engage in performative acts of civil disobedience, followed by more violent tactics of iconoclastic destruction and even martyrdom. Their iconoclastic violence can be understood as a form of discourse, speech by other means, that seeks to discredit adversaries, topple established institutions, and impose their own moral authority.

In our age when political ideologies have become secular religions, activist zealots are committing acts of iconoclastic violence as ritualized demonstrations of their commitment to moral purpose and purity.

CHAPTER 3

Damnatio Memoriae

On July 21 in 356 BC, an obscure arsonist of uncertain origins called Herostratus committed an unspeakable act in the prosperous city of Ephesus. He set fire to the sacred Temple of Artemis.

In Ephesus, on the west coast of modern-day Turkey, the worship of Artemis was a Hellenized version of a regional cult of an Anatolian goddess. The colossal temple to the Greek goddess was—along with the Egyptian pyramids and hanging gardens of Babylon—one of the seven wonders of the world. The Roman writer Pliny the Elder described the massive temple, with its 127 columns standing sixty feet high, as "the most wonderful monument of Græcian magnificence."[1] The goddess of fertility and childbearing held special meaning in Ephesus, where Artemis was venerated as the protector of the local population.[2]

The famous temple had already been destroyed by flood in the seventh century BC, but it had been reconstructed in marble a century later in 560 BC. The fire lit by Herostratus in 356 BC razed the structure in only a few hours. Reduced to a smoldering ruin of charred marble, the temple's destruction caused great wailing and lamentation among the Ephesians.

Herostratus was arrested and confessed. His motive for setting the blaze, he said, was to achieve ever-lasting fame. He was seeking *kleos*—or glory—for having destroyed the sacred Temple of Artemis.

Herostratus was executed for his sacrilege. But Artaxerxes III, the Achaemenid "king of kings," wanted the arsonist punished beyond the grave. To ensure that Herostratus never achieved his professed goal of everlasting fame, he was sentenced to damnatio memoriae. His name and memory were condemned to eternal oblivion. It was henceforth forbidden to even mention the name of Herostratus.

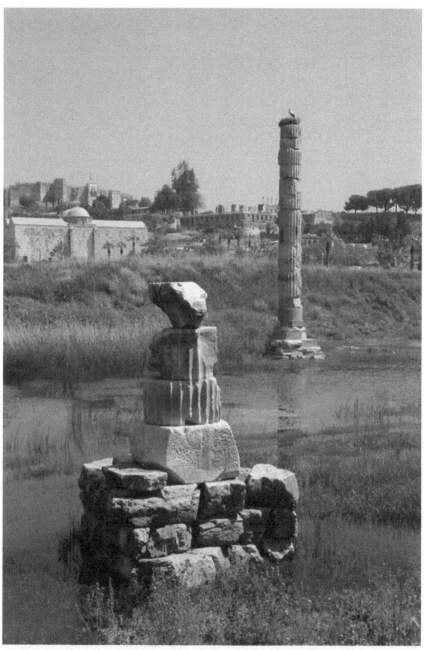

The remains of the Temple of Artemis in Ephesus, one of the seven wonders of the ancient world, outside Selçuk, Turkey. *Photo by Simon Jenkins, Wikimedia Creative Commons.*

The fact that Herostratus's name is being mentioned here, in these pages more than two thousand years later, demonstrates that posthumous damnatio memoriae did not produce the desired result. Therein lies the fundamental paradox of the sentence: it does not erase memory; it prolongs memory of both perpetrator and disgraceful act.[3] The unmentionable name becomes embedded in the popular imagination. Even in the ancient world, the historians Strabo and Theopompus mentioned Herostratus, though Cicero and Plutarch only referred to his shameful act without giving his name.

Today, the name Herostratus has entered the language to describe someone who commits a horrendous crime to achieve notoriety—or "Herostratic fame." The ancient arsonist was a precursor of the all-too-familiar modern psychopathology of fame-seeking through criminal violence. We live in a culture where anonymous individuals can give meaning to their lives by committing an unspeakable crime and attaining notoriety for it. In most cases, the targets of these irrational impulses are cherished icons: sometimes famous monuments and statues, sometimes famous people venerated as idols.

Following John Lennon's murder in New York City in 1980, his assassin admitted that he had shot the iconic Beatle to usurp his fame. The assassination of the pop icon was a desperate claim on notoriety. The same motivation was ascribed to Lee Harvey Oswald, the assassin of John F. Kennedy. Oswald was one of life's mixed-up losers who achieved infamy by shooting the president of the United States while Kennedy was riding in a motorcade through the streets of Dallas.

The existentialist philosopher Jean-Paul Sartre evokes this anti-hero archetype in his short story "Erostratus." Inspired by the tale of Herostratus, Sartre's story is about a Parisian man, Paul Hilbert, who suffers from insecurity and sexual impotency. Looking down at the streets from his seventh-floor balcony in Montparnasse, he observes other people with contempt. Hilbert eventually procures a pistol with six bullets and decides to murder people randomly in the streets to achieve notoriety. Sartre's story, published in 1939, foreshadowed the modern era of isolated narcissists striking out for recognition through rampage killing. For Sartre's anti-hero, violence is a desperate claim on personal identity. In the end, however, he fails to follow through with his planned mass shooting. On a Montparnasse boulevard, he shoots one man in the stomach three times, shouting "rotten bastard," then flees from a crowd of witnesses who give chase. He takes refuge in a café and locks himself in the lavatory with no escape.[4]

In the post-9/11 world, Herostratus has become the prototype for the publicity-seeking mass murderer or terrorist whose aim is to shock world opinion. Experts in terrorism sometimes use the term *Herostratus Syndrome* when assessing the motives for blowing up buildings and flying airplanes into skyscrapers.[5] Ethnologist Pierre Centlivres drew a connection between the burning of the

Temple of Artemis and the Islamist demolition of the Buddhas in Afghanistan more than two thousand years later. The Taliban destruction of the Bamiyan Buddhas, argued Centlivres, "shows intriguing similarities with the destruction of Artemis Temple: the eradication of a monument, sacred as well as emblematic and belonging to the cultural heritage, an attack against piety and beauty, a religious offence and an outrage to an art monument. In other words, a sacrifice in all its ambiguous meanings."[6]

Followings its destruction by fire, the Temple of Artemis was reconstructed and rose again from its ashes. It achieved renewed fame under the Romans when the Christian apostle Paul visited Ephesus to spread the gospel of Christ. It was in Ephesus, circa 55 AD, that Paul provoked a riot among the idol-makers who were selling figures of Artemis at the temple. Paul's anti-idolatry preaching threatened their idol-selling business. The Book of Acts recounts how a silversmith named Demetrius led a rebellion against Paul. When the riot broke out, the locals began chanting, "Great Artemis of the Ephesians!"[7] Paul was obliged to flee hastily from the city.

The Temple of Artemis appears elsewhere in the New Testament, this time in the apocrypha about the works of apostle John in Ephesus. This story is remarkable for its dramatic iconoclasm. Around 64 AD, after apostle Paul had been decapitated in Rome, John was in Ephesus building a Christian community there. On the Artemis festival day when worshippers of the goddess were dressed in white, John showed up at the temple in black. Offended by his impiety, a furious crowd was on the verge of attacking him. John scaled a pedestal and threatened the mob with the power of the Christian God. Miraculously, the temple's altar was suddenly torn asunder. Sacred vessels crashed. Images of the Ephesian deities smashed to the ground. The entire temple collapsed, killing the priest of Artemis. The astounded crowd was so shaken and terrified that they cried out for mercy, lying on their faces in supplication, tearing their clothes and weeping. They converted instantly to Christianity. Through John's awe-inspiring act of iconoclasm, monotheism triumphed over pagan gods and their idols.[8]

The Temple of Artemis was finally destroyed for good. In the third century AD, marauding Germanic Goths invaded Anatolia by sea and laid waste to the region's major cities. When they plundered Ephesus, the famous temple was not spared. Reduced to a ruin, the temple became a quarry, its marble fragments used to build a new Byzantine city. Today, little remains of the once-glorious Temple of Artemis.

More than two thousand years later, we don't recall the name of the architect who designed the Temple of Artemis. Yet we still repeat the name of the man— despite his damnatio memoriae sentence—who burned it to the ground in 356 BC.

Four years before the 9/11 attacks, a terrorist bloodbath occurred on the banks of the Nile near Luxor.

On November 17, 1997, six Islamist gunmen stormed the mortuary temple of the Egyptian pharaoh Hatshepsut. The terrorists first shot armed guards outside the pharaoh's tomb. Once inside, they systematically murdered dozens of foreign tourists, shooting and butchering them with machetes while shouting, "*Allahu Akbar!*"

Following the massacre, the gunmen engaged in a three-hour stand-off with Egyptian security forces as gunfire cracked through the Valley of the Kings, famous for the tomb of Tutankhamen. All six gunmen were shot dead. Egyptian police later arrested 45 militants belonging to the Islamist terrorist group Jamaa Islamiyya, devoted to the overthrow of the Egyptian government.

The death toll of innocent victims was horrific. Fifty-eight tourists were murdered, most of them from Switzerland, Germany, and Japan. Six Britons, including a five-year-old girl from England, were also among the dead.[9]

The Luxor massacre, as it was later called, dealt a devastating blow to tourism in Egypt. It also, tragically, brought international attention to the ancient pharaoh Hatshepsut, whose magnificent funerary temple was the site of the atrocity.

Hatshepsut, who ruled from 1479 to 1458 BC, was a unique pharaoh for many reasons. Most remarkably, Hatshepsut was a woman—but she ruled as a male. Her iconography changed over time, transforming female traits to more male characteristics as she assumed the identity of kingship. Hatshepsut is also known as the pharaoh who was officially sentenced to a damnatio memorie curse.[10] A thousand years before the Greeks, the erasure of memory on statues and icons was practiced by the Egyptians.

Following Hatshepsut's death, her stepson and successor, Thutmose III, had her name eradicated from history. At her mortuary temple in Deir el-Bahari, statues of Hatshepsut were ripped out and dumped in a quarry. Her name was erased from all public records.[11] There is some dispute about when precisely this happened—immediately after her death, or many years later. There is also debate about Thutmose's motives behind the erasure of his stepmother. An important clue is that Hatshepsut had been Thutmose's regent during his youth. It is possible that Thutmose never forgave his stepmother for ruling in his place, even though there is evidence that she was a wise and skillful pharaoh. She undertook ambitious construction projects—temples, obelisks, icons, sculptures. Shrines to many deities were placed in Hatshepsut's own temple to enhance her reputation as a divine-right ruler.

Thutmose's damnatio campaign against the memory of his stepmother was tremendously efficient. Every inscription about her was erased. In some instances, Thutmose replaced her name with that of his father, Thutmose II.

So effective was the erasure of her memory that Hatshepsut's name was never mentioned by later Egyptian scribes, and her great works were credited to other pharaohs. Hatshepsut's existence was not discovered until the early nineteenth century, when French orientalist Jean-François Champollion—famous for deciphering the Rosetta Stone—figured out the mystery from examining statuary. A male pharaoh had in fact been a woman, Hatshepsut.[12]

Like Hatshepsut, the pharaoh Akhenaten also suffered a damnatio memoriae curse. Akhenaten, who ascended to the throne in 1345 BC, had a large misshapen head and an androgynous appearance in his depictions. His queen was the famous Nefertiti. His son and successor was even more famous: Tutankhamun, commonly known today as "King Tut." As pharaoh, Akhenaten moved his capital from Thebes to a new location in Amarna. More importantly, he broke with Egypt's polytheism of multiple deities to pursue a policy of monotheism around a cult of the sun god, Aten.

Akhenaten was, in that respect, a precursor of the Biblical tradition of Moses and Abraham, who insisted on the existence of only one God.[13] Akhenaten proclaimed Aten as "sole god" and changed his own name from Amenhotep IV to Akhenaten, for "servant of Aten." Under Akhenaten's rule, temples to traditional deities were closed and shrines to Aten were constructed throughout the kingdom. At the temple of Hatshepsut, he had the name of Egyptian god Amun erased and replaced with the name of Aten. His rejection of Amun in favor of Aten brought the additional expedience of eliminating the powerful priesthood who controlled Egypt's polytheistic religion.[14]

Akhenaten's monotheistic legacy met the same fate as Hatshepsut's reign. His son Tutankhamun brought back Egypt's traditional polytheistic worship of multiple gods. Tutankhamun's counter-revolution to undo his father's "Atenist heresy" involved an ambitious scheme to repair and restore monuments, inscriptions, and shrines of old deities.[15] Temples of Aten were demolished. Akhenaten's statues were destroyed and his name erased from the list of kings. Akhenaten was forgotten entirely for twenty-five centuries, until the nineteenth century when the existence of the "heretical" pharaoh was discovered.[16]

The Greeks and Romans, following the Egyptian tradition, inflicted damnatio memoriae as punishment by memory erasure. In the Hellenistic world, where religious and civic spheres were merged, anthropomorphic statues of living deities were omnipresent in the civic space so citizens could give praise to the gods. Also visible everywhere in Greek cities were herm statues. They were rectangular stone pillars featuring the bearded head of Hermes, god of travelers, with his erect phallus pointing upward. Herm statues, which were believed to ward off evil, were placed in front of doorways, on street corners, in the agora, and along roads.

In 415 BC, Athenians awoke one morning horrified to discover widespread destruction of herm statues. The statue faces had been mutilated and their erect penises hacked off. The timing of this act of public vandalism was suspicious. At that very moment, Athens was engaged in the Peloponnesian War with Sparta and was about to launch a naval attack against the enemy. The profanation of Hermes statues seemed like a terrible omen. The ancient historian Thucydides tells us that great rewards were offered to anyone with information about the perpetrators of this sacrilege.

"The matter was taken very seriously," wrote Thucydides, "for it seemed to be ominous for the expedition and to have been done in furtherance of a conspiracy with a view to a revolution and the overthrow of the democracy."[17]

Some believed, as Thucydides suggested, that the vandals had been part of an oligarchic conspiracy against Athenian democracy. Others insisted that the destruction had merely been the handiwork of reckless youths belonging to a drinking club. Two dozen suspects were finally arrested. Some of the accused were put to death; others had their property confiscated.[18] The destruction of property as memory erasure was a common punishment in ancient Greece. It found its origins in Greek tragedies which recounted how the gods destroyed the houses of the wicked. The razing of a house was a symbolic act that marked the ruin of an entire family or aristocratic dynasty.

Since Greek aristocrats displayed their power by erecting elaborate funerary monuments, these also became the target of iconoclastic violence. In some cases, graves were attacked and bodies dug up. Corpses were tossed outside the city in a morbid ceremony of postmortem exile. Eradication of memory was thus associated, physically, with denial of burial. For grievous crimes such as treason, an entire family could be disinterred and their bones cast outside the city walls. The Greeks also prominently displayed the names of traitors and criminals on public *stelai* to ensure that their disgrace endured. This was the opposite of damnatio memoriae, which was meant to erase memory. Public inscriptions on stelai were a wall of shame whose purpose was to evoke disgrace and reinforce the values of Athenian democracy.[19]

Athenians were shocked when Alcibiades, one of the generals commanding the Athenian fleet against Sparta, was accused of taking part in the mutilation of the herms. Famous for his male beauty, Alcibiades was a student of Socrates and adopted son of the Athenian leader Pericles. He denied the charges against him and accepted to face trial upon his return from a military expedition. No matter, he was sentenced to death *in absentia.* On the run from Athenian law, Alcibiades defected to the enemy Spartan camp. This gave the iconoclastic outbreak against the herms enormous political and military significance. In exile, Alcibiades advised the Spartans on how to defeat the Athenians—which is precisely what happened at the conclusion of the Peloponnesian Wars.

The birth of Athenian democracy had its own idolatrous legend through the tyrant-slaying male lovers Harmodius and Aristogeiton. In the middle of the sixth century BC, the tyrant Peisistratos had seized power by overthrowing the old aristocratic regime. Peisistratos ruled by reducing the powers of established elites and pandering to common Athenians. He instituted the Panathenaic Games, an athletic and religious festival that combined sporting and musical events with sacrifices to the goddess Athena in the Parthenon. He also inaugurated a festival in honor of Dionysus, god of wine and sensual pleasures. Peisistratos was succeeded by his son Hippias, who ruled jointly with his brother Hipparchus.

Two aristocratic male lovers, Harmodius and Aristogeiton, were opposed to the tyranny of the Peisistratids dynasty. In 514 BC, they concocted a plan to rid Athens of the ruling clan by assassinating Hippias and Hipparchus. The double murder was carefully planned for August during the religious procession at the Great Panathenaea festival. When the fateful day arrived, just before beasts were to be sacrificed, Harmodius and Aristogeiton set upon Hipparchus and stabbed him to death. The slain tyrant's bodyguard killed Harmodius on the spot. Hippias, who survived the assassination, had the other assassin, Aristogeiton, executed.

The historian Thucydides claimed that the motive for Hipparchus's assassination had not been a noble political aim, but a love dispute after Hipparchus attempted to seduce Harmodius. In short, the motive was *eros*, not *demos*. Whatever the motivations, the murder of Hipparchus failed to rid Athens of tyranny in the short term. Following the death of his brother, Hippias became paranoid and unleashed even greater repression on the population. Four years later, however, Hippias was overthrown and fled into exile in Persia. Finally, after the fall of the Peisistratids tyranny, the great epoch of Athenian democracy in the fifth century BC was born.

Athenians celebrated the martyred tyrant-slayers Harmodius and Aristogeiton with an idolatrous cult. Statues of the two assassins were erected in the Athenian agora.[20] The bronze statues were sculpted in the neo-Attic classical style. They showed both men naked, clean-shaven Harmodius with his upraised right hand about to stab the tyrant, and bearded Aristogeiton thrusting one arm forward in a similar gesture of attack with a sword. The statues, known as the *Tyrannicides*, became revered symbols of Athenian freedom. They ranked among the most venerated statues of Antiquity.[21]

The *Tyrannicides* were so famous that they were coveted as trophies by enemy Persians during the sack of Athens in 480 BC. Following the historic Persian victory at Thermopylae, the armies under Xerxes I cut a path of destruction through Greece. Most Athenians fled the city. Only a few remained behind to defend the Parthenon. Overwhelmed by the Persian invaders, many threw

themselves over the Acropolis walls. Others took refuge in the Temple of Athena Polias, but the Persians tracked them down and slaughtered them.

The Persian iconoclastic fury inflicted on the Acropolis was merciless. The invaders tore down the walls of the citadel, set fire to the temples, vandalized the adornments, smashed statues, and mutilated reliefs. This was not random vandalism; it was vindictive destruction of the most sacred place in Athenian society. The Persians took axes to statues, hacking away at torsos, buttocks, and breasts. Arms were broken off; legs were amputated. On the faces of statues, the nose, chin, and cheeks were smashed with hammers. The genitals, too, were mutilated. But the iconic *Tyrannicides* statues were too valuable to be destroyed. Xerxes spirited them away and took them back to Persia.

The Persian destruction of the Parthenon was a massive trauma to the Athenian psyche. The Greek orator Lycurgus observed that nothing was restored so Athenians could forever remember the impiety of the barbarian invaders. Persian vandalism was to remain part of the Greek's historical memory. Not a single demolished shrine would be rebuilt.[22]

Over time, however, Athenians started to rebuild their city. It took three decades before construction of the Parthenon commenced under the great statesman Pericles. Many of the broken statues destroyed by the Persians were buried as if they were actual corpses, making no distinction between stone and flesh. These were the same statues discovered by German archeologists in the nineteenth century and labeled "*Perserschutt*"—or "Persian debris."

The Greeks finally exacted revenge for the sack of Athens when Alexander the Great defeated the Persian empire in 330 BC. After occupying Babylon, Alexander continued to the Persian capital Persepolis in modern-day Iran. His army looted the city's great treasures before burning the imperial palace and butchering the population. In the palace, Alexander stopped before a toppled statue of Xerxes, the Persian king who had sacked Athens. The Greek historian Plutarch tells us that Alexander gave thought to putting the statue upright, but decided against a magnanimous gesture and left it overturned.[23] Alexander found the famous *Tyrannicides* statues in the city of Susa. He carefully ensured that the venerated sculptures were returned to Athens as a symbol of the Pan-Hellenic alliance against the Persians.[24] Two different sets of the *Tyrannicides* stood in the Athens agora until the second century AD. They were eventually lost, though marble copies were made in the Roman period.

The Romans, like the Greeks, merged the civic and religious and linked the fate of statues and monuments to their own glory and disgrace. Iconoclastic violence was integrated into Roman military victories. When the Romans vanquished a foreign city, they captured the statue—or palladium—that they believed held the soul of the city. They either destroyed the palladium or took it

back to Rome as a trophy. When the emperor Constantine moved the empire's capital from Rome to Constantinople, he brought the Roman palladium with him for the same symbolic purpose. Constantine also plundered statues from the places he conquered and decorated his capital with them. While not iconoclastic destruction, this practice repurposed old statues and gave them new meaning in a different setting.[25]

A damnatio memoriae sentence was a dreaded punishment in Rome, whose civic culture attached great importance to the preservation and honoring of memory. As in Greece, the function of damnatio memoriae was to send ideological messages that enforced loyalty and forged identity around Roman values. The threat of disgrace or memory erasure (known as *oblivia*) was greatly feared.[26] This underscores again the paradox of damnatio memoriae: it was a double-edged sword, inflicting disgrace and oblivion. Eternal shame was feared just as much as eternal oblivion.

Anyone designated as an enemy of the state, including disgraced Roman emperors, was condemned to damnatio. The Senate had the power to declare someone a *hostis publicus*, or enemy of the people. Senators could also issue posthumous sentences of damnatio memoriae, which not only condemned someone's name to oblivion but also stipulated that every physical trace of their existence be erased from the public record. For disgraced emperors sentenced posthumously to damnatio memoriae, their statues were toppled, their images erased from coins, and their tombs desecrated. Their names were unmentionable upon pain of death.[27] Nero, like Caligula before him, was sentenced to damnatio for an accumulation of crimes, not least of which the murder of his own mother, Agrippina. Damnatio memoriae enacted symbolic punishment of tyrants and, in the same act, legitimized the disgraced emperor's successor through monumentalization. Following Caligula's assassination, for example, his portraits were reworked to resemble his successor Claudius. Similarly, images of Nero were transformed to resemble other emperors including Vespasian, Titus, and Trajan.[28]

The emperor Domitian met the same fate as Caligula and Nero. Domitian, who according to ancient historians gave himself the title *"Dominus et deus"* (Lord and God), was assassinated in 96 AD. His own court officials stabbed him to death while he was signing official papers. Widely despised as a tyrant, Domitian was quickly sentenced posthumously to damnatio memoriae. The mutilation of his public statues and monuments began at once. His coins were melted and his name scratched from public records. The Roman author Pliny the Younger, whose career had benefited from Domitian's patronage, rejoiced at the destruction of the emperor's statues, perhaps because he was keen to ingratiate himself to the new emperor, Trajan. Pliny even boasted of his participation in the iconoclastic fury.

"How delightful it was to smash to pieces those arrogant faces, to raise our swords against them, to cut them ferociously with our axes, as if blood and pain would follow our blows," wrote Pliny.[29] Here again was an example of how iconoclastic violence frequently makes no distinction between the statue as object and the figure represented—in this case, a Roman emperor. An attack on a statue is tantamount to a physical assault on a living person. In the mind of the assailant, the marble or bronze is transformed into bones and flesh that are smashed and mutilated.

As the fate of Herostratus demonstrated in the Greek period, a damnatio curse in Rome could, paradoxically, guarantee everlasting fame. Nero, for example, became a venerated cult figure after his death. The enormous Colossus Neronis statue adjacent to the Roman colosseum remained standing for centuries. In the second century AD, the megalomaniacal emperor Commodus had the column transformed into a statue of himself. This was a common trick in Rome after emperors were disgraced by a damnatio sentence. Instead of demolishing their statues, the head was removed, and a new imperial head of the disgraced emperor's successor was attached to the torso. It is believed that the Colossus Neronis survived until the sack of Rome in 410 AD, when it was likely toppled.

The damnatio memoriae curse reappeared in the Middle Ages and continued well into the Renaissance. In Italian city-states, officials were still sentencing tyrants, traitors, religious sects, and enemies of the state to damnatio, often burning down residences of those condemned to public disgrace.[30] On one level of interpretation, these acts of destruction echoed the ancient Roman razing of Carthage. They also had profound Biblical resonances. In Deuteronomy 12:3, the Israelites are commanded to erase all traces of foreign religions: "Break down their altars, smash their sacred stones and burn their Asherah poles in the fire; cut down the idols of their gods and wipe out their names from those places."

It is not surprising that damnatio memoriae reappeared in Renaissance Italy, a period when the values and customs of the ancients were being revived. The Roman cult of *fama* and glory was back in vogue. So was its counter-narrative of *infama*—stigma, shame, and disgrace. In Italian city-states, a damnatio sentence required a physical record of the condemned person's disgrace visible in public places. This frequently took the form of a *pittura infamante* (defaming portrait) displayed in public as an iconic form of social punishment. These defamatory paintings often depicted the disgraced person hanging upside down. Alternatively, a *colonna d'infamia* (column of infamy) was erected in public as a physical symbol of shame.

In early fourteenth-century Venice, the nobleman Bajamonte Tiepolo attempted to overthrow the doge on the Feast of Saint Vitas. The coup failed, however, and Tiepolo fled into exile. Venice's Grand Council sentenced him to

damnatio memoriae and razed his opulent palazzo. To reinforce his disgrace, a colonna d'infamia was erected on the site of Tiepolo's demolished residence. The column bore an inscription about Tiepolo's "infamous treachery" as a warning to anyone who committed treason in Venice. Distraught by the presence of the column standing on the ruins of his palazzo, Tiepolo dispatched one of his loyal followers to destroy it. But the secret envoy was caught and punished for his attempted iconoclastic act. At the site today a plaque can still be viewed, inscribed "LOC. COL. BAI. THE. MCCCX," which translates as "location of column of Bajamonte Tiepolo 1310."[31] More than seven centuries later, Bajamonte Tiepolo's public disgrace endures.

In fifteenth-century Florence, the city was controlled by the powerful Medici family, headed by Lorenzo de Medici. This was the era of Machiavelli, when family dynasties controlled Florence while maintaining the appearance of republican values and institutions. The great adversaries of the Medici clan were the older Pazzi dynasty, who enjoyed connections to the papacy as the pope's bankers. The Pazzis deeply resented Lorenzo de Medici's power.

At Easter in 1478, Francesco de' Pazzi plotted to have Lorenzo de Medici assassinated. The assassination attempt, tacitly approved by Pope Sixtus IV, occurred during a mass in the city's gothic Duomo cathedral at precisely the moment when Lorenzo and his brother Giuliano de Medici were kneeling to receive the Eucharist. The assassins repeatedly stabbed Giuliano de Medici, who bled to death on the cathedral floor. Lorenzo, wounded superficially in the neck, escaped into the sacristy and survived. The Pazzi conspirators fled and ran through the streets of Florence shouting, "Liberty! Liberty!"

Lorenzo de Medici immediately ordered a damnatio memoriae vendetta against the entire Pazzi dynasty. He wanted the Pazzi family wiped out. So powerful was Lorenzo de Medici's voice in Florence that a frenzied mob quickly hunted down the Pazzi conspirators. Some seventy people were murdered in two weeks. They were tortured and mutilated, their noses and ears sliced off. Others were decapitated and their heads paraded through the streets on spears. The Pazzi patriarch, Jacopo de' Pazzi, was tracked down, tortured, and hanged from the windows of the Palazzo della Signoria. Lorenzo de Medici commissioned the artist Sandro Botticelli to paint a pittura infamante fresco of eight Pazzi conspirators hanging upside down.[32]

Even after his gruesome death, Jacapo de' Pazzi's ordeal was not over. The damnatio vendetta moved to the next phase of inflicting violence on his corpse. His cadaver, entombed in the family crypt, was dug up and dragged to the city walls and thrown into a ditch. This was a reenactment of the Church's posthumous excommunication rituals, which involved exhuming corpses and burying them outside of sacred spaces. Jacapo de' Pazzi's cadaver was finally thrown into the Arno river. Children fished out the corpse and hung it again, this time on

a willow tree, where the body was flogged before being thrown back into the river.[33] Machiavelli wrote of Jacopo de' Pazzi's postmortem humiliation: "It was such an awful instance of the instability of fortune to see so wealthy a man, possessing the utmost earthly felicity, brought down to such a depth of misery, such utter ruin and extreme degradation."[34]

The surviving Pazzis were forever banished from Florence. In the city, it was forbidden to utter their name in public.

Damnatio memoriae is still with us today. Some would claim we have dropped the Latin and given it a simpler name: "cancel culture."

Cancel culture—and the so-called woke ideology that drives it—are the subject of acrimonious debates today. Some argue that cancel culture is one of society's great ills, a symptom of leftist hysteria and a spiraling obsession with moral purity. Others claim it's an obsession not on the left, but on the religious right. Some deny that cancel culture even exists.

By most definitions, cancel culture is fueled—like damnatio memoriae—by a moral compulsion to blame, accuse, scorn, shame, and sentence to disgrace and oblivion those deemed guilty of offenses, real or imagined. For those targeted, the consequences can be extremely unpleasant, and sometimes catastrophic. They become objects of public opprobrium and ostracization. Sometimes they lose their livelihood after being fired by employers. Their reputations are irrecoverably tarnished.

Cancel culture is frequently described with semantics associated with religious zealotry. Detractors call its proponents "puritanical." Like Puritans in history, they claim, those who "cancel" others morally judge their conduct and, if found offensive, insist that they be shamed and shunned. Targets of cancel culture are frequently the famous and powerful. When celebrities are targeted, cancel culture is associated with another religious practice: iconoclasm. When the famous are "cancelled," their iconography is attacked. Their idols are toppled and smashed.

Perhaps the first tragic victim of this form of iconoclasm in our celebrity-obsessed culture was John Lennon. In 1966, when the Beatles were at the height of their fame, Lennon gave an interview to a British newspaper in which he said: "Christianity will go. It will vanish and shrink. I needn't argue about that. I'm right and I will be proved right. We're more popular than Jesus now."[35] When the interview was published in London's *Evening Standard* in March that year, Lennon's quote about Christianity elicited little reaction in Britain. But when the same interview was republished four months later in an American magazine, it provoked a storm of controversy.

Protestors in the United States smashed Beatles records after John Lennon said the group was "more popular than Jesus." *Wikimedia Creative Commons.*

In the United States, a country with a large Christian evangelical population, many were outraged by Lennon's statement that he was "more popular than Jesus." In the backlash, American radio stations organized a "Ban the Beatles" campaign. Furious Beatles fans smashed the group's vinyl records. In South

Carolina, the Ku Klux Klan staged "Beatles Bonfires" at which their records were burned. These incendiary rituals evoked the purification rites of early Christian fanatics who plundered Greek and Roman libraries and tossed "forbidden" non-Christian books into bonfire flames. In America, the burning crosses of the Ku Klux Klan supplied the bonfires of vanities into which Beatles records were tossed.[36] Meanwhile, John Lennon and the other Beatles members received death threats. On their tour of America, Lennon couldn't escape questions about his "more popular than Jesus" remark. He eventually clarified his comments with a public apology in the hope that the controversy would die down.

"I said we were more popular than Jesus, which is a fact," said Lennon. "I believe Jesus was right, Buddha was right, and all of those people like that are right. They're all saying the same thing, and I believe it. I believe what Jesus actually said—the basic things he laid down about love and goodness—and not what people say he said."[37]

The vinyl-smashing of Beatles records was a symbolic form of damnatio memoriae intended to erase the group's songs from collective memory. The iconoclastic fury was not an aberration in American culture. As the past few decades of "culture wars" have demonstrated, iconoclastic rage is deeply embedded in the recesses of the Anglo-American psyche.[38] John Lennon's ordeal in the mid-1960s was not unlike today's purity spirals that seek to inflict chastisements and demand atonement. Purity spirals are often associated with the "woke" left. But as the iconoclastic smashing of Beatles records demonstrated, these acts also play out on the evangelical right. Another example is evangelical lobbying for the banning of books that "offend" Christian values. Like their evangelical adversaries on the right, so-called "woke" activists protest against "offensive" books and call for their suppression. Cancel culture is a combat for the normative power to reshape society's dominant values in strict alignment with their own moral convictions.

Ideological postures on right and left may be different, but both are asserted with the certitude of religious dogma. Their adherents reject all contradiction and insist on damnatio memoriae sentences for those who deviate from accepted truths. Opponents must suffer consequences for their moral failures. Their houses are not razed like in Renaissance Italy; instead, they suffer moral forms of violence—shame, discredit, ostracization, and the destruction of their reputations and careers. Cancel culture is driven by a compulsion to castigate and inflict punishments on ideological adversaries.

Christopher Schelin, a professor of political theology, observes that cancel culture has many traits in common with the traditional system of internal discipline in evangelical churches. At Baptist churches, members accused of sins that violated moral standards—from alcoholism to social dancing—were found guilty by a vote. Once guilt was established, they were punished with admoni-

tion or, more serious, excommunication. The latter was shunning, a religious form of damnatio memoriae. The guilty were banished from the community of faith and forgotten as irrecuperable.

"At first glance, evangelical disciplinarians and progressive 'cancelers' may seem worlds apart," observes Schelin.

> Yet I believe they share certain key features. They both express what can be described as a purity ethic that aims to root out behaviors deemed to be harmful from the body politic. Both struggle with the question of appropriate response. Do the offender's actions warrant exclusion? Is there an opportunity for rehabilitation and, if so, how is this achieved? Both disciplining and canceling are also, in my view, acts of meaning-making that may be called religious.[39]

Schelin argues that cancel culture is a secular version of the "sacred canopy" that gives structure and meaning to the lives of the faithful. "It provides order to one's experience of the world," he observes. "Secularization has, in many cases, transferred the function of religion to other domains, especially politics."[40] Historically, this was precisely the function of damnatio memoriae. Its punishments established the normative boundaries of acceptable conduct in both the religious and political spheres.

Rock musician Nick Cave publicly dismissed cancel culture as a "bad religion run amuck." But paradoxically, he observes, cancel culture lacks the compassion at the core of Christian faith. "As far as I can see, cancel culture is mercy's antithesis," said Cave. "Political correctness has grown to become the unhappiest religion in the world. Its once honorable attempt to reimagine our society in a more equitable way now embodies all the worst aspects that religion has to offer and none of the beauty—moral certainty and self-righteousness shorn even of the capacity for redemption."[41]

The assassination of John Lennon can be interpreted as a quasi-religious form of iconoclastic violence. Pop stars like Lennon are idols worshipped like gods. As a member of the Beatles and later in the 1970s, his iconography was ubiquitous, reinforced by the power of his many iconic songs—from "Lucy in the Sky with Diamonds" and "Strawberry Fields" to "Imagine." Like other famous figures in the pantheon of celebrity—from Greta Garbo and Marilyn Monroe to Elvis Presley and James Dean—the iconography of the Beatles conveyed an aura that inspired enchantment, desire, and yearning. In our consumer culture, fame is "commodified" by the market dictates of mass production. Celebrity icons and idols are "fetishized" by the millions of fans who venerate their images.[42]

Andy Warhol's iconic portraits of famous people made a direct connection between celebrity culture and commodity fetishism. His portraits of famous

people—Jacqueline Onassis, Mick Jagger, Debbie Harry—became icons in our celebrity culture of image veneration and fame fetishization. The word *fetish*, not coincidentally, has religious origins. Originally from Latin *facticius* for "artificial"—*fetish* derives from the Portuguese *feitiço*. It was used by sixteenth-century Portuguese colonizers in West Africa to describe the religious idols of the local native populations. To fetishize an object is to fall under the spell of its mystical powers of enchantment. In our modern celebrity culture, images of iconic figures such as John Lennon are fetishized objects of idol worship.

This can help explain why Lennon provoked a scandal in the 1960s when he compared the fame of the Beatles to Jesus Christ. On the surface, he was doing little more than stating a fact. John Lennon and the Beatles were pop idols elevated to the status of quasi-deities. Their images were adulated by millions in a culture where celebrity worship was a new secular religion. For fundamentalist Christians, however, Lennon's "more popular than Jesus" declaration made him a false idol. His statement provoked an iconoclastic rage that found justification in Biblical prohibitions against idols and icons.[43] That Lennon had dared to compare himself favorably with Jesus was a sacrilege.

Tragically, the controversy in the mid-1960s surrounding Lennon's "more popular than Jesus" statement would resurface fifteen years later in the mind of the man who assassinated him. Lennon's killer, Mark David Chapman, was by his own admission a Beatles fan who had grown up worshipping John Lennon. Like millions of other youths around the world, Chapman had fetishized the iconography of the Beatle and was obsessed with his music and fame. After Chapman shot Lennon outside the ex-Beatle's apartment in Manhattan, the media portrayed him as a deranged fan. The role of religion was largely overlooked in the news coverage of Lennon's murder. Chapman himself claimed, however, that his motivation for killing Lennon was religion.

Mark Chapman was a born-again Christian. He confessed that he had turned against the famous Beatle after recently reading about his "more popular than Jesus" comments. In the weeks before he shot Lennon, he had also been listening to his song "God" and was infuriated by the lyrics. In the song, Lennon sings that he doesn't believe in God or Jesus or the Beatles, that he only believes in himself and his wife Yoko. In Chapman's mind, John Lennon, the music icon he once idol-worshipped, was a false prophet.

"He told us to imagine no possessions," Chapman recalled in an interview. "And there he was with millions of dollars and yachts and farms and country estates, laughing at people like me who had believed the lies and bought the records and built a big part of their lives around his music."[44]

Chapman's obsession with John Lennon abruptly turned from idol worship to bitter disenchantment. The close proximity of these two psychological states

was captured in a famous photograph taken on the night he shot Lennon. Earlier that day, Chapman was photographed when he approached the ex-Beatle to seek an autograph on a copy of Lennon's most recent album. Lennon graciously obliged. The photo shows Lennon signing the album cover while Chapman looks on. This was Mark Chapman the idol-worshipping fan. Only a few hours later, when John Lennon and Yoko returned home to their building off Central Park, Chapman approached Lennon again—this time to assassinate him with bullets. Chapman's fixation on Lennon was mixed with resentment and hatred because the iconography of the famous pop star was competing in his head with Jesus Christ. Chapman murdered Lennon to destroy his idolatrous powers. But the act of iconoclastic violence only enhanced Lennon's status as a cult figure of veneration.

Chapman stuck to his religious script during his trial. In court, he claimed that God had commanded him to change his plea from insanity to guilty.[45] After his life sentence, Chapman founded a prison ministry called All About Jesus to lead inmates to Christ. In 2020, after forty years behind bars, Chapman stated that, if he were ever released from prison, his goal would be to preach the Gospel and spread the word of God.[46]

The tragic irony of John Lennon's death is that he was assassinated by a fan who both venerated and resented the power of his iconography. By murdering one of the most famous people in the world, Mark Chapman—like Herostratus—achieved his own kind of everlasting notoriety.

CHAPTER 4

Forbidden Images

Botticelli's *Birth of Venus* is one of the most famous paintings in history. A Renaissance masterpiece, it shows the Greek goddess of beauty emerging from the foamy sea, floating weightlessly, one hand cupped over her breasts, her long golden hair blown by the winds, carried by a giant scallop shell toward the shores of Cyprus.

The *Birth of Venus*, commissioned by the powerful Medici family in 1485, is an image embedded in our collective imagination. The pop artist Andy Warhol made four screen-print icons of Botticelli's Venus. The painting has also been evoked by pop stars—including Lady Gaga and Beyoncé—in music videos and on album covers. The *Birth of Venus* has been copied on at least two *New Yorker* magazine covers and used in advertisements to sell everything from Adobe Illustrator software to Reebok sneakers.[1] It is part of our shared cultural iconography.

Today the iconic Botticelli work is on display in Florence's Uffizi Gallery. So is another famous Botticelli painting, *Primavera*, also inspired by classical mythology. Other Botticelli works on pagan themes are sadly lost forever. They were burned to ashes in 1497 by a fanatical iconoclast who regarded the works of art as accursed objects of sin and blasphemy.

The fanatic was the artist himself. It was Botticelli who tossed his own paintings onto bonfires of purifying flames.

Botticelli created some of the most voluptuous paintings of the Italian Renaissance. The sensual beauty of his works later inspired the Pre-Raphaelite and Art Nouveau movements in the nineteenth century. In his own lifetime, however, Botticelli fell under the spell of the fanatical monk Girolamo Savonarola and turned against his own work.

Savonarola is regarded today as an archetype of religious fanaticism. Revered as a prophet in Florence at the end of the fifteenth century, he believed that he was in direct communion with God. He was also a strident iconoclast who saw

The Birth of Venus, by Sandro Botticelli.

wickedness in sacred statues and images. Savonarola was the first significant religious figure in Renaissance Europe to revive the iconoclastic belligerence that had wreaked havoc in the early centuries of Christianity. The firebrand priest's rebellion against the Catholic Church spread like wildfire throughout northern Europe over the following century. His fulminations against the moral corruption of the pope made him, though a Catholic priest, a harbinger of the Protestant Reformation. He was, in many respects, a precursor of the purity spirals that have enflamed our contemporary culture wars.

While Savonarola was a visionary who changed the world, his fall from grace was also a cautionary tale. His fanatical religious movement in Florence was hardly a revolution of liberation. He transformed Florence into an oppressive theocracy that was doomed to end tragically. Many of his followers met the same fate. One of them was Sandro Botticelli.

In Savonarola's day, Florence was at the center of a flourishing Renaissance culture of humanism whose influences were turned toward classical Greece and Rome. In the fifteenth century, influential family dynasties were fighting over power in Florence. The Pazzi clan had orchestrated a failed assassination on Lorenzo de' Medici, who exacted revenge by having the Pazzis hunted down, tortured, and murdered. The Medicis commissioned the young Botticelli to paint a *pittura infamante* of the Pazzi conspirators to be displayed in public. The Medicis were also patrons of artists including Michelangelo and Leonardo da Vinci. The

pope in Rome was another great patron of the arts, commissioning works by the era's greatest artists including Botticelli.

Savonarola arrived in Florence as a young priest to work for the Medicis, but quickly grew disillusioned. Everywhere he looked, he saw blind wickedness. In his sermons, he began excoriating the Medicis and the pope for their worldly corruption. He prophesied that the "sword of God" would bring terrible tribulations to Italy. He warned that the Day of Judgment was imminent. This apocalyptical message struck a chord with Florentines. Savonarola's blistering sermons soon attracted as many as 15,000 worshippers in Florence's Duomo cathedral. At the pulpit, he proclaimed Florence as the New Jerusalem. It was his mission to found a republic as the City of God. His followers were mesmerized. Many wailed during his enflamed sermons.

Savonarola's fame quickly spread throughout Europe. When the French king Charles VIII invaded Italy in 1494, he agreed to a private meeting with the famous Dominican monk. When the two met, Savonarola praised the French monarch for cleansing Italy of its sins. Charles VIII must have been impressed by the self-styled religious prophet. The French army of 25,000 troops left Florence intact as they cut a path of destruction on their way to Naples. The Medici clan, for their part, were forced to pay a tribute to the French king.

With their city spared devastation by the invading French army, Florentines were convinced that their good fortune was the divine work of the God-sent prophet Savonarola. The rebellious priest was now in a position to take control of Florence. The Medicis had fled into exile and could not stop the monk's power grab. Savonarola's political instrument was his populist "Piagnoni" movement (named after the weepers and wailers at his sermons). After creating a Grand Council in 1494, he purged Florence's political elites and brought in democratic reforms and measures to improve the condition of the poor.

There was a darker side to Savonarola's City of God, however. He transformed Florence into a religious surveillance state, prohibiting homosexuality, gambling, swearing, even singing. For all these sins, torture was used to extract confessions. Those found guilty of blasphemy had their tongues cut out. Savonarola's moral purification enforcers were Christian shock troops called "Bands of Hope"—similar to the *parabalani* death squads who terrorized pagans and murdered the philosopher Hypatia in fifth-century Alexandria. Savonarola's enforcers patrolled the streets of Florence looking for any sign of immodesty in dress or manner.[2]

Sinfulness in paintings was another target of Florence's morality police. Savonarola was particularly incensed by Medici-commissioned art and its obsession with pagan images from Greece and Rome. He was not alone in his opposition to worldly iconography. There was a growing feeling in his day that religious art was reviving the ancient tradition of idolatry. Savonarola railed against works of

art that treated sacred Christian themes because, in his view, they were corrupted by humanistic adornments appealing to the senses. Paintings of the Virgin Mary, he claimed, portrayed her as a sensual figure exciting lust. "You give the Virgin the costume of a courtesan," he wrote.[3]

Savonarola could well have been commenting on Botticelli's sacred paintings. The artist had produced a number of works showing the Virgin with the infant Christ—for example, *Mary with the Child and Singing Angels*. The Virgin resembled almost exactly the Greek goddess of beauty in his work, *Birth of Venus*. Botticelli's Venus is nude, whereas he painted the Virgin clothed and veiled, though he gave Mary the long golden hair of the Greek goddess. The eroticization of the Virgin was not unknown in Renaissance Italy. Renaissance artist Giorgio Vasari recounted the story of the Florentine who commissioned a picture of the Virgin from the painter Nunziata. The patron, frustrated with painters incapable of producing works that were not lascivious, stipulated that he wanted a chaste image of the Holy Virgin that would not incite sexual desires. Nunziata painted a Virgin with a beard, which itself would have been considered blasphemous.[4]

As ruler of Florence, Savonarola decreed an aesthetic reformation that revived the simplicity of the primitive Church and the unadorned message of the Gospel. Images of the Virgin as anything but a figure of chastity were forbidden. These evangelical aesthetics anticipated later iconoclastic revolts against sacred icons and idols by Protestant reformers including Calvin. For Savonarola, the destruction of sinful images was commanded by scripture. His method to eradicate them was purification by fire. Thus was born the infamous "bonfires of the vanities"—or *falò delle vanità*—ritual still associated with his name.

Savonarola's Bands of Hope enforcers charged through the city banging on doors, bullying people into handing over their "vanities." They expropriated all sinful objects—paintings, sculptures, books of poetry, cosmetics, perfumes, mirrors, musical instruments, playing cards, dice, jewelry, ornaments of any kind—and carried them off to the Piazza della Signoria for purifying incineration. The date for the ritual burning was chosen for its symbolism: the annual spring carnival. The word carnival (from *carne vale*) signifies "farewell to flesh" just before the approaching fast at Lent. In other parts of Europe bonfire rituals before Lent were called "carnival fires."[5] In Savonarola's carnival rite, worldly vanities were tossed onto seven pyres, each representing one of the deadly sins, and torched in a massive bonfire. Books were included among the vanities for burning. Among them were volumes of Boccaccio, Dante, Petrarch, and Ovid. Female statues by sculptor Donatello were also tossed onto the flames.

Savonarola's purification bonfires were not a somber affair. On the contrary, they took place in a festive ambiance with processions of children chanting and singing lauds. The purification ceremony was a ritual of religious jubilation

before the holy Lent. The iconoclastic destruction of sinful objects was not fueled by fury, but by joy and ecstasy in a fevered ritual of collective *jouissance*. Trumpets and cymbals sounded to the glory of God as smoke from the burning vanities rose into the sky.[6] The act of destruction was a performative rite of life-affirming exultation. These carnival-like rituals surrounding bonfires of vanities symbolized the purification of the flesh from its worldly attachments.

Sandro Botticelli had fallen under Savonarola's influence through his brother Simone, who was among the fanatical monk's most devout followers. Converted to Savonarola's cult, Botticelli disavowed his previous artworks inspired by pagan mythology. In 1497, he was present in Piazza della Signoria and tossed his sinful paintings onto the flames. Giorgio Vasari described the scene: "The people were so inflamed by Friar Girolamo Savonarola, and he wrought upon them so strongly with his words, that on that day they brought to the place a vast quantity of nude figures, both in painting and in sculpture, many by the hand of excellent masters, and likewise books, lutes, and volumes of songs, which was a most grievous loss, particularly for painting."[7] Botticelli's masterpieces *Birth of Venus* and *Primavera* survived the purifying flames only because they belonged to the Medicis and were safe at the family's country Villa di Castello. The artist now focused his talents on painting unvarnished Christian images inspired by Savonarola's apocalyptical sermons. One notable Botticelli painting in this genre was *Lamentation over the Dead Christ*, a dolorous icon showing Christ's body collapsed in the arms of the Virgin Mary who is consoled by the disciple John.

Savonarola's bonfires had a clear political agenda. Condemned works of art were incinerated for their offensive profanity, but purification rituals also reinforced Savonarola's power in Florence. It is significant that the bonfires did not take place at the cathedral, but in the Piazza della Signoria in front of the city council. Bonfires of vanities were religious purification as political theater.

Florence's theocratic experiment proved short-lived. It was condemned to fail if only because Savonarola challenged two powerful institutions: the Papacy and the Medici dynasty. Impatient with Savonarola's denunciation of papal corruption, Pope Alexander VI excommunicated the defiant monk and had him arrested for heresy. Under ecclesiastical interrogation, Savonarola was subjected to torture, or *tormento*, using the infamous method known as *strappado*. His hands bound behind his back, he was yanked up by a pulley so that his arms were drawn over his head, causing agonizing pain as his shoulders dislocated. Savonarola finally confessed that he was a false prophet. He was sentenced to death.

On May 23, 1498, Savonarola was dragged to the scaffold in Piazza della Signoria along with two loyal followers. Their heads were shaved, a customary degradation ritual, before they were led to the cross-shaped gallows and hanged. Their punishment was not over. Their limp bodies, hanging from chains

attached to the cross, were suspended over a massive fire. In the eyes of the assembled throng, the spectacle must have resembled one of Savonarola's own purification bonfires in the very same square. As the bodies were slowly consumed by flames, the Florentine mob screamed insults at the corpse of the priest they once hailed as a prophet.

Following his execution, Savonarola's ashes were scattered in the Arno river so there could be no relics for veneration. For the Medici dynasty, Savonarola's downfall was a blessing. The Medicis were restored to power not only in Florence but also in Rome. In 1513, Giovanni de Medici was elected pontiff as Pope Leo X.

Savonarola was not forgotten, however. Despite the lack of a tomb or relics, a martyr cult grew around his name. The political philosopher Machiavelli, who had personally witnessed Savonarola's execution, made Savonarola famous in his celebrated treatise, *The Prince.* Machiavelli drew lessons from the ill-fated monk to furnish advice to all princes. For Machiavelli, Savonarola had come to grief because he was an unarmed prophet who failed to grasp that new political orders must impose their constitutions through force. Savonarola's downfall was a lesson in the cruel realities of political power.

Botticelli never recovered from Savonarola's downfall. Following the Dominican monk's execution, the artist fell into destitution and produced little work. He died in poverty in 1510 at age 65. One of his final paintings, *The Mystical Nativity*, is on display in London's National Gallery.

Today, a marble statue of Savonarola stands in a public square in Florence named after him. It shows Savonarola dressed in monastic robes, raising a gold cross with his right hand, the other hand clutching the head of a lion (symbol of Florence), his eyes fixed fiercely on passersby.

The taboo of the forbidden image was not invented by Savonarola. It is indelibly etched in the cultural psychology of Judeo-Christian civilization.

It doesn't matter if one is devoutly religious or agnostic, the serpents of temptation are everywhere, slithering and hissing through our culture with rich offerings of sensual images to excite our desires. It is the forbidden nature of images that provokes some to attack and destroy them.

The original prohibition against images, as we have seen in previous chapters, is the Biblical prohibition in the 10 Commandments: "Thou shalt have no other gods before me. Thou shalt not make unto thee any graven image, or any likeness of anything that is in heaven above, or that is in the earth beneath, or that is in the water under the earth."[8] The Israelites disobeyed their jealous God, however. While waiting for Moses to come down from Mount Sinai, they turned to Aaron, who melted their golden earrings to make a statue of a calf.

The Israelites worshipped the golden calf by making burned offerings and festively drinking and dancing in a state of undress before the idol. The nakedness of the Israelites established a clear connection between idolatry and sensuality. Worshipping the golden calf was a sinful indulgence in sensuous pleasure. Facing the wrath of God, the only possible remedy was iconoclastic destruction and terrible punishments for the sinners. Moses seized the idol, burned it in a fire, ground it into powder, mixed it into water, and made the children of Israel drink it. In Exodus 32:35, we read: "And the Lord plagued the people, because they made the calf."[9]

Even outside of Biblical scripture, the sensual power of statues is one of our oldest cultural myths. The Greek myth about Pygmalion is the most famous tale of sexual desire stimulated by a statue. As told by Ovid in *Metamorphoses*, the sculptor Pygmalion is disenchanted with women after observing their wretched lives of shame in prostitution.[10] He vows to live a celibate life free of carnal temptations. He carves an ivory sculpture of a female figure. The statue is so exquisitely beautiful that he falls in love with his own creation. Inflamed with admiration, Pygmalion caresses and kisses the sculpture and even makes a bed for her. When he attends the festival of Venus, he makes offerings to the goddess and, standing before the altar, prays that his sculpture will come to life and become his wife. Venus hears his plea and grants his wish. When Pygmalion returns home and kisses the sculpture, the ivory turns to soft flesh. His statue-bride soon gives birth to their daughter, Paphos, for which a town in Cyprus is named.

The Pygmalion myth has inspired countless works of art over the centuries—statues, paintings, poems, plays, even modern-day films and musicals such as *My Fair Lady*. The core element of the narrative is erotic obsession with a work of art. The central theme is the power of enchantment that visual representations hold over our emotions and desires. For Pygmalion, looking upon the statue reveals the tension between the object viewed and the subjective eye of the beholder. The capacity to "see" invites desire. It was visual temptation that provoked Savonarola's indignation against paintings in his own day. He believed that the secularization of art in Renaissance Italy was transforming sacred images—especially of the Holy Virgin—into worldly figures that excited erotic desires.

The eroticization of sacred art continued long after Savonarola's short-lived theocracy. The papacy that Savonarola denounced commissioned Michelangelo to work on the Sistine Chapel. When the great artist completed the "Last Judgement" on the Sistine Chapel altar walls, Pope Paul's master of ceremonies, Biagio de Cesena, warned the pontiff that the fresco was a swarm of naked bodies. The figure of Christ resembled a muscular Roman god, and the Virgin Mary appeared to be modeled on the goddess Aphrodite. Biagio de Cesena advised the pope that the work belonged in a brothel, not in a papal chapel. One of

Michelangelo's pupils, Daniela da Volterra, was later commissioned to paint loincloths on the nude figures. There were later suggestions that the work should be destroyed entirely, but subsequent popes opted for more retouches to cover up offending nudity.[11]

Despite the repression of sensuality during the Protestant Reformation, sensuous aesthetics and architecture flourished in the Counter-Reformation when religious art showed a predilection for nude figures of baroque extravagance. Artists of this period included Bernini, Caravaggio, and Rubens. A classic example of this style is Bernini's marble sculpture, *The Ecstasy of Saint Teresa*, dated circa 1647. In the chapel of Rome's Santa Maria della Vittoria, the sculpture depicts the Spanish nun with her head thrown back, swooning, her lips open and eyes closed, as if having an orgasm, while an angel hovers overhead holding a thrusting spear. The posture is unmistakably erotic. The sensual depiction of Saint Teresa may have been an allusion to her own memoirs in which she recounted her passionate youth, including a lesbian relationship, before entering a convent.

Following on Botticelli, the goddess Venus continued to be a figure of erotic excitement through the high Renaissance. The most sensual painting of the goddess is undoubtedly the *Venus of Urbino*, completed by the Italian painter Titian in 1534. Venus is depicted nude and reclining languorously on a bed, her hair falling on her shoulders, with one hand touching her pubic hair. She is staring seductively at the viewer. The painting inspired the French artist Manet's work, *Olympia*, which also shows a nude woman reclining on a bed with an African servant girl in the background. In 1880, Mark Twain described the *Venus of Urbino* as "the foulest, the vilest, the obscenest picture the world possesses."[12]

If discreet censorship was the practice at the Vatican, eroticized art in private hands sometimes provoked more dramatic reactions. This was the fate of Correggio's *Leda and the Swan*, completed in 1530. The painting was inspired by the famous Greek myth about Leda, the queen of Sparta, who is raped by the god Zeus transformed into a swan. The child born of their coupling was the Greek beauty Helen, whose abduction sparked the Trojan War. The Leda and the Swan myth has appeared in many works of art from ancient times to modern era—Greek sculptures, Roman frescoes, paintings by Leonardo da Vinci, Michelangelo, François Boucher, and Paul Cézanne. Correggio's painting, inspired by Michelangelo's work, was originally part of a series of images on the mythological theme of *Amori di Giove*—"loves of Jupiter."[13] The paintings in this series depicted the god Zeus—Jupiter in Roman mythology—in an erotic act of sexual seduction or rape. The Leda painting shows her reclining on the banks of the river Eurota, with Cupid nearby holding his lyre. Zeus in the form of a swan is thrusting between her legs while pecking at her chin.

The painting was eventually acquired by Philippe, Duke of Orléans, who was the regent of France from 1715 to 1723 during the boyhood of Louis XV.

When the regent died in 1723, his son Louis d'Orléans effectively became heir to the throne because Louis XV was still only thirteen years old and unmarried. Louis d'Orléans was by all accounts headstrong, eccentric, and filled with passion for life—especially young women, hunting, and the military. As a *prince du sang*, his marriage was arranged according to the custom of making political alliances. His spouse, German princess Jeanne de Bade, died in childbirth in 1726 in their Parisian residence at the Palais Royal. Her death left the young Duke of Orléans an inconsolable widower at age twenty-three. Though still technically heir to the French throne, Louis refused other marriage arrangements and threw himself into religious devotion. His piety was so intense that he became known as "Louis le Pieux." It was during this phase of his life that Louis contemplated the Correggio painting in his family's collection. The lascivious image of Zeus raping Leda, her milky legs open to the thrusting swan, must have provoked profoundly disturbing emotions.

One day Louis attacked the painting with a knife. The assault irreparably destroyed Leda's head. It was as if Louis had targeted the focal point of her erotic ecstasy. It is impossible to know if Louis d'Orléans's motive for destroying the painting was religious purity. There can be no doubt, however, that the image held tremendous power over his thoughts, possibly exciting feelings of sexual arousal. There is also evidence that Louis suffered from psychological instability. He abandoned his royal palaces and retreated to a Parisian abbey on the Left Bank, where he slept on a straw mattress without sheets, drank only water, and woke every day at four o'clock in the morning. He dressed like a pauper and devoted himself to acts of charity in the name of Christian penitence. He made copious notes on the Book of Apocalypse. Toward the end of his life, his behavior was increasingly eccentric. He refused to believe that death was inevitable. In this conviction, he was wrong. He died in February 1752 at age 48.[14]

Correggio's painting changed hands several times after Louis d'Orléans's death. A number of attempts were made to repair the damage to Leda's head. The work today belongs to the Gemäldegalerie collection in Berlin.

Correggio's *Leda and the Swan* belonged to Louis d'Orléans's private collection. Works of art on public display are different. When paintings or sculptures exhibited for public viewing are targeted, attacks are unpredictable and motives often difficult to comprehend.

People who attack publicly displayed art works are often considered to be psychologically unstable. In some cases, they appear to be compulsive attention-seekers, like Herostratus setting ablaze a famous temple to achieve everlasting fame. Sometimes political motives are attributed to acts of violence against iconic works of art. In attacks that seem irrational, as opposed to politically

calculated, the perpetrators are usually treated in the media and courts as mentally ill. But iconoclastic attacks on artworks are much more complicated than most accounts in the media suggest.

Iconoclastic violence on art, though it seems spontaneous and irrational, often follows a recurring pattern. The targets are paintings and sculptures that depict Biblical and sacred images (such as the Virgin), or pagan themes with erotic figures. In virtually every case, the image or sculpture appears to have excited desires and fears in the attacker who regarded the image as offensive or forbidden. The artwork elicits powerful feelings of excitement or revulsion. The attack is an attempt by the assailant to neutralize the artwork's powers of enchantment and seduction.

Iconoclastic attacks in public art galleries have a long history. In 1890, the painting *The Return of Spring* by William-Adolphe Bouguereau was on display at an exhibition in Omaha, Nebraska. Bouguereau was a French academic painter who rebelled against the Impressionist movement in the late nineteenth century. His work revived the fleshy Renaissance style with paintings on classical and Christian themes—from Greek goddesses to portraits of the Virgin Mary. Like Botticelli, Bouguereau painted a *Birth of Venus* showing the goddess erotically naked with flowing red hair. *The Return of Spring* was in the same genre, an allegorical nude depicting the season in the form of a voluptuous female nude in a meadow, clutching her breasts as winged cherubs hover around her.

At the exhibition in Omaha, a young man named Carey Judson Warbington threw a chair at the painting. After his arrest, Warbington said he had been offended by the image. He attacked the painting because he did not want his mother or sister to see it. "I did it to protect the virtue of women," he declared. He said he knew he would go to prison for his rash act, but had no regrets because it was "worthwhile to sacrifice one man's life to rid the world of so corrupting a sight as that picture!"[15] Warbington was found insane at his trial and acquitted. He subsequently committed suicide.

Bouguereau's paintings were already creating a sensation in America. Among them was his work *Nymphs and Satyr,* an enormous canvas showing fleshy nymphs cavorting around a male satyr as they attempt to lure him into a nearby pond. In 1882, tobacco heiress Catherine Lorillard Wolfe purchased the work, but later sold it for $10,000 to wealthy New York hotel owner Edward Stokes. He displayed the painting prominently in the barroom of his Hoffman House establishment at Broadway and Madison Square in Manhattan. While the painting was intended for the eyes of Hoffman House's bourgeois patrons only, it soon caused a sensation and became an object of intense public curiosity. Ladies visited Hoffman House to get a glimpse of the painting. The bar became so popular that Edward Stokes had to institute visiting hours. As historian David Scobey put it: "*Nymphs and Satyr* made a stir because it both expressed and contained

transgressive female sexual power. Its theme of dangerous eroticism would have been obvious to any Gilded Age viewer."[16]

Photographic prints of *Nymphs and Satyr* were soon circulating in New York. Edward Stokes even put the image of the naked nymphs on the labels of his own branded cigar boxes. The public interest in *Nymphs and Satyr* eventually caught the attention of the New York postmaster Anthony Comstock, the state's chief censor. Comstock was also founder of the evangelical Christian association called New York Society for the Suppression of Vice. He used his authority to get a court order declaring *Nymphs and Satyr* prints illegal on the grounds that they "deprave and corrupt those whose minds are open to such immoral influences."[17]

Bouguereau's other controversial painting, *Return of Spring,* was vandalized a second time in Omaha nearly a century after the first attack in 1890. In 1976, the painting was on display at Omaha's Joslyn Museum. A 37-year-old man in the gallery grabbed a nearby bronze statue and threw it at the canvas. The perpetrator was a window cleaner who was working at the gallery. Like the attacker in 1890, the assailant appears to have been provoked by the sensuality in the painting's nudity.

Repeat attacks on the same artwork are not uncommon. In 2011, a 57-year-old French man entered London's National Gallery and defaced with red spray paint Poussin's 1643 work, *The Adoration of the Golden Calf.* After spray-painting the canvas, he shouted something in French and waited for the police to arrest him.[18] The parts of the painting he covered in spray-paint were the semi-naked figures of the Israelites worshipping the golden calf.

It wasn't the first time Poussin's *Adoration of the Golden Calf* had been attacked. In 1978, a man attacked the painting in the same London gallery using a knife to cut through the image of the golden calf. The man arrested was a 27-year-old Italian, Salvatore Borzi, who worked as a dishwasher in London. The media were baffled by Borzi's motive. As one newspaper noted about the painting: "It's not offensive. It just depicts the Israelites dancing around the golden calf." Borzi himself could not explain his act, except to say that "it pleased me to do it."[19]

Puzzlement over motives, in both these cases, revealed a lack of awareness of the theme addressed in the painting. Poussin's work was inspired by the famous Biblical scene in which Moses warns the Israelites against idolatry. Both mutilations of this work were iconoclastic attacks against an image that itself was about iconoclasm. It is difficult to imagine that this particular painting was the target of two attacks as pure coincidence.[20] Borzi was nonetheless diagnosed as mentally ill. Psychological experts declared him schizophrenic, and he was sentenced to two years in prison.

Michelangelo's famous *Pietà* marble sculpture in Rome's Saint Peter's Basilica was the object of a similar attack. One of Michelangelo's greatest works, the

sculpture shows the Madonna holding the limp body of Christ after he was taken down from the cross. The writer Vasari recounted his reaction when he saw the sculpture for the first time in 1550: "It is a miracle that a rock, which before was without form, can take on such perfection that even nature sometimes struggles to create in the flesh."[21] The statue was considered so lifelike that, experts observed, the veins in Christ's arms seemed to be still holding blood and the folds in the Virgin's veil appeared to be muslin and not marble.

On Whit Sunday in 1972, after mass in Saint Peter's Basilica, a man jumped over the barrier in the Capella della Pietà and began smashing the statue of the

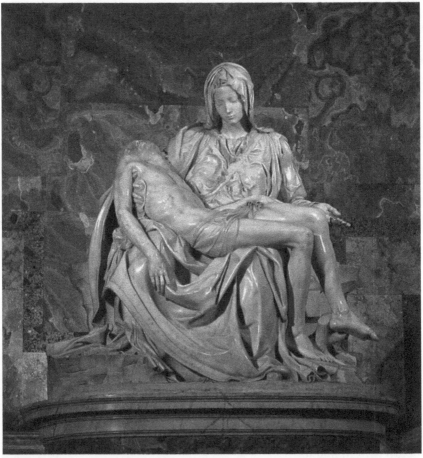

Michelangelo's *Pietà* was attacked with a hammer in 1972 by a man who declared himself to be "Christ risen from the dead." *Photo by Stanislav Traykov, Wikimedia Creative Commons.*

Virgin with a hammer. The Madonna's left arm broke off, her nose was smashed, and an eyelid damaged.

"I am Jesus Christ!" the assailant shouted while striking the sculpture with 12 hammer blows. "Christ has risen from the dead!"

The attacker was immediately arrested, insisting that he was Christ and that God had commanded him to destroy the statue. He was identified as an Australian geologist, László Toth, from a Hungarian family. He had moved to Italy the previous year convinced that he was Jesus Christ. He said he smashed the Madonna statue because God is eternal and therefore cannot have a mother.[22]

László Toth's motives for smashing the *Pietà* sculpture have been analyzed diversely. A Jungian psychological explanation argued that Toth was responding to an "archetypal" female figure.[23] In *Time* magazine, art critic Robert Hughes wrote: "Nobody will ever know what went through the scrambled circuits of Laszlo Toth's brain. . . . But one may guess: Toth had lost all power to distinguish between an image and the reality it connotes."[24] For others, the obvious explanation is an irrational reaction to religious iconography. Like similar acts of vandalism against religious art, Toth's hammer attack on the *Pietà* was described as "messianic iconoclasm."

Another incident occurred in Amsterdam in 1975 when a man used a serrated knife to slash Rembrandt's *The Night Watch* at the Rijksmuseum. The assailant was a 38-year-old former teacher, Wilhemus de Rijk, who was immediately apprehended after the attack. "I was commanded by the Lord," he declared. "God himself instructed me to do it. I am the Messiah."[25]

Authorities in the Netherlands took a different view. They concluded that Wilhemus de Rijk was suffering from mental illness. "Anyone who attacks *The Night Watch* must be a lunatic," said the museum's director, Pieter van Thiel.[26] The violence inflicted on the Rembrandt work was a repeat of a similar knife attack on the same painting in 1911. *The Night Watch* was attacked yet again in 1990 when a man sprayed acid over the painting.

In Rome, László Toth was committed to a psychiatric institution and deported to Australia two years later. The restored *Pietà* went on display again in Saint Peter's Basilica ten months after the attack. This time it was protected by a shield of bulletproof glass.

Oscar Wilde's tombstone in Père Lachaise cemetery is similarly protected by glass, though for entirely different reasons. Wilde died penniless in 1900 while living in self-imposed exile in Paris following his trial for homosexuality and prison term in England. He was initially buried in a pauper's grave in the Paris suburb of Bagneux. A decade later, some of the playwright's loyal friends raised money from wealthy donors to move Wilde's remains to Père Lachaise in Paris. The American sculptor Jacob Epstein was selected to design the new tombstone for Wilde's grave.

Epstein, who lived in London and became a British citizen in 1911, was an avant-garde artist who liked to push boundaries with his work. His personal life reflected the same attitude. He led a high-profile life in London as a married man with many mistresses. One was Kathleen Garman, one of the famous "Garman sisters" who were great beauties in London society. Epstein and Garman's daughter was Kitty Garman, the artist and muse who became the painter Lucien Freud's first wife.

Epstein's art, like his life, was the subject of controversy. In London, his work on the façade of the British Medical Association building faced a prudish backlash. After receiving the commission in 1907, Epstein produced eighteen carved nude figures that symbolized man's relationship to the universe. The nude statues were fitted into niches on the building's façade forty feet above street level. It didn't take long for the nude figures to be noticed, however. The National Vigilance Association, whose headquarters were just across the road, complained that the sculptures were an "affront to public decency."[27]

A public scandal flared up over Epstein's nude figures but quickly died down, only to be reignited two decades later in 1935 when the Rhodesian government bought the building and announced that the statues were to be removed at once. This second threat to Epstein's nude sculptures triggered a new controversy. Britain's most eminent figures from the arts—including National Gallery director Kenneth Clark—successfully petitioned to prevent the Rhodesian government from destroying the statues. The nude statues were eventually cut away under the pretext that they were crumbling.

When he received the commission for Oscar Wilde's tombstone, Epstein chose to sculpt an Egyptian-style winged sphinx with a large headdress in full flight. He also endowed the sphinx with large testicles. The sculpture arrived in Paris in 1914 and was unveiled by the poet Aleister Crowley, but not without a great deal of difficulty and some controversy. The prefect of Paris ruled that the testicles were indecent and demanded that they be removed or covered with a tarpaulin. It was eventually agreed that a bronze plaque in the shape of a butterfly would cover the genitals. Epstein objected to the bronze butterfly and refused to attend the unveiling. The butterfly was later removed and the testicles fully exposed.[28]

Oscar Wilde's tomb attracted admirers for decades. The testicles, remarkably, were uncontroversial—until 1961, when the tombstone was mysteriously vandalized. Someone hacked off the genitals. It was rumored that two English ladies visiting the cemetery had been so shocked at the sight of the testicles that they castrated the sphinx. It is possible, if not entirely likely, that this tale was apocryphal. It is nonetheless edifying. A tale about two English ladies attacking stone genitals reveals something about French perceptions of easily shocked puritanical values in England. According to the familiar cliché, the respectable

English sensibility finds the image of a penis shocking, offensive, forbidden. It was also said that a Père Lachaise cemetery keeper found the genital fragments and used them as paperweights.[29] Whatever the veracity of this account, to this day the sphinx figure on Oscar Wilde's tombstone has no testicles.

A different kind of damage to Wilde's tombstone occurred in subsequent decades as legions of fans came on pilgrimages to pay homage to the celebrated Irish wit. Many scribbled adoring graffiti messages and left lipstick marks on the tombstone. Kissing Oscar Wilde's tombstone became a cult-like ritual for his admirers. Over the years, however, the constant touching and graffiti scribbling caused damage to the massive, winged sphinx. The degraded state of Wilde's gravesite was an example of how idolatry, paradoxically, can produce an unexpected form of iconoclasm.

On the centenary of Oscar Wilde's death in 2000, the gravesite was so damaged that it desperately needed repair. Wilde's grandson, Merlin Holland, stated publicly: "If these people want to honor Oscar Wilde's memory, then they should leave the bloody tomb alone. It's made me very angry."[30]

Wilde's gravesite was painstakingly restored and unveiled in 2011. Today, those who come to Père Lachaise to venerate Oscar Wilde cannot touch his tombstone. Like Michelangelo's *Pietà* in Rome, the gravesite is sealed off by a plate-glass partition.

CHAPTER 5

Conquistadors

On a winter night in early January 1998, a commando of Native American activists launched a stealth attack on a bronze equestrian statue in the town of Alcalde, New Mexico.[1]

The attackers didn't smash the statue with hammers or pull it down with ropes. The vandalism was focused and surgical. They used a power saw to amputate the right foot, including boot and stirrup, of the figure on horseback. The targeted precision was a deliberate message of historical vengeance. This was iconoclasm as vendetta.

The figure on the equestrian statue was the Spanish colonizer, Juan de Oñate—known as the "last conquistador." The monument was modeled after the famous equestrian statue of Roman emperor Marcus Aurelius dressed in full battle armor. Oñate was a hero in Spanish historical legends about the colonization of the Americas. For Native Americans, however, he was a hated figure of colonial oppression.

Oñate was born in Mexico into a family of Spanish nobility. He married the granddaughter of Hernán Cortés, the legendary Spanish conqueror of Mexico and the Aztec Empire. Oñate became governor of the Spanish colony of Nuevo Mexico and in the late sixteenth century led colonial expeditions northward to present-day Colorado. He was usually accompanied by Franciscan priests to convert the local indigenous population to the Christian faith.

On Ascension Day in 1598—commemorating Christ's rise to heaven— Oñate proclaimed the entire territory as the property of King Philip II of Spain. In a speech rich in Biblical cadences, Oñate declared that all these lands "from the leaves on the trees in the forests to the stones and sands of the river" now belonged to his Christian monarch. The ceremony, which included High Mass, was embellished by a play that showed the native population embracing Christ as their savior.[2] This historic event is still celebrated in the region today as "La

Toma"—literally, "the taking"—marking the Spanish possession of lands north of the Rio Grande.

Four centuries later, the attack on Oñate's statue in northern New Mexico occurred against a backdrop of ceremonial pageantry. That year, celebrations were being prepared throughout the state to commemorate the 400th anniversary of the Spanish conquest. Six years earlier, Americans had celebrated the 500th anniversary of Christopher Columbus's discovery of the New World in 1492. In this festive decade of Spanish colonial celebration, the Juan de Oñate statue in Alcalde was commissioned by Emilio Naranj, a Democratic senator and political power broker in the state. Other cities in New Mexico and Texas had their own plans to commission statues of Juan de Oñate.

Despite these festive celebrations, Oñate remained a divisive figure in New Mexico. He was a symbol for two conflicting historical narratives—one Hispanic, the other Native American.[3] Nearly two decades before the Black Lives Matter movement swept through America with its message about racism and social injustice, the legacy of Juan de Oñate in the Southwest was provoking disputes between Hispanics and indigenous Americans in a bitter contest over historical memory.

For Hispanic descendants of the original Spanish colonizers, Oñate was revered as a foundation figure in their collective history. He established a trade route between Mexico and Santa Fe, introduced the horse to the region, and brought Catholicism to the new colony. Oñate's modern-day biographer described him as the "George Washington of New Mexico."[4] Since the nineteenth century, statues of conquistadors like Oñate had been proud symbols of Hispanic identity vis-à-vis Anglo-American dominance of the West. In northern New Mexico, the popular Fiestas de Santa Fe celebrating Spanish culture featured reenactments of the Oñate conquistador saga. During the celebrations marking the 400th anniversary of the Spanish conquest, radio stations throughout New Mexico played a tribute song to the great conquistador, "Corrido de Juan de Oñate."[5]

For Native Americans, Juan de Oñate was a resented symbol of Spanish colonial oppression and enslavement of the indigenous population. Oñate was responsible for the infamous massacre of Acoma people in 1599. The Acoma were rebelling against Spanish encroachment on their territory and, in an ambush, killed thirteen Spaniards. In retaliation, Oñate's men razed Acoma villages and slaughtered the native population. Some 800 Acoma men, women, and children were massacred in the carnage.[6] Of the 500 surviving Acoma, the girls were put in convents under the care of the Franciscans, and the boys were sent away to be raised as Christians. Acoma males over age 12 were sentenced to twenty years of servitude—in effect, slavery. Two dozen adult male Acoma were subjected to an unspeakable act of cruelty. Oñate ordered that their right foot be chopped off.[7]

In January 1998, the morning after the attack on the Oñate equestrian statue, a group called "Friends of Acoma" sent a photo of the amputated foot to the *Albuquerque Journal* bureau in Santa Fe. "We took the liberty of removing Oñate's right foot on behalf of our brothers and sisters of Acoma Pueblo," the group said in a statement claiming responsibility for the attack. "We see no glory in celebrating Oñate's fourth centennial, and we do not want our faces rubbed in it."[8]

The amputated bronze foot was replaced, and local Alcalde police closed the case. At the ceremony where the foot was reattached to the statue, the director of the Oñate Monument Center, Estevan Arrellano, was asked about Oñate's cruel historical legacy. "Give me a break," he replied. "It was 400 years ago. It's okay to hold a grudge, but for 400 years?"[9]

Arrellano's remark revealed little understanding of the power of statues and images as symbols of collective memory. The attack against the Oñate was political discourse through iconoclastic violence. For Native Americans who still felt humiliated by Spanish conquest and massacres of indigenous people, the statue of Juan de Oñate was regarded as the living embodiment of the conquistador. Assailing a bronze statue of Oñate was akin to physically assaulting the man himself.

The controversy over Juan de Oñate was far from resolved with the amputation of a bronze foot. In El Paso, Texas, where Oñate had first crossed the Rio Grande, local authorities commissioned a colossal thirty-six-foot equestrian statue of the famous conquistador mounted on a rearing horse. Created by sculptor John Sherrill Houser—son of artist Ivan Houser, who had worked on Mount Rushmore—it was described as the largest equestrian statue in the world. The enormous bronze Oñate was to be the centerpiece in a series of twelve statues honoring iconic figures from the region's history. The monument series—which included statues of Mexican revolutionary Pancho Villa and Wild West outlaw John Wesley Hardin—was intended to boost local tourism. But the project quickly degenerated into an acrimonious public debate about historical memory.

The Oñate statue, in particular, sparked a firestorm of criticism. As part of the publicity build-up to the statue's unveiling, the bronze Oñate torso and horse's head were displayed at a local El Paso shopping center in 1998. A maquette of the statue meanwhile was erected inside the El Paso airport. The visibility of these Oñate monuments triggered a backlash and calls for the project to be cancelled. A member of the Acoma tribe, Petuuche Gilbert, appeared before the El Paso city council to protest: "I speak on behalf of the Acoma men who had their feet severed and who were then enslaved for twenty years," he said. "It is simply wrong to honor a person who causes so much grief, pain, and destruction."[10]

The local population in El Paso, located on the Mexican border, were just as divided about their identity as Hispanics and indigenous people in neighboring

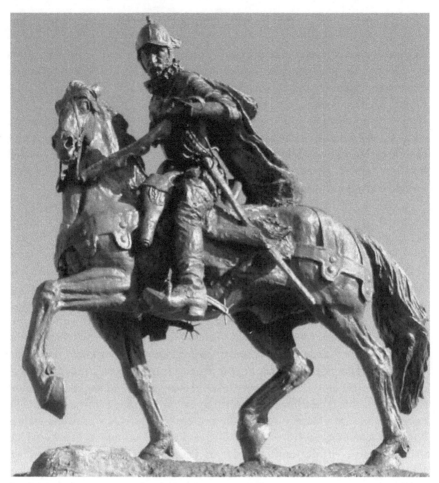

Protestors amputated the right foot of the equestrian statue of conquistador Juan de Oñate in Alcalde, New Mexico. *Photo by Advanced Source Productions, Wikimedia Creative Commons.*

New Mexico. In El Paso, the identity schism divided Chicanos (Mexican Americans) and those who identified as Hispanics with ancestral ties to the mother country, Spain. A survey in 2002 revealed that most people in the city identified as Hispanic.[11] Those opposed to the statue claimed that it represented a "Eurocentric" framing of the region's history, while others observed that Oñate was a symbol of a "fantasy heritage" that fictionalized a history of brutal colonization. One of the supporters of the Oñate statue project, Sandra Braham, insisted that the unveiling go ahead as planned. "It's like saying Columbus didn't discover America," she said.[12]

The Oñate statue was finally unveiled in El Paso in April 2007. Mounted on horseback, the bronze Oñate was holding a scroll of *la toma* in his outstretched right hand, symbolically representing the possession of the colonized territories. His helmet was adorned with a figure kneeling before Christ on the crucifix, making an iconic connection between the Spanish conquest and the Christian faith. El Paso authorities named the statue *The Equestrian* to avoid controversy over the association with Oñate's name, though the figure on horseback was unmistakably the controversial conquistador.

The choice of El Paso airport, instead of the town center, was another attempt to avoid controversy.[13] But that wasn't sufficient to appease critics. At the unveiling ceremony, a group of Acoma showed up to protest, holding up signs accusing Juan de Oñate of "genocide." They also dangled a mock severed foot as a symbolic allusion to the amputated feet of their ancestors in the Acoma Massacre atrocity.

The debate over Oñate statues in the American Southwest demonstrated how identities are powerfully shaped by collective memory. Conflicts over memory are battles over the power to write historical narratives, even if they are "imagined" history. Whether Juan de Oñate actually ordered the foot amputations of two dozen Acoma men is not known for certain. It could possibly be a legend, or perhaps a historical exaggeration.[14] But historical facts are secondary in the narrative constructions that shape shared memory and forge collective identities.

The Acoma protestors who sawed off Oñate's bronze foot were not just exacting revenge for a crime they were certain he committed four centuries earlier. For them, attacking the statue was tantamount to inflicting violence on Juan de Oñate himself, as if his spirit inhabited the bronze figure. By attacking the statue, they were neutralizing Oñate's symbolic power over their historical narratives. And yet, paradoxically, iconoclastic attacks on the statue only reinforced the authority of Oñate as a venerated figure in the Hispanic population. Iconoclasm for some encouraged idolatry for others.

While the controversy over the Oñate statue was still raging, sculptor John Sherrill Houser gave an interview to the *New York Times*. "The main challenge for us is to create something powerful enough and of such artistic quality that people want to keep it around," said Houser. "The bronze will endure over thousands of years. All the political squabbles will perish."[15]

Houser was correct in the short term. When he died in 2018, his equestrian statue of Juan de Oñate was still on display at the El Paso airport. But the controversy over his bronze creation as a symbol of Spanish colonial oppression was far from over. It will likely continue as long as Juan de Oñate's statue remains standing.

When conquistador Hernán Cortés's fleet landed on the shores of the Yucatan peninsula five centuries ago, a clash of civilizations was inevitable.

As they made contact with the native peoples in the New World, the Spanish were horrified by the religious rituals they practiced to nourish their gods. Human sacrifice, including sacrificial rituals of babies, was widespread among the natives. The Spaniards sometimes became victims to these gruesome rites. Several years before Cortés's expedition, Spanish shipwreck survivors had been forced to take refuge on the Yucatan coast, where they were captured by local Mayans. Their fate was stomach-churning. Several were sacrificed to the Mayan gods and eaten in cannibalistic rituals. The others were taken as slaves.

When Cortés landed in Mexico in 1519, his superior Spanish military techniques—cavalry, guns, cannons, broadswords, crossbows, war dogs—proved decisive in defeating the Mayans. Cortés's primary goal in Mexico was economic, notably the search for gold and silver, but his colonial project required moral justification. This was provided by Christianity. Franciscan priests accompanied Cortés on his expeditions. But converting the indigenous peoples to the Christian faith was challenging. Unlike the British and French adventures on the northern continent, where colonizers encountered nomadic natives, the Spanish came across a sedentary civilization with its own cities, palaces, and temples. Before the local population could be converted to the cross, their religious idols and icons had to be destroyed

The Spanish iconoclastic violence inflicted on indigenous religious objects was relentless. They destroyed temples, idols, and icons before erecting crosses and Catholic churches where pagan shrines had stood. The campaign of violence followed the same pattern of destruction that stretched back to the early Christians who smashed Greco-Roman temples and built churches on the same sacred places. The purpose in both instances was identical. The destruction of polytheistic shrines obliterated the symbolic power of pagan idolatry and superimposed Christian iconography.[16]

Cortés's conduct on the island of Cozumel, off the coast of the Yucatan peninsula, was particularly revealing. It was here that Cortés, upon arriving on the island with a fleet of eleven vessels and 550 men, first laid eyes on the great Mayan temples. When the Spanish came into contact with the island's people, at first they attempted to convince the natives to abandon their pagan shrines and replace them with images of the Virgin Mary and accept Christian baptism. The contemporary writer, Francisco López de Gómara, wrote that the Mayans were asked to "give up their idols, their bestial rites, and their abominable bloody sacrifices and eating of men."[17] But gentle persuasion did not work on the Mayans. The Spanish had to resort to violence. To demonstrate the impotence of Mayan deities, Cortés had his men push religious statues down the steps of the main Mayan temple, breaking them into pieces. He then ordered the construc-

tion of a makeshift Christian altar on top of the temple, where a Catholic priest celebrated mass.

There was some irony in the brutality of Spanish iconoclasm. While Cortés's men were smashing religious temples in Mexico, in Europe the Catholic Church was orchestrating a Counter-Reformation against a wave of Protestant iconoclastic fury. In the Old World, the pope imposed idols and icons. In the New World, the Church was iconoclastic. As Carlos Eire observed in his book, *War Against the Idols*: "It is good to keep in mind that just about the same time the soldiers of Charles V replaced the 'horrible idols' of the Aztecs with 'beautiful' crosses and images of Mary and the saints in the New World, Protestant iconoclasts were wreaking havoc on these objects in lands nominally ruled by him in Europe."[18] In the New World, Spanish iconoclasm was a violent assertion of religious domination by a foreign power over native populations practicing pagan rites to unknown gods. Cortés destroyed indigenous temples to build the religious foundations of a colonial society whose sole faith was Catholicism.

The Spanish encountered a serious challenge farther inland when they came upon the Aztecs, also known as the Mexica, in the area around modern-day Mexico City. The religion of the Aztecs was polytheistic but centered on their sun god Huitzilopochtli (meaning "Hummingbird of the South"). Huitzilopochtli was also a god of warfare. The main Aztec temples were located in the

Aztec Great Temple in Mexico. *Photo by Gary Todd, Wikimedia Creative Commons.*

capital city, Tenochtitlán, with a population of some 300,000. The Aztecs practiced human sacrifice, cutting beating hearts from bodies, on a scale that utterly horrified the Spanish. According to a Dominican friar, Diego Durán, the Aztecs sacrificed over 84,000 people in one four-day religious festival at the Great Temple of Tenochtitlan. Historians believe this figure is exaggerated, but most accounts report staggering numbers of people being sacrificed to the Aztec gods. According to one contemporary observer, the smell of blood was so strong that it was "unendurable to the people."[19] Since the gods needed sacrificial offerings to save the world, the Aztecs were constantly seeking new victims by conquering their neighbors. Needless to say, other indigenous peoples in the region lived in mortal fear of the Aztecs.

When the Spaniards arrived in Aztec territory, Cortés was initially received with great ceremony by emperor Montezuma. Cortés's diplomatic relations with the Aztecs were greatly assisted by his interpreter, an indigenous girl called Doña Marina, known as "La Malinche." She had been offered as a gift to Cortés during his conquest of the Yucatan peninsula. The daughter of an indigenous chief who mastered different tribal languages in the region, La Malinche not only was indispensable to Cortés as his interpreter but also became his mistress and mother of his son.[20]

Initial diplomatic courtesies between Cortés and Montezuma quickly grew tense, especially after the Spaniards got a first-hand look at blood-splashed Aztec temples filled with skulls from sacrificial victims. This is likely where the first iconoclastic designs formed in the minds of the Spaniards. Cortés had already ordered the destruction of idols at Veracruz (which means "true cross") to prevent the native peoples from worshipping and performing sacrifices. As tensions grew between the Spanish and their Aztec hosts, Cortés decided to seize Montezuma and make him a prisoner in his own palace.[21] A cross and a statue of the Virgin Mary were erected atop the Templo Mayor, or "Great Temple."

The Spanish soldiers in the Aztec capital, numbering about 1,400, finally decided to launch a preemptive assault on the city. At a sacrificial religious festival for the god Huitzilopochtli, Cortés's men made their move. What followed was a horrific bloodbath. They slaughtered hundreds of Aztec priests and warriors. They tortured and raped the women and unleashed their war dogs on Aztec nobles. They destroyed Aztec shrines and constructed Christian altars using the stones from the ruins of pagan temples. The Aztecs counter-attacked the Spaniards, who were still holding Montezuma captive. They killed and captured dozens of Spanish soldiers and sacrificed them to their gods. The counter-strike failed, however, and Montezuma was killed in the mayhem. The Spanish nonetheless remembered this setback as "La Noche Triste," or Night of Sorrows.

The Spanish finally crushed the Aztecs for good in August 1521. The indigenous population was not only overwhelmed by Spanish military force but also

devastated by European disease. As one of Cortés's followers put it: "When the Christians were exhausted from war, God saw fit to send the Indians smallpox."[22] Now that Montezuma was dead, Cortés took the Aztec emperor's daughter Isabel as his mistress. Isabel Montezuma lived another thirty years, converted to Christianity, and gave birth to Cortés's illegitimate daughter. The child was named Leonor Cortés Montezuma—future grandmother of another conquistador, Juan de Oñate.[23]

Following the Spanish triumph in Mexico, more Catholic priests arrived from Spain to convert the native population to Christ. Within three decades, the Spanish colony counted some 380 Franciscans, 212 Augustinians, and 210 Dominicans, followed by the Jesuits, who arrived in the 1570s. The conversion of natives was a crucial part of the colonial mission. The indigenous people had a choice: Christianity or slavery. As historian David Weber put it, "When sixteenth-century Spaniards asked Indians to choose between Christianity and slavery, it may seem in retrospect as though they offered the natives no real choice. Nonetheless, in the prevailing Spanish *mentalité*, Indians did have a choice, even if they made the wrong one and brought the wrath of Christendom down upon themselves."[24] While this may seem unspeakably cruel, the Spanish were unashamed about the combination of military conquest and religious conversion. When natives resisted Spanish pressures to convert to Christianity, they frequently became victims of implacable violence. Juan de Oñate's massacre and enslavement of the Acoma in 1599 was a horrific example of Spanish brutality in the face of native defiance.

Many defeated Aztecs eventually showed openness to the Christian religion as priests conducted their evangelization. Still, the transition from their polytheistic religion to a faith in one sole God was difficult. Some natives remained attached to aspects of their old religion. The phrase "idols behind the altars" became familiar, describing how pagan religious statues were hidden behind altars in Catholic churches.[25] Despite the success of evangelical campaigns, Spanish iconoclastic destruction continued when necessary. In 1531, the chief inquisitor of Mexico wrote to a Franciscan priest: "Five hundred temples have been leveled to the ground, and more than twenty thousand figures of the devils they worshiped have been broken to pieces and burned."[26]

The Spanish conquest effectively destroyed Maya and Aztec civilizations. Mexico remained under Spanish colonial rule, with Catholicism as the dominant religion, for three centuries until independence in 1821. Today, much of the Mexican population claims mixed race, though the country's tiny elite is largely European. In Mexico City, where the Spanish conquistadors destroyed the Aztec capital, a statue of Cortés and his mistress La Malinche was erected in 1982. Called *Monumento al Mestizaje*, it was unveiled as a celebration of Mexico's mixed-race roots stretching back to the union between Cortés and La Malinche,

who symbolized a Mexican version of the Pocahontas story in America. The monument also featured a statue of their son, Martin, the *mestizo* product of the historic couple's love, with a lion and eagle on each side of Mexico's founding family.

The *Monumento al Mestizaje* statue stirred controversy in Mexico. Many resented the monument as a symbol of colonial conquest. They regarded La Malinche not as a beloved figure, but as a traitor who served the interests of the Spanish colonizers. In Mexico the term *malinchism*—or *malinchismo*—means a cultural fascination with all things foreign. The word *malinchistas* designates people who are more attracted to other cultures than to their own. *Malinchistas* are sellouts. Little wonder the monument of Cortés and La Malinche became a target. The small statue of their son Martin—the "first true Mexican"—was ripped from the memorial and stolen. It was never found or replaced. Eventually, the entire monument was relocated to the edge of the city.[27]

In March 2019, as the 500th anniversary of the Spanish conquest of Mexico drew near, the country's president called for a historical reckoning. Andrés Manuel López Obrador publicly demanded an apology from both the pope and the king of Spain for the colonial oppression and suffering inflicted by conquistadors on indigenous peoples in the early sixteenth century.

"It wasn't just about the encounter of two cultures," said López Obrador, standing in front of the ruins of a Mayan temple in Tabasco. "It was an invasion. Thousands of people were murdered during that period. One culture, one civilization, was imposed upon another to the point that the temples—the Catholic churches were built on top of the ancient pre-Hispanic temples."[28]

The Spanish-Peruvian writer Mario Vargas Llosa countered that the Mexican president was the one who should be apologizing to his own people. López Obrador, he argued, should explain to them "why Mexico, which joined the western world 500 years ago and has enjoyed full sovereignty as an independent nation for 200 years, still has millions of marginalized, poor, uneducated, and exploited Indigenous people."[29]

Following López Obrador's call for an official apology from the pope, the Vatican remained silent. But another pontiff, John Paul II, had already visited Mexico and stood at the ruins of the same Mayan temples in 1993. That papal ceremony was held at the 400-year-old Virgin of Izamal monastery, a couple hundred yards from a Mayan temple once used for sacrificial rituals. John Paul II insisted that the Catholic Church had been a "tireless defender of the Indians," and condemned the legacy of the colonialist who attempted to erase indigenous culture. The pope watched a troupe of indigenous dancers wearing dragon masks as they performed a rain dance to the Mayan god Itzamná.[30]

The king of Spain coldly rejected López Obrador's demand for an apology. The Spanish monarch remained silent, but the government in Madrid issued a

terse statement: "The arrival, 500 years ago, of Spaniards to present Mexican territory cannot be judged in the light of contemporary considerations. Our two brother nations have always known how to read our shared past without anger and with a constructive perspective."[31]

In Spain today, a Hernán Cortés monument stands in his hometown of Medellín. It depicts the Spanish conqueror on a massive pedestal, holding a cross aloft while stepping on the decapitated head of a native Aztec next to broken pieces of pagan idols and altars. The iconoclastic symbolism is unequivocal: the great conquistador trampling on the indigenous civilization that he subjugated in the name of Christ.

In 2010, activists calling themselves "Citizens Anonymous" defaced the Cortés statue by covering it in red paint to symbolize the blood and slaughter of the Spanish conquest. In a communiqué, they demanded that the "fascist" statue of Cortés be replaced by a monument to the memory of the indigenous peoples slaughtered by the Spanish.[32]

The foot-amputated statue of Juan de Oñate in northern New Mexico finally came down. Fearing it would be attacked and pulled down by protestors, in June 2020 local authorities in Alcade dismantled the statue and placed it in storage.

Farther south in New Mexico, an attack on another Oñate statue in Albuquerque provoked a violent confrontation and gunshots. Protestors wrapped a chain around the Oñate statue and tugged on it while chanting, "Tear it down!" Other protestors struck the statue with pickaxes. A violent clash erupted when a local militia group showed up to protect the monument. Someone pulled out a gun and shot a protestor, though not fatally.

Following the outbreak of violence, local Albuquerque authorities had the statue removed. "Our history has not always been harmonious at all," said Albuquerque mayor Tim Keller. "It has been filled with atrocities and with bloodshed and with challenges. And those scars are still very fresh. Essentially, they're like scabs over a wound and they can be picked off and the bleeding begins again."[33] Meanwhile in El Paso, Texas, the colossal equestrian statue of Oñate at the city airport was attacked and spray-painted with the words, "Your god is not my god."[34]

The timing of these attacks on Oñate statues was not a coincidence. In the wave of violence against Confederate monuments following the murder of George Floyd, statues of Juan de Oñate in the Southwest once again became targets as symbols of colonial oppression. Native Americans were making common cause with the Black Lives Matter movement sweeping through the country. Equestrian statues of Oñate were among the dozens of monuments that came crashing down over the summer of 2020 in spontaneous outbursts of iconoclastic destruction.

"There is this groundswell from the public that has led people to say these are symbols of white supremacy and they have to come down," said Lecia Brooks, outreach director for the Southern Poverty Law Conference.[35]

The iconoclastic violence spread to California, where protestors toppled statues of Father Junípero Serra, the eighteenth-century Franciscan priest who founded Spanish missions in the American West. Junípero Serra was canonized by Pope Francis in 2015. In California, however, he had long been resented by Native Americans as the embodiment of colonial exploitation and forced conversions to the Catholic faith. In 2015, only days before his canonization, protestors attacked Father Serra's mission at Carmel-by-the-Sea. They toppled and defaced Serra's statue and inscribed "saint of genocide" on his tomb. Two years later, a statue of Serra at a mission in Santa Barbara was decapitated. Stanford University meanwhile announced that it would rename buildings memorializing Junipero Serra due to his association with the treatment of Native Americans. In the wave of violence against statues in 2020, statues of Saint Junípero Serra throughout California were knocked down.

In San Francisco, a statue known as *Early Days* near City Hall was taken down in 2018. The statue, erected in 1894, showed a native Indian cowering at the feet of a Spanish *vaquero* cowboy whose hand is raised in victory while a Catholic priest points to heaven as a sign of saving the native's soul. The statue left no doubt about the colonial message: physical subjugation and spiritual salvation. The *Early Days* statue had long been resented by Native Americans, and many requests had been made to have it removed. Now it was finally gone.

Indigenous protests against oppression spread beyond the United States. In South America, native activists in Colombia toppled statues of Christopher Columbus and Spanish conquistadors as symbols of slavery and genocide. In May 2021, Misak indigenous protestors toppled a statue of conquistador Gonzalo Jimenez de Quesada in the center of Bogota. The protestors declared in a statement: "Historically he was the biggest slaughterer, torturer, thief and rapist of our women and our children."[36] In Mexico, a massive statue of Columbus was removed from the capital's main avenue in 2020. The following year, Mexico City's mayor Claudia Sheinbaum announced that a pre-colonial figure of an indigenous women would be erected on the empty pedestal where Columbus had stood. Sheinbaum said the new statue, called *Young Woman of Amajac*, represented "the fight of women, particularly the indigenous ones, in Mexican history."[37]

Statues of the famed explorer James Cook were defaced in Hawaii, Australia, and New Zealand. When Captain Cook initially arrived in Hawaii in 1778, local natives believed he was a deity and referred to him as *akua*, which meant "god." Like the encounter between the Spanish conquistadors and Mexicans, however, relations between Cook's men and the local Hawaiians grew tense, and

violence erupted. The natives killed Captain Cook and disemboweled his body in a funeral rite. Cook's legend grew, and he became a heroic icon, even treated to his own "Apotheosis" painting.[38] Today, however, he is a symbol of colonial exploitation and genocide in the South Pacific. In June 2020, Black Lives Matter activists in Sydney, Australia, defaced a Cook statue in Hyde Park with the spray-painted words, "No Pride in Genocide." In January 2022, someone vandalized a Cook monument in Hawaii marking the spot where the explorer met his end. The words "You Are On Native Land" were sprayed on the obelisk.[39]

In Canada, iconoclastic attacks spread throughout the country's western region over the summer of 2021. The violence was triggered by the discovery of remains of more than 1,000 indigenous children in unmarked graves at residential schools run by the Catholic and other churches. For more than a century, some 150,000 indigenous children had been forced to attend church-run residential schools as part of an official policy of assimilation. Abuse at these schools was widespread, and thousands of children died of disease and neglect.[40]

The revelations of the children's unmarked graves, and the outbreak of violence that it provoked, dealt a shocking blow to Canada's national psyche. On the "Canada Day" holiday in July 2021, indigenous protestors toppled a statue of Queen Victoria in front of the legislature in Manitoba. They spray-painted the monument red to signify the blood of colonial oppression. A statue of the current monarch, Queen Elizabeth II, was also pulled down.[41] The violence escalated as protestors torched and burned Catholic churches to the ground. Some indigenous leaders called for all Catholic churches to be razed, while other leaders pleaded for the violence to cease. For Canada's indigenous people, who had been converted to Christianity and baptized, churches remained a physical symbol of the erasure of their ancestral religion. As one indigenous Canadian put it, "We are a spiritual people and that spirituality was transferred to Christ, because that was the only way our people could pray. That was the only way that they could worship."[42]

As statue-toppling and church-burning spread through Canada's western provinces, the Canadian government called on Pope Francis to issue a formal apology to the country's indigenous people for the role played by the Catholic Church in these atrocities. The pope agreed to meet with the country's indigenous leaders at the Vatican.

It wasn't the first time Pope Francis apologized for the treatment of indigenous peoples in the Americas. On a visit to Bolivia in 2015, the pontiff had apologized for the sins of the Church in the New World. "I say this to you with regret: Many grave sins were committed against the native people of America in the name of God," said the Pope. "I humbly ask forgiveness, not only for the offense of the Church herself, but also for crimes committed against the native peoples during the so-called conquest of America."[43]

The painful history of the Spanish conquest in the Americas leaves many lessons about the nature of religious idolatry—and the iconoclastic drive to smash and destroy the idols and icons of other religions. The Spanish conquistadors sincerely believed they were civilizing pagan peoples and bringing them into the only true religion of Christian worship. The destruction of pagan temples was commanded by God. The consequences for the native peoples of the Americas, however, was the destruction of their civilization.

The mutilation of conquistador statues today is vendetta iconoclasm—statue-smashing as historical vengeance. The motives are not religious, they are claims on social justice and historical memory. Disputes over these historical narratives, and the bronze statues that symbolize them, are far from over.

Part II

REVOLUTION

CHAPTER 6

Eikon Basilike

On the morning of his execution, Charles I took a final walk in London's St. James's Park with his beloved pet dog, a toy spaniel called Rogue.

It was a cold January morning in 1649. The king was wearing an extra shirt under his pale-blue silk waistcoat. He didn't want to shiver in the sharp cold, fearing the crowd assembled in front of Banqueting House would believe he was trembling from fear.

Following his walk in the park, the king was escorted to Whitehall, where he prayed in Banqueting Hall. On the ceiling was an apotheosis fresco depicting his father, James I, as God. When Charles I stepped outside into the cold air, the crowd gazed at their monarch in silence. Those close to the scaffold might have noticed the teardrop pearl earring, embedded in a gold crown and cross, hanging from the king's left ear.

"I go from a corruptible to an incorruptible Crown, where no disturbance can be," declared the king. Those were Charles I's final words.[1]

The king bent and put his head on the block, his eyes open. The signal was given by the monarch's outstretched arms. The executioner brought down the axe. It severed the king's head with one blow.

The crowd let out a horrible groan. Soldiers surrounding the scaffold immediately dispersed the crowd. Some managed to approach and dip handkerchiefs in the king's blood. Others took blood-stained bits of the scaffold as relics.

The king was dead. After nearly a decade of civil war, the monarchy in England was abolished. The kingdom was now a republic. Oliver Cromwell would soon be declared lord protector.

In the new Puritan republic, the royal crown was melted down, statues of the Stuart kings removed from all buildings, and scepters torn from the hands of royal sculptures. Charles I's statue in the Royal Exchange was taken down and the words *Exit Tyrannus* painted on the pedestal.

Charles I was dead in the flesh, and his statues toppled, but almost immediately the monarch was resurrected as an icon with his own idolatrous cult.

The famous Van Dyke portraits of Charles I reveal that he was acutely conscious of the power of his own image. It was fitting that the Stuart monarch had left a spiritual memoir titled *Eikon Basilike*—Greek for "royal icon" or "royal image." In the king's posthumous pamphlet—subtitled *The Pourtrature of His Sacred Majestie in His Solitudes and Sufferings*—Charles portrayed himself as a Christ-like martyr. His physical appearance on the frontispiece—long hair, beard, gaunt expression—reinforced the Christ-as-martyr image. The timing of *Eikon Basilike's* publication, almost immediately after the king's execution, suggested that the text had been carefully prepared in Charles I's inner circle. The book was a literary attempt by a British monarch to create a posthumous cult of royal veneration.[2]

Eikon Basilike was so successful with the public, going through at least twenty printings in one year, that Oliver Cromwell feared a monarchist backlash. It was decided that a Puritan-sponsored book must be published to smash apart Charles I's royal self-justifications. Charles had proclaimed himself a royal icon; the published rebuttal would be an iconoclastic attack on the deceased king's image.

The task of writing the literary hatchet job went to one of the greatest poets of the age: John Milton. Famous for his epic, *Paradise Lost*, Milton had been allied to the Puritan cause during the Civil War. He was a formidable pen to critique and dismantle Charles I's legacy. Milton's tract was fittingly titled *Eikonoklastes*—or "iconoclast." Puritan iconoclasts had attacked idols in churches during the Civil War. Now through John Milton they were smashing the king's icon after his execution. *Eikonoklastes* portrayed Charles I as a tyrant.

Milton's counterattack, translated into Latin and French and widely distributed, backfired immediately. One reason was its disrespectful tone, heaping scorn and mocking the monarch in his grave. Another was the tract's style. Milton's detailed point-by-point rebuttal of Charles I's claims failed to capture the public's attention. Charles I's *Eikon Basilike*—known as the "King's Book"—resonated more with the public because it was a poignant confession. It sacralized and mystified kingship. It posthumously transformed Charles I from flawed monarch into a seventeenth-century royal celebrity. Charles I's image on the book's frontispiece circulated widely in engravings, woodcuts, badges, and mementoes.[3] While the public spurned the Puritan diatribe in *Eikonoklastes*, the powerful impact of *Eikon Basilike* kept the mystique of monarchy alive.

The standard interpretation of the English Civil War is a familiar narrative. In the 1640s, England was torn apart by a bitter power struggle between a recalcitrant Stuart monarch and a representative parliament seeking more powers. When civil war broke out, Oliver Cromwell's Puritan "Roundheads" defeated

and toppled the Catholic-leaning king and his supporters known as "Cavaliers." The victory of the Puritans ended divine-right monarchy and heralded parliamentary democracy. This interpretation of the English Civil War as a "liberal" revolution provided moral justification for the rebellion against the British monarchy in America a century later. It's a powerful myth that has endured for centuries. All political revolutions need founding mythologies, and England's was no different. But the social, political, and religious dynamics that pushed England into revolution in the 1640s were much more complex.

The Puritan iconoclastic violence that wreaked havoc throughout Charles I's kingdom was the culmination of a much longer cycle of idol-smashing in England. Hostility to statues and icons was deeply etched in the Reformation culture of rebellion that had exploded more than a century earlier. Overthrowing a divine-right monarchy required widespread destruction of its symbols. King-breaking and "thing-breaking" were inseparably joined in the same purpose.[4]

A wave of iconoclastic violence had swept through England in the early phase of the Reformation in the sixteenth century. The Tudor monarchs—first Henry VIII, followed by his daughter Elizabeth I—exploited iconoclasm to legitimize their own authority. Though not personally opposed to idols and images in churches, they understood that Protestant iconoclasm was now deeply entrenched in England's political culture. When Charles I ascended to the throne, iconoclastic insurgency was spinning out of control and turning against the monarchy.

The English Civil War, while fueled by sectarian passions, was a political revolution of regime change. Oliver Cromwell's Puritan forces forcibly overthrew an existing order of monarchy and established a republic. Besides war on the battlefield, the Puritans engaged in a campaign of iconoclastic violence whose goal was the obliteration of the old order's symbols of authority. England's divine-right monarchy was attached to the image. It was toppled by a Puritan political program attached to the word. Revolution was driven by iconoclastic fury.

While Puritan iconoclasm declared itself to be emancipatory, it was in fact fueled by sectarian intolerance. The Puritans were not seeking liberty; they were asserting religious forms of moral and political control over English society. In that respect, the overthrow of the monarchy in England was essentially an "illiberal" revolution driven by authoritarian religious passions—the same moral culture that Puritan exiles were implanting in the American colonies while civil war raged in England.

Cromwell's republic was short-lived, but the English revolution had far-reaching consequences that reshaped the modern world.

A century before the English Civil War, Henry VIII bestrode his age like a colossus. He was a monarch of gargantuan appetites, passionate obsessions, and unspeakable cruelty.

His larger-than-life legend tends to focus on Henry's multiple wives and conflict with the pope, who refused to grant him a divorce so he could marry Anne Boleyn. The English Reformation is often framed as a nationalistic Tudor narrative with Henry VIII in the leading role, kicking everything off with his famous rupture with the Catholic Church to create a Protestant England later championed by his daughter, Elizabeth I. It's a compelling narrative, but doesn't quite tell the whole story. The Reformation was a long and protracted saga whose seeds were planted even before Henry VIII.[5]

The movement against the Catholic Church and its idolatrous practices had been building more than a century before Henry's reign. In England, the fourteenth-century theologian John Wycliffe opposed icons, attacked monasteries, and rejected the veneration of saints. "We who call ourselves Christians sin more often in idolatry than do barbarians," he lamented in *De Eucharista*.[6] Wycliffe's followers, known as the Lollards, committed acts of cross-breaking because the Bible commanded it. The Lollards insisted on the *sola scriptura* principle, which asserted the primacy of the Bible. In 1415, the pope declared Wycliffe a heretic and excommunicated him despite the inconvenient fact that Wycliffe had been dead for more than thirty years. Wycliffe had died in 1384 and was buried in Leicestershire. No matter, the Church ordered his remains disinterred from consecrated ground, and his body was burned.

Growing opposition to the pope set the stage for German theologian Martin Luther, who in the early sixteenth century ignited another battle with the Church. Luther's main grievance was the papal practice of selling indulgences to raise cash for the Vatican. Luther was not against idols and icons like the Calvinists. He was opposed only to worshipping them. Editions of his own translation of the Bible included woodcut images. Luther moreover was aware that the Bible featured competing views on images and idols—for example, the passage in Exodus 25:18 in which God commands that two gold cherubim adorn his throne could hardly be described as hostility to idols. Despite his own theological positions, Luther could do little to stop the frenzy of iconoclastic belligerence against the Catholic Church spreading like wildfire through Germany. The entire continent was soon in upheaval as icon-smashing riots ripped through northern Europe.

Henry VIII had been king for only six years when Martin Luther dispatched his famous "95 Theses" list of disputations on Catholic doctrine and papal practices.[7] The pope in Luther's day was Leo X. Born Giovanni de Medici, he was the second son of the powerful Medici patriarch, Lorenzo the Magnificent. Giovanni de Medici benefited from a spectacular series of promotions in the Vatican sys-

tem: appointed a cardinal at the age of thirteen, he never bothered becoming a priest. Leo was thirty-seven when elected pope in 1513. He spent lavishly on renovating St. Peter's Basilica and commissioned artists such as Raphael to produce paintings for the Vatican rooms.

Henry VIII, who became king in 1509, initially took sides with Leo X against Martin Luther. Henry even published a tract supporting the pontiff against the recalcitrant German theologian. But after Henry instigated his own conflict with Rome over the delicate matter of divorce, he switched sides and embraced the spirit of the Reformation. Henry was largely indifferent to the finer points of theology, except when he found political expedience in them. He preferred to focus on here-and-now problems, like the state of his treasury—more specifically, the troubling realization that his kingdom was on the verge of bankruptcy due to costly foreign wars. Henry needed cash quickly, and he knew where to find it.

When Henry surveyed his vast kingdom, he saw papal power everywhere. The pope possessed a quarter of the landed wealth in England. The Church operated some nine hundred religious houses throughout the country and managed a network of four thousand monks, three thousand canons, three thousand friars, and two thousand nuns. Papal income from religious houses in England was double the amount Henry VIII's crown estates yielded annually.

Henry's confrontation with Pope Leo X over his divorce provided a timely pretext to make a confiscatory move on the Church's assets. But Henry needed a less obviously selfish rationale. It was provided, ironically, by Henry's former adversary, Martin Luther. In his 1521 tract, *De Votis Monasticis,* Luther argued that monasteries had no basis in scripture. Henry found another pretext in the scandalous rumors circulating about the depraved morality inside England's monasteries. It was murmured that they were places of licentious behavior where monks and nuns engaged in secret lives of moral debauchery and superstitious practices.

In 1536, Henry's influential counselor, Thomas Cromwell, orchestrated "visitations" to monasteries throughout the realm, ostensibly to assess the value of monastic wealth for tax purposes. Cromwell also collected salacious and damning information that cast grave doubts on the moral rectitude of monastic life. Among his shocking discoveries were acts of sodomy committed by priests and, heterosexually, monks guilty of lascivious conduct with women. This evidence was damning. For Henry VIII and his close circle of royal advisers, the purging of monasteries in England was long overdue. The solution: dissolve monasteries throughout the kingdom.

The infamous Dissolution of the Monasteries was a systematic campaign of iconoclastic destruction of Church property in England. On the surface, it was a smash-and-grab asset seizure. As one observer put it, Henry's attack on Church

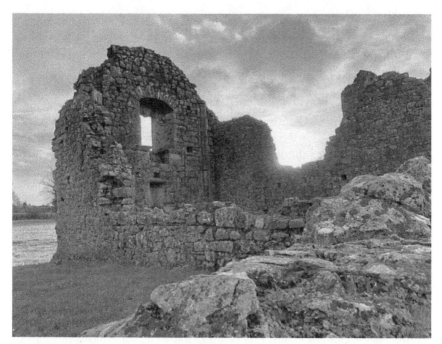

The ruins of Hore Abbey in County Tipperary, Ireland. Following the dissolution of the monasteries in 1540 by order of king Henry VIII, the monastery's assets were seized by the British Crown. *Wikimedia Creative Commons.*

property was "surprisingly short of ideology, let alone theology, and almost entirely a story of greed." The architectural historian Howard Colvin described the dissolution as "the greatest single act of vandalism in English, perhaps in European history."[8] Other historians argue, however, that despoiling the Church's assets was not Henry's primary motive. Iconoclastic zeal and a desire for religious purification was also a factor.

"The dissolution of the monasteries was not only—or even primarily—an exercise in aggressive state fiscalism," observed Peter Marshall in his history of the English Reformation. "It was a spectacular, public, evangelical campaign, announcing the purification of the English Church, and denigrating the values and ideals the monasteries had stood for. Royal injunctions against displays of relics seem motivated equally against the idolatrous character of such veneration and outrage at exploitation of the faithful for pecuniary gain."[9]

Henry VIII was not personally hostile to religious idols and icons in churches. In the past, cross-burnings and iconoclastic assaults on churches had been the work of radical religious groups such as the Lollards. In Henry's reign, it was no longer fanatical sects attacking icons and idols. The king's closest advisers

were leading proponents of the English Reformation. Icon-smashing was now sanctioned by royal decree. Iconoclastic destruction was unleashed by law.

A year after Henry married Anne Boleyn in 1533, he proclaimed the *Act of Supremacy*. Armed with this new statute, the king seized the Church's assets in England. A royal injunction was imposed on all religious icons as "the most detestable sin of idolatry."[10] In the first wave of iconoclastic fury, attacks focused on church idols and icons that had been "abused" or were objects of "superstition"—in other words, icons venerated with prayers, cherished as objects of pilgrimages, or relics believed to possess miraculous powers.[11] Henry VIII's men ransacked Catholic churches and smashed icons, idols, frescoes, and statues. They pillaged and destroyed monastic libraries. They stripped the lead from church roofs. They despoiled shrines to saints. Between 1536 and 1540, more than eight hundred religious houses were suppressed. Roughly seven thousand monks, nuns, and friars were evicted.

Some iconoclastic acts were particularly gruesome, targeting not hard idolatrous objects but the soft flesh of putrefied cadavers. In Canterbury Cathedral, the reliquary containing the remains of Saint Thomas Becket had been a pilgrimage site for centuries. Becket was the archbishop who had stood up to another English king called Henry—Henry II. In 1538, Henry VIII issued a proclamation decreeing that Becket was to be stripped of his status as a saint. The king sent his men to Canterbury, where they demolished Becket's shrine, desecrated his tomb, and according to Pope Paul III, burned his remains.[12] The cult of Becket was proscribed, and all statues or images of him were destroyed. It could now be said that Thomas Becket had been murdered twice—first by Henry II, then posthumously by Henry VIII.

A few months later, the pope excommunicated Henry VIII. The Tudor monarch was unmoved, however. Iconoclastic violence continued to rip through his kingdom. By 1540, the destruction of Church icons and idols had wiped out much of England's cultural heritage.[13] Some mutilated abbeys were sold or given to members of the aristocracy; others were transformed into English churches or left as ruins. As historian Margaret Aston observed in her book *Broken Idols*: "To reformers of the sixteenth century, it was a truism that in order to build it was necessary to destroy. Their New Jerusalem was a commanding edifice, and it could be erected up on old foundations."[14] This followed precisely the same pattern as early Christian iconoclastic destruction of Greco-Roman pagan temples on which Christian churches were constructed. In Reformation England, stainglassed Catholic churches were dismantled and demolished to make way for unadorned Protestant places of worship.

Following Henry VIII's death in 1547, his son Edward VI—only a boy when he ascended to the throne—accelerated the official policy of iconoclastic destruction. Under the influence of hardline Reformist leaders such as Thomas

Cranmer, archbishop of Canterbury, the young king issued an injunction that took iconoclasm to a new level. Now all images and idols in the kingdom were to be removed from churches—not just "abused" or "superstitious" images, but everything from shrines to candlesticks.[15] So-called "blanchers" cleansed the insides of churches by whitewashing their murals. Edward VI was hailed as the "new Josiah," the boy monarch in the Book of Kings who destroyed and burned the idols of Baal. A propaganda painting of Edward VI depicted the young king with the pope slumped at his feet and branded with the words *idolatry* and *superstition*.[16]

Edward VI ruled for only six years before his early death at age 15 in 1553. He was succeeded by his Catholic sister Mary ("Bloody Mary"), who restored the sacred status of idols and icons. Suddenly the cross and images of the Virgin Mary and the saints were back in vogue. But too much damage had been done. The word and image were now irreconcilable adversaries in England. When Elizabeth I succeeded her half-sister in 1558, the new Protestant monarch reversed official policy once again by returning to official iconoclasm.

We tend to regard the Elizabethan period as an enlightened era that produced the great works of William Shakespeare. In truth, it was a time of political tensions and relentless campaigns of violence on religious objects. Elizabeth's coronation was celebrated with bonfires and the burning of roods. During her long reign, people broke crucifixes, defaced figures of the saints, and denuded altars throughout England. The Elizabethan homilies included a sermon titled "Against Peril of Idolatry," which stated that "images which cannot be without lies, ought not to be made, or put to any use of religion, or to be placed in churches and temples."[17]

While it's true that Elizabeth was personally cautious about violence against crosses and religious images, her episcopate was resolutely more strident on the question. By 1570, tensions with the pope were so poisoned that Pious V excommunicated Elizabeth, declaring her a heretic and calling on her subjects to disobey her or face excommunication themselves. In Protestant England, this unleashed a torrent of anti-papal hatred that provided further incentive to break and burn idols. Legislation followed that prohibited the possession of crosses, images, and beads. As historian Julie Spraggon observed, Elizabethan I's iconoclastic legacy was extensive: "By the end of the sixteenth century shrines, reredoses, statues of saints and carved rood figures had all been removed and destroyed, wall paintings were whitewashed over and their place taken by scriptural texts."[18]

When Charles I became monarch in 1625 at age 25, the Stuart monarch was immediately suspected of Catholic sympathies. For the king's adversaries, Charles embodied the elevation of the altar over the pulpit. The ambiance of his court was wafting with the odor of Catholic incense. Charles had brought back religious trappings that Puritans fiercely opposed as idolatry. The most damning evidence was his Catholic wife, Henriette-Marie de Bourbon, sister of

French king Louis XIII. Her influence on Charles was said to be great. He even had a private Roman Catholic chapel, designed by Inigo Jones, constructed for her next to St. James Palace in London. Charles also appointed William Laud, a staunch anti-Calvinist, as archbishop of Canterbury. As early as the 1620s, Laud was bringing idols and images back into churches. In 1632, Charles I's star chamber court fined the recorder at St. Edmund's Church in Salisbury for destroying a stained-glass window that depicted God the father.[19] This was one of many examples of how Laud's policies antagonized English Puritans and provoked a backlash of iconoclastic fury.

English Puritan arguments against icons and statues were the same as those asserted by Calvinists, Lutherans, and Anabaptists on the continent. The prohibition of idols and graven images was explicit in Biblical scripture. Protestants rejected the Catholic connection between incarnation and icon. The word of God in the Bible was the sole source of knowledge and truth. The printing press empowered Puritan campaigns against idols. Pamphleteering armed Puritans with the power to propagate the word against the image. People had access to the vernacular Bible translated into English. Those with no access to Latin could read and cite Biblical scripture. Polemical tracts against idolatry circulated feverishly. So did pamphlets excoriating the Pope and exhorting the English to smash statues and icons throughout the kingdom. Iconoclasm was both discourse and action.

As Charles I became increasingly engaged in a standoff with his parliament, the Puritan culture of rebellion turned fiercely against the king. In parliament, the Puritan faction had become sufficiently powerful to insist on widespread religious reforms. Charles I stubbornly rejected them. The resulting tensions led inexorably to civil war.

From the outset of the war, belligerence against statues and icons was widespread in Puritan campaigns against the king. The destruction of idols was a political necessity to obliterate royal power and its symbols. Iconoclasm was even enacted in law. A parliamentary ordonnance decreed the removal and abolition of idolatrous images in churches. The targets for destruction were itemized: fixed altars, altar rails, chancel steps, crucifixes, crosses, images of the Virgin Mary, and pictures of saints or superstitious inscriptions. In London, an alderman smashed the painted windows in his parish church. Sir William Stringett was a particularly prodigious destroyer of Catholic art. When visiting a colleague's house, he spotted a painting of the resurrected Christ on the wall. He drew his sword and sliced through the painting.[20] Little consideration was given to the aesthetic quality of paintings and statues destroyed and lost forever. Like Savonarola in his Florentine theocracy, the English Puritans suspected beautiful images as dangerous temptations.

A favorite target of Puritan idol-breakers were crucifixes.[21] In May 1643, a massive crowd gathered around Cheapside Cross in London to watch parliamentary troops pull down the monument with ropes. A pamphlet about its toppling was titled "The Downfall of Dagon," a reference to the Book of Samuel in which the destruction of the Philistine god Dagon's idol is recounted. As the Biblical allusion suggested, the toppling of the Cheapside Cross was a symbolically important act. The stone monument of Eleanor of Castile, queen consort of king Edward I, had stood in the capital since the late thirteenth century. Topped with a crucifix, it featured statues of God, the Virgin holding the infant Christ, and a dove representing the Holy Ghost. The Cheapside Cross had already been assailed in 1581 when iconoclasts removed the infant Christ and defaced the Virgin. In another attack twenty years later in 1601, Mary lost her infant again and the assailants stabbed the Virgin in the breast.[22]

When the Cheapside Cross finally came crashing down in 1643, bands of soldiers "reacted by Sounding their Trumpets, and shooting off their peeces, as well as shouting-out with their voices, and echoing out their joyfull acclamations at the happie downfall of Antichrist in England."[23] Psalm-singing and rituals of exultation were common during acts of destruction. These ceremonies of jubilation echoed the iconoclastic rites of earlier Christian fanatics in history. In the ancient world, Christians chanted hymns and poured holy water on pagan idols to drive out the demons they believed inhabited the statues. In Renaissance Italy, Savonarola's bonfires of vanities belonged to the same tradition of Christian rituals of ecstatic jubilation. Tossing vanities into purifying flames was accompanied by chanting and singing of lauds. In sixteenth-century London, the toppling of the Cheapside Cross was similarly an occasion for rejoicing.

Some looked at London's St. Paul's Cathedral as an abominable idol of papal worship. A radical Puritan called Simon Chidley described the cathedral as an "old bawdy house of the whore of Babylon"—a New Testament reference to Rome. Biblical references like this were a constant fortifier of iconoclastic zeal.[24] Another symbolic target was Canterbury Cathedral, where Henry VIII had ordered Saint Thomas Becket's shrine destroyed in 1538. More than a century later in 1642, the cathedral was attacked again. A hundred men used a rope to pull down the statue of St. Michael the archangel. A minister climbed up a ladder and, with a pike, smashed a stained-glass image of Becket. In London, the queen's private chapel at St. James Palace was another target for demolition. That Charles I's French wife Henriette-Marie celebrated Catholic mass in the chapel was not a secret. There had even been assaults on the chapel to stop "idolatry" from being practiced inside. In March 1643, parliament ordered the Capuchin friars attached to the chapel arrested and had all "superstitious" objects inside demolished. The chapel was ransacked—altars smashed, images mutilated, orna-

ments burned. A bonfire outside was lit to burn crucifixes, images, and books. The Capuchin friars were deported back to France.[25]

Most parliament-ordered iconoclastic violence was carried out by county committees, Puritan aldermen, church wardens, and soldiers in Oliver Cromwell's army. In 1643, Cromwell's men stormed the Peterborough cathedral and ransacked everything inside. They raised their muskets and shot at a ceiling painting of Christ surrounded by saints and four evangelists. Other soldiers attacked and destroyed the royal tombs of Mary Stuart and Henry VIII's first wife Katharine of Aragon. The tomb of Mary Stuart, Queen of Scots, was empty because in 1612 her son, King James I, had moved her exhumed remains to Westminster Abbey. Cromwell personally joined in the destruction at Peterborough cathedral, climbing a ladder to knock out a crucifix in the west window. Cromwell's troopers later quartered their horses in the cathedral. The royalist newspaper *Mercurius Aulicus* reported that Cromwell and his troops "did most miserably deface the Cathedrall Church, breake downe the Organs, and destroy the glasse windowes, committing many other outrages on the house of God which were not acted by the Gothes in the sack of Rome, and are most commonly forborn by the Turks when they possesse themselves by force of a Christian city." [26] The destruction of other cathedrals followed. Cromwell's men despoiled churches from Canterbury and Chichester to St. Paul's and Winchester. They demolished altars, smashed stained glass, and destroyed religious statues, carvings, crosses, vestments, prayer books, organs, tombs, and effigies.

A particularly strident iconoclast in the Puritan camp was William Dowsing, a provost-marshal for the parliamentary army in eastern England. Dowsing's other title was commissioner for the destruction of monuments of idolatry and superstition. In that role, he was Parliament's iconoclastic enforcer. Dowsing kept detailed records of his icon-smashing campaigns. In one journal entry, he wrote, "We beate down 3 crucifixes, and 80 superstitious pictures, and brake the rayless, and gave order to deface 2 gravestones with pray for our souls."[27] In 1643, Dowsing personally supervised the ransacking of the chapel in Porterhouse College at Cambridge University, where his men pulled down statues of two winged angels and four saints and smashed the stained glass and all the religious iconography on the walls and pews. He also conducted an image-breaking tour of Cambridgeshire and Suffolk churches during which he personally supervised, crowbar and hammer in hand, the destruction of all their idols and icons. Of the 245 churches he visited, he smashed to pieces roughly 90 percent of the icons. At Jesus College, Cambridge, he destroyed 120 images in a single day. Dowsing assiduously cited Biblical commands and Hebrew examples—notably the iconoclastic king Josiah—to justify his acts of destruction.[28]

Parallel to official public violence, many acts of destruction were random and spontaneous. A mob in Chelmsford smashed a stained-glass church image

of Christ while celebrating Guy Fawkes day. The following Sunday when the rector of the church preached against these violent acts, a crowd assaulted him and called him "a popish priest" dressed in "rags of Rome." The destruction of religious images, official and spontaneous, was part of a larger movement to impose moral purity on society. Iconoclasm was a purifying ritual, a "sacrament of forgetfulness" that obliterated contested beliefs and practices of the past.[29] Every cross pulled down and icon smashed was a blow against a divine-right monarchy consigned to oblivion.

Charles I was finally taken prisoner by Cromwell's New Model Army. The iconoclastic fury of the Puritan revolution was now about to eliminate the most powerful icon in the kingdom: the monarch himself. His execution was iconoclasm as regicide.

England's Puritan republic proved short-lived. Cromwell's revolution had succeeded because it was driven by a powerful Puritan faction in parliament who were zealously attached to Biblical literalism. But the revolution entrenched a political program of religious fundamentalism into the laws of the land that proved intolerable.

Despite their emancipatory discourse, the Puritans were not always champions of rights and freedoms. They were hell-bent on imposing their own religious dogmas and convictions on the entire population. For those who did not share them, Cromwell's Puritan republic must have felt like an oppressive theocracy in which the state meddled in every aspect of daily life. The country was subject to strict moral codes of conduct. Inns and alehouses were shut down. So were theaters, suspected of inflaming public emotions. New laws banned cursing, wearing makeup, public drunkenness, gambling, cockfighting, and bearbaiting. A blasphemy law was passed to suppress radical sects, followed by a law against adultery that imposed a death sentence for adulterous women and their lovers. Prostitution was also targeted by cracking down on "nightwalking." Brothel-keepers were whipped, branded on the forehead with the letter *B*, and imprisoned for three years. In 1656, over 400 prostitutes in London were rounded up and shipped out to Barbados. Cromwell also took measures against Christmas celebrations suspected of immoral excesses. On Christmas Day, soldiers patrolled the streets and seized festive food.[30] These scenes of soldiers morally policing the streets of London recalled the fanatical monk Savonarola's Christian shock troops patrolling the streets of Florence and punishing all signs of immodesty.

Over time, these strict Puritan measures became deeply unpopular with the English people. Cromwell's personal rule as lord protector turned out to be just as authoritarian as the divine-right monarch he had deposed and executed. He even came close to assuming the mantle of monarch himself, insisting that he be addressed as "Your Highness." The Puritan republic was, in effect, a dictatorship.

When Cromwell died suddenly of kidney stone disease in 1558, his death left a power vacuum when his son Richard failed to impose himself as his father's successor. Cromwell's republic soon collapsed. It had lasted a little more than a decade. Many in England were relieved that the Puritan interregnum was mercifully over.

When Charles II was proclaimed king, cannons were fired, church bells rang out, and people lit bonfires to celebrate the Restoration.

In May 1660, the new king, long exiled in France, returned triumphantly to London in great pomp and ceremony. As his procession entered the city, thousands cheered to the blast of trumpets and the beat of drums. Charles II's image soon appeared on all sorts of novelties, from playing cards to theater tickets. Known as the "Merry Monarch" and famous for his many mistresses, he was the opposite of a Puritan. After his proclamation as king, people were free to drink to the king's health in the streets. Pubs were renamed "King's Head" after him.

A pressing issue was how to resolve the bitter conflicts from the Puritan republic festering in the memory of the people. Parliament passed a "Law of Oblivion" shortly after Charles II's return, making it illegal to publicly remember the tumultuous events of the Civil War and Puritan rule. It was illegal to speak or publish opinions about someone's conduct during the "late troubled times." Events under the Puritan interregnum were condemned to collective damnatio memoriae—or, in the text of English law, "perpetual oblivion."[31]

The same law offered amnesty to those who had committed crimes during the Civil War—except the regicides who had signed Charles I's death warrant. The traitors responsible for the king's execution would be punished and remembered. The regicides were tried at the Old Bailey and sentenced to death. One of them was Major-General Thomas Harrison, who had been Cromwell's top officer in the New Model Army. Harrison was hanged, drawn, and quartered at Charing Cross. The diarist Samuel Pepys, present at the execution, observed that on the scaffold Harrison looked "as cheerfully as any man could do in that condition."[32]

Oliver Cromwell was already dead and buried in Westminster Abbey, so a special posthumous punishment was designed for him. His body was exhumed and publicly dragged to the Tyburn gallows, where Marble Arch is located today. His cadaver was strung up all afternoon before being pulled down. The corpse was then decapitated. Cromwell's head was impaled on a pike and displayed in front of Westminster Hall, where Charles I had been tried and sentenced to death. To celebrate the "execution" of Cromwell, commemorative items were produced, including tobacco boxes that featured an image of Charles I on the lid. Also featured was an image of Cromwell, open mouthed, a halter round his

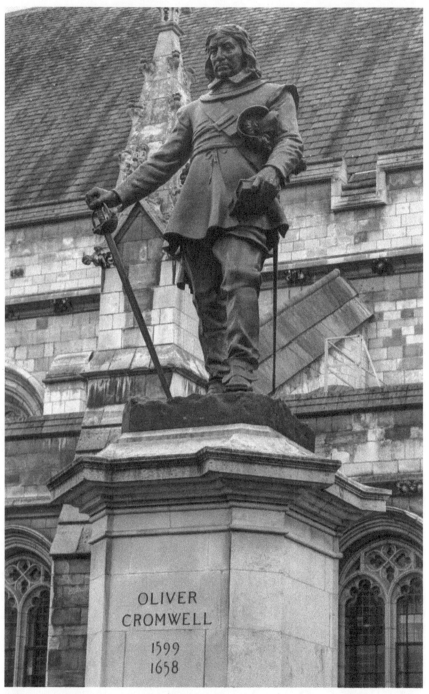

Statue of Oliver Cromwell in Parliament Square, London. *Wikimedia Creative Commons.*

neck, next to the Devil.[33] Cromwell's head remained displayed on a pike at Westminster Hall for two decades before harsh winds blew it off in a storm.

Today, Oliver Cromwell and Charles I keep close company as prominent statues in central London.

The statue of Cromwell stands in front of parliament. Erected in 1899 on the 300th anniversary of his birth, it depicts the lord protector standing as grimly in bronze as he stood in the flesh during his life, holding a Bible in one hand, a sword in the other, a lion at the base of the pedestal. One imagines that Cromwell, a strident iconoclast, might look upon his own statue today with consternation. The Puritan idol-smasher had become an idol himself—confirming yet again that iconoclasm inevitably produces new forms of idolatry.

In Charing Cross, near Trafalgar Square, stands an equestrian statue of Charles I only a few hundred yards from the king's place of execution on that cold January morning in 1649. The statue had been cast during the king's lifetime, but after his execution it was sold to be melted down. For reasons that remain a mystery, the statue survived. After the Restoration in 1660, Charles II acquired the statue and had it placed on the pedestal where it has stood, unmolested, since 1675.

Charles II's restoration lasted twenty-five years, but the Stuart monarchy under his brother James II was overthrown for the same reason that had provoked the Civil War. James II was not just suspected of Catholic sympathies; his devout Catholicism was widely known. His brief reign was toppled after three years. The "Glorious Revolution" of 1688 put a Protestant on the throne: James II's daughter Mary and her Dutch husband, William of Orange. A Bill of Rights followed in 1689. A modern parliamentary democracy was finally born.

The iconoclastic impulse was not dead, though. While it remained largely dormant in England, it found a new and more receptive culture in the American colonies, where many English Puritans had fled to establish their own city on a hill.

King George on a Horse

Five days after the Declaration of Independence, George Washington was in New York City to have the revolutionary document voted by the colonial assembly. The declaration had been passed by the Continental Congress in Philadelphia on the historic date of July 4, 1776.

In New York, Washington presided over a public reading of the declaration to his troops and local citizens gathered on the common where City Hall Park is located today in Lower Manhattan. The place for the public reading had been carefully selected. On this spot, members of the anti-taxation Sons of Liberty—famous for orchestrating the Boston Tea Party—had erected a towering "liberty pole." Liberty poles, standing eighty feet high, were symbols of defiance to the British. The poles were often ornamented with objects like red Phrygian caps. This one was topped with a gold vane inscribed with the word *liberty*.[1]

Washington was hoping that a public reading of the Declaration of Independence would rouse his troops and galvanize patriotic emotions in New York. The text, drafted by Thomas Jefferson, personalized the colony's grievances against the British monarch, George III, cast in the role of tyrant. The crowd listened in rapture as the indictments against George III were read out:

> He has plundered our seas, ravaged our coasts, burnt our towns, and destroyed the lives of our people. He is at this time transporting large armies of foreign mercenaries to complete the works of death, desolation and tyranny, already begun with circumstances of cruelty and perfidy scarcely paralleled in the most barbarous ages, and totally unworthy the head of a civilized nation. . . . A Prince whose character is thus marked by every act which may define a tyrant, is unfit to be the ruler of a free people.[2]

The proclaimed words produced the desired effect on the crowd, though George Washington undoubtedly was surprised by what happened next. Stirred to action, the inflamed mob charged down Broadway in the direction of Bowling Green park to find the statue of the "royal brute of Great Britain." United in their fury against the British king, some were soldiers and sailors, others were members of the Sons of Liberty movement, and many were ordinary American patriots.

Once in the Lower Manhattan park, the mob smashed the cast-iron fence surrounding the equestrian statue of George III. They threw ropes over the statue and pulled with all their force until George III fell from the marble pedestal and shattered. The crowd attacked the fallen king, ripping George III from his horse. They used axes to hack off the regal nose. They clipped off the king's laurel wreath. Someone fired a musket ball into George III's head. Finally, the mob decapitated the monarch and dragged the leaden body parts through the streets of New York.

George Washington was displeased with the mob violence, which appeared to be the handiwork of the Sons of Liberty. Washington granted that the incident had been motivated by "zeal in the public cause," but he was irritated by the riotous conduct and stated that, in future, such matters must be left to proper authorities.[3] The general public mood was more approving. A Philadelphia newspaper triumphantly reported the symbolic execution of the British king: "The equestrian statue of George III, which Tory pride and folly raised in the year 1770, was by the sons of freedom laid prostrate in the dirt, the just desert of an ungrateful tyrant!"[4]

The fallen statue of George III had been commissioned in 1766 as a gesture of American gratitude for the British repeal of the hated Stamp Act. A statue of William Pitt the Elder, the British prime minister, was also commissioned. Pitt had argued in the British parliament to have the Stamp Act repealed because Britain had no right to impose taxes on the colonies. In America, the Stamp Act had sparked widespread protests and mob violence. In 1765, the effigy of stamp tax administrator Andrew Oliver was hung from a large elm tree, then pulled down and beheaded before being set ablaze. When the Stamp Act was repealed in 1766, William Pitt became an instant hero in America. In South Carolina, a statue of Pitt styled as a classical orator was erected in Charleston to joyous popular acclaim. The flag flying above the statue declared, "Pitt and Liberty."[5] Pitt's monarch, George III, also benefited from this brief public mood of colonial gratitude, even though the monarch had given his royal assent to both the tax and its repeal.

In New York, the two statues—George III and William Pitt —arrived in the city four years after being commissioned in London. Their unveiling in April 1770 was treated as an important civic event. The George III statue was unveiled

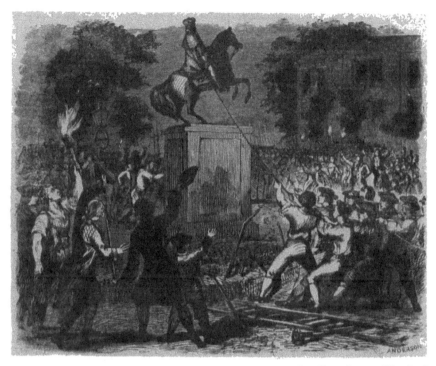

Pulling down the equestrian statue of George III in Bowling Green, Manhattan, New York. Illustration by Thomas Addis Emmet, 1880.

in the Bowling Green park with great ceremony, including a thirty-two-gun cannonade, in the presence of the city's most eminent citizens.[6] Modeled on the famous equestrian statue of Marcus Aurelius in Rome, it depicted George III as a Roman emperor mounted on his horse, one arm raised in *adlocutio* style. The comparison with the philosopher-emperor was immensely flattering for George III, as Marcus Aurelius was greatly admired in the eighteenth century. The William Pitt statue, showing the British prime minister in a Roman senatorial toga, was erected nearby in Lower Manhattan.

New York General Assembly members praised the George III statue in glowing terms. It was an expression of gratitude for the "singular blessings derived from him, during his most auspicious reign." Things went downhill quickly, however, as relations between the American colonies and the mother country deteriorated. More British-imposed taxes followed. In a mob protest British soldiers shot at the crowd and killed several people. Finally came the Boston Tea Party at the end of 1773. Against this turbulent backdrop, the George III statue lost its status as a grandiose symbol of American gratitude. It became an object

of hatred and was defaced in protests. The city of New York even passed an anti-desecration law to combat vandalism inflicted on the statue.

Following the iconoclastic attack on the statue in July 1776, many of the hacked fragments of George III scattered to the winds. The monarch's head was carried off to be displayed on a pike in front of a tavern in upper Manhattan. Other body parts were transported to a military depot in Litchfield, Connecticut. They were melted down to make 42,088 musket balls to be fired at red-coated British troops.

William Pitt's statue, though terribly disfigured, remained standing. It was decapitated and both its arms had been hacked off. The headless Pitt statue stood as a battered symbol of colonial belligerence for more than a decade. The mutilated statue was also an object of curiosity. Local shopkeepers boasted of their proximity to the statue to attract customers. Eventually, the Pitt statue was regarded as a nuisance and an obstacle to improvements of the Wall Street area in Lower Manhattan. It was finally removed in 1788, but that wasn't the end of the statue's afterlife. Over the next several decades, the Pitt statue was constantly relocated, including to the American Academy of the Fine Arts. By the 1830s, it had been relegated to a cluttered cellar, hidden from public view. It later ended up in the public room of the Fifth Ward Hotel in the Tribeca area of Manhattan. Finally, it was acquired by the New York Historical Society, where it remains to this day.[7]

For American revolutionaries, the destruction of George III's statue in 1776 was an iconoclastic act of nation-founding that ushered in a new political order. It was iconoclasm as political discourse. The Declaration of Independence gave legal effect to the birth of the American republic. The toppling of the British king's statue was a symbolic act of regicide. On a deeper symbolic level, the decapitation of George III was a replay of Charles I's execution in London in 1649.

The American Revolutionary War was, more generally, a reenactment of the Puritan overthrow of the English monarchy a century earlier.[8] The underlying causes for both ruptures were the same: the refusal of a bourgeois gentry to consent to onerous taxation, triggering a bitter standoff between an authoritarian monarch and a representative assembly. Puritans in the American colonies had fervently supported Oliver Cromwell's war against Charles I. A century later, many American patriots regarded themselves as descendants of the English Puritans who had fought in Cromwell's army. It was also remembered that Charles I had persecuted the Puritans who fled to New England. The descendants of the Pilgrim settlers in America, albeit for different motives, had now "executed" another tyrannical British king.

The narrative of the Pilgrim Fathers is the national foundation myth in American history. It wasn't until the revolutionary period in the late eighteenth century, however, that the cult of the Pilgrims was born. The fact that the Puri-

tans were regarded as religious fanatics in England is usually expurgated from the narrative. The familiar legend is the one of Pilgrims landing at Plymouth Rock in New England to escape persecution. This founding myth forged a deep connection between the Puritan spirit and American nation building.[9]

Puritanism was a powerful force in the early colonial elites. Samuel Adams, who was active in the Sons of Liberty movement and organized the Boston Tea Party, was a devout Puritan and governor of Massachusetts. He was a cousin of the second president of the United States, John Adams, whose father was a Puritan deacon. Another prominent American of this era was Philadelphia physician Benjamin Rush, one of the signatories of the Declaration of Independence. Rush embraced an American Enlightenment worldview, and his religious views, considered Christian universalist, were not aligned with Puritan beliefs. Rush nonetheless believed that the United States was a project of divine providence and argued in favor of a Bible used as a textbook in every public school. He also proposed that the following inscription appear above every courthouse door: "The Son of Man Came into the World, Not To Destroy Men's Lives, But To Save Them."[10] Rush wrote in a letter to a correspondent in England that his values of liberty were cultivated by his Puritan ancestors.

"I am the great-grandson of an officer, John Rush, who fell fighting against King Charles I under Oliver Cromwell," wrote Rush. "Our family inherits besides his spirit, his sword and buckler. We prize this sword above gold, and often view it as a monitor of the value of liberty, and as one of the means of preserving it."[11]

Like Benjamin Rush, many Americans before the revolutionary war felt inspired by the struggles of their Puritan ancestors who had thrown off the yoke of tyrannical monarchy in England. The English Civil War was remembered as the "Grand Rebellion." Americans regarded their forefathers' journey to the colonial Promised Land as akin to the Biblical story of the Hebrew escape from slavery in Egypt. Thomas Jefferson frequently evoked this Biblical narrative to cast America as a new Promised Land. "The Exodus event in and through which God had formed his chosen people prefigured the formation of the American nation," declared Jefferson in his second inaugural address as president of the United States.

When the revolutionary war began, Americans regarded the rebellion against the British king as an extension of the same narrative. They would have been acutely mindful of the Biblical prohibition against idol worship of a foreign god. Like their forefathers in England, they were animated by idol-smashing impulses commanded by Biblical scripture. As historian Susan Juster observes: "Anglo-American Puritans conflated the despised physical objects of 'popish' worship (altars, roods, crucifixes) with the rituals and gestures that had grown up around these objects in medieval ecclesiology (kneeling, making the sign of the

cross, bowing before the altars)."[12] Attacks and ransacking of Anglican churches were not uncommon in the American colonies—for example, the desecration of Trinity Church in New York in 1714. They were usually perpetrated by Puritans and Quakers driven by sacred rage against idolatry.

Though commercial elites in the American colonies had been willing to unveil a statue of George III as a gesture of gratitude, the monument was, in Biblical terms, an object of colonial idol worship of an imperial golden calf. Little wonder Americans, their spirit of rebellion emboldened by their rejection of onerous taxation, were quick to turn against the idol.

The equestrian statue once looked upon benignly quickly became a detested symbol of tyranny. And like the golden calf, it was toppled and destroyed.

The nation-founding destruction of the George III statue ignited a frenzy of iconoclastic violence that raged throughout the revolutionary wars.

Following the playbook of Cromwell's war against Charles I, every symbol of British "tyranny" in America needed to be destroyed in a political program of erasure. The British monarch's name was removed from all government documents. Royal portraits of the king were pulled down. Streets named after the king and other British royal figures were rebaptized. In Boston, King Street became State Street. In New York City, King's College was renamed Columbia.

This type of official damnatio memoriae was more common in the North. In the South, which had been loyal to the British crown during the English Civil War, many names—Georgetown and the state of Georgia—were left unchanged.[13] Though in Savannah, Georgia, locals staged a mock funeral procession of the king in front of the Court House in a ceremony symbolizing the burial of tyranny.

Along with official erasure, some attacks were grass roots and spontaneous. In many cities, Americans staged mock trials of George III and reenacted his "execution." Sometimes the British king was burned in effigy. There were also reenactments of the toppling of George III's statue, using statuary replicas fabricated with paper mâché or other materials. Images of the monarch in public places were vandalized. Tavern signs with the royal arms were mutilated. Coins struck with George III's portrait were sometimes refused as currency. When the Declaration of Independence was read at the State House in Boston in July 1776, Abigail Adams was present at the event. Adams wrote to her husband, future U.S. president John Adams, that someone shouted from the balcony, "God save our American States!"

"Then three cheers which rended the air, the bells rang, the privateers fired, the forts and batteries, the cannon were discharged, the platoons followed and every face appeared joyful," recounted Abigail Adams. "After dinner the king's

arms were taken down from the State House and every vestige of him from every place in which it appeared and burnt in King Street. Thus ends royal authority in this state, and all the people shall say Amen."[14]

The American culture of anti-British sentiments endured well into the following century. Hostility toward Britain was sometimes etched onto memorials to American soldiers who had fallen during the Revolutionary War. An obelisk monument in Paoli, Pennsylvania, erected in 1817 to memorialize Americans killed in the infamous "Paoli Massacre" was inscribed with the words: "SACRED to the memory of the PATRIOTS who on this spot fell as sacrifice to BRITISH BARBARITY." A second inscription read: "The atrocious massacre which this stone commemorates was perpetrated by BRITISH TROOPS under the immediate command of MAJOR GENERAL GREY." The capitalized letters provided a strong clue of emotional emphasis on anti-British rhetoric. The recent War of 1812 against the British would have made the acrimony even more powerfully felt.[15]

It was an unfortunate coincidence that the first president of the United States was, like the hated British monarch, also named George. But if there were any figure worthy of civic veneration in America, it was most certainly George Washington. Attempts to transform Washington into a venerated icon—during his lifetime and after his death—put the young American republic's democratic political culture to the test.

In the early years of American independence, some believed Washington should become America's first homegrown king—an idea that had been proposed for Oliver Cromwell following the English Civil War. But like Cromwell, Washington rejected the proposal. He understood that, despite patriotic efforts to glorify his name, Americans were resolutely hostile to monarchy. They were also profoundly iconoclastic. Statues glorifying kings and great men were an idolatrous European tradition.[16]

This didn't prevent several proposals to honor George Washington with public statues. In 1783, the Continental Congress voted to erect a statue of Washington in the nation's capital, but the plans floundered. There was even a suggestion that a statue of Washington be raised on the eighteen-foot marble pedestal in Bowling Green where the equestrian George III had once stood. This idea was remarkable in its implications, for Washington would have literally usurped George III on the very spot where the king had been a victim of symbolic regicide. The plan was never followed up, understandably given Washington's explicit refusal of the title of king. It can nonetheless be wondered whether, in proposing a George Washington statue for the George III pedestal, Americans were subconsciously seeking to fill the symbolic void left by the regicide of George III.[17] Perhaps this can explain, more generally, why there was great interest in the erection of public statues of Washington.

After Washington's death, the idea of a mausoleum monument resurfaced. One of the biggest boosters for a Washington monument was a Virginia congressman, Henry Lee III, who was the father of future Confederate general Robert E. Lee. Others in Congress were opposed, however. Nathaniel Macon, a congressman from North Carolina, declared that "monuments are good for nothing." Public statues, he claimed, were "acts of useless and pernicious ostentation" contrary to the spirit of the American republic. Macon believed that in a democratic society no man should be elevated to the status of venerated semideity. "If we decline raising a mausoleum to Washington, no man who succeeds him can ever expect one reared to his memory," Macon reasoned. "On the other hand, if we now raise one to Washington, every pretender to greatness will aim at the same distinction."[18]

When the question came to a vote, the House passed the resolution to construct a Washington monument. The vote didn't get through the Senate, however. Three decades later, John Quincy Adams observed in his memoirs the iconoclastic character of the young American republic. "Democracy has no monuments," he noted. "It strikes no medals; it bears the head of no man upon its coin; its very essence is iconoclastic."[19]

There were two primary reasons for hostility to glorifying statues and monuments in the United States following the revolution. The first has already been underscored: the deeply religious nature of the young republic from early Puritanism to later forms of Protestant revivalism. This was the young America whose colonial beginnings were marked by the Puritan witch trials in Massachusetts, the persecution of Quakers, and the oppressive religious culture described by novelist Nathaniel Hawthorne in *The Scarlet Letter*. For Christian fundamentalists in the nineteenth century, Biblical scripture was more powerful than the image or idol. The Bible was the highest source of knowledge and truth.

The second reason was more elitist: the influence of Enlightenment values. The Founding Fathers—Thomas Jefferson, James Madison, Benjamin Franklin—were profoundly attached to the Enlightenment principles embedded in the Constitution. While these values were not resolutely hostile to statues and images, they were implicitly iconoclastic. In his letters, Jefferson referred to the "idolatry and superstition of the vulgar" and removed references to miracles and the supernatural in his own version of the Bible.[20] If Puritans destroyed idols and icons in strict adherence to their reading of Biblical prohibitions, Enlightenment thinkers like Jefferson regarded idolatrous veneration as belonging to the realm of superstition. In that respect, Christian fundamentalists and Enlightenment thinkers shared, though in different ways, an opposition to idolatry and a preference for the written word. Protestant iconoclasts who smashed images in churches replaced them with the Bible as the infallible source of truth. The

Enlightenment-inspired Founding Fathers, for their part, sought to instill a civic culture of constitutional idolatry.[21]

The Enlightenment neutralized the incantatory power of idols not by demolishing them, but by secularizing them. This was accomplished by placing them in public museums. It is no coincidence that great museums were created during the Enlightenment—the British Museum in 1753, the Louvre in 1793. Elites of this period gave paintings and sculptures asylum in museums where they were dispossessed of their mystical power. In a museum, they could no longer be regarded as sacred. Or perhaps, more accurately, they were re-sacralized according to the emerging modern aesthetic ideals that transcended institutional religion. The idol had a new status: it was called art. Paintings and sculptures were not sacred objects of enthrallment; they became objects of secular veneration admired for their aesthetic qualities. If art lost its sacred powers of enchantment, its appreciation offered the bourgeoisie the pretense of social distinction vis-à-vis the lower classes.[22] Works of art that didn't find their way into museums were neutralized in a different way. They were commodified by becoming objects to be bought and sold on the market. They went under the hammer not to be smashed, but to be auctioned.[23]

Prominent political figures in the young American republic were, on the whole, cautious about erecting statues and monuments that promoted civic veneration. There were exceptions, of course. The Enlightenment, after all, was reverentially turned back toward classical Greek and Roman civilization. This explains why the American republic's capital city was designed on the Greco-Roman architectural model. Where public statues appeared in the early years of the American republic, they were often styled on the classical model. In that respect, there was continuity with the figurative styles under British rule. The gilded lead statue of George III in Manhattan had been modeled on emperor Marcus Aurelius, and William Pitt's marble statue depicted him wearing a Roman toga.

George Washington was personally reluctant about the prospect of statuary glory. He opposed the artistic obsession with the Greco-Roman figurative style, or what he called "servile adherence to the garb of antiquity."[24] The reverential aura around his image was such, however, that he finally consented to pose for a statue. It may be that the offer was difficult to decline because it came from his home state, Virginia, where the proposed statue was to be displayed in the legislature's rotunda.

Washington agreed to the idea of a statue under pressure from Thomas Jefferson, but made his ambivalence known. He wrote to the Marquis de Lafayette, "Although I had no agency in the business, I feel myself under personal obligations."[25] Washington even submitted to the complicated process of having a life mold made of his face so French sculptor, Jean-Antoine Houdon, could work on

the statue in France. The life-size marble statue, unveiled in 1796 a year before Washington left office, was said to be a perfect likeness of its subject. In keeping with Washington's personal preference, it depicted him in a pedestrian pose in simple attire, eschewing the traditional equestrian style modeled on Roman emperors. The statue showed Washington as a country gentleman holding a cane with a plow behind him—a citizen-farmer Cincinnatus figure returning to the simple life after serving his nation at war.

Posthumous statues of George Washington were not monuments of glorification erected outdoors in public squares. Most were destined, like the Houdon sculpture in Virginia, for display in legislatures. An example was the "Washington Enthroned" monument, commissioned in 1832 on the centenary of his birth. Destined for the U.S. Capitol building, the statue depicted Washington seated on a throne as a semi-naked Greek god Zeus. Washington undoubtedly would have been horrified by the statue portraying him as a Greek deity. Many who viewed the statue in the Capitol were shocked to see a bare-chested Washington seated on a throne. It was eventually relegated to the east lawn of the Capitol, then subsequently placed in a museum for more disinterested contemplation.

A hagiographic cult nonetheless grew around the image of George Washington in the decades after his death. The painter John James Barralet produced an apotheosis of Washington that depicted the late American president as a Christ-like figure rising from his tomb in a ray of light surrounded by allegorical figures of Liberty, Genius, Immortality, Hope, and Charity.[26] Washington's iconography soon became omnipresent. His face appeared on everything from coins and prints to pottery. Statues of Washington, once erected in official buildings, now took their place in public squares. His image also switched from citizen-statesman to military commander-in-chief. The reason for this transformation was undoubtedly the War of 1812 against the British. Americans were once again fighting the imperial British enemy whose armies had invaded the capital and attacked the White House. Monuments to the great general George Washington, once commander-in-chief during the Revolutionary War, symbolized the resurgence of defiant patriotism. An example in this genre was the colossal Washington Monument inaugurated in Baltimore in 1815. Completed in 1829, it showed a commander-in-chief Washington atop a towering column. The design was styled after the Vendôme Column in Paris, completed in 1810, with emperor Napoleon perched atop a column modeled on Trajan's Column in Rome.

Apart from these examples of statuary tributes to George Washington, the antebellum period in America was relatively modest about the glorification role of monuments, except for memorials to soldiers who had fought in the wars against Britain. The famous Washington Monument—a 500-foot obelisk in the

U.S. capital—was not a statue but a stone structure. It was commissioned in 1848 but not unveiled until 1885 due to the interruption of the Civil War. Even after it was inaugurated, the poet Walt Whitman evoked America's iconoclastic spirit by lamenting in a poem on the Washington Monument, "Ah, not this marble, dead and cold." For Whitman, the only true monument was "freedom, poised by toleration, swayed by law."[27]

Whitman's warning against idolatry was not in step with the patriotic mood in America during the second half of the century. The surging Industrial Age of nation-building dramatically changed attitudes toward public statuary. The United States, like other young nations, was looking for myths, legends, and heroes. Statues and monuments erected in public spaces were promoted as symbolic expressions of collective identity and patriotic fervor. The aftermath of the Civil War brought a culture of memorial and hero worship. Statues in both the North and South flourished as powerful symbols of shared identity.

Innovations in urban design also facilitated a great burst of "statue mania" that took off in the late nineteenth century. In the bold new era of industrialization and technological progress, nations were rivaling one another to trumpet their grand ambitions. Capital cities and commercial centers— Paris, London, Brussels, New York, Chicago—showcased grandiose projects at world fairs where the latest technological marvels were on display. Major cities carved out grand boulevards, promenades, and public squares that created new spaces for urban embellishments.[28] Breaking with traditions that devoted public spaces to statues of monarchs, the statue-mania era was fused with patriotic humanism and the cult of the "great man." The statue-mania ethos was a bold expression of Nietzsche's "monumental" history that seeks to glorify and inspire.[29]

It was in this zeitgeist of national pride that the French Republic came up with the idea of offering the United States a glorious gift in the form of a colossal statue named Liberty. Today, the Statue of Liberty holding a torch aloft in the New York harbor is arguably—along with the Eiffel Tower—the most recognizable and cherished monument in the world. The Statue of Liberty resonated with the American patriotic spirit in the late nineteenth century.

If there was an idol whose worship was acceptable in America, it was the Statue of Liberty. It did not glorify any particular individual, but was an allegory that symbolized a cherished principle. It was, in that respect, a perfect symbol of the values for which the Pilgrim Fathers claimed to stand. The monument also served as a symbol of harmony and stability in a young nation that had just been torn apart by a Civil War. The Statue of Liberty gave the entire nation a new idol to venerate. As James Simpson observed in his book, *Under the Hammer:* "Stabilization is only ever possible by the erection of an alternative idol, an idol capable of disguising and disowning its status as idol. Nothing can arrest iconoclasm in the name of liberty, that is, but the erection of statues of Liberty."[30]

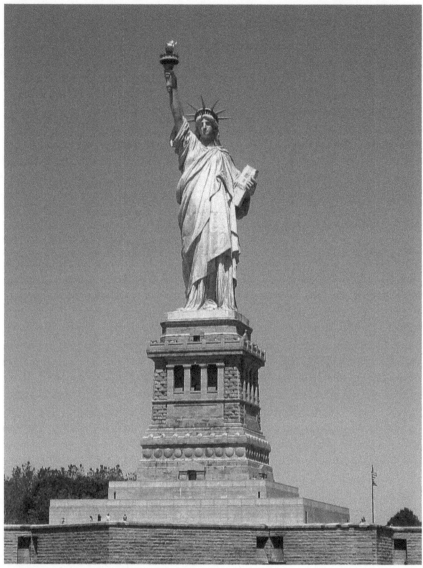

A gift from France: the Statue of Liberty, New York City. *Photo by Jiuguang Wang, Wikimedia Creative Commons.*

The original idea for the statue came from prominent French jurist Edouard de Laboulaye, an expert on American politics and ardent anti-slavery activist. Like other French republicans, Laboulaye had been traumatized by the assassination of Abraham Lincoln in 1865. His idea for a statue symbolizing liberty was

meant as a gesture of good will and fraternal bonds between France and America as the United States neared the centenary of the Declaration of Independence. The project was delayed, however, by tumultuous events in France—the Franco-Prussian War in 1870, the fall of the Second Empire, and the upheaval of the Paris Commune. This was not a great era of liberty in France. The timing wasn't right to present the United States with a statue named "Liberty Enlightening the World."

In the 1870s, after the Third Republic barely squeaked through as the chosen system of government in France, the moment was more propitious. French sculptor Frédéric Bartholdi started work on the enormous statue to be shipped to America in time for the centenary in 1876. The deadline was impossible to meet, however, mostly due to lack of funds to build and transport the sculpture. In New York, governor Grover Cleveland rejected a request to provide funding. To raise money, pieces of the copper statue went on tour in the United States as objects of curiosity. In 1876, for example, the arm holding the torch was exhibited in Philadelphia as part of the fundraising drive. Back in Paris, the statue's head was displayed on the Champ de Mars at the city's world's fair in 1878.

Finally in 1885, the statue arrived in New York, disassembled in pieces, on a French frigate called Isère. But there was still no pedestal on which to mount the statue. It languished in a warehouse while the American Committee for the Statue of Liberty attempted to raise funds for a pedestal. New York newspaper magnate Joseph Pulitzer, always on the lookout for a civic cause to sell papers, put his *New York World* behind the project. Thanks to Pulitzer's cheerleading efforts in the *World*, small donations poured in, and in no time, more than $100,000 (nearly $3 million in today's money) was raised.

The Statue of Liberty, standing 305 feet tall, was finally unveiled on Bedloe's Island on October 28, 1886. Nearly a million people lined the streets for a massive parade running down Fifth Avenue from 57th Street to Lower Manhattan. The procession featured George Washington's personal carriage drawn by eight horses. On the New York harbor, crowds boarded rowboats, barges, yachts, and streamers to observe the unveiling ceremony from the water.

There were some discordant notes in the celebration. American suffragists denounced the ceremonies as a "farce" since women in America were not accorded the same "inalienable rights" as men. The African American newspaper *Cleveland Gazette* made a similar argument in an editorial. "'Liberty Enlightening the World,' indeed!" noted the newspaper. "The expression makes us sick. This government is a howling farce. It cannot, or rather *does not*, protect its citizens within its *own* borders."[31] Despite these controversies, the Statue of Liberty was immensely popular, admired as a magnificent achievement of design, engineering, and vision. It was proclaimed the first wonder of the modern world.

The Statue of Liberty almost faced competition on the New York harbor from another famous female figure: Queen Victoria. The previous year, members

of various British associations in New York—including the British Benevolent
Society and the Sons of St. George—had voted to fund a colossal statue of
Queen Victoria to be erected overlooking the bay on Staten Island.[32] The monu-
ment was to stand 250 feet taller than the nearby Statue of Liberty.

That there was nostalgia in America for the British monarchy might seem
puzzling, especially given the iconoclastic belligerence inflicted on Queen
Victoria's grandfather, George III. By the late nineteenth century, however,
Americans had become increasingly Anglophile, especially with the Colonial
Revival movement. In the years leading up to the centenary of the Declaration
of Independence in 1876, many "lineage" groups sprang up—Daughters of
the American Revolution, Society of Cincinnati, Knickerbocker Club, Society
of Iconophiles—with a mission to promote shared Anglo-American Protestant
historical links with the mother country. While these organizations were on the
surface patriotic, membership to some was restricted to direct descendants, male
and female, of British Americans. In short, they promoted values of British pedi-
gree.[33] The prominence of these lineage groups underscored an undercurrent of
Anglophilia in American social elites. Only a century earlier, anti-British rhetoric
had been the norm. In the late nineteenth century, the bourgeoning Colonial
Revival culture fetishized the British connection. The upper classes in America
regarded their British heritage as a mark of distinction from the immigrants ar-
riving at Ellis Island in the shadow of the Statue of Liberty. Put bluntly, it was a
nostalgic ideology of Anglo-Saxon superiority.

As part of this movement, groups such as the Daughters of the American
Revolution and Society of Cincinnati were active in promoting statues, monu-
ments, and plaques to make visible the ancestral connection with Britain. The
Daughters of the American Revolution supported the plan for a statue of the
"good Queen Victoria."[34] Not much came of the project for a variety of reasons.
One was a concern that a statue of a British monarch on American soil, especially
in New York, might provoke hostile reactions from Irish Americans at a sensitive
time of Irish "home rule" nationalism back in Britain.

An enormous statue of Queen Victoria never appeared in New York City.
The Statue of Liberty had the harbor all to herself.

In Lower Manhattan today, there is no trace of the George III statue in the Bowl-
ing Green park. The marble pedestal was taken down more than two centuries
ago in 1818, though the original metal fence that surrounded the statue still
stands.

Today the park has achieved notoriety for two new statues standing, face
to face, almost in defiance of each other. One is the sixteen-foot-long bronze
sculpture *Charging Bull*, a massive, raging beast with head lowered and nostrils

flaring. Erected after the stock market crash of 1987, the snorting bull became an iconic symbol on Wall Street where investors love bull markets. It was nonetheless vandalized several times, usually by anti-capitalist protestors who defiantly painted the beast's bulging testicles.

The other statue is the four-foot bronze figure called *Fearless Girl*, a ponytailed female figure with hands firmly on her hips. Initially planned as a temporary public sculpture, *Fearless Girl* quickly became a cultural icon for female empowerment in the #MeToo era. The juxtaposition of the two statues, staring menacingly at each other, spurred a gender equality debate that pressured corporations to appoint more women to their boards.

The feminist statue's iconography became so powerful—and a tourist magnet for selfie takers—that the *Charging Bull* sculptor Arturo Di Modica publicly complained about the competing statue. He was evidently irritated that the popularity of *Fearless Girl* had cast his own sculpture in a negative light.[35] It was finally agreed to move *Fearless Girl* to a permanent home in a nearby location outside the New York Stock Exchange. At the spot where *Fearless Girl* once stood, a plaque on the ground was installed with an outline of the bronze girl's footprints inscribed with the words, "Stand for her."

The symbolic confrontation between *Charging Bull* and *Fearless Girl* demonstrated that the Bowling Green site in Lower Manhattan was still alive with powerful iconography provoking strong reactions from the public. It also revealed how much public symbols had changed over the previous two and a half centuries.

Meanwhile, the George III statue has made a surprising comeback—not in equestrian form, but in broken pieces of cherished relics.

The mob that mutilated the royal statue at Bowling Green in 1776 hadn't succeed in melting down all the shattered pieces to be turned into musket balls. Before the monarch's decapitated head could be displayed on a pike at a tavern in upper Manhattan, it was stolen by British loyalists and buried in the Bronx to be saved from further mutilation. A British army captain called John Montresor arrived in New York and had the George III head disinterred and sent back to London. Montresor wanted his fellow Britons to see evidence of the appalling conduct of the "ungrateful people" in America.[36]

In England, the monarch's head became the property of Lord Charles Townshend, the powerful British politician behind the onerous taxes that had sparked rebellion in the American colonies. His wife Lady Townshend enjoyed showing the head to guests. One first-hand account was provided by the former governor of Massachusetts, Thomas Hutchinson, who was visiting London in 1777 and called on Lord and Lady Townshend at their residence in Portman Square. "Lady Townshend asked me if I had a mind to see an instance of American loyalty," wrote Hutchinson. "And going to the sopha, uncovered a large gilt head, which

at once appeared to be that of the King. . . . The nose is wounded and defaced . . . but retains a striking likeness."[37] The head vanished at the end of the eighteenth century and has never been recovered.[38]

Other George III statue body parts were similarly protected by British loyalists. On the trip to Litchfield, Connecticut, where the statue fragments were to be melted down, an overnight stop was made at a town called Wilton. Local British loyalists managed to get their hands on fragments and bury them in fields and bogs. The careful burial of the statue pieces, ensuring that George III received a dignified interment, conferred on the objects the status of real body parts.

It took generations for these pieces to be unearthed and authenticated. Several resurfaced in the nineteenth century. A twenty-one-inch fragment of George III's forearm and hand wasn't dug up until 1991, when a local Wilton resident accidently uncovered it in his garden. The land belonged to a monarchist during the Revolutionary War and the property was used to shield British agents. The tail of George III's horse, a prize piece among the remnants, is today in the possession of the New York Historical Society along with the mutilated statue of William Pitt. The society also boasts in its collection a fragment of the pedestal on which the George III statue was mounted. It had been used as the tombstone of an officer in the Royal Highland Regiment buried in New Jersey. After the graveyard was leveled, it was put to use as a kitchen step in the house of Jersey City mayor Cornelius Van Vorst.[39]

Long before these exhumations, George III had already been resurrected in the imagination of the American public. In the nineteenth century, woodcut images of the statue toppling began appearing, followed by more formal paintings of the event in the 1850s. One painting by Johannes Oertel depicted American patriots of all social classes pulling down the statue while native American chiefs look on. Another painting by William Walcutt featured an African American boy in front of the statue. These paintings soon inspired engravings and illustrations in periodicals that further spread images of the George III statue toppling in American popular culture—though sometimes with the native Indians and African American figures deleted.

The Anglophilia of Colonial Revival culture at the end of the nineteenth century facilitated George III's comeback. The historical connection to Britain, even the toppling of a monarch's statue, was cherished as shared experience. By the early twentieth century, there even were proposals to revive the statue of George III in Bowling Green. Others suggested that a new monument should show American patriots pulling down the statue. Reenactments of the event also became popular, often using paper mâché replicas of the statue. In September 1909, the toppling of George III's statue was the centerpiece in a public act of performance in New York City. The city was staging its Hudson-Fulton parade

that year to celebrate the 300th anniversary of the discovery of the Hudson River. New York civic leaders sponsored lavish events and a parade in Manhattan with historical floats to educate new immigrants about the country's history. The parade, which ran a hundred blocks from the Upper West Side to Washington Square, included a float reenacting the George III statue toppling. On one level, the visual performance symbolized historical rupture; but more importantly, the mock iconoclasm in the parade was a reenactment celebrating America's foundation narrative.[40] The toppled statue of George III was transformed into a cherished symbol of America's founding mythology.

More than a century later, the equestrian statue of George III was resurrected yet again in 2016. In a Brooklyn studio, a replica of the statue was constructed atop an eight-foot marble pedestal to be displayed in a historical tableau at Philadelphia's Museum of the American Revolution. Visitors to the exhibit were encouraged to consider whether they would have joined the mob pulling down the statue. The museum director said the exhibit's aim was to challenge the idea that the American Revolution was "controlled, tame, elegant, done by statesmen in drawing rooms that had green tablecloths."[41]

The many resurrections of George III's statue hold diverse lessons about the nature of iconoclastic violence. One is that toppled statues have an uncanny capacity for perseverance after they have been destroyed. Following their destruction, they continue to live on, sometimes in physical reconstructions, sometimes in collective memory. What is said of Humpty Dumpty may well be true. After his great fall, all the king's horses and all the king's men couldn't put Humpty together again. But he can return, even in broken pieces, with his symbolic power still intact.

The fate of George III's statue reminds us that objects of iconoclastic destruction are never completely obliterated. What was once mutilated and buried, we disinter and resurrect as objects of fascination. The act of destruction not only recognizes the power of the object but also perpetuates its hold over our imaginations—sometimes as sacred relic, sometimes as fetishized object, sometimes as subject of reinterpretation.

Violent acts of iconoclastic destruction are rarely final. They inevitably inspire new forms of idolatrous veneration.

CHAPTER 8

Storming the Bastille

The French Republic was born from an act of iconoclastic destruction: the storming of the Bastille prison.

In early July 1789, the mood in Paris was explosive. The French population was suffering from dire economic conditions exacerbated by a poor harvest. Parisians had rallied behind the newly constituted National Assembly in a showdown with the nobility and clergy, who held all the powers. In the streets of the French capital, large crowds were clashing with royal regiments.

On July 12, protestors set fire to a customs gate along the Seine not far from where the Eiffel Tower stands today. They ransacked the building and attacked two allegorical statues representing the regions of Normandy and Brittany. On the same day, another crowd seized statue busts of the exiled Duc d'Orléans and the king's popular minister, Jacques Necker. As they carried the busts in a procession through the city, dragoons arrived to repress the protest. The busts were destroyed in a bloody clash in the Tuileries.

On the fateful morning of July 14, a mob seized thousands of muskets and other ammunition from the Les Invalides. The firearms lacked ammunition, however. The mob headed to the Bastille prison to seize gunpowder kept inside the fortress. The Bastille had long been hated by the people of Paris as a symbol of royal oppression. On that day, only a handful of prisoners were incarcerated in the Bastille. One was Auguste-Claude Tavernier, the man who had unsuccessfully attempted to assassinate king Louis XV some twenty years earlier. The infamous Marquis de Sade, whose name gave us the word *sadism*, had been released only weeks before.

After a tense standoff, the Parisian mob assailed the fortress. Dozens were killed in violent clashes. The prison governor, the Marquis de Launay, eventually surrendered, and the mob stormed the prison. Once inside, they seized the Marquis de Launay and dragged him through the streets. The furious crowd beat

and stabbed him to death. His head was sliced off, stuck on a pike, and paraded through Paris before it was tossed into the Seine.

The populist fury in Paris that day ignited the revolution that toppled the Bourbon monarchy. The upheaval on July 14, 1789, established a direct link between iconoclastic violence and revolution.[1] The rioters who attacked the Bastille were tearing down an entire order.

The storming of the Bastille still resonates today. Every July 14, it is memorialized in France with celebrations, fireworks, and a military parade as the country's national holiday, or "*fête nationale.*"

The turbulent events that ignited the assault on the Bastille bore remarkable similarities to those that had triggered the American Revolution thirteen years earlier: a stubborn monarchy, a crisis in representative democracy, and onerous taxation on the bourgeoisie. In France, it was exacerbated by economic crisis and high bread prices. Marie Antoinette never made the haughty remark "Let them eat cake"—it was a literary fabrication—but king Louis XVI and his scandal-plagued Austrian wife were objects of growing disaffection, if not utter hatred.

One significant contrast made the French Revolution fundamentally different from its American precursor. The American Revolution was a colonial rebellion against a distant monarchy. In the American colonies, there had been relatively little construction of statuary symbolism to reinforce British authority. American revolutionaries had little more than George III's statue to topple. Following the revolutionary war, the British packed up and went home, leaving the lost colony to the Americans. In France, the divine-right Bourbon monarchy had benefited from centuries of physical symbolism—churches, statues, monuments—visible throughout the kingdom. The Bourbon monarch was resident in France. In the French Revolution, regicide was not a symbolic act. The monarch was decapitated in public under the blade of a guillotine.

The iconoclastic project in revolutionary France was a massive undertaking, targeting political, religious, and artistic artifacts. The obliteration of the Ancien Régime legacy required relentless violence whose goal was the erasure of the feudal monarchy and the creation of a new republican society. A political program of destruction was necessary to establish the symbolic foundations of the new Jacobin state.[2]

Revolutionary iconoclasm in France was both officially decreed and spontaneous violence. Official iconoclasm went much deeper than assaults on physical statues and monuments.[3] The campaign of destruction was total war on the past. Jacobin revolutionaries obliterated even traditional measures of time. The old calendar was abolished and replaced with a new revolutionary system considered more rational and natural: ten days in a week, three weeks in a month, twelve months in a year, with the remaining days as patriotic holidays for citizens to

cultivate civic virtues. The new *calendrier républicain* marked a rupture with the superstitious Christian nomenclature of the old feudal order.

The *tabula rasa* destruction in revolutionary France manifested ambiguities and contradictions. Iconoclastic erasure was accompanied by new kinds of idolatry to promote republican cults of veneration. The Jacobins repurposed monuments and edifices as foundation blocks for their new republican order. Like early Christians who built churches on the ruins of demolished Greco-Roman temples, French revolutionaries converted Catholic churches into secular temples where they celebrated the civic values of the Republic. Even the crumbled Bastille prison was repurposed. Its stones were reused to construct the Concorde bridge stretching across the Seine in front of the Palais Bourbon. Smaller fragments of the Bastille were sculpted into miniature replicas of the prison as collectors' items. The mini Bastilles were preserved as relics symbolizing the destruction that had eradicated the old order.

Iconoclastic violence came in successive waves during the revolution. Early attacks targeted symbols of the "feudal" monarchy and religious "superstition," followed by more widespread assaults on statues and monuments, culminating in acts of destruction whose goal was total annihilation. The violence took different forms, from scraping away inscriptions and renaming places to toppling statues and desecrating tombs.[4] Paradoxically, revolutionary iconoclasm produced its own iconography. Engravings and propaganda paintings narrated the salient events of the revolution—for example, images of the Bastille being stormed and pictures of the people ripping furniture from aristocratic houses.[5]

The "de-Christianization" of France began immediately after the abolition of the clergy's privileges. Monastic orders were dismantled, and the Church was subordinated to secular authorities. The French state seized Church property and sold it off at bargain prices. Violent acts of destruction against churches were widespread. People smashed statues of saints and knocked over crosses and altars. In Paris, the Sainte-Chapelle was stripped of its royal arms and symbols. At Les Invalides, the altar to the Virgin was destroyed, and the equestrian relief sculpture of Louis XIV on the façade was defaced. Many religious objects were repurposed or altered to serve the new republican order. In the cathedral at Chartres, the Assumption of the Virgin sculpture was transformed into a female figure representing liberty by putting a red Phrygian cap on Virgin Mary.

Streets and towns with religious connotations were renamed, especially those named after saints. Saint Tropez was changed to Héraclée, Saint Malo became Victoire Montagnarde, and Saint Izague was renamed Vin-Bon. Saint Ouen was renamed Marat after the radical Jacobin leader Jean-Paul Marat. Thirty towns were named after Marat. In Paris, Montmartre was henceforth known as Mont Marat. Many people changed their birth names if they sounded

royal or religious. Men called Louis gave themselves Roman names like Brutus or Spartacus; and surnames such as Leroy or Lévesque became La Loi or Liberté. The *sans-culottes* revolutionaries even petitioned to abolish the word *vous* on the grounds that its formality was too hierarchical. They believed that everyone should be informally addressed as *tu* to create equality in all social interactions.[6]

Following the bloodbath of the August 1792 insurrection, when the Tuileries Palace was stormed, the revolution reached a point of no return. A new phase of political iconoclasm was unleashed at the instigation of radical Jacobins such as Maximilien Robespierre, who called for all monuments symbolizing "despotism" to come down. A year earlier after the capture of Louis XVI, Parisian mobs had pulled down busts of kings, erased the royal *fleur de lys* from signs, and covered large royal statues with black cloth to signify the death of the monarchy. Following the storming of the Tuileries Palace, revolutionary attacks on public spaces accelerated. Crowds roamed the capital in search of royal statues to topple so they could be melted down and turned into cannons.[7]

An obvious target was the massive bronze equestrian statue of Louis XV in the middle of the vast square named after him. Standing proudly between the Champs-Élysées and Tuileries, the warrior king statue of Louis XV, with elaborately sculpted bas reliefs on the pedestal, had been mocked over the years, notably with graffiti and *affiches* plastered on the pedestal to deride the monarch. Despite his official "*bien aimé*" moniker, the long-ruling Louis XV was far from universally loved in France. In 1789, the statue was molested following the storming of the Bastille, attacked as a surrogate for the ruling monarch Louis XVI.

Three years later in 1792, the Louis XV statue came crashing down. The right hand of the toppled king was severed and carted off. It found its way into the possession of the scandal-plagued writer, Henri Masers de Latude, who had been imprisoned in the Bastille on the orders of Louis XV's mistress Madame de Pompadour.[8] Latude kept Louis XV's severed hand as a trophy (it's in the Louvre's collection today). After the statue was pulled down, Place Louis XV was renamed Place de la Révolution (today it's called Place de la Concorde). A female statue of Liberty made of painted plaster was erected on the pedestal of the toppled Louis XV monument. In that respect, the Louis XV statue was not destroyed; it was transformed into a new republican symbol.[9]

Other Bourbon statues were toppled on the same day. Closer to the Bastille, the statue of Louis XIII in Place des Vosges was knocked down. In Place Vendôme, the massive equestrian statue of Louis XIV, unveiled in 1699, was also pulled down. So was another statue of the Sun King in Place des Victoires. This statue depicted Louis XIV as a Roman emperor, standing victoriously on a plinth, crowned with laurels, with four slaves in chains at the base, each a symbol

of a vanquished nation. A year earlier, a Parisian mob had broken the chains to symbolize liberation from Bourbon tyranny. Now the entire statue came down.

The following day, it was Henri IV's turn to suffer symbolic regicide. His bronze equestrian statue had been standing on the Pont Neuf since 1614, commissioned by his widowed queen, Marie de Medici, four years after his assassination. The statue was the first equestrian statue of a French monarch erected in a public place.[10] It depicted Henri IV in the equestrian style modeled on the famous equestrian statue of Roman emperor Marcus Aurelius. At the base of the pedestal were four chained captives representing the four enslaved corners of the world to symbolize the French king's domination over the globe. Henri IV had been a beloved king, a Protestant who converted to Catholicism to establish peace in his kingdom. But public affection for "good king Henri" did little to save his statue in the furious heat of revolution.

Following these spontaneous outbursts of violence, the Legislative Assembly decreed that all monuments erected to glorify feudal tyranny were an offense to the eyes of the French people. All signs and symbols "erected in honor of despotism" were to be demolished. The bronze in royal statues was to be melted down and used as ammunition in defense of *la patrie*.[11]

The phase of revolutionary fury known as "La Terreur" accelerated and intensified iconoclastic violence. The Terror was triggered by the assassination of Jean-Paul Marat, who in July 1793 was stabbed in his bath by the moderate Charlotte Corday. A few months later in October, Marie-Antoinette was beheaded near the spot where her husband Louis XVI had been guillotined. The Terror pushed revolutionary zeal beyond symbolic destruction of royal statues and symbols. Every trace of the old order was targeted for erasure—monarchy, religion, art, civic symbols. Inside churches, figures of Christ were decapitated and the statues of the Virgin disfigured. Religious paintings were trampled. Church bells were pulled down and melted to make cannons. At Notre Dame and Saint Sulpice, makeshift scaffolding was erected so statues of saints, angels, and popes carved in upper niches could be reached and smashed. Notre Dame was secularized, its altar dismantled and replaced with a shrine to Liberty inscribed with the words "To Philosophy." A mob pulled down and decapitated the twenty-eight kings of Judah statues in the gallery running along the front façade of Notre Dame—mistakenly believing they were kings of France.

In many places, religious statues were replaced with busts of Jean-Paul Marat, the revolution's official "saint." Public commemorations of Marat became anti-clerical ceremonies consisting of three rituals: a church was inaugurated as a Temple of Reason, a bust of Marat was unveiled, and a bonfire was lit to burn all royal and religious statues, paintings, and icons from the detested Ancien Régime.[12] The most celebrated Temple of Reason was the Pantheon. The massive

neo-classical church on the Left Bank of Paris was transformed in 1791 into a secular temple dedicated to the glory of France's great men ("*Aux Grands Hommes la Patrie Reconnaissante*"). In 1794, one of the first great men entombed in the Pantheon was the philosopher Jean-Jacques Rousseau. Not far away was the crypt of his great intellectual adversary, Voltaire, famous for his hostility toward religion with the motto, "*Écrasez l'infâme!*"[13]

Jacobin revolutionaries faced a dilemma concerning the fate of artworks. While rampaging mobs made no aesthetic concessions to statues and icons, leaders of the Revolution steeped in Enlightenment values wished to preserve works of art. As revolutionary Bertrand Barère declared, "The revolutions of a barbarous people destroy all monuments, and the very trace of the arts seems to be effaced. The revolutions of an enlightened people conserve the fine arts, and embellish them, while the fruitful concern of the legislator causes the arts to be reborn as an ornament of the empire."[14] In France, a compromise between destruction and preservation was found. It was decided that monuments and paintings worth conserving would be put in public museums. A Monuments Commission, which included the painter Jacques-Louis David, was set up to make these assessments.

This did not mean that the iconoclastic violence against artworks ceased. Jacques-Louis David himself became increasingly radicalized as a Jacobin hardliner and insisted on a more aggressive approach to iconoclastic destruction. He had initially called for the preservation of the statue of Louis XIV in Place des Victoires, but changed his mind and arranged for a statue of Liberty to replace the toppled monarch. David even organized an anti-royalist bonfire ceremony for the occasion. Effigies of France's kings and other artifacts were burned in an expiatory sacrifice.[15] Works of art were also tossed onto *auto-da-fé* flames in rituals reminiscent of Savonarola's bonfires of vanities in fifteenth-century Florence. "The arts are going to recover their dignity, they will no longer prostitute themselves celebrating tyrants," declared David, whose revolutionary works included the famous *Marat Assassinated* painting depicting the murdered Jacobin leader in his bathtub.[16] Painters who had created "obscenities that revolted republican morals" were subjected to Jacobin struggle sessions in which they were harassed and forced to publicly "abjure their former errors." One unfortunate victim of these punitive rituals was Louis-Léopold Boilly, who promised to use his paintbrush in the future "in a more worthy manner."[17] Boilly atoned for his sins by producing a more patriotic work, *The Triumph of Marat*.

The Louvre was created in 1793 as a public museum to house works of art that henceforth belonged to the people of France. It offered asylum to many artworks that otherwise may have been targets for destruction. The equestrian statue of Henri IV was demolished, but the figures of four slaves chained to the pedestal were spirited off to the Louvre, where they remain today. The creation

of the Louvre, and secularization of art more generally, was in many respects a bourgeois Enlightenment project. By putting artworks into museums, they were dispossessed of their symbolic power by conferring aesthetic autonomy on them.[18] The patriots who visited the Louvre to gaze dispassionately upon "feudal" artworks inside the museum were sometimes the same revolutionaries who threw themselves into violent acts of iconoclastic destruction in the streets of Paris.

Outside the hushed confines of Louvre galleries, the revolutionary fury advanced to its most gruesome phase as the Terror spiraled out of control. In July 1793, the National Convention decreed that the nation needed to be cleansed of the memory of France's deposed "tyrants."[19] The expiation would be accomplished through the destruction of the royal tombs in the Saint Denis basilica outside Paris. Only through total obliteration of the feudal monarchy's legacy—including the corpses of deceased monarchs—could a new republican order be constructed.

The plan initially was to melt down the bronze and other metals on the royal tombs and make "patriotic" bullets to further the revolution. The scope of the edict was extended, however, to include the destruction of all royal tombs as symbols of the feudal system. The decree was tantamount to a posthumous damnatio memoriae sentence on every French monarch who had ever reigned. Iconoclasm was shifting from violence inflicted on bronze and marble to the mutilation of putrefied flesh. The physical punishment of corpses reconnected with traditions of violence against cadavers stretching back to the corrupt *saeculum obscurum* papacy when, in 897 AD, Pope Formosus's corpse was exhumed, put on trial, found guilty, and decapitated. Ironically, the desecration of royal tombs in France was justified in religious terms with reference to the Bible. It was regarded as the fulfilment of Jeremiah's warning that God would annihilate an entire race and scatter its buried ancestors.[20]

The ghoulish attack on royal tombs scrupulously followed the new republican calendar. The first phase of desecration was timed with the Festival of Reunion on August 10, celebrating the triumph of national unity on the first anniversary of the Republic.[21] Inside Saint Denis basilica, the Jacobin patriots appointed to the gruesome task began by systematically dismantling the coffins of the Valois monarchs—François I, Henri II, Catherine de Medici, and others. They first stripped away the lead for recasting. Then they ripped the corpses of monarchs from their crypts and tossed them in a trench. Next they moved to the Bourbon tombs. The desecrators smashed tombs and removed the cadavers including Henri IV, Louis XIII, and Louis XIV. When the coffin of Louis XIII was broken open, the king's famous black mustache was still visible on his decomposed face. In the tomb of Louis XIV, the Sun King's remains were discovered to be as black as ink. The royal cadavers were pulled from their coffins

and mutilated, their hair torn away from skulls, fingernails pulled off. Some of the corpses gave off an unbearably foul odor. Vinegar and burned saltpeter were used to mitigate the stench of putrefaction.

The body of king Henri IV astounded those who opened his tomb. It was perfectly embalmed and instantly recognizable. The king was so remarkably well-preserved that a cast was taken of his face. The cadaver was then dragged to the front of the basilica and propped up in a chair for passersby to inspect. A soldier cut a lock from the cadaver's beard. A woman cursed the corpse and struck it so hard that it crashed to the ground.[22] The corpse of Louis XIV's illustrious marshal, Henri de La Tour d'Auvergne, was treated with more respect, as he was considered a great military hero. His cadaver was displayed reverentially. The revolutionary Camille Desmoulins, an old friend of Robespierre, cut off the right pinky finger as a souvenir.

In total, the cadavers of 46 kings, 32 queens, and 63 royal princes were ripped from their coffins and mutilated. The corpses were dumped in a common grave north of the basilica. Each line of the French monarchy had its own pit filled with lime to accelerate decomposition. Some local Parisians descended into the pit in search of morbid relics ripped from the corpses of the kings and queens that had once ruled France. It was gruesome business, but for Jacobins the desacralization of the Bourbons was a necessary rite. French kings were no longer sacred. Their bodies were tossed in common pits, despised by the people.

The Jacobins next turned their attention to the highest symbol of faith—God. In France's new secular society based on reason, God was abolished and replaced by a "Supreme Being" with no connection to Catholic theology. The Jacobins shrewdly understood, as Machiavelli had observed, that religion is to be valued for its political effectiveness rather than for its theological correctness. The new religion in France was called a "Cult of Reason," a notion inspired by the philosopher Rousseau who advocated for a civic religion. Religion was now an essentially political project to incite the veneration of citizens. Religious passions were transferred to the political sphere. France's new civic religion reached its ceremonial high point when a "Festival of Reason" was held in Notre Dame in November 1793—or, according to the republican calendar, on 20 Brumaire of Year II.

Despite its virtues of rationalism, the republican calendar scarcely survived the French Revolution. It continued to be used, perhaps remarkably, until 1805. One of the calendar's most memorable dates was 9 Thermidor (July 27, 1794), when the fanatical Robespierre was arrested and, the next day, hauled to the guillotine.

The radical Jacobin leader responsible for the Terror became the victim of his own infernal machine. The French Revolution ended up devouring its own children.

The main beneficiary of revolution was Napoleon Bonaparte. The revolution's violent and chaotic energy catapulted him to power on "18 Brumaire" of the new calendar, the date of Bonaparte's *coup d'état* in 1799.

Napoleon quickly abandoned many of the values that had inspired the French Revolution. He did away with the Republic's grand utopian projects. The Jacobin obsession with a Supreme Being and temples of Reason were not compatible with the worldview of a military general with ambitions of conquest, plunder, and glory. The Jacobin calendar was erased and the old system of dates restored. Catholic masses returned. Slavery, which had been abolished by the Jacobins, was reinstated in the colonies.

Proclaimed emperor in 1804, Napoleon demonstrated that he was a builder, not a destroyer, of statues and monuments. The Napoleonic imperial regime required its own majestic symbolism. Personality cults dedicated to Marat and Robespierre were pushed into the background to make way for a new culture of veneration around the figure of the emperor. Napoleon's personality cult was promoted with a rich tableau of imperial iconography using symbols, sculptures, paintings, and especially public monuments to celebrate his military victories.

Painter Jacques-Louis David's vast canvas of Napoleon's coronation in 1804 was particularly revealing. On display in the Louvre today, the large-scale propaganda tableau shows Napoleon in Notre Dame holding the imperial crown aloft at the altar as his empress, Josephine, kneels before him. This Notre Dame was not a revolutionary "Temple of Reason" but a Catholic cathedral sacralizing an imperial coronation. In the painting, Pope Pius VII is seated behind Napoleon, raising his hand in a gesture of pontifical blessing. Ironically, only a decade before, Jacques-Louis David had been a radicalized Jacobin. Now he was putting his considerable talents at the service of Napoleon's imperial narrative.

In Place Vendôme, where an equestrian statue of Louis XIV had been pulled down in 1792, Napoleon erected a massive column modeled on Trajan's Column in Rome. The column was topped with a statue of Napoleon styled as a Roman emperor. The narrative of Napoleon's military victories over the Austrians and Russians at the Battle of Austerlitz was etched into the column's surface. The same military triumph was celebrated with the construction of the Arc de Triomphe at one end of the Champs-Élysées. Napoleon would never see the completion of the Arc de Triomphe. It wasn't inaugurated until 1836, two decades after his defeat at Waterloo and fifteen years after his death.

Restored to the throne after Napoleon's exile, the Bourbon king Louis XVIII wasted no time in avenging the Jacobin iconoclasm inflicted on the monarchy. Replicas of toppled royal statues were created and installed at the same locations where they had been pulled down. In 1818, a new equestrian statue of Henri IV was erected on the Pont Neuf, though without the four slaves in chains. The restored Bourbons were not above sly gestures of historical vengeance. The bronze

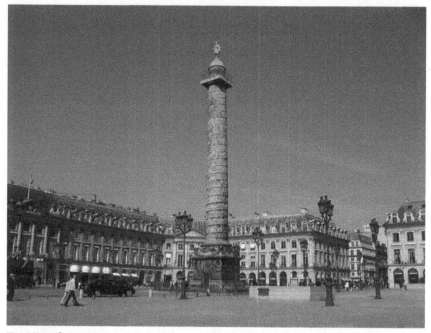

The Vendôme Column in Paris, erected by Napoleon Bonaparte. *Wikimedia Creative Commons.*

statue of Napoleon atop the Vendôme Column was removed, melted down, and used to make the new Henri IV statue on the Pont Neuf.[23] Four years later in 1822, an equestrian statue of Louis XIV was restored to its place of honor in Place des Victoires. A statue of Louis XIII was, in like manner, returned to Place des Vosges in 1825. The revival of these statues in highly visible places throughout Paris provided another demonstration that iconoclastic destruction is never final—neither in cultural memory, nor even in physical presence. Destroyed statues and monuments make unexpected comebacks and reassert their symbolic power.

Napoleon's statue on the Vendôme Column set a record for resurrections. After the monarchy's restoration in 1814, it was removed and, as previously noted, melted down. A royal white flag was put in its place atop the column. Under the Bourbons, merchants selling images of Napoleon or any revolutionary symbol risked prison. When the Bourbon monarchy fell for a second, and final, time in 1830, the Orléanist citizen-king Louis-Philippe had a new statue of Napoleon restored to the top of the Vendôme Column. This time Napoleon was not in Roman garb; he was dressed in his soldier's uniform. In 1852 when Napoleon's nephew was proclaimed emperor as Napoleon III, he replaced the

statue yet again. In keeping with imperial iconography, Napoleon reappeared on the column once again as a Roman emperor.

Karl Marx famously remarked about Napoleon III, comparing him unfavorably to his uncle Napoleon Bonaparte, that history repeats itself—the first time as tragedy, the second time as farce. Marx made another observation, less famous, in his essay *The Eighteenth Brumaire of Louis Bonaparte*. Published the same year that Louis Bonaparte proclaimed himself Napoleon III, Marx made a prediction: "When the imperial mantle finally falls on the shoulders of Louis Bonaparte, the bronze statue of Napoleon will come crashing down from the top of the Vendôme Column."[24] Marx may have been wrong about many things, but on the subject of Napoleon III he was undeniably perceptive.

Following Napoleon III's defeat in the Franco-Prussian War in 1870, the Second Empire collapsed and the emperor fled into exile in England. The Prussian forces advanced on Paris and surrounded the city with their cannons. During the siege, relentless Prussian shelling finally broke the city's morale as Parisians were crippled by disease and starvation. The French capital capitulated in late January 1871. After the Prussians finally departed, the French government was left to fight a bloody civil war against radical elements of the National Guard inciting insurrection. Paris became an urban war zone as French government troops attempted to assert authority over the rebel capital controlled by radical Communards. In the chaos and bloodshed through the spring of 1871, the rebels led a furious iconoclastic attack on Napoleonic monuments. They started, as Karl Marx had predicted, with the statue of Napoleon atop the Vendôme Column near the Tuileries.

On May 16, 1871, Communards used ropes to pull down the towering column. This was not spontaneous mob violence. It was official iconoclastic demolition. The destruction, presided over by National Guard battalions with a band playing "La Marseillaise," was ritualized as triumphant ceremony. When the column hit the ground and shattered, Communards draped a red flag over the pedestal. For the first time, Parisians had a close-up look at the statue of Napoleon Bonaparte, dressed in a Roman toga, lying on his back, his bronze head and eyes turned upward to the sky. When the writer George Sand learned of the column's toppling, she wrote in her journal from her French country house: "It is unfathomable that the French army isn't putting an end to this orgy."[25] The novelist Gustave Flaubert wrote to Sand: "I think that we should have sent the entire Commune to the galleys and forced these bloodthirsty imbeciles to clean up the ruins of Paris, while chained at the neck like slaves."[26]

In the aftermath of the Paris Commune upheaval, the Vendôme Column was repaired and erected again under the Third Republic in 1875. The statue restored to the column's apex was a Roman-style Napoleon, laurel-crowned and holding a globe surmounted by the winged figure of Victory. It's this statue of

Napoleon that can be seen today atop the Vendôme Column. Between 1810 and 1875, Napoleon's statue in Place Vendôme was erected, destroyed, and resurrected several times. The statue at the top of the column today is the fourth Napoleon.

The Paris Commune's legacy of destruction was not restricted to the toppling of Napoleon's column. The radical Communards unleashed a scorched-earth campaign of arson against public buildings in the French capital. Communard vandalism reconnected with Jacobin iconoclasm during the French Revolution. The violence was reckless and relentless. Communard soldiers stationed at the Tuileries Palace, ancestral home of the French monarchy, set the building on fire and watched it burn to the ground. The palace, connecting the two wings of the Louvre, was a smoldering ruin when the flames died. Next to go up in flames was the Hôtel de Ville, which the Communards were using as their headquarters. Murals by Delacroix and Ingres were incinerated as black smoke sent a massive plume over the city. Among other buildings set on fire were the courts, police headquarters, the Châtelet theater, and Saint-Eustache church. Fires were lit at Notre Dame and the Palais Royal, too, but the flames were extinguished in time to prevent major damage.

After the fall of the Commune, a spiritual monument was constructed on the French capital's highest point in Montmartre, once called "Mont Marat." The Byzantine-style basilica of Sacré Coeur was meant to absolve the French nation of its decades of sin and folly between the French Revolution and the Commune.

Some French leaders, such as George Clemenceau, opposed the basilica's construction, claiming that Sacré Coeur was an insult to the legacy of the French Revolution. Sacré Coeur was constructed nonetheless.

Inaugurated in 1919, Sacré Coeur still stands today as an architectural symbol of absolution.

For a casual viewer strolling through the streets of Paris today, the city's statues and monuments seem to express a grandiose harmony of purpose. Yet in truth, the statues standing in the French capital's public squares reflect an uneasy accommodation of France's tumultuous history.

In a country with deep ideological divides, there is a public monument for everyone—from the towering Marianne statue in Place de la République to a gilded bronze Jeanne d'Arc near the Louvre. Many of France's kings returned long ago to their original places in the capital's public squares. And Napoleon is still perched atop the Vendôme Column in front of the Ritz. Despite the country's long history of discord, the legacy of statues and monuments that embellish the French capital somehow conveys an aura of majestic harmony.

A perfect example of this monumental harmony can be observed in Place de la Concorde. No other place in France has been so profoundly marked by historical trauma. It was here that both Louis XVI and Marie Antoinette were executed. When Louis XVI was guillotined here in January 1793, the equestrian statue of his grandfather, Louis XV, had already been pulled down. Only the pedestal remained at the center of the square. When Marie Antoinette followed her husband to the guillotine in October that year, a statue of Liberty had been placed on the pedestal. The enthroned female figure of Liberty looked down at Marie Antoinette, as if in judgment, as the disgraced queen mounted the scaffold.

After the Bourbon restoration in 1814, a statue of Louis XVI was planned for the vast square, but only the pedestal had been completed when the Bourbon monarchy fell in 1830. Under the citizen-king Louis-Philippe, a new plan was unveiled: a 75-foot-high Egyptian obelisk that had just arrived from Egypt would be erected in the square. The Luxor obelisk had stood for 3,000 years outside the temple of the pharaoh Ramesses II, also known as Ozymandias. The obelisk was a gift to France from the Ottoman governor of Egypt, Muhammad Ali. In France, fascination with Egyptian iconography was a legacy of Napoleon's conquest of Egypt and the translation of the Rosetta Stone by French orientalist Jean-François Champollion. Napoleon had wanted to take Egyptian obelisks

The Luxor Obelisk in the Place de la Concorde, Paris. *Photo by Guilhem Vellut, Wikimedia Creative Commons.*

back to France and adorn Paris with them, in imitation of the Roman emperors who had erected obelisks in the Eternal City.

The Luxor obelisk arrived in Paris in 1836. It was erected in Place de la Concorde before a massive crowd, with the monarch Louis-Philippe himself looking on. The obelisk was placed on the same pedestal originally intended for the statue of Louis XVI, guillotined only a few dozen yards from where the obelisk went up. Finally, Place de la Concorde—as its name suggested—was politically neutralized. Louis-Philippe was explicit about this intention when remarking about the obelisk: "It will remain in place because it recalls no memory of a political event."[27] He was correct. The Luxor obelisk still stands in Place de la Concorde today, unmolested.

The Egyptian theme was embellished in 1989—the bicentenary of the French Revolution—with the inauguration of the glass pyramid in the Louvre courtyard. The pyramid and Luxor obelisk are lined up in perfect symmetry with a view straight up the Champs-Elysées to Napoleon's Arc de Triomphe.

On the other side of the Seine, the Pantheon stands as the greatest architectural legacy of the French Revolution. A church converted into a secular temple, the Pantheon provides a grandiose example of how revolutionary iconoclasm in France gave birth to new forms of republican idolatry. The enshrining of the philosopher Voltaire's remains at the Pantheon in July 1791 gave occasion to great public celebrations in Paris.

In more recent times, a statue of Voltaire stood for decades in a small garden in Paris near the banks of the Seine. It was a replica of a Voltaire statue erected nearby in 1885, but that statue had been dismantled and melted down by the Nazis during the occupation. The new statue's location in the garden near the Académie Française was likely chosen for its proximity to Quai Voltaire, where the philosopher died in 1778.

For decades, Parisians strolling through the Left Bank were familiar with the statue of Voltaire holding a book. But in mid-August 2020, the Voltaire statue suddenly vanished.

The backdrop to Voltaire's disappearance was widespread social upheaval. Over the preceding weeks, statues in America and around the world were being vandalized and toppled in the wake of George Floyd's murder in Minneapolis. The culture wars in America had spread to France, where the nation's statues were being contested and vandalized. In Paris, anti-racist activists were spraying paint on statues of French colonial generals.[28] In front of the France's parliament, a statue of Louis XIV's powerful minister, Jean-Baptiste Colbert, was defaced with hostile graffiti: "*Négrophobie d'État.*" In the French territory of Martinique, locals toppled a statue of Victor Schœlcher, a nineteenth-century French statesman whose achievements included the abolition of slavery in 1848. For some,

the attack on Schœlcher's statue was shockingly misguided. But the local population in Martinique evidently resented his anti-slavery positions as paternalistic.[29]

The statue of Voltaire in Paris had previously been defaced with paint and graffiti. This time, however, the city of Paris ordered its removal. The official reason given was that the statue needed to be cleaned. The timing nonetheless seemed suspicious. The Paris city council was dominated by a group of left-wing councilors who were ideologically receptive to the iconoclastic protests sweeping through American cities. In France, Voltaire had already been targeted by anti-racist protestors not for his philosophical ideas, but because he had made a personal fortune from investments in colonial trade and had written disparagingly about Africans. The Enlightenment philosopher, they argued, was emblematic of the White patriarchy responsible for colonialism and racism.[30]

The removal of Voltaire's statue openly defied public statements made by France's president Emmanuel Macron following iconoclastic violence in America. Macron declared publicly that, unlike in the United States, France doesn't remove statues from public places. "The Republic won't erase any name from its history," he said. "It will forget none of its artworks, it won't take down statues."[31]

Perhaps Paris authorities were attempting to shield the Voltaire statue from further violence. More than a year after its removal, however, the statue never reappeared. The small pedestal on which Voltaire once stood looked increasingly like a neglected gravestone. Finally, the city of Paris announced that Voltaire would not return to the Left Bank garden, but would find a home, more out of public view, at the Paris faculty of medicine.[32]

The mystery surrounding the statue's disappearance demonstrated a fundamental fact about iconoclastic destruction. There is no iconoclasm without idolatry. Objects of idolatry become targets of iconoclastic violence. Voltaire became a target, it appeared, precisely because he was a figure of veneration in France.

Voltaire's missing statue presents a puzzling paradox. While his tomb enshrined in the hushed vaults of the Pantheon confers on him the grandeur of a revered national icon, in the unruly streets of Paris, his statue is contested, defaced, and vandalized by a generation revolting against the values on which the Pantheon was founded. These conflicted reactions to Voltaire are a symptom of the tumultuous times we live in.

The philosopher, meanwhile, enjoys the unique double status of venerated idol and object of iconoclastic protest.

CHAPTER 9

Marxist Idolatry

Following the overthrow of the Tsar in 1917, one of the first monuments erected by the Bolsheviks was in tribute to a Russian revolutionary hero. But he was not Russian. It was a statue of Maximilien Robespierre.

The radical Jacobin leader might, on the surface, seem a puzzling priority as Soviet icon. For the Bolsheviks, however, the French Revolution was the historical playbook for their grand designs for a new Soviet society.[1] Russian revolutionaries, including Vladimir Lenin and Leon Trotsky, revered and emulated the Jacobins. Lenin's revolutionary model was Robespierre. He described the Jacobin leader as "Bolshevik *avant la lettre*."[2]

The unveiling of Robespierre's statue in Moscow in November 1918 kicked off Lenin's "monumental propaganda" campaign celebrating heroes of the Russian Revolution. Lenin turned his mind to the propaganda role of statues almost immediately after the Bolsheviks seized power. His plan was both iconoclastic and idolatrous. On one hand, physical traces of the tsarist regime were to be obliterated. At the same time, new statues and monuments would be erected to forge Soviet collective memory. In short, iconoclastic destruction and symbolic replacement.

In April 1918, Lenin issued a decree titled, "On the Dismantling of Monuments Erected in Honor of the Tsars and Their Servants." Public statues and monuments with no historical significance or artistic merit were to be taken down and destroyed or melted down for "utilitarian purposes." Lenin was in a particular hurry to get rid of the "more hideous" tsarist statues. He ordered their removal by the end of the month.[3]

The idolatrous component of Lenin's propaganda strategy was titled "Formulation of Projects for Monuments to the Russian Socialist Revolution." He was acutely aware of the importance of rituals and images for the revolution's success. Lenin had carefully studied the use of rites and symbols in Robespierre's

Jacobin revolution. He regarded revolutionary France's secular Festival of the Supreme Being and other public rituals of civic devotion as templates for Russia. On May Day in 1918, for example, a festival in Petrograd featured a Roman float with the goddess Liberty wearing a white tunic and holding a torch aloft.[4]

Lenin's thinking about iconography was greatly influenced by another Frenchman, Gustave Le Bon, famous for his 1895 work on mass psychology, *The Crowd: A Study of the Popular Mind*.[5] Le Bon had observed firsthand how crowd psychology had shaped social upheavals in France. In 1871, he witnessed the burning down of the Tuileries Palace by radical Communards. In his book, Le Bon stressed the importance of idols and images for manipulating the masses. "Crowds, being only capable of thinking in images, are only to be impressed by images," he observed. "It is only images that terrify or attract them, and so become motives of action."[6] Le Bon predicted that the modern world was entering a period where crowd psychology would shape history. Those who seek power must therefore understand how to manipulate the masses with images. This insight had a powerful impact on Lenin's thinking (and later on Adolf Hitler and Benito Mussolini).[7]

Lenin launched his monumental propaganda campaign with tight deadlines to have statues unveiled for the first anniversary of the October Revolution. He drew up a list of sixty-seven "distinguished persons" worthy of statues to be admired by the proletariat. Marx and Engels were on the list, of course. So was Robespierre and fellow French revolutionary Danton. There were more unexpected names, such as the Roman slave Spartacus and Romantic composer Frédéric Chopin. To meet Lenin's deadline, the statues were hastily fabricated using plaster and paper mâché. Several were late or never completed, but the Robespierre statue was produced on time.

On November 3, 1918, the Robespierre monument was unveiled before a large crowd in Moscow's Alexander Garden near the Kremlin. During the ceremony, Bolshevik revolutionary Lev Kamenev praised Robespierre for "crushing the French counterrevolution with an iron hand and creating a Red Army."[8] Ironically, no public monument of Robespierre existed in his native France, where his name was indelibly linked to the atrocities of the Terror. In Moscow, the Robespierre statue was followed in February 1919 by another monumental tribute to Danton. The statue featured a gigantic head of Danton perched on a pillar in Moscow's Revolution Square.

Why were the Bolsheviks so obsessed with Robespierre and the French Revolution? One explanation is the "fires in the minds of men"—a term taken from Dostoevsky—that drive them to reenact the past with the burning passions of the present.[9] The fact that French Jacobinism was the horror of aristocracies throughout Europe also must have endeared Robespierre to the Bolsheviks. Karl Marx's interest in events in France—he wrote about Napoleon III and the

Paris Commune—further reinforced the importance of French history. Marx's political universalism, it might be argued, was compatible with the values of the Jacobin revolutionaries. Both Jacobins and Bolsheviks were also hostile to established religion. The Jacobins smashed the power of the Catholic Church and expropriated its property. For Marx, religion was a system of superstitions that distracted the masses from consciousness of their material condition. One of Marxism's main goals, according to Lenin, was to "carry on the struggle against all religious bamboozling" of workers. Religion had to be dispossessed of its powers for communism to prevail as the new religion of the masses.[10] Eradicating the influence of religion was therefore central to the revolutionary project.

As in revolutionary France, the Bolsheviks' first iconoclastic targets were religion and monarchy. The Orthodox Church's property was nationalized without compensation. The Bolshevik state took control of all religious schools, which were henceforth run by a Commissariat of Enlightenment. The press meanwhile was encouraged to publish "the most monstrous slander and heinous blasphemy against the Church and its servants."[11] In a move reminiscent of the Jacobins' reinvention of time, the Bolsheviks abandoned the Julian calendar of the Russian Orthodox church and switched to the Gregorian calendar. Religious holidays were replaced by secular days, including Bloody Sunday (January 22) and Overthrow of Autocracy Day (March 12). Another holiday, Paris Commune Day (March 18) underscored Bolshevik reverence for the revolutionary tradition in France.

Lenin was cautious about taking the assault on the Church too far, fearing it might stoke the flames of a counter-revolution. "The proletarian dictatorship must consistently effect the real emancipation of the working people from religious prejudices," wrote Lenin, "doing so by means of propaganda and by raising the political consciousness of the masses but carefully avoiding anything that may hurt the feelings of the religious section of the population and serve to increase religious fanaticism."[12] The Bolsheviks nonetheless had to confront the reality that the Orthodox Church was actively siding with the "white" forces loyal to the tsarist regime. Clerical activism against the Bolsheviks included military brigades known as "Jesus Regiments" and "Orders of the Holy Cross." Priests delivered sermons blessing counter-revolutionary armies. The Bolsheviks were merciless in their repression of this clerical resistance. During the Civil War between 1918 and 1920, they unleashed a campaign against the clergy in which twenty-eight bishops were murdered, thousands of clerics imprisoned, and twelve thousand laymen killed for religious activities. In 1922, more than 8,000 people were executed or killed, including 2,691 priests, 1,962 monks, and 3,447 nuns.[13]

Tsarist symbols were also targeted for obliteration to demythologize the Romanovs. But here the iconoclastic destruction was more selective. Portraits of

Nicholas II were removed and hidden in the attics of government buildings. Fire trucks equipped with ladders roamed around Moscow and took down imperial emblems, especially the Romanov eagle and coat of arms. Tsarist emblems were torn from gates. Sometimes dynamite was needed to blow them up.[14] In 1918, a towering statue of tsar Alexander II in Moscow was demolished. Alexander II had been assassinated in 1881 by members of the "People's Will" revolutionary group. The Russian Orthodox Church of the Savior on Spilled Blood was later constructed on the site of the assassination in Saint Petersburg. In Moscow, Lenin ordered a monument to the great writer Tolstoy, who had been excommunicated by the Church, to be erected on the spot where the Alexander II statue stood. He also ordered the destruction of a massive statue of another tsar, Alexander III, seated enthroned in front of Moscow's Cathedral of Christ the Savior. The toppling of the Alexander III monument was reenacted in the opening scene of Sergei Eisenstein's classic film *October*.[15]

While this was a busy schedule of demolition, Lenin grew impatient with the slow implementation of his iconoclastic decrees. It was also executed unevenly. The statue of Alexander III in Moscow came crashing down, but an equestrian statue of Peter the Great in St. Petersburg remained standing. In Lenin's view, the organized violence against tsarist statues in Russian cities was only limited demolition—especially compared with Jacobin attacks on royal statues in Paris.

Statue of Vladimir Lenin in Bishkek, Kyrgyzstan. *Wikimedia Creative Commons.*

There was a reason for these delays. Lenin had delegated the task of selecting targeted statues to a committee of artists. They made their decisions under the proviso that works with "historical" or "artistic" significance could be preserved. In revolutionary France, furious mobs had roamed the streets of Paris and spontaneously attacked royal statues. Under the Bolsheviks, decisions to demolish statues were more bureaucratic.[16] Lenin specifically gave orders for certain statues of the "tsars and their servants"[17] to be demolished, but the committee sometimes decided in favor of preserving them. When statues of tsars were taken down, they were often carefully dismantled, not furiously toppled. The Jacobins incited mobs; the Bolsheviks worked by committee. The contrast was reversed for the execution of monarchs. The Jacobins put Louis XVI and Marie Antoinette on trial before their public execution by guillotine. The Bolsheviks ordered the tsar and his entire family secretly murdered in July 1918 without a trial.

The statue of Robespierre in Moscow had a short life, a victim of the fragile materials with which it was constructed. Only a few days after its unveiling, the Robespierre monument was discovered crumbled in Alexander Garden. There were reports that it had been blown up by counter-revolutionaries. Others claimed that it had simply collapsed due to its poor construction. Whatever had killed off Robespierre, it was an inauspicious start to Lenin's monumental propaganda program.

The next phase of Bolshevik propaganda would be much more effective, however, thanks to the image—and body—of Lenin himself.

After Lenin's death in 1924, his successor, Joseph Stalin, decided to transform Lenin into a Bolshevik icon of secular worship. The official veneration began with the renaming of Saint Petersburg as Leningrad. Stalin next created a cult around Lenin's tomb. Against the wishes of Lenin's widow, Stalin ordered his embalmed body to be displayed like a sacred relic in a Red Square mausoleum. Lenin's corpse was turned into a "living sculpture" for public adoration.[18] He became the first Soviet saint, resistant to putrefaction, venerated in perpetuity by the proletariat.

A year after Lenin's death, the British economist John Maynard Keynes insightfully made the connection between religion and Soviet ideology. "Like other new religions, it is filled with missionary ardor and ecumenical ambitions," observed Keynes. "But to say that Leninism is the faith of a persecuting and propagating minority of fanatics led by hypocrites is, after all, to say no more or less than that it is a religion, and not merely a party, and Lenin a Mahomet, and not a Bismarck."[19]

Not everyone in the top Soviet leadership approved of the sacralization of Lenin's body. Leon Trotsky was against it, arguing that it revived the abolished idolatrous practices of the Orthodox Church. Stalin disagreed. He saw the advantages in channeling the emotions of religious mourning into new communist

cults of personality. Stalin's view prevailed. The number of statues and monu-
ments dedicated to Lenin reached 70,000.[20]

With the transformation of Lenin into a Marxist saint, official atheism un-
der Stalin was relentless. A League of the Godless was created to step up Soviet
eradication of religious influence. The Orthodox ritual of baptism was abol-
ished and replaced by a Marxist rite called "*Oktiabrina*"—or "Octobering"—in
which babies were baptized with Soviet-compatible names such as "Barrikad,"
"Gertruda," and "Marlen" (a contraction of Marx and Lenin). Anti-religious
museums sprang up everywhere to spread the scientific gospel of communism.
The policy of "museumification" desacralized religion by turning it into an ob-
ject of study in keeping with principles of scientific materialism. The Donskoi
Crematorium, built on the grounds of a monastery, promoted an atheistic view
of death with no afterlife. The Moscow Planetarium celebrated science as the
triumph over the darkness of religion. In 1931, Stalin ordered the destruction
of the colossal wedding-cake Christ-the-Savior cathedral in Moscow, where
Tchaikovsky's "1812 Overture" had its world premiere in 1882. It was razed to
the ground.

At the height of the Great Terror in 1937, Stalin closed more than 8,000
churches and arrested 35,000 "servants of religious cults." Most of the Orthodox
Church hierarchy were exiled or murdered. By the end of the decade, the Ortho-
dox Church had been virtually destroyed in Russia. On the eve of the Bolshevik
Revolution in 1917, there had been more than 50,000 churches in Russia. Now
fewer than 1,000 remained.[21]

Cults of personality through statues were accelerated under Stalin—now
with himself included as an object of veneration. By the 1930s, statues of Lenin
and Stalin were ubiquitous in Soviet cities. In public buildings, every room
featured their busts. City centers were also festooned with massive images of
Marx and Engels. Other venerated heroes included martyrs killed in the October
Revolution and, later, in the Second World War (known as the "Great Patriotic
War").

The physical scale of Soviet statues was megalomaniacal, reaching heights
of forty meters. Statues of Lenin usually showed him in dramatic rhetorical pos-
tures. Images of Stalin were less theatrical. His iconography conveyed an image
of a comforting father of his people. A famous image of Stalin in 1936 showed
him receiving a bouquet of flowers from a seven-year-old Buryat girl, Geyla
Markizova. When the photo of Stalin hugging the little girl appeared on the
front page of the Soviet newspaper *Pravda*, he liked it so much that he ordered
the image to be widely circulated for propaganda purposes. Stalin also commis-
sioned a marble statue of the image from renowned sculptor Georgi Lavrov. Mil-
lions of miniatures of the sculpture were produced and distributed throughout
the Soviet Union in schools and hospitals and other buildings. The little girl in

the photo became a famous icon known as the "Happy Soviet Child." But her iconic fame did little to help her family's fortunes. Two years later in 1938, Stalin had her father arrested as a spy and executed. The rest of the family was exiled to Kazakhstan.[22]

Soviet art was also instrumentalized as propaganda to visualize collective experience in a socialist society. In the early years after the revolution, Soviet art embraced constructivism and avant-garde forms as a rejection of bourgeois conventionality. But under Stalin that style faded and was replaced by so-called "Socialist Realism," usually depicting scenes of happy peasants and workers. Soviet statuary expressed an obsession with monumental scale and muscular physiques. Sculptures combined Art Deco and Socialist Realism to show figures in athletic postures. This was the Soviet "New Man" turned boldly toward a brave new world. Like the Jacobins in France, the Bolsheviks were erasing every trace of the past to build a new social order.

The Soviet policy of erasure provided a pretext for a Marxist form of damnatio memoriae. Following the Great Purge in the 1930s, damnatio became widespread. Stalin's adversaries were labeled enemies of the people, murdered, and their names erased from history. The most famous damnatio target was Trotsky. Stalin not only ousted and exiled Trotsky but in 1940 had him assassinated by a Soviet agent, who used an ice pick to murder him. Trotsky was henceforth an "unperson," expunged from Soviet history, his image cropped from all photos.

Stalin's own personality cult, like Lenin's, was constructed on the religious model of the tsarist regime that the Bolsheviks had overthrown. As Stalin himself was quoted as saying: "Don't forget that we are living in Russia, the land of the Tsars. The Russian people like it when one person stands at the head of the state."[23]

When Stalin died in 1953, his body was embalmed so he could join Lenin in the Red Square mausoleum as another venerated Soviet saint.

Stalinist idolatry and personality cults set the tone for Marxist regimes outside of the Soviet Union.

There is some irony in the pervasiveness of personality cults in Marxist states. For one thing, cults of personality—secularized forms of religious veneration that transform a political leader into a god-like figure—are anti-Marxist. Karl Marx was explicitly opposed to all forms of idolatry.[24] Marxism is atheistic. Personality cults are quasi-religious. They are allied with the Romantic spirit embodied by Napoleon Bonaparte, not with the scientific rationalism that Marxists proclaimed as their guiding principle.

Despite these paradoxes, idolatry and personality cults are, following on the Soviet example, the hallmark of Marxist dictatorships. The ubiquitous

iconography of Mao Zedong in China and massive 66-foot-tall statues of the Kim dynasty's "Great Leaders" in North Korea demonstrate the quasi-religious nature of personality cults in communist regimes. Authoritarian regimes of all kinds similarly use imagery and statues of leaders to promote cults of personality—the Assad dynasty in Syria, Gaddafi in Libya, Saddam Hussein in Iraq, the ayatollahs in Iran, to name only a few. In Turkmenistan, dictator Saparmurat Niyazov promoted a personality cult with an enormous 50-foot gold-plated statue of himself standing on a 250-foot plinth in the capital city, Ashgabat. Following Niyazov's death in 2006, his successor, Gurbanguly Berdimuhamedow, had the monument dismantled. In 2020, Berdimuhamedow erected a 19-foot golden statue in the center of the capital—not a statue of himself, but of his favorite dog, a Central Asian shepherd breed known locally as the Alabai.[25]

In communist China, the iconoclastic war on religion was even more brutal than in Russia. When Mao Zedong's communists triumphed in 1949, the country had been torn by civil war for decades. Like the Bolsheviks, Mao was determined to build a new socialist society turned toward the future. Old religions were regarded as a feudal system of superstitions that had held China back from progress. Mao identified "Four Olds" that were obstructing China's progress: old ideas, old culture, old customs, and old habits.[26] China needed to purge its history to reach the Communist end state. Iconoclasm became official policy as part of China's great leap forward.

In 1950, China invaded Tibet and waged a merciless war on the Buddhist religion and culture. Buddhist monasteries were widely perceived as rich landholders and hence easy targets for expropriation. The communists confiscated Buddhist temples and redistributed land to workers. In the 1960s, Mao created an ideological militia of indoctrinated youth, the Red Guards, who dressed in severe unisex clothing and terrorized, humiliated, and murdered enemies of the revolution. The Red Guards attacked Tibet's holiest shrine, the Jokhang Temple, located in the center of the capital Lhasa. Tibetan students who had been indoctrinated in China spearheaded the campaign of violence against the religious shrines. Buddhist monasteries were destroyed with dynamite and artillery, libraries were pillaged, and rare books and paintings were burned.[27]

Red Guard attacks on the "feudal" vestiges of religion also targeted Confucianism. In late 1966, about 200 Red Guard militants assailed the sacred Qufu Temple. They broke statues of Confucius, smashed monuments, and tore up paintings and calligraphy. In a gruesome replay of the Jacobin desecration of France's royal tombs, the Red Guards smashed the shrines and dug up the graves of Confucius and his descendants.[28] Some 1,000 tombstones were knocked over and nearly 2,000 graves desecrated. Mass looting followed after the Red Guards discovered gold, silver, and jewelry in one of the graves. In total, some 6,618

relics were destroyed, 2,700 rare books were burned, and over 10,000 trees were cut down.

Like Stalin, Mao was not opposed to his own personality cult. During the first wave of the Cultural Revolution in the late 1960s, some 2,000 statues of Mao went up throughout China. Many were erected on university campuses, often depicting him with one outstretched arm and open hand waving. In the city of Chengdu's Tianfu Square where the Red Guards destroyed the ancient palace of the Shu kingdom, a towering 98-foot marble statue of Mao was erected in its place.

Chinese communists used the Stalinist technique of manipulating photos for propaganda purposes and airbrushing pictures to remove images of comrades who had become "unpersons."[29] During the Tiananmen protests of 1989, young Chinese activists defaced a giant poster of Mao Zedong. After martial law was declared and the protest crushed, the vice chairman of the Communist Party, Zhao Ziyang, was arrested and inflicted with a damnatio sentence for his sympathy with the uprising. He had made the error of dialoguing with protestors and declaring to them: "You are not like us. We are already old, we do not matter anymore."[30] Following his house arrest, Zhao was ejected from the party and airbrushed out of photographs. His name was erased from all mentions in the media and Chinese textbooks. Similar practices of historical erasure are common in North Korea. After the execution of Kim Jong-Un's uncle, Jan Song-thaek, North Korean state media erased him from history entirely. Every mention of his name was deleted from online archives and photographs.

China's policy of erasure has been called the "Great Forgetting." Official erasure of history means that some events never happened—for example, the Tiananmen Square massacre of pro-democracy protestors in 1989. On this event, official policy is collective amnesia. The forgetting is not a passive state, it is enforced with violence and threats—both inside and outside of China. In 2017, China brandished threats to make Cambridge University Press remove online access in China to some 300 articles in the journal, *China Quarterly*. The articles, most of them about the Cultural Revolution and the Tiananmen crackdown, were deemed too sensitive by the Communist Party. Incredibly, Cambridge University Press complied and blocked access to the journal, but changed its position after a storm of outrage in the media.

In 2018, China passed a new law, called the "Heroes and Martyrs Protection Act," making it punishable to slander Communist Party heroes and revolutionary martyrs.[31] The law was one of many measures to police language, sanitize historical memory, and punish those guilty of so-called "historical nihilism." The definition of that term was imprecise—officially, it signified "stripping history of its meaning." What it meant, in reality, was any denial of the official

version of history as dictated by the Communist Party according to Marxist notions of historiography. Perpetrators of "historical nihilism" are those who advance imperialist and cosmopolitan perspectives.[32]

The Chinese regime's official history is based on a combination of national mythology and Marxist theory. This censored approach to history has earned China the nickname "People's Republic of Amnesia." Historical censorship involves iconoclastic destruction when necessary, especially in Hong Kong where pro-democracy protestors resisted the Communist Party's authority. At the end of 2021, Hong Kong University removed a 26-foot sculpture, "Pillar of Shame," commemorating the victims of the Tiananmen Square massacre in Beijing. The sculpture depicted fifty twisted bodies piled on each other to symbolize the lives lost in the Communist regime's bloody repression of the pro-democracy protest. The dismantling of the sculpture was part of the regime's crackdown on political dissent in Hong Kong.[33]

Selective memory in China also means that figures from the past can reappear, restored to their former glory. In recent years, Mao Zedong has made an extraordinary comeback. When he died in 1976, Mao left a gruesome legacy of famine and mass murder. Millions had been killed in the ideological purges of his Cultural Revolution, which his successors described as "ten years of chaos." The post-Mao regime ensured that little was known about his atrocities. But today the cult of Mao is surging again, especially with Chinese youth. China's embrace of capitalism, and the growing inequalities it has brought, explain in part why many are turning to Mao's writings. They are nostalgic for a more rigorous form of communist revolution. In Hunan province, Chinese youth make pilgrimages to Changsha to pose for photos in front a massive stone sculpture of young Mao.

Mao has also become a Marxist saint. Like Lenin's embalmed corpse in Moscow, Mao's body (or perhaps a replica) is on public display in a mausoleum in Beijing's Tiananmen Square—the same place where, in 1989, thousands of Chinese youths rebelled against the regime. China's leader Xi Jinping has channeled the Mao mythology to legitimize his own rule. In Tiananmen Square today, mugs and souvenirs feature the images of both Xi Jinping and Mao Zedong. Two personality cults are juxtaposed, their iconography cohabiting on trinkets for sale.[34]

Xi Jinping has largely reversed the official policy of iconoclasm. The regime is now integrating Chinese heritage—once scorned as "feudal"—into its new vision of socialism with "national" characteristics. Cultural heritage and communist ideology are now regarded as harmonious. In this new approach to religion, old shrines and monuments cannot be damaged. Confucian heritage, in particular, has been officially embedded in China's new nationalist ideology. The smashed icons in the Qufu temple have been reconstructed and Confucian

shrines restored as tourist attractions.[35] The same Communist Party that mobilized Red Guards to destroy religious shrines as feudal relics is now spinning an ideological narrative praising these cultural artifacts as symbols of Chinese national identity. The Communist regime is also using Confucius Institutes as part of a "soft power" strategy asserting Chinese influence globally. Many Confucius Institutes have been set up on foreign university campuses, including in the United States and Britain, though they have been criticized as a "Trojan horse" for Chinese propaganda and influence.[36]

China's official hypocrisy toward religion may seem startling. But the Chinese regime can no longer rely on Marxist saints to unite the country. It is now reaching back to the country's pre-communist past to find themes that can be rendered compatible with Marxist ideology. With Confucianism officially recognized, the Orwellian paradox has been accomplished. What was once persecuted is now venerated. State-sponsored iconoclasm has become its opposite: official idolatry.

This is a consistent theme with iconoclastic violence. The targets of destruction inevitably return with their symbolic power intact—sometimes exploited for political purposes, sometimes reinterpreted, but never eradicated. The symbols that were once banished, shamed, and desecrated are unexpectedly resurrected to confer legitimacy on the same regime that once officially reviled them.

Joseph Stalin's posthumous sainthood didn't last. During the "de-Stalinization" period after his death in 1953, his body was removed from the mausoleum where it had been on display next to Lenin.

Stalin was buried a few hundred feet away near the Kremlin wall. A simple dark granite stone was inscribed, "J.V. STALIN 1879–1953." A bust of the Soviet dictator was added later.

Stalinist idolatry died with Stalin. In death, he suffered the same damnatio memoriae sentence that he had inflicted on many others.

Stalin's successor Nikita Khrushchev had hundreds of Stalin statues pulled down. An exemption was accorded to the statue in Stalin's hometown in Georgia. But that statue was removed in 2010 in a symbolic gesture as the Georgian government established closer ties to the West.

A massive Stalin monument in Budapest met a much harsher fate. During Hungary's October Revolution in 1956, protestors toppled the bronze Stalin standing on a limestone pedestal. Only Stalin's boots remained on the pedestal. Protestors used a tractor to drag the statue to the National Theater, where they ripped off Stalin's head. In Poland, Stalin's name was scratched off a statue in Warsaw's Palace of Science and Culture. The statue depicted a young man holding a book inscribed with four names: Marx, Engels, Lenin, Stalin. The first

three names were left intact. In Prague, a statue of Stalin was once the city's most famous monument, visible from any point in the Czech capital. A 30-meter colossus made of granite, it showed Stalin leading his followers. Commissioned in 1949 when Stalin was still alive, it took six years to complete and wasn't unveiled until 1955 after the Soviet dictator's death. But the monument became a victim of the official policy of de-Stalinization. It was blown up in 1962 under pressure from Moscow. In recent years, the platform on which the massive sculpture once stood has become a popular spot for skateboarders.[37]

After the fall of the Berlin wall in 1989, the scope of iconoclasm throughout the Soviet Union spread to encompass the entire legacy of communist dictatorship. The populations in Soviet-ruled countries turned on statues that had dominated their public squares. Television reports showed statues of Lenin and Stalin knocked down to jubilant cheers of crowds. This iconoclastic violence was mostly spontaneous, though in some cases it was guided by local political elites with their own agendas. In 2007, the Estonian government removed a bronze statue of a Soviet soldier in Tallinn and placed it in a nearby cemetery for Russian soldiers.[38] In the Bulgarian capital of Sofia, a Soviet Army Memorial featured a group of Soviet soldiers bravely heading into battle. In 2011, guerilla artists calling themselves Destructive Creation painted the soldiers in the brightly colored uniforms of American cartoon characters—Superman, Captain America, Wonder Woman, Batman, Robin, Joker—charging into battle under a stars-and-stripes American flag. The Russian government reacted angrily to the satirical attack, calling on the Bulgarian government to find and punish the "hooligans" who had painted the monument.[39]

In Russia, the approach to Soviet-era monuments was ambiguous. Some monuments, especially war memorials, remained important symbols of Russian national identity. Other Soviet statues, especially propaganda monuments, were contested and disavowed. Many of these Soviet-era statues have since ended up in Moscow's "Fallen Monument Park" (sometimes called the "Park of Totalitarian Art"). It's an open-air sculpture museum with more than 700 statues—from Marx and Lenin to Stalin and Brezhnev—displayed for their historical value. Created in the 1990s shortly after the collapse of the Soviet Union, the "Fallen Monument" statue graveyard decontextualizes Soviet-era monuments to neutralize them ideologically. Many feature inscriptions with the disclaimer: "The monument is in the memorializing style of political-ideological designs of the Soviet period. Protected by the state."[40] Today the sculpture park is a popular destination for tourists who come to inspect fallen Soviet statues with the curiosity one normally accords kitsch objects. Moscow residents visit the park, walking their dogs and stopping at a café to buy iced lattes while strolling past the statuary vestiges of an era whose legacy evokes mixed emotions.

The statue park concept was also adopted in Budapest, where a similar graveyard for Soviet-era monuments is called Memento Park. Known as "the place where communist statues went to die," Memento Park operates as a tourist attraction selling communist memorabilia. Besides the predictable statues of Lenin, Marx, Engels, as well as Hungarian communist leaders, the park features sculptures in the Socialist Realism style typical of the Soviet era. One of the attractions is a replica of the famous toppled Stalin monument showing only the Soviet dictator's boots on the pedestal. It's not the original statue, but a sculpture titled "Stalin's Boots" by Hungarian architect Ákos Eleőd.

Despite the perception of widespread destruction of Soviet statues, many monuments survived the iconoclastic fury of the 1990s. There has even been a resurgence of Soviet-era statues in recent years, especially in Russia. Vladimir Putin has appropriated the symbolic power of monuments from Russia's history—both Tsarist and Soviet—to forge a new Russian identity that does not turn its back on the past. Putin's pragmatic approach to collective memory (reviving Russian Orthodox religion and memorializing the Soviet era's triumph over Nazism) also has legitimized his new brand of authoritarianism and ethnic Russian nationalism.[41] Even Ivan the Terrible, infamous for mass executions and land confiscations, enjoys a place of pride in the new Russia. In 2016, a massive statue of the sixteenth-century tyrant was unveiled in the city of Oryol south of Moscow. More than 500 people in Oryol signed a petition opposing the monument, but the local governor supported the statue, arguing that Ivan the Terrible defended the country and the Orthodox Church from Russia's enemies.[42] When Putin ordered an invasion of Ukraine in early 2022, the Russian Orthodox patriarch blessed the military operation.

Like the Confucianist revival in China, Putin has restored the symbolism of the Orthodox Church and used it as part of Russia's "soft power" strategy globally. In 2016, an onion-domed Holy Trinity Orthodox Church appeared in Paris in the shadow of the Eiffel Tower. The same year in Moscow, Putin inaugurated a massive statue of Saint Vladimir near the Kremlin. Saint Vladimir was the prince who converted Russia to Christianity in the tenth century. "Prince Vladimir has gone down forever in history as the unifier and defender of Russian lands, as a visionary politician," Putin said. "Today our duty is to stand up together against modern challenges and threats by basing ourselves on this spiritual legacy."[43]

Joseph Stalin, too, is making a comeback in Russia. While October 30 is still a day devoted to the memorialization of Stalin's victims, his name is no longer associated only with purges and gulags. Two days after Putin's inauguration as Russian president in 2000, he unveiled a Victory Day plaque at the Kremlin commemorating Stalin as a war hero. Many Russians today regard Stalin as the heroic leader who defeated the Nazis during the "Great Patriotic War." With

Putin's blessing, statues of Stalin are appearing across the country. Putin argues that Stalin was, like Oliver Cromwell and Napoleon, a man of his time. "It seems to me that the excessive demonization of Stalin is one way to attack the Soviet Union and Russia—to show that Russia still bears the birthmarks of Stalinism," said Putin an interview with the American film director Oliver Stone. "We all have some birthmarks, so what?"[44]

The fate of Lenin statues is particularly instructive about the status of Soviet-era monuments. When the Soviet Union collapsed in 1991, there were some 7,000 statues of Lenin in Russia. Moscow counted eighty Lenin statues in its parks and public squares. After the fall of the Soviet Union, hundreds of Lenin statues were knocked down. In 1995, a large bronze statue of Lenin was removed from the Kremlin and rusticated to his country house outside Moscow. That left only one large Lenin monument in the Russian capital. Inaugurated in 1985 in October Square, it was a massive monument in the Socialist Realist tradition showing Lenin, his coat blown by the wind, atop a large pedestal surrounded by Bolshevik revolutionaries. Anti-communist activists called for the statue to be removed. On the monument's base, they draped a banner inscribed: "Subject to dismantlement as part of decommunization."

Outside of Russia, the image of Lenin has been even more controversial. In Ukraine, there were more than 5,000 statues of Lenin when the Soviet Union collapsed in 1991. Some two thousand were knocked down in the following decade. Another wave of iconoclastic attacks on Soviet-era statues swept across the country in 2013. Protestors pulled down a Lenin statue in central Kyiv after pro-Russian president Viktor Yanukovich refused to pursue integration into the European Union.[45] The following year, Yanukovich was ousted from power in the country's Maidan Revolution and replaced by a pro-European president, Petro Poroshenko. In 2015, Ukraine passed "memory laws" banning Soviet statues and all images, anthems, and street names associated with the Soviet Union in an official policy of "decommunization." Statues of Lenin came crashing down, including the massive Lenin monument in Kharkiv. Ukrainians attacked, mutilated, and decapitated virtually every remaining Lenin statue in an iconoclastic fury known as *Leninopad*, or "Leninfall."[46] While some Lenin statues were removed by Ukrainian officials, many were attacked and toppled by groups of young anti-Soviet nationalists. In Odessa, a statue of Lenin was replaced with one of Darth Vader from *Star Wars*.[47] One Soviet-era statue that survived the iconoclastic rage was the massive, 62-foot *Motherland* monument in Kyiv. It could not be taken down because it commemorated the Second World War. Following Putin's invasion of Ukraine in early 2022, Russian soldiers "executed" a statue of Ukraine's national poet, Taras Shevchenko. The statue, in Borodjanka near Kyiv, was shot in the head. At the same time, Ukrainians defiantly dismantled Russian statues throughout the country, including

a Soviet-era "friendship monument" in Kyiv to mark historical ties between Russia and Ukraine. They also used sandbags to protect their own Ukrainian national statues and monuments.

In communist East Berlin during the Soviet era, an enormous 60-foot pink-granite statue of Lenin was unveiled in the city's Leninplatz for the 100th anniversary of his birth in 1970. A crowd of 200,000 attended the inauguration celebrating the statue as a symbol of the "unshakable friendship" between East Germany and the Soviet Union. Following the toppling of the Berlin Wall in 1989, however, the Lenin monument was doomed. The only question was what to do with the detested statue: preserve it, destroy it, or modify it? Several innovative ideas were proposed by the local artistic community. One was to let vines grow over it. Others suggested artistic reinterpretation. A Polish artist projected images on the statue to transform Lenin into a "shopper" carrying cheap electronics products.

Following German reunification, it was decided to pull down the Lenin statue. Local residents opposed the plan, however, and appealed to the courts to stop the statue's dismantling. A German court rejected the appeal, arguing that the statue had been erected "in the service of a propaganda cult." And so Lenin came down. The head was removed and the statue cut into more than a hundred pieces. The dismembered fragments were buried in a sandpit, almost as if the body parts were Lenin's remains. Opponents to the statue's gruesome fate denounced it as "blind destructive fury." They claimed it was tantamount to "the elimination of history" and warned that book burnings would be next. Pro-Soviet protestors showed up at the former Leninplatz—now named United Nations Square—and spray-painted silhouettes of the monument on the ground.[48]

Like so many condemned monuments, the same statue of Lenin rose Lazarus-like from the dead. In 2015, Lenin's head was dug up, exhumed from its grave like a cadaver. It was subsequently put on display in a Berlin exhibition about Germany's history titled "Unveiled." Lenin's head was later consigned to the Citadel Museum in Spandau. There it joined a graveyard of other statues from Germany's controversial past—from militaristic Prussian to idealized Aryan figures from the Nazi era.

Lenin made yet another comeback, this time in the German city of Gelsenkirchen. In June 2020, the local Marxist-Leninist Party erected a statue of Lenin outside its headquarters. In the city of some 260,000, many residents were outraged at the sight of a Lenin statue. The municipal council resolutely opposed it, calling Lenin a symbol of "violence, suppression, terror and immense human suffering."[49] The council attempted to stop the statue's unveiling with a hashtag campaign called "#NoPlaceForLenin." But an upper court ruled in favor of the Marxist-Leninists.

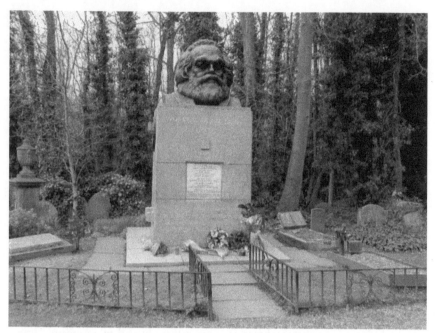

The gravesite of Karl Marx in Highgate Cemetery, London. *Wikimedia Creative Commons.*

The statue's unveiling attracted intense media interest, if not for political reasons, for its unusual timing. It came in the aftermath of George Floyd's murder when activists throughout America and Europe were toppling statues of figures who symbolized oppression. For the Marxist-Leninists in Gelsenkirchen, however, Lenin was a champion of freedom. "The time for monuments to racists, anti-Semites, fascists, anti-communists and other relics of the past has clearly passed," said the party's spokesperson Gabi Fechtner in a statement. "Lenin was an ahead-of-his-time thinker of world-historical importance, an early fighter for freedom and democracy."[50]

It may seem extraordinary that in the twenty-first century Marxists are still committed to idolatry of their cult heroes—despite Karl Marx's explicit opposition to personality cults. Perhaps even more surprising, Karl Marx himself has become an icon—and, predictably, a target for iconoclasts.

Marx died in London in 1883 and was buried in a modest gravesite next to his wife, Jenny, who had died in 1881. Lenin visited Marx's grave in 1903 while on a trip to London. Over the subsequent decades, the gravesite in Highgate Cemetery fell into neglect. In the 1950s, the Communist Party of Britain found another location about a hundred yards away. The remains of Marx and his wife

Jenny were disinterred and reburied there in 1954. Two years later, a massive bronze bust of Marx was set on a marble pedestal inscribed with the words, "Workers of all lands unite."

Today the tombstone is a pilgrimage destination for Marxists the world over. They come to pay homage to the revolutionary philosopher who changed the course of world history. The gravesite has also been the target of anti-Marxist vandals who come to deface and mutilate Karl Marx's final resting place.

The first attacks began only a few years after the monument was installed. The tomb was painted over and defaced with yellow swastikas and other graffiti. In the 1970s, a pipe bomb exploded at the base of the monument. Someone also attempted to saw off Marx's nose. In early 2019, there were two consecutive attacks on the gravesite. Vandals used hammers to hack away at Marx's name on the white marble plaque. In the second attack, the gravestone was sprayed with red paint inscribed with "doctrine of hate," "architect of genocide," "terror and oppression," and "mass murder."[51]

"For some, Marx is a great source of inspiration, and for others he is responsible for all sorts of terrible things," said Ian Dungavell, the head of Friends of Highgate Cemetery Trust. "But he's dead, he rests underneath, and it's sad that some won't respect those who are dead to the point of smashing their graves."[52]

Today, the gravesite is protected by round-the-clock video cameras installed in surrounding trees. It is perhaps fitting that, in today's surveillance society, Karl Marx's tomb is monitored by the watchful, unblinking eyes of Big Brother.

CHAPTER 10

Nazi Meltdown

In the final days of the Second World War, the U.S. Army's Third Division took the German city of Nuremberg. American troops marched into the town's massive Nazi stadium, where they draped over the giant swastika perched above the grandstand.

It was from this stadium's rostrum, modeled on the ancient Greek Pergamon Altar, that Adolf Hitler mesmerized thousands at mass rallies throughout the 1930s. It was here that 200,000 Nazi faithful were treated to "cathedral of light" spectacles with luminous shafts shooting into the night sky. It was here that Leni Riefenstahl shot her famous propaganda film, *Triumph of the Will*, showing a sea of 700,000 enraptured Germans saluting their führer as he delivered enflamed speeches.

On April 22, 1945, American soldiers scaled the stadium and attached dynamite to the marble swastika. When they ignited the charge, the infamous Nazi emblem exploded into a thick ball of smoke above the vast Zeppelin Field. The obliteration of that swastika on Hitler's grandstand was a powerful symbolic act of iconoclasm. The war was finally over. The Nazi ideology was defeated. A week later, Hitler's charred body was found in his Berlin bunker.

The Third Reich had lasted scarcely a dozen years. After Hitler's defeat, everything was done to erase every trace of his horrific legacy. Yet still today, Nazi symbols from that dark era are indelibly etched in historical memory.

Nazi ideology was propagated with a coherent system of iconography—emblems, banners, paintings, propaganda films, statues, buildings—with the image of the führer at the apex.[1] Nazi symbols were borrowed from the Teutonic legends evoked in the operatic cycles of Wagner fervently admired by Hitler. The origins of the swastika stretched back even further to ancient India where it featured on Hindu temples. The word *swastika* comes from the Sanskrit *svástika* for "wellbeing." It also figured on ancient Greek and Roman coins and Celtic stone

monuments. In the late nineteenth century, the German archaeologist Heinrich Schliemann unearthed swastika signs when he made his famous discovery of the ancient city of Troy. It was that connection that fascinated Hitler. Since the same symbol had been discovered on artifacts of ancient German tribes, he saw in the swastika a symbol linking Germans and ancient races with a common Aryan ancestry.

Nazi nostalgia for feudal Teutonic mythology underscored an important distinction between German fascism and Marxist regimes. The Bolsheviks, like the Jacobin revolutionaries in France, were determined to erase the feudal past and build a new society turned toward the future. Bolshevik ideology announced a "New Man" social order. While there were some elements of the "New Man" visions in fascism—especially in Mussolini's Italy—the Nazi movement was nostalgically turned back toward the past. The Nazis rejected the modernist rationalism of Soviet Marxism. Nazi racial ideology celebrated Germany's feudal past and its romantic myths and symbols.

Hitler regarded Nazism as the culmination of a longer saga of German triumphalism. The fact that he called his regime the "Third Reich" demonstrated that his nationalist vision traced its origins through a longer historical narrative. The First Reich was the Holy Roman Empire founded by Charlemagne. The Second Reich was the German Empire consolidated under Bismarck. Nazism was not a rupture with the past; it was the final realization of Germany's great aspirations. The Nazis didn't invent new symbols, they borrowed them from history. Like the swastika, the Nazi eagle—or "*Reichsadler*"—was another ancient symbol. The eagle had been the *aquila* emblem of the Romans, and was later used by both Charlemagne and Napoleon. The eagle was also the symbol of Bismarck's German Empire, from which the Nazis borrowed the Iron Cross.

This arsenal of symbolism borrowed from German history may explain why the Nazis were relatively disinclined to iconoclastic destruction. The Nazis did not target the symbols of a previous epoch for obliteration. They borrowed many of their symbols from the past. Unlike the "New Man" social orders of the Jacobins and Bolsheviks who held the past in contempt, Nazi ideology was deeply invested in symbols and myths from history.

There were two exceptions however: the Weimar Republic and the Jews. Both were targeted for erasure.

The Nazis did not overthrow the Weimar Republic. On the contrary, Hitler's party contested elections in the Weimer Republic, whose president, Paul von Hindenburg, appointed the Nazi leader as chancellor. Hitler did not, strictly speaking, come to power in a revolution. He arrived in office by constitutional means. Once installed at the head of government, however, he wasted no time seizing personal power, especially after the Reichstag fire in 1933. The Nazis quickly dissolved the Weimar Republic to impose a one-party fascist state on

Germany. Hitler didn't violently overthrow an old regime, but he exploited the faltering institutions of the Weimar Republic from within. His usurpation of power was a revolution in everything but name.

Once in power, the Nazis destroyed all traces of the previous regime to impose a radically new political program. The Weimer Republic represented everything the Nazis despised. The city Weimer had been at the center of the German Enlightenment, home to literary giants including Goethe and Schiller and later composer Franz Liszt. In the inter-war years of the 1920s, the Weimer Republic—so named because its constitution was drafted in the city—was also home to the modernist Bauhaus movement in design and architecture. The Weimer interlude championed avant-garde art—from Expressionism and Cubism to Dada and jazz music. These aesthetic movements were anathema to the Nazi spirit inspired by Teutonic romanticism. In contrast to the Weimer Republic's decadent "asphalt culture," the Nazis promoted a return to pan-German, blood-and-soil *Völkisch* culture.[2]

Nazi policy toward Weimer iconography was total erasure. In Berlin, streets bearing the names of Weimer statesmen were renamed. Ebertstraße, named after the Weimar Republic's first president Friedrich Ebert, was renamed Hermann-Göring-Straße after Hitler's second-in-command. First World War memorials commemorating Germany's fallen soldiers were spared because they were a reminder of the humiliation inflicted on the German nation by the traitors who had surrendered in 1918. Statues of Jews, on the other hand, were removed and melted down. The bronze statue of the German-Jewish composer Felix Mendelssohn standing outside the Düsseldorf Opera House was destroyed.

The Nazis unleashed a more violent attack on Germany's intellectual culture and literature with infamous book-burning bonfires. Part of a campaign called "Action Against the un-German Spirit," book burnings were ideological cleansing rituals by fire—or *Säuberung*. The books tossed on purification flames were the published ideas of Jewish, liberal, and leftist authors. Lists of books were drawn up and pulled from the shelves of bookstores and libraries to be thrown on these massive bonfires. Among German authors targeted were Karl Marx, Thomas Mann, Bertolt Brecht, and Sigmund Freud. Foreign authors blacklisted included Ernest Hemingway, Jack London, Theodore Dreiser, and André Gide. In May 1933, some 20,000 books were set ablaze in Berlin's Opera Square. Hitler's propaganda chief, Joseph Goebbels, organized the bonfires with the complicity of Nazi student organizations whose slogan was, "We've conquered the state, but not the universities."

"The era of exaggerated Jewish intellectualism is now over," declared Goebbels. "If you students assume the right to cast the intellectual filth into the flames, you must also assume the responsibility of removing this garbage and clearing the path for truly German works."[3] The German poet Heinrich Heine

had been prescient, a century earlier, with his admonition: "Wherever they burn books they will also, in the end, burn human beings."[4]

The Nazis quickly focused on constructing their own iconography. Statues, symbols, monuments, and buildings were considered important expressions of Nazi ideology. There was one exception: the führer. Hitler discouraged statues and images of himself. It's tempting to speculate that since Hitler had a metaphysical image of himself as führer, he wished to be regarded as a deity and consequently, like God, could not be represented by idols and icons. Some busts of Hitler were made, however, including one that was discovered in Paris after the occupation and secretly stored in the basement of the French Senate. This bust was likely used to adorn the office of a top Nazi officer in Paris.[5]

Hitler preferred monumental propaganda that represented *deutsche Volkskörper*—or the "body of the German people." Statues depicted idealized Germanic bodies inspired by ancient Greek and Roman models of human perfection praised by Hitler as "Greco-Nordic." Two of Hitler's favorite sculptors, Josef Thorak and Arno Breker, produced many of the muscular male nude statues in the neoclassical style. Hitler hand-picked Thorak and Breker to design the statues embellishing the Berlin stadium, which hosted the Olympics in 1936. The stadium's neoclassical architecture made the Third Reich's connection to ancient Greece symbolically explicit. Thorak also sculpted the massive horses—called *Striding Horses*—standing outside Hitler's chancellery in Berlin. The Nazi chancellery was just one new structure designed by Hitler's chief architect Albert Speer as part of the reconstruction of the capital to be called "Germania."

Hitler had a clear vision of Nazi aesthetics. Artistic expression was not autonomous or "art for art's sake." The function of culture was to propagate Nazi ideology.[6] Hitler explicitly articulated his vision for art in Germany at a Nuremberg rally in 1934. In his speech, published the same year under the title "Art and Its Commitment to Truth," Hitler declared that German art must express the greatness of its Greco-Roman origins. He praised the "spark of Hellenism" that inspired the artistic spirit of European civilization, which, he argued, must resist contamination by "foreign" influences. To this end, German film, theater, and opera companies were purged of communists and Jews. The well-known actor Hans Otto, who was a communist, was dismissed from the Prussian State Theater in Berlin. The Jewish composer Arnold Schoenberg, famous for his atonal music, was targeted by the Nazis for his "degenerate" compositions. Schoenberg fled to Paris before emigrating to the United States.

Hitler, a failed painter in his youth, took a particularly keen interest in the visual arts. All forms of modernist art were rejected for their association with the Weimer Republic. Modern art was labelled "un-German," a code term for Jewish. "The whole stammering stream of what these cubists, futurists, Dadaists, and others have to say about art and culture is neither racially sound nor tenable

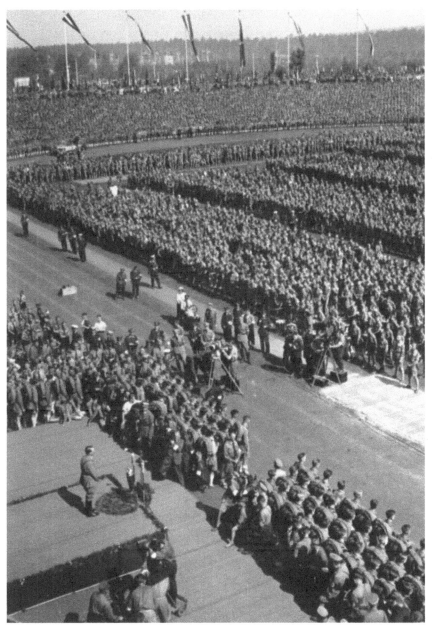

The Nuremberg Stadium, where Adolf Hitler orated to mass crowds. *Wikimedia Creative Commons.*

from the point of view of the *Volk*," declared Hitler in his Nuremberg speech.[7] On Hitler's orders, some 500 avant-garde artworks were removed from Germany's modern art gallery, Kronprinzenpalais, which was shut down in 1936. The same year, Joseph Goebbels banned art criticism in Germany on the grounds that it had been distorted by "Jewish cultural hyperalienation."[8]

Goebbels stepped up his campaign against "un-German" art the following year. He ordered the confiscation of more than 16,000 works of modern art from public museums. Instead of destroying them, Goebbels opted for cultural erasure based, paradoxically, on public exhibition. Germans would see with their own eyes the "degenerate" character of Jewish art and how it offended accepted forms of *Völkisch* expression.

In 1937, a "Degenerate Art" (*Entartete Kunst*) exhibition traveled to eleven cities including Munich, Berlin, Vienna, Leipzig, and Weimar. The exhibition's publicity pitch was, "German *Volk*, come and judge for yourselves!"[9] The art show was organized thematically to guide the negative reactions of visitors. Themes included "Revelation of the Jewish Racial Soul," "An Insult to German Womanhood," and "Nature as Seen by Sick Minds." Most of the 650 sculptures and paintings exhibited were from the Weimer period.[10] Among the "degenerate" paintings on display were works by Chagall, Paul Klee, Van Gogh, Picasso, and Kandinsky. While the exhibition suggested that the paintings revealed the "sick minds" of Jews, in fact only six of the 112 artists featured in the show were Jewish.[11]

The Degenerate Art exhibition was timed in conjunction with another show, "Great German Art" (*Große Deutsche Kunstausstellung*) of Nazi-approved works. This exhibition featured works showing idealized Aryan nudes inspired by classical Greece and heroic figures from medieval mythology. Hitler personally attended the exhibition's inauguration in Munich and gave a speech attacking modern art for its depravity. Degenerate art, he said, was an insult to "German feeling."[12] Ironically, the Great German Art show proved less popular than its "degenerate" rival. More than a million people visited the Degenerate Art exhibition in Munich—three times more than the number who attended the Great German Art show. In total, 2 million people visited the Degenerate Art exhibition throughout Germany.

When the two exhibitions were closed, some of the "degenerate" works were sold at auction—including a Van Gogh self-portrait—to raise money for the Nazi Party. Top Nazi officials took other works for their private collections. Hermann Göring, a notorious collector of looted art, helped himself to several works. In 1939, the Nazi Commission for the Exploitation of Degenerate Art ordered the Berlin Fire Brigade to incinerate the remaining works.

By the end of the 1930s, persecution of Jews in Germany was relentlessly pursued in an official policy of damnatio memoriae. Nazis were determined to

erase Jews from historical memory, first through destruction of their culture, then through the final solution of extermination.[13] An alarm bell sounded with the infamous *Kristallnacht* pogroms of November 1938. The name *Kristallnacht* ("Night of Broken Glass") was an unmistakable historical allusion to iconoclastic violence. Nazi storm troopers destroyed hundreds of synagogues, smashed Jewish-owned shops, and forced thousands of Jews into concentration camps. One camp, Buchenwald, just outside Weimar, had been ready since July 1937.

The timing of *Kristallnacht* was no coincidence. It began on German theologian Martin Luther's birthday: November 10. Luther had written anti-Semitic tracts believed to have inspired Nazi ideology. In his 1543 treatise, "The Jews and Their Lies," Luther wrote, "First, to set fire to their synagogues or schools and to bury and cover with dirt whatever will not burn, so that no man will ever again see a stone or cinder of them. . . . Second, I advise that their houses also be razed and destroyed. For they pursue in them the same aims as in their synagogues."[14] In 1933, the Nazis celebrated the 450th anniversary of Luther's birthday and declared November 10 as *Der Deutsche Luthertag* (German Luther Day). Five years later, the "broken glass" destruction of Jewish property—including the burning of synagogues—was an echo of the *Bildersturm* icon-smashing in Germany during the Reformation. Today there are Kristallnacht memorials throughout Germany, many of them erected on the site of the synagogues that were attacked and burned to the ground.[15]

In the months just before *Kristallnacht,* international opinion toward the Nazi regime was still relatively neutral. At the Paris International Exposition in 1937, Germany boasted pride of place among the world's other great nations. The event in Paris, held from May to November that year, was the last great European world fair before the conflagration of war two years later. The event's "peace and progress" theme reflected the twin anxieties of the decade. Fascism was on the march with Hitler, Mussolini in Italy, and Franco in Spain. In the Soviet Union, Stalin was revealing the ugly face of communism with purges and show trials. French director Jean Renoir's classic film, *La Grande Illusion*—a penetrating critique of the psychology of nationalist ideologies that foreshadowed the coming war—opened in Paris cinemas that year. The title of Renoir's film could have been the unofficial theme for the world's fair in the French capital.[16]

The location for the Paris International Exposition was the area surrounding the Eiffel Tower. The old Palais du Trocadéro was ripped down and replaced with a new modernist structure whose monumental architectural style was in fashion in the 1930s. The Soviet and Nazi pavilions were accorded center stage on the "Avenue of Peace" at the bottom of the Trocadéro facing the Eiffel Tower. Nazi architectural icons squared off, face to face, with Soviet monumental propaganda like dueling ideologies engaged in a staring contest.

The Soviet pavilion was a monumental-style structure topped with a gigantic 78-foot steel sculpture called "Worker and Collective Farm Woman." It depicted an industrial worker and woman peasant clutching a hammer and sickle in a dramatic forward-thrusting motion. The sculpture was a classic icon of communist "Socialist Realism" propaganda.

The facing Nazi pavilion was designed by Hitler's trusted architect, Albert Speer. It was a towering, windowless neoclassical rectangle with a limestone façade and fluted piers whose recesses featured swastika-patterned mosaics. On each side of the entrance stood statues of muscular Aryan figures created by Hitler's favorite sculptor, Josef Thorak. Perched atop the pavilion was a massive Nazi eagle clutching a swastika in its talons.[17] At night, the towering structure became a shaft of luminosity, evoking the "cathedral of light" effect at Hitler's mass rallies in Nuremberg.

The contrast between the Soviet and Nazi pavilions was visually striking. On one side, a massive sculpture of male and female Soviet workers was dynamic, thrusting, almost flying into the air. On the other side, the Nazi pavilion was an austere architectural expression of Germany's will to power symbolized by the gilded Nazi eagle.

When the Paris world's fair ended in November 1937, the Soviet and Nazi pavilions were demolished. Less than three years later, the Nazi army was marching triumphantly into Paris as a victorious occupying power.

Following the German army's invasion of Paris in June 1940, Adolf Hitler made a personal visit to the French capital.

In the early morning hours of June 23, the führer slipped into the City of Light in a heavily guarded motorcade. Making a quick tour of Paris that lasted only a few hours, Hitler gazed at the glorious architecture and monuments that he had long admired. He stood on the Trocadero esplanade with its splendid view of the city in the shadow of the Eiffel Tower. The führer's motorcade then whisked him to Les Invalides, where he paid homage to Napoleon in his enormous oak sarcophagus. Hitler made a stop in front of the École Militaire and descended from his chauffeured vehicle to contemplate the equestrian statue of Marshal Joffre. Joffre was one of France's great heroes of the First World War, during which Hitler himself was a low-ranking German corporal. Hitler's admiration for Joffre may explain why that statue was spared destruction in the campaign of Nazi demolition of statues throughout the French capital.

During the occupation of Paris, the Nazis systematically dismantled and melted down statues and monuments that they found offensive. Two goals motivated Nazi iconoclastic violence in Paris: first, vengeance for the humiliation inflicted on Germany by France after the Great War; and second, the purging

of French Republic statues and monuments from public spaces. For the Nazis, the Third Republic was the morally corrupt equivalent of the decadent Weimer Republic.

One of the first Nazi acts of iconoclastic vengeance in Paris was the destruction of a statue of French general Charles Mangin standing near Les Invalides. Mangin was the French military commander who had defended Verdun in the First World War. After the war, his 10th Army had occupied the Rhineland. Locals accused Mangin's Black French African colonial troops stationed in the Rhineland of raping German women. This humiliation was remembered by Germans as *"Die Schwarze Schmach"*—or "Black Disgrace." The sight of the Mangin statue must have been particularly infuriating to Hitler when he visited the Les Invalides in June 1940. It depicted General Mangin with an arm outstretched and pointing, leading his soldiers into battle against the Germans. Hitler personally ordered its immediate destruction. Only four days later, it was blown up with dynamite. Mangin's bronze head was recovered and conserved in the Invalides army museum.

Hitler also ordered the destruction of a monument in the Tuileries commemorating the heroic British nurse Edith Cavell. Cavell had been arrested and executed by the Germans during the First World War for assisting Allied soldiers to escape occupied Belgium into the Netherlands. When German officers executed her by firing squad, her death provoked international outrage. The press in Britain, the United States, and France portrayed the German "Huns" as barbarians. Hitler obviously remembered this incident and how it had tarnished Germany's image. The Cavell monument in the Tuileries was demolished.

The Nazi assault on French statues also targeted Third Republic monuments erected in the "statue mania" period during the Belle Époque. The Third Republic's monumental legacy was prodigious. In the late nineteenth century, hundreds of "great man" statues and monuments had been erected throughout the country as figures of civic veneration. Leaders of the Third Republic were keen to forge national identity around a secular ideology that marked a rupture with the royalist and authoritarian traditions of the past. The French Republic was securely in place, but monarchism and Bonapartism were still powerful movements. Statues and monuments were symbols of the republic's secular, universalist values. At the end of the Second Empire in 1870, only eleven "great man" statues adorned the French capital. In the following decade under the Third Republic, thirty-four such monuments were erected in Paris. More than fifty appeared in the next two decades until 1900, followed by fifty-one statues in the decade from 1900 to 1910. By the First World War, there were more than 150 "great man" statues in Paris. They were so omnipresent that the painter Degas wryly compared them to dog excrement. "One puts iron wire around the lawns of public gardens to prevent sculptors from depositing their works therein," he observed.[18]

A highly visible example of the "great man" statue was the massive ninety-foot monument of statesman Léon Gambetta in the Tuileries near the Louvre. It was Gambetta who, on September 4, 1870, after Napoleon III's defeat, declared the end of the Second Empire and proclaimed the birth of the Third Republic. Gambetta was later prime minister and a powerful figure in French politics, but he died at age 44 in 1882. The Gambetta monument, unveiled six years after his death, depicted him in a heroic posture, his arm outstretched, surrounded by soldiers at the bottom of the pedestal, with an allegorical figure of Democracy and a winged lion at the apex.

A classic statuary figure of the era was not a "great man," but Marianne, the feminine goddess of Liberty venerated during the French Revolution. Under the Third Republic, Marianne was revived as a symbol of the nation's universal values of liberty. Another statue in this style was the *Triumph of the Republic* monument erected in Place de la Nation in 1879. It showed Marianne standing atop a globe in a chariot pulled by lions surrounded by allegorical figures representing peace and justice. The monument stood in the center of a wide pond in which statues of snapping crocodiles represented threats to the republic.[19]

By the end of the Belle Époque, statue mania in France had reached such extraordinary excesses that the city of Paris decided in 1911 to put a ten-year moratorium on the erection of monuments. That prohibition turned out to be unnecessary after the outbreak of the First World War. Following the war, the obsession with statues of great men embodying republican values gave way to the memorialization of military heroes. A bronze statue of France's wartime leader, Georges Clemenceau, was erected on the Champs-Elysées in 1932 three years after his death. The statue of French general Charles Mangin—the one later blown up on Hitler's orders—was erected in the same year.

Besides Mangin, an obvious iconoclastic target for the occupying Germans was the Léon Gambetta monument. After the fall of Napoleon III in 1870, Gambetta had proclaimed France's Government of National Defense against the invading Prussians. During the occupation, Nazi headquarters in Paris were located on Rue de Rivoli just across from the Tuileries, where the Gambetta monument was hard to miss. The Nazis ordered its destruction. The bronze elements were ripped away to be melted down, while the stone portion was carted off and put into storage. Six other statues of Gambetta in Paris were similarly demolished. There was no place for Third Republic heroes in German-occupied Paris. Other Parisian monuments destroyed by the Nazis included statues of philosopher Jean-Jacques Rousseau and novelists Victor Hugo and Emile Zola. The Nazis remembered that Zola had famously defended the Jewish captain Alfred Dreyfus with his celebrated "*J'Accuse!*" declaration in the French press.[20]

In non-occupied France, the Vichy regime shared the Nazi goal of eradicating symbols of the Third Republic. The official Vichy slogan ("*travail, famille,*

patrie") underpinned the regime's "*révolution nationale*" marking a complete rupture with the Third Republic's secular values. Vichy values reconnected with a nostalgic vision of France as a traditional Catholic country. Marshal Pétain's collaborationist government showed no mercy to the statuary legacy of the Third Republic. In October 1941, the Vichy regime decreed that all bronze statues "lacking significant historical or artistic values" were to be melted down and recycled for French industry. Most of the metal was shipped to Germany, where it was used in Hitler's armament factories. The process under the Vichy regime was cumbersome, however, because it was delegated to committees of artistic experts. Like the Bolsheviks in Russia, Vichy bureaucrats insisted that some statues be spared due to their historical or artistic merits. Bronze statues of the sculptor Rodin, for example, were spared destruction.[21] In German-occupied Paris, top Nazis including Hermann Göring looted art galleries and plundered priceless paintings and other treasures in the city's museums for their own personal gain.[22]

The Nazis exempted some statues in Paris from destruction. A special category of "incontestable national heroes" was created to spare statues of revered figures from French history—especially kings and religious figures. Statues of monarchs and saints didn't offend the Nazi occupiers. The equestrian statues of Louis XIV and Henri IV in Paris were accordingly left unmolested. Hitler's hero Napoleon Bonaparte was also exempted, of course. Napoleon's massive victory column in Place Vendôme remained standing. So did the gilded equestrian statue of Joan of Arc—a French hero against the English—erected near the Louvre in 1874. Today, the same statue has been politically appropriated by France's far-right nationalists for their annual May Day rallies.

The equestrian statue of Charlemagne in front of Notre Dame presented a unique dilemma for the Germans. Some top Nazis despised Charlemagne—"*Karl der Grosse*" in German—because of his infamous massacre of Saxons. For Hitler, however, Charlemagne was a powerful symbol of German empire. One of Hitler's SS divisions was named "Charlemagne." In 1942, two years after the invasion of France, Germans held celebrations to commemorate the 1,200th anniversary of Charlemagne's birth. In Nazi-occupied Paris, melting down a statue of *Karl der Grosse* was out of the question. The statue of Charlemagne therefore remained untouched. It still stands today in front of Notre Dame.

When the Germans finally retreated from Paris after the Liberation in 1944, they had obliterated most of the Third Republic's heroic monuments from the statue mania period. Roughly 1,700 bronze statues and busts had been dismantled throughout France, about 60 percent of them in the Nazi-occupied zone including Paris. Of the roughly 250 statues and monuments that stood in the French capital just before the war, more than 75% of them were gone.[23]

Remarkably, the Léon Gambetta monument in the Tuileries survived the Nazi meltdown carnage because it was not made of bronze. The figure of

The equestrian statue of Charlemagne in front of Notre Dame Cathedral in Paris. *Photo by Dietmar Rabinc, Wikimedia Creative Commons.*

Gambetta was made of stone. It had been stored instead of destroyed. Several decades after the war, the Gambetta statue emerged from its long dormancy. In 1982, on the hundredth anniversary of his death, it was dusted off and erected in Square Édouard-Vaillant in the twentieth arrondissement of Paris. It stands in the same square today.

After the war, Germany underwent a painful period of "de-Nazification" to eradicate all traces of Hitler's Third Reich.

The de-Nazification policy, imposed on Germany by the victorious Allies, was a program of top-down, political iconoclasm. Its primary goals were the

liquidation of Hitler's National Socialist Party and the abrogation of Nazi laws. A third goal was the obliteration of Nazi symbols.

An Allied decree titled "Liquidation of German Military and Nazi Memorials and Museums" ordered that Third Reich statues and monuments be destroyed within eighteen months with a final deadline of January 1, 1947. Parks, streets, and public places named after anyone or anything associated with Nazism or German militarism were renamed. Parades and singing of Nazi anthems were banned. So was any public display of Nazi flags and wearing of Nazi uniforms, badges, and military decorations. The display of swastikas (*Hakenkreuz*), Nazi flags, and the SS "bolts" was criminalized.[24]

In compliance with the Allied decree, the West German government systematically destroyed Nazi statues and monuments. The glorified male Nazi figures created by Hitler's favorite sculptors, Josef Thorak and Arno Breker, were dismantled. Many Nazi buildings were razed entirely. Swastikas and other Nazi emblems were scraped from building façades. Schools named after Hitler or top Nazis were rebaptized. In Mannheim, the Adolf-Hitler-Schule became the Goethe-Schule. Even bridges with Nazi names were renamed. After their trial and execution, top-ranking Nazis were buried in unmarked graves so they would never become shrines. Adolf Hitler had no burial plot. Following his suicide in a bunker beneath the Reich Chancellery, the Allied forces filled it with concrete so it would never become a pilgrimage site. The Reich Chancellery, once flanked by Thorak's *Striding Horses* sculptures, was eventually demolished.

While the obliteration of symbols removed physical vestiges of the Nazi regime from public view, it did not erase Nazi ideology from German culture. Symbolic destruction cannot eradicate beliefs and values. The Allies quickly realized it was impossible to purge German institutions of Nazi members. In German schools, courts, and bureaucracies, most employees were members of the Nazi Party. Political reeducation was not going to happen overnight. Many Germans were nostalgic about Adolf Hitler, who they still regarded as a great leader. For two decades after the war, German schoolteachers remained silent about the Holocaust. It wasn't until the 1960s that Germans began to confront the horrific legacy of the Nazi period. Despite this national reckoning, Nazi icons and symbols were fetishized and venerated by neo-Nazis. The swastika became a symbol of the far-right neo-Nazi movement around the world.

Even in Germany, some Nazi monuments remarkably survived. The Olympic Stadium in Berlin, once a Nazi showcase to the world, is still standing today. It was in this stadium where Leni Riefenstahl shot her mesmerizing Nazi propaganda film about the 1936 Olympic Games. The entire stadium complex remains intact, including Karl Albiker's famous statues of muscle-bound discus throwers and relay runners. Only the swastikas are gone, removed after the war. In 2006, the stadium was at the center of the world's attention again when

Germany hosted the World Cup soccer final. Arno Breker's sculptures outside the stadium were still standing, despite complaints from some who found them offensive. The same year, the works of Breker—whose career as a sculptor flourished in post-Nazi Germany—were treated to a lavish exhibition in the northern German city of Schwerin.

The resurrection of Hitler's favorite sculptor did not go unnoticed. "It is wrong to recognize an artist who created the physical images of Nazi ideology," said Klaus Staeck, the president of the Berlin Academy of the Arts. "He was not only a protégé of Hitler's, but a profiteer." [25] The Nobel laureate Günter Grass defended the Breker exhibition, arguing that it encouraged debate on how talented artists were attracted to the Nazi ideology. Grass himself had served in the Nazi Waffen-SS as a teenager at the end of the war, yet concealed this fact for most of his life.

Hitler's art gallery in Munich, the Haus der Kunst, also survived de-Nazification. Not only is it still standing today but also, remarkably, some swastika symbols in the ceiling tiles and window grills are intact and visible to visitors. Other Nazi statues and symbols have turned up unexpectedly after going underground for many decades. In 2015, German police discovered long-lost Nazi statues when conducting raids in the town of Bad Dürkheim to break up a black-market art ring. Among the statues seized were Josef Thorak's *Striding Horses*, which once stood outside Hitler's Reich Chancellery. Also seized was a massive granite relief by Arno Breker. The statues had vanished into Red Army hands after the war and spent decades stored at a Soviet military base outside Berlin. After the Berlin Wall was demolished in 1989, the statues were smuggled into West Germany and sold to rich industrial families with a taste for Nazi memorabilia. The horse statues were purchased by German businessman Rainer Wolf, who was also in possession of several Nazi statues including Breker's *The Herald*, a massive bronze Nazi superman figure. The value of the two Thorak horses in 2015 was estimated at several million dollars.[26]

The fascist monumental legacy in Italy and Spain also remains intact today. In the northern Italian town of Bolzano near the Austrian border, Mussolini's "Victory Monument" is still standing. Erected in 1928, the white marble arch adorned with *fasces* sticks is known as the world's first fascist monument. Constructed on the orders of Mussolini, the monument symbolized the Italianization of the German-speaking South Tyrol region annexed by Italy after the First World War. A "House of Fascism" in Bolzano featured a massive bas relief showing Benito Mussolini on horseback with Il Duce's slogan, "*Credere, Obbedire, Combattere*"—"Believe, Obey, Fight." Following the war, the Victory Monument became a contentious symbol: a rallying point for far-right movements, and vandalized by anti-fascist groups. A high metal fence was constructed around the monument, and there was discussion of destroying it altogether. But in 2014,

officials opted for a more creative approach. Instead of tearing it down, the monument was "recontextualized" to preserve its artistic integrity and historical significance while neutralizing its fascist symbolism. A museum was built in a crypt below the monument to provide historical context. Also, an illuminated quote from Hannah Arendt was emblazoned in Latin, Italian, and German across the frieze: "Nobody has the right to obey."[27]

"This was an opportunity for the city to have an honest conversation about its history," said Hannes Obermair, a history professor at the University of Innsbruck who was one of the experts given the task of deciding the monument's fate. "The disputes are less about the past than about the present. So what kind of society are we now? Are we a society riven by past ideologies or are we a democratic and pluralistic society that believes in the values of participation, tolerance and respect for humanity?"[28]

In Spain, a "Pact of Forgetting" law following General Francisco Franco's death in 1975 meant that fascist monuments were left unmolested. The biggest monument to Franco's glory was the Valley of the Fallen where the fascist dictator was buried in a mausoleum featuring a huge cross and the remains of more than thirty thousand people who had died during the Civil War. Franco's burial there was intended as a symbol of national reconciliation. The crypt was even consecrated by Pope John XXIII in 1960. The site remained controversial, however, for it contained the remains of Franco and victims of fascism.

In 2007, a Spanish law of "Historical Memory" was passed to override the "Pact of Forgetting" adopted three decades earlier. The atrocities of the Franco dictatorship would not be forgotten. Franco's fascist regime was declared "illegitimate" and its victims compensated. Memorialization of Franco in the Valley of the Fallen was prohibited. Spain's conservative Popular Party voted against the law and accused the ruling Socialists of exploiting historical memory for partisan political purposes.

In 2019, the fascist dictator's remains were finally removed from the Valley of the Fallen. The exhumation of Franco, whose body was moved to his wife's gravesite, was meant to mark the end of his glorification. Still, Franco loyalists and family members in attendance at the exhumation ceremony chanted, "*Viva España! Viva Franco!*" In early 2021, the last statue of Franco on Spanish soil was taken down. It was a bronze statue of the dictator erected in the tiny Spanish enclave of Melilla in north Africa.[29]

In Germany today, Third Reich symbols are officially banned, and the law prohibits the display of Nazi insignia or chanting of Hitler-era slogans. But neo-Nazis find innovative ways to get around these restrictions. Instead of holding up Nazi flags, they brandish the old Reichsflagge from the German Empire. While not a Nazi emblem, the flag evokes a period of German militarism. Neo-Nazis sometimes hold up the Norwegian flag (red and indigo blue) because that Nordic nation corresponds to their idea of Aryan racial purity.

German neo-Nazis have also appropriated fashion brands as cryptic logos. The New Balance sneaker, for example, is their preferred footwear, because of the letter "N" emblazoned on the shoes. The association between New Balance sneakers and neo-Nazis has spread globally. In the United States, some have dubbed the brand "the official shoe of white people."[30] In 2016, the founder of the White supremacist site *The Daily Stormer* encouraged followers to buy New Balance shoes as a sign of their solidarity with the "Trump revolution."[31] New Balance, founded in Boston in 1905, put out a public statement distancing the brand from its White supremacist fans. Other American alt-right groups, such as the Proud Boys, have embraced the Fred Perry fashion brand for its black polo shirt with yellow trimming that evokes the Nazi color scheme.

In Germany, where the original Nazi uniforms were made by Hugo Boss, neo-Nazis have embellished their fashion fetish for New Balance sneakers with black Lonsdale bomber jackets. The attraction of the British brand is the sequence of the four letters "NSDA" in the word "Lonsdale" emblazoned across the back. It's only one letter short of "NSDAP," the acronym of Hitler's Nazi party (*National Sozialistische Deutsche Arbeiter Partei*). The term *Lonsdale youth* has been used to designate far-right young people engaged in the neo-Nazi movement. Unlike New Balance, whose public statements have been cautious, Lonsdale has come out more forcefully against right-wing extremism. Lonsdale launched a publicity campaign whose slogan was "Lonsdale loves all colors."

"This 'NSDA' is pure coincidence," said Ralf Elfering, the company's spokesman in Germany. "It's important for us to clearly position the brand in opposition to right-wing extremism and racism."[32]

For most of these fashion brands, the appropriation of their insignias and colors by neo-Nazis is a public relations headache that blows over. For neo-Nazis, however, it demonstrates the potency of symbolism. Their determination to find new emblems when laws prevent them from using authentic Nazi symbols reveals, yet again, that iconoclasm often engenders new forms of idolatry. Attempts at damnatio memoriae erasure of detested symbols produces the opposite effect by inspiring fetishized iconography that keeps alive the values they represent, however despicable.

In 2016, a statue of Hitler kneeling in prayer fetched the staggering price of $17.2 million at auction in New York. The statue, created in 2001 by Italian artist Maurizio Cattelan, was sold at Christie's "Bound to Fail" auction, where works for sale "explore the theme of failure." Financially, the auction was hardly a failure: it raised a total of $78 million. The price paid for the Hitler statue, titled *Him*, was $7 million more than estimated. Many described the statue as "creepy," but its sale demonstrated that Hitler's iconography was still fetishized.[33]

Meanwhile in the German town of Bornhagen, monuments have been used to shame neo-Nazi extremists. In late 2017, the controversial far-right politician Björn Höcke woke up one morning to discover a small-scale replica of Berlin's Holocaust Memorial outside his house. Höcke, a member of the right-wing Alternative for Germany party, had sparked controversy by railing against the Holocaust Memorial. "Germans are the only people in the world who plant a monument of shame in the heart of the capital," he said.

The radical artist collective Center for Political Beauty—which describes itself as an "assault troop that establishes moral beauty, political poetry, and human magnanimity"—decided to shame Höcke in his hometown. In a guerilla stealth operation, activists installed the Holocaust Memorial replica—twenty-four cement slabs—outside his house. Höcke's political party denounced the prank as "psychological warfare." Death threats were made against the activists, and the pop-up monument site was put under police surveillance.[34]

The shame tactic against Björn Höcke was reminiscent of a famous statue in South Korea intended to shame Japan for atrocities committed during the Second World War. In Seoul, a statue of two bronze chairs erected in 2011 faced the Japanese embassy. Called the *Statue of Peace*, one of the bronze chairs was empty, the other occupied by the figure of a life-size Korean woman dressed in a traditional *Hanbok* costume, her fists clenched, a small bird perched on her shoulder. The statue was deliberately installed across from the Japanese embassy to commemorate the 200,000 Korean "comfort women" who were exploited and abused as sex slaves by Japanese soldiers. Its location outside the Japanese embassy triggered a diplomatic incident between South Korea and Japan. In 2015, Japan finally agreed to acknowledge involvement in the mistreatment of the Korean "comfort women" during the war. Japan also insisted that the statue be removed. But Korean activist groups refused to move it. Soon some forty statues of "comfort women" appeared all over South Korea with the same intention of shaming the Japanese. The so-called "statue wars" between the two countries continue to this day. The *Statue of Peace* remains a contentious symbol of unresolved politics of memory.[35]

In Germany, activists at the Center for Political Beauty presented Björn Höcke with an ultimatum: they would remove the replica monument in front of his house if he agreed to drop to his knees in front of the Holocaust Memorial and beg for forgiveness for Germany's atrocities during the Second World War. Höcke accused the activists of "blackmailing" him, but they insisted they were merely offering him a "deal." Höcke's far-right Alternative for Germany party likened the Center for Political Beauty to a criminal organization and called for them to be investigated by police. The artist collective argued, for their part, that their actions were "performance" and not criminal activity.[36]

In Nuremberg, meanwhile, the vast Zeppelin Field where Adolf Hitler once held mass Nazi rallies still stands, a vestige of a dark chapter in history condemned to eternal infamy. Hitler's favorite architect, Albert Speer, designed the Zeppelin Field, choosing limestone for the massive Pergamon-inspired grandstand from which Hitler delivered his speeches. The Third Reich was meant to last a millennium but collapsed after only twelve years. But Hitler's limestone rostrum escaped the de-Nazification program.

The Zeppelin Field's post-war survival reveals the ambiguity with which local authorities have dealt with the most infamous architectural symbol of the Nazi era. After American soldiers blew up the gigantic Nazi eagle on the grandstand, GIs stationed in Nuremberg played baseball on the field. Later, American teenagers attending the U.S. high school on the nearby military base used the field for football practice. In 1955, the American evangelist Billy Graham held a mass religious rally on Zeppelin Field. Two decades later in the 1970s, rock stars including The Who, AC/DC, Billy Joel, and Bob Dylan performed concerts on the same spot where Hitler had once hypnotized mass gatherings with "cathedral of light" spectacles. When Bob Dylan played at the Zeppelin Field in 1978, many in the audience were military personnel from U.S. army bases.[37]

Today the Zeppelin Field is protected by law and cannot be destroyed. But while legally protected, the forces of nature and harsh German winters are slowly eroding its foundations. The field where thousands of Nazi Stormtroopers once goose-stepped is covered in brown grass. Signs around the site warn visitors, "Danger of collapse!" and "Enter at Your Own Risk." Unfit for religious revivals and rock concerts, it is a dilapidated vestige slowly crumbling like an ancient ruin. Local authorities have been faced with a dilemma they avoided confronting for decades: should the Nazi stadium be saved?

Despite its grim past, many regard the Zeppelin Field as a symbol of a chapter in German history that should never be forgotten. The main argument for conserving the site, however, is unexpectedly pragmatic: tourism. The Zeppelin Field and the surrounding Nazi rally grounds are one of Nuremberg's top attractions. Every year, some 250,000 tourists visit the site. Many visitors are curious to learn about a dark chapter in Germany's history. Others are far-right admirers of Hitler making a pilgrimage to a venerated place.

In 2015, local Nuremberg authorities called for funds to restore the site to prevent its collapse.[38] Finally, the city unveiled an ambitious $100 million renovation project. There are nonetheless opponents to the Zeppelin Field's preservation. Some favor a "controlled decay" solution, arguing that the former Nazi rally grounds should be left to the forces of nature. Those who support this approach claim that renovating the site will attract Nazi fetishists. Those concerns seemed credible in early 2019 when black-clad German neo-Nazis staged a torch-wielding march on the Zeppelin Field and mounted the grandstand where Hitler had once stood at the rostrum.[39]

Julia Lehner, the city's chief culture official, attempted to reassure critics that restoring the former Nazi rally grounds was strictly a conservation project. "We won't rebuild, we won't restore, but we will conserve," said Lehner. "We want people to be able to move around freely on the site. It is an important witness to an era—it allows us to see how dictatorial regimes stage-manage themselves. That has educational value today."[40]

The Zeppelin Field conservation project, when completed in 2025, will have the twin goals of preserving historical memory and attracting "Nazi tourism" revenues. But the debate about Third Reich monuments will almost certainly continue raising troubling questions: What should be done about symbols of evil regimes with legacies of tyranny and genocide?

In Germany today, Adolf Hitler will not be resurrected like Stalin and Mao. There are no statues of Adolf Hitler in public places. No street or public squares are named after him. But if you look close enough, the physical legacy of the Nazi regime has not entirely vanished.

Part III

REVOLT

CHAPTER 11

Beeldenstorms and Black Lives Matter

In the Flemish town of Ghent, 1566 was a *wonderjaar*—a year of wonders. It was the year that changed everything.

Ghent was a wealthy town in the sixteenth century. The population of some 40,000 enjoyed prosperity thanks to the thriving textile trade in draperies. The Dutch low countries—stretching from northern France into Belgium and the Netherlands—counted some of Europe's most powerful commercial centers. A new class of craftsmen and urban merchants had become influential and gained control over local councils. As a spirit of civic-minded independence flourished, the feudal Spanish monarchy that ruled over the Dutch provinces seemed increasingly distant.

The uneasy combination of these two factors—a self-sufficient Dutch society and an absolutist Spanish monarchy—inevitably created tensions. The devout Catholicism of the monarch, Philip II, made him hostile to the bourgeoning Calvinist culture spreading through the low countries. For decades, the local population had witnessed with mounting horror their own townspeople arrested and subjected to Spanish-style inquisitions. Those found guilty of heresy were decapitated or burned at the stake.

Spanish persecution in the low countries was captured in Pieter Bruegel the Elder's famous painting, *The Massacre of the Innocents*. Inspired by the New Testament story of King Herod ordering the slaughter of all male infants in Jerusalem, Bruegel's tableau transposed the Biblical scene of slaughter to the Dutch provinces. It shows Spanish troops wantonly killing babies in a snowy Flemish village. Philip II's military governor, the Duke of Alba, is depicted clad in black on horseback, surrounded by his Spanish troops armed with vertical pikes, looking on as murderous mercenaries go about their infanticidal slaughter.

Besides relentless persecutions, the Dutch provinces were paying high taxes to a Spanish monarchy that had centralized power and alienated the local

Pieter Bruegel the Elder's *The Massacre of the Innocents*.

nobility. To make matters worse, in 1565 the region suffered a poor harvest and severe grain shortages. For many, the wonderjaar was actually a *"hongerjaar"*—a year of famine. The common people increasingly regarded their rich overlords with envy and hatred.

In the summer of 1566, the tinderbox finally exploded. Starting in August, local Flemish citizens unleashed a furious attack on statues and churches in towns and cities. Within days, a wave of iconoclastic violence swept like wildfire throughout the provinces. Rioters rampaged through towns, attacking churches. They overturned altars, mutilated images, decapitated statues, and destroyed vestiaries. They smashed open crypts of patrician families and desecrated the coffins, hacking limbs from cadavers. In Ghent, they demolished the statue of Spanish Hapsburg monarch Charles V standing at the town's Keizerpoort imperial gate. The vortex of destruction spun furiously through the Dutch provinces over the following weeks. Authorities were powerless to stop the violence.

Historians have long considered the Dutch revolt of 1566 as a perplexing enigma.[1] The *Beeldenstorm* (literally, "statue storm") that ripped through the low countries was extraordinary for its contagious effect. An entire population was suddenly in the grip of an irrational fury, as if intoxicated by rage against every symbol of authority—both Catholic Church and Hapsburg monarchy. As historian Peter Arnade observed, "The iconoclastic riots of the late summer and

fall of 1566 shattered more than just altarpieces, tabernacles, paintings, statues, and relics. They struck the political landscape like a huge tornado, cutting a swath of destruction that many had seen coming but whose intensity no one had predicted."[2]

The iconoclastic destruction was partly motivated by religion. Many of the rioters—but certainly not all—were Calvinists smashing idols and icons in Catholic churches. Their attacks on churches fit into a pattern of Reformation violence commanded by Biblical prohibitions. But religion offers only a partial explanation of what happened in the Dutch provinces in 1566. The fact that rioters in Ghent destroyed a statue of the Hapsburg monarch Charles V demonstrated that the fury was also political. In Ghent, the local population harbored bitter memories of Charles V's brutal repression of an uprising twenty-five years earlier. In 1539, the town's leaders had revolted against a tax to subsidize the Habsburg monarchy's wars with France. When the uprising failed, Charles V personally went to Ghent to punish its citizens. He abolished the privileges of guilds and built a citadel fortress as a physical threat against any future unrest. The monarch didn't stop there. Charles V summoned the town's aldermen and other officials to his palace in Ghent and made them grovel for pardon. Some were forced to dress like condemned criminals, barefoot with white penitential garb and a noose around their necks.

The iconoclastic violence in the summer of 1566 was the result of decades of simmering resentment directed at an oppressive Spanish monarchy. The Beeldenstorm uprising was a revolt, not a revolution. The rioters were not seeking to topple a regime. The violence was largely spontaneous, with limited organized leadership, and without specific goals beyond revolting against injustice and persecution. The events that began in 1566 are described as the "Dutch Revolt" for that reason. The term in Dutch, *Nederlandse Opstand*, confirms the same description of revolt. The Beeldenstorm violence was, in sum, iconoclasm as political discourse and protest.

The Dutch Republic, it is true, was on the horizon, but it would not be proclaimed until more than two decades later in 1588. In the short term, the Beeldenstorm upheaval was a spontaneous eruption of violence against a repressive Catholic monarchy.

One of the enigmas surrounding the Beeldenstorm riots is how the statue-smashing fury exploded so suddenly.

The deeper historical origins reveal, however, that the dramatic events of 1566 were not unexpected. In fact, they were predicted and even dreaded.

Four decades earlier, Martin Luther's rebellion against the Catholic Church profoundly disrupted the political landscape in northern Europe. Among

Portrait of the iconoclastic German theologian Thomas Müntzer.
Wikimedia Creative Commons.

Luther's early Reformation allies were theologians Andreas von Karlstadt and Thomas Müntzer, who together kicked off an iconoclastic movement against the Church. In 1522, Karlstadt incited a mob to storm the Wittenberg church and destroy its alters and icons. Luther was personally against iconoclastic violence and became adversaries of both Karlstadt and Müntzer. But Luther was power-less to stop the iconoclastic destruction, called *Bildersturm* in German. As the violence spread throughout Germany and Switzerland, zealots smashed idols in churches and burned convents and monasteries.

The inflamed sermons of Karlstadt and Müntzer eventually rallied the sup-port of German peasants. Facing starvation after crop failures, many peasants were ripe for revolt against the aristocracy and clergy. They listened with rapt attention to Anabaptist preachers, who decried serfdom as incompatible with Christian liberty and fulminated against the exploitation of aristocratic landown-ers. In 1524, a revolt exploded and accelerated into a full-scale Peasants' War. Peasant armies, some counting as many as 15,000 men, marauded from town to town burning convents, monasteries, libraries, and palaces. The Peasants' War was, in many respects, a dress rehearsal for the Beeldenstorm riots four decades later. The causes were virtually the same: an explosive mixture of religious dissent and populist rebellion against the feudal system. The Peasants' War was short-lived, however, eventually put down by troops. The bloodshed was horrific. More than 100,000 German peasants were slaughtered in the repression.

By mid-century, the Reformation had spread throughout northern Europe, where Protestants were increasingly emboldened by their growing economic and political influence. In France, where the Huguenots were a powerful minority, iconoclastic violence was tearing through the country. In 1562, Huguenots van-dalized the royal tomb of Louis XI and ripped the corpse of François II from his royal crypt and threw his cadaver to the dogs. In England, following a short but volatile Catholic reign under Queen Mary ("Bloody Mary"), she was succeeded in 1558 by her half-sister, Elizabeth I, who was a Protestant. While Elizabeth was hardly an active supporter of Calvinists and Anabaptists—she found them to be a nuisance—many preachers in the Dutch provinces fled to England for safe haven from persecution under the Catholic Hapsburg monarchy.

In the low countries, Charles V abdicated in 1555 and left the Dutch prov-inces to his son, Philip II. Charles had warned Philip in 1539 that the low coun-tries were trouble. The region, he said, was a place of "divisions and factions, riots and uprisings" orchestrated by an "unappreciative and unruly people."[3] Philip II was inflexible toward Calvinists. Under his reign, the region became a bloodbath of inquisitions, persecutions, and executions. Many unrepentant Calvinists were burned at the stake. If they were lucky, they were strangled to death before being engulfed in flames. Those who repented were treated more mercifully: they were beheaded by the sword. A different fate, equally horrific,

awaited heretical women: they were drowned or, in some cases, buried alive. Between 1523 and 1566, some 1,300 accused heretics were put to death in the Dutch provinces.[4] Eventually, the grim spectacle of public executions provoked revolt. In 1564, protests broke out in Antwerp at the execution of a Calvinist preacher named Christoffel Fabricius. While he was being burned at the stake, the crowd sang psalms and threw stones at officials.

By early 1566, the mood in the Dutch provinces was tense.[5] The low countries had been prosperous, but the ranks of a growing proletariat of day laborers in the drapery industry was swelling in many towns. The region was suddenly hit by economic downturn. The local Dutch nobility seized on this atmosphere of crisis to make demands on the Hapsburgs. In April 1566, they presented the monarchy with a petition complaining about the anti-heresy inquisition, which they judged as a breach of their civil liberties. They also demanded more legislative powers.

Philip II, who could not speak the language of his Dutch subjects, had delegated rule over the low countries to his half-sister, Margaret of Parma. She was more conciliatory, listening to the advice of Protestant nobles such as William of Orange. She accepted some of the demands in the petition. But one of her advisers, Baron Gilles de Berlaymont, dismissed the petitioners as "nothing but beggars." The word *beggars—gueux* in French, *guezen* in Dutch—was an insult that stuck. The Dutch nobles formed a protest group called the Order of the Beggars. They held festive banquets—hence the term *Beggars' Banquet*—throughout the summer of 1566 as their movement of revolt gained momentum.

Meanwhile, ordinary people were flocking to Calvinist hedge sermons— *hagepreken* in Dutch—held outside of towns, where preachers fulminated against the Catholic Church. Hedge sermons had to be held outdoors because Calvinist beliefs were considered heretical, and consequently no church was open to them. These mass gathering in fields, often held at night under lamplight, soon became politically volatile. Firebrand Calvinist preachers such as Sebastian Matte, who had returned from exile in England, delivered passionately militant sermons. Many worshippers arrived at hedge sermons armed with knives and clubs, which they brandished while singing psalms. A sympathetic local nobility often allowed use of their lands to hedge sermons, and in some cases provided armed protection.[6]

By the summer of 1566, an unruly populist movement was ready to explode.[7] Local magistrates attempted to cobble together militia to protect towns from possible riots. The regent, Margaret of Parma, warned her brother Philip II in Spain that social upheaval in Ghent was imminent. She believed that the local people were attracted to the Calvinist hedge sermons—some attended by as many as 14,000—out of desperation. "The great problem is people's poverty," she wrote, adding that the poor economic climate "raises emotions and provokes them to novelties and to the pillage of the rich."[8]

It was too late. The first violent eruption occurred in the small town of Steenvoorde, in modern-day northern France. Following a hedge sermon by preacher Sebastian Matte, locals attacked and ransacked the Saint-Lawrence chapel. The violence quickly spread. Drunken mobs stormed into towns and lit bonfires in front of churches and pillaged everything in sight. They attacked monasteries and convents and mutilated works of religious art inside churches. They raided the refectories and cellars, eating and drinking everything they could get their hands on. They drank out of liturgical vessels and smeared butter on walls.

In Ghent, the explosion was particularly violent. Intoxicated rioters loudly sang psalms while cutting a path of destruction with hammers and picks. Inside churches, they smashed altar pieces and stained glass windows, toppled statues, mutilated paintings, and burned books. They held mock trials of sacred images. A statue of the Virgin Mary was knocked over. At the church of Saint Nicholas, a teenaged boy entered an unlocked chapel of a patrician family and cut off the hands and disfigured the faces of its statues. In the Carmelite cloister, mobs attacked tombstones and cut the eyes on mural portraits. In St. Bavo's Cathedral, a Van Eyck paneled altarpiece, *Adoration of the Mystic Lamb*, was saved in the nick of time. A quick-thinking church guardian dismantled the altarpiece and hid it in the cathedral tower before the mob came crashing through. When the whirlwind of destruction was over in Ghent, rioters had ransacked Saint Bavo's, seven parish churches, twenty-five cloisters, ten hospitals, and seven chapels.

The Beeldenstorm rioters came from a wide range of backgrounds—from butchers and soap-makers to tradesmen and merchants and members of the minor nobility.[9] While most were Calvinist, some were not. Many were textile laborers who had been financially struggling and were drawn by the magnet of the hedge sermon rebellion. Calvinist preachers, too, came from different backgrounds, had different motives, and were not a cohesive movement.[10] The rioters generally benefited from the tacit support of the elite class of "Beggars" among the minor nobility who were opposed to Spanish authoritarianism. Broadly speaking, the driving motivations of the Beeldenstorm riots ranged across three agendas: religious purity, social justice, and political reform.

When the violence petered out, local Calvinist elites and nobles—notably the Protestant aristocrat William of Orange—made specific demands on the Hapsburg monarchy. First, they insisted on a pardon for the rioters. They also demanded freedom of religion and called for a new session of the legislature. In short, impunity and more powers for the local population. Philip II was having none of it. Taking a hard line, he marginalized his sister, Margaret de Parma, and dispatched his own man to the Dutch provinces to restore order.

The man for the dirty job was Spanish general Fernando Alvarez de Toledo, Duke of Alba—known as the "Iron Duke." True to his nickname, Alba ruthlessly imposed a military occupation on the Dutch provinces. He set up a Council

of Troubles to track down and punish the iconoclasts. It was the old Spanish Inquisition brought back in another form. The local population dubbed Alba's new inquisitory tribunal the "Council of Blood."[11] During Alba's military reign of terror, more than 8,000 people were tried for heresy or treason, sometimes both. Many fled to England or Germany and were convicted in absentia. In total, more than 1,000 were executed, most of them within two years of the Beeldenstorm riots.[12]

Executions were public, either by hanging or burning flames, and often were gruesome spectacles. Calvinists preferred death by burning because it offered the prospect of martyrdom. Hanging was considered abject and shameful. In Cateau-Cambrésis, a preacher named Jean Lesur had one hand hacked off before he was hanged. Another man, Jean Hermès, was hanged for using a hammer to smash a church organ and rood screen. A butcher named Guillaume du Mont was executed for putting the head of Christ on a candelabra and performing a mock flagellation, shouting, "If you are God, say something!" In Bailleul, a man named Jean de Bleuf was executed for having contemptuously tossed holy baptismal waters on worshippers.[13] Some condemned Calvinists showed defiance on the scaffold, shouting "*Vive les gueux!*" before their execution. Those put to death had their property confiscated. The roads between towns were overrun with thousands of family members of the condemned fleeing desperately toward an uncertain future.

Some high-profile figures from the local nobility were executed to set an example. Among them were the Count of Egmont and Count of Hornes. Neither was Protestant. They were members of the elite who had grown disaffected with Philip II's rule from Spain. Accused of attempting to exploit the chaos to increase their own political powers, their crime was *lèse majesté*. On June 5, 1568, the two nobles were taken to the great square in Brussels, where a massive crowd was guarded by 3,000 Spanish troops. On the scaffold, Egmont went to his death dressed in aristocratic finery. He kissed a crucifix and, before the axe swung, cited one of Christ's utterances on the cross, "Father, into thy hands I commend my spirit." Hornes followed and was decapitated less ceremoniously. Both their heads were fixed on pikes and displayed to the public. The crowd dipped handkerchiefs in the blood as it spilled from the scaffold.

The Beeldenstorm revolt now had its own martyrs. Egmont and Hornes became legends in local folklore. Egmont was later celebrated as a figure of Romantic heroism. In 1787, the great German writer Goethe wrote a play titled *Egmont* for which Beethoven later composed music.

The Beeldenstorm riots in the 1560s are a long way from today's statue-smashing revolts. Yet in many respects the Dutch protestors were precursors of today's

social justice activists who topple statues and deface monuments in the streets of North America and Europe.

The most obvious similarity is in the character of the violence. Like the sixteenth-century *beeldenstormers*, social justice iconoclasts today are engaged in a revolt against power. Like the Dutch rioters, they are rebelling against what they perceive to be systemic discrimination, injustice, and oppression. Activists are calling for fundamental changes in society, but they are not attempting to overthrow states and replace regimes. Also, in both cases the upheaval was spontaneous, unexpected, and brief. In 1566, the outburst of iconoclastic violence began in August and ripped through the Dutch provinces for several weeks. In 2020, the murder of George Floyd sparked a wave of statue-smashing protests that continued for weeks throughout the summer and then subsided.

While both revolts were spontaneous, in many respects they were inevitable. The mood in the Dutch provinces had been tense for months, even years, before the first outbreak of violence. In the United States, resentment toward statues of Confederate soldiers had been building for years, and there had been sporadic attacks on monuments associated with slavery and colonialism.

Both waves of iconoclastic fury produced a contagion effect. The Beeldenstorm violence quickly spread throughout the low countries. The contagion was facilitated by the close proximity of towns in Flanders, where the vandalism first erupted. In America, statue-smashing quickly raged throughout the country thanks largely to social media. The violence spread globally as local activist groups worldwide watched videos of Black Lives Matter (BLM) statue-toppling on Twitter, Facebook, and YouTube. In both instances, the spontaneous violence was largely lacking an organizational leadership structure. The Beeldenstorm riots were prompted by hedge sermons preachers, and the Black Lives Matter movement had leaders using social media. But in both cases the iconoclastic destruction lacked centralized leadership commanding the actions of those on the ground toppling and defacing statues.

Collective memory was another critical factor in both instances. In the Dutch low countries, the Calvinist minority carried the bitter memory of decades of persecution as "heretics." They remembered their humiliation in 1539 when Charles V forced the leading citizens of Ghent to grovel at his feet. African Americans similarly felt humiliation and bitterness after generations of discrimination stretching back to slavery, Jim Crow, and segregation. The Calvinists in the Dutch provinces were not only marginalized but also persecuted and executed. In the United States, African Americans had similarly been harassed by authorities for generations, victims of excessive police violence and prosecutions in the courts. Fatal shootings of Black Americans by police had provoked angry backlashes in the African American population long before George Floyd's murder. It is also important to underscore that African Americans, like sixteenth-

century Calvinists, had been enjoying growing economic and political power. In the low countries, Calvinists were a prosperous minority with increasingly strong voices in the civic sphere, though they remained marginalized due to their religion. In the United States, Black Americans were becoming politically organized and had stronger voices in the institutional system, not only in politics but also through organizations such as Black Lives Matter.

It might be argued that the Beeldenstorm upheaval was fundamentally different from Black Lives Matter iconoclasm because the targets were different. The beeldenstormers mainly attacked churches, while BLM activists targeted secular statues in public places. This is largely true, though the Beeldenstorm rioters also toppled a statue of Charles V and desecrated tombs of patrician civic leaders. The important point of convergence is that both inflicted violence on symbols of authority and oppression. In the Dutch provinces, those symbols were religious and royal—the Catholic Church and Hapsburg monarchy. In America, they were mainly symbols of slavery and colonialism.

Reactions to the iconoclastic revolts were also similar. In the Dutch provinces, local populations were horrified by the iconoclastic violence. Most stood by helpless as hundreds of enraged rioters smashed up churches. The Hapsburg authorities described the Calvinist protestors as "infected" with fanaticism, as if they were suffering from disease or psychosis.[14] Likewise during the statue-smashing fury over the summer of 2020, many were shocked by video footage of mobs toppling statues and defacing monuments, some of them cherished historical figures including Abraham Lincoln and Winston Churchill. While many supported the statue-smashing, others regarded the protestors as unhinged and lawless vandals. The notion of infectious disease was also present in framing the frenzy of violence. The statue-smashing rage exploded in the spring of 2020 at the height of the first pandemic wave. People in many countries were physically confined by lockdowns. Statue-smashing protestors were not "infected"—to use Margaret de Parma's term describing Calvinists—but their actions were, in part, driven by pent-up emotions caused by the physical confinements imposed on the population in a pandemic.

The most debatable convergence of the two iconoclastic outbreaks is the question of religion. There can be no doubt that the Beeldenstorm riots were driven by Calvinists who felt oppressed and persecuted by the Catholic Inquisition. Not all beeldenstormers were Calvinists, but the thrust of the movement was undeniably fueled by religious convictions. The same cannot be said of the BLM movement. The protestors who toppled statues in 2020 did not appear to be motivated by religious passions. Critics nonetheless called the Black Lives Matter movement a "cult," a term that connotes quasi-religious devotion. Some BLM leaders, for their part, described themselves as "Marxist," an ideology that is usually atheistic.

Black Lives Matter founder Patrisse Cullors, speaking of herself and co-founder Alicia Garza, said, "We do have an ideological frame. Myself and Alicia, in particular, are trained organizers; we are trained Marxists." Garza described herself as a "queer social justice activist and Marxist."[15] Donald Trump picked up on this terminology to dismiss Black Lives Matter as a "Marxist group that is not looking for good things for our country."[16] The Trump-supporting evangelical right in America were likewise hostile to the BLM movement. Some evangelical organizations claimed Black Lives Matter was being driven by a "Godless agenda" and that its "woke" ideology was antithetical to Christian values.[17]

Karl Marx is often quoted as having said that "religion is the opiate of the masses," though that is not precisely what he wrote. Marx was an atheist, but he was less dismissive of religion than many believe. Marx regarded religion as the wrong answer to the right question. His precise observation about religion is: "Religion is the sigh of the oppressed creature, the heart of a heartless world, and the soul of soulless conditions. It is the opium of the people." That nuance establishes a connection between Marxism, religion, and social justice activism.[18]

Historically, the civil rights movement in America was deeply embedded in religion, both Christianity and Islam. Martin Luther King Jr. was a Baptist minister who preached peaceful protest to achieve rights for Black Americans. His rousing speeches, richly embroidered with evocations of the "Promised Land," evoked Biblical themes and imagery. On the more militant side of the civil rights movement, Malcolm X belonged to the Nation of Islam, though his estrangement from that movement set the stage for his assassination in 1965. Despite claims of "Marxist" inspiration, the Black Lives Matter movement shows indisputable signs of religious influence in both its philosophy and its actions.

Some have argued that Black Lives Matter is essentially a spiritual movement. Theology professors Hebah Farrag and Ann Gleig observe that BLM incorporates spirituality into its social justice agenda. In an article titled "Far from Being Anti-Religious, Faith and Spirituality Run Deep in Black Lives Matter," they argue that claims that BLM is a "Marxist" movement fail to acknowledge its profoundly religious character. "What we found was that BLM was not only a movement seeking radical political reform," they observed, "but a spiritual movement seeking to heal and empower while inspiring other religious allies seeking inclusivity."[19]

Farrag and Gleig interviewed Black Lives Matter founder Patrisse Cullors, who openly discussed the importance of spirituality in her movement. "When you are working with people who have been directly impacted by state violence and heavy policing in our communities, it is really important that there is a connection to the spirit world," said Cullors, who grew up as a Jehovah's Witness and later embraced Ifa, a west African Yoruba religion. "For me, seeking spirituality had a lot to do with trying to seek understanding about my conditions—how

these conditions shape me in my everyday life and how do I understand them as part of a larger fight, a fight for my life. People's resilience, I think, is tied to their will to live, our will to survive, which is deeply spiritual."[20] BLM affiliated organizations, too, are also deeply attached to Christian theology. One is the Nap Ministry. It was founded by Tricia Hersey, who grew up in the Black Pentecostal Church of God in Christ and holds a degree in divinity. The BLM movement also uses terms such as *healing* and *transformative justice*, which have roots in the Quaker tradition's community approach to social problems.

The issue of religion in the Beeldenstorm and BLM riots raises the more delicate issue of their illiberal character. Sixteenth-century Calvinists, though struggling to emancipate themselves from the yoke of Catholic oppression, were fanatically intolerant and sought to impose their own religious dogmas on others. Calvinism was obsessed with religious doctrine and moral purity. Some historians compare Calvinists to the iconoclastic branch of Sunni Islam known as "Wahhabism." Like Calvinism, Wahhabism historically was a fundamentalist movement that revolted against religious orthodoxy. Both Calvinism and Wahhabism opposed all forms of idolatry and advocated a more ascetic form of religious practice.[21] In the Arab Peninsula, the House of Saud embraced Wahhabism in the eighteenth century before revolting against the ruling Ottomans, attacking Mecca in 1803 and inflicting massive iconoclastic destruction on the holy city. Wahhabism today remains the official religion in both Saudi Arabia and Qatar.[22] Activist movements today are frequently described as Puritan or Calvinist to underscore the same intolerance. The Black Lives Matter movement, and "woke" culture more generally, face similar criticism for dogmatic belligerence, illiberal attitudes, and obsession with moral purification.

The repression of the Beeldenstorm riots is less easily compared with responses by authorities to the statue-smashing upheaval in 2020. In the Dutch low countries, the Duke of Alba imposed a brutal military occupation that lasted years. The "Spanish Fury," as it was known, inflicted unspeakable atrocities on the population. In 1572, the Spanish army sacked the Flemish town of Mechelen, pillaging and slaughtering the residents. In 1576 in Antwerp, mutinous Spanish soldiers looted and plundered the city for over three days, murdering some 7,000 people. The sack of Antwerp was so shocking that it united the northern provinces, including Catholics, against the Spanish crown. During the explosion of unrest in American cities in 2020, the U.S. government deployed physical force against rioters but not on the same scale of brutality. Within days of George Floyd's murder, violence erupted in hundreds of American towns, provoking looting and arson. Many mayors imposed curfews to stem the violence. Some thirty states sent in the National Guard to quell the unrest. In the first week of June, more than 11,000 people were arrested.[23] The response by

U.S. authorities was repressive, but it cannot be compared with the Hapsburg bloodbath.

The most difficult comparison between the Beeldenstorm riots and iconoclasm today is their long-term consequences. It's too early to assess the impact of statue-smashing protests in our own era. In the Dutch provinces, the Calvinist riots produced short-term and longer-term consequences. In the short term, the Spanish repression restored order, but the uprising continued to rage until it became a full-blown Dutch Revolt. The long-term result was the break-up of the Spanish provinces. The Calvinist north became the republic of Holland, while the rest (modern-day Belgium, Luxembourg, and northern France) remained Catholic under Spain's absolutist monarchy. Protestant Holland later prospered in what is known as the "Dutch Miracle" of the seventeenth century. The Dutch republic became a powerful economy and global empire, thanks in no small part to the hard-working Calvinist population that had rebelled against the Spanish monarchy.

A moment of high symbolism in the Dutch Revolt came a decade after the Beeldenstorm riots with the so-called Pacification of Ghent in 1576. Following the horror of the Spanish sack of Antwerp, the Dutch provinces put aside their religious differences to build a common front against Spanish rule. The Dutch provinces agreed to drive out the Spanish, end the persecution of Calvinists, and bring a peaceful return to civil rights and liberties. Another clause in the Pacification imposed a duty of "oblivion" on the Beeldenstorm riots. Amnesty was granted to all who had committed violent acts. Everyone was henceforth obliged to treat these events as if they had never happened. In short, the Beeldenstorm riots were subjected to a collective form of damnatio memoriae. They were erased by decree from official memory.

This "oblivion" duty may explain why Dutch accounts of the revolts over the following century either didn't mention the Beeldenstorm riots, or alluded to them only briefly. Some Catholics in the Dutch Republic, it is true, kept the memory of church destruction alive with commissioned paintings of the vandalism inflicted on their church idols and altars. In Antwerp, a surviving statue of St. Willibrord was returned to the Church of Our Lady, where it became associated with miracles. In Mechelen, where citizens were slaughtered by Spanish troops, damaged statues were erected on the city walls as signs that the town was protected by saints.[24] But overall, the official *omertà* was observed, or past troubles mentioned only to put the blame down to a few fanatics.

Historically, legally instituted "acts of oblivion" were not uncommon following political upheavals. They stretched back to ancient Greece, where in 403 BC the Athenians enacted oblivion on crimes committed during the oligarchy. In the early modern era, the Treaty of Westphalia in 1648—which finally established

the status of the Dutch provinces—stipulated "perpetual oblivion and amnesty" on all crimes committed during the previous wars. In England following the Civil War, the republican parliament passed an act of oblivion to make peace with royalists. Following the restoration of the monarchy, a "Law of Oblivion" made it illegal to publicly remember the "late troubled times" of the Puritan interregnum.[25] Americans followed the same tradition when, following the Civil War, President Andrew Johnson declared an "Act of Oblivion" to amnesty all supporters of the Confederate cause. A century later after the Second World War, Winston Churchill called for an "act of oblivion against all the crimes and follies of the past" so European nations could move peacefully together toward a united continent. More recently, following the Franco dictatorship in Spain, a "Pact of Forgetting" was adopted in 1977 to erase from official memory the atrocities of the Civil War and fascist rule and, by doing so, facilitate a smooth transition to democracy.[26]

While amnesty can be legally enacted, collective amnesia is more difficult to legislate. Living memory doesn't forget the past. At some point, however, memory becomes history, no longer within the reach of lived experience. And yet we constantly seek to resurrect collective memory from the annals of history, to breathe new life into its glories and torments, to invest it with meaning through symbolic acts of memorialization and iconoclastic destruction. Friedrich Nietzsche observed that humans, unlike beasts grazing in a field, are chained to the past. They are unable to learn to forget and are always hanging on to past things. And this, asserted Nietzsche, is the source of their perpetual unhappiness. While we cannot entirely escape the past, the excessive burden of history will cause the present to degenerate and crumble away. There is a line at which the past must be forgotten, observed Nietzsche, or it will become "the gravedigger of the present." Those who are compelled to sit in judgment of the past, he warned, are dangerous because they see the present only as the product of aberrations, passions, mistakes, and crimes of earlier generations.[27]

Nietzsche's contemporary, the French historian Ernst Renan, famously stated that for nations to thrive, their citizens "must forget many things."[28] In France, he cited the massacre of Protestants in 1572. Renan did not mean that the St. Bartholomew Massacre must be erased from history books, but that the event must be consigned to the past and cease to haunt the French nation. Nations cannot constantly relive perceived sins of the past and seek to purify them in the present through revolt and violence.

This distinction between memory and history, and the need for "forgetting," is relevant to our contemporary debates about statue-smashing. Perhaps there is a point at which it is wiser to consign events in the past to the status of history. The Pacification of Ghent may provide useful lessons when seeking to appease the rancorous emotions of collective memory. The best solution may be to put

aside differences, make peace with past upheavals, and move forward with re-
newed commitments in the present. This is admittedly an enormous challenge
in a culture that legitimizes iconoclastic violence as expiatory acts of retribution
and emancipation.

The enduring image of the Spanish massacres in the Dutch provinces reveals
how we can be tormented and haunted by the past. Over the centuries, Bruegel
the Elder's famous painting *The Massacre of the Innocents*, described above, has
been the subject of different layers of meaning and interpretations. Replicas of
the painting were made, including by Pieter Bruegel the Younger, who copied
many of his father's works.

That painting fell into the possession of the Holy Roman Emperor, Rudolf
II, who was an avid collector of art. Rudolf, a member of the Hapsburg dynasty,
was displeased by the depiction of the brutal slaughter of babies ordered by an-
other Hapsburg. He had the work overpainted to remove images of slaughtered
infants in a Flemish village.[29] Artists retouched images of the murdered babies
and turned them into bundles of clothing, food, geese, and livestock. The dark
image of the Duke of Alba was blurred so there was no resemblance to him.
These changes to the painting transformed the image from a scene of horrific
slaughter to a less shocking image of mere plunder.

The original Bruegel painting was later purchased by England's king Charles
II and today is in the British royal collection at Hampton Court.[30] It's the ver-
sion censored by Rudolf II. Another copy, faithful to Bruegel's original scene
of merciless slaughter of infants, still exists today. It can be found in Vienna's
Kunsthistorisches Museum.

CHAPTER 12

Suffragettes and Bohemians

On the morning of March 10, 1914, just after ten o'clock, a small woman neatly dressed in a tight gray coat and skirt walked into London's National Gallery carrying a sketch book.

After wandering through the gallery for more than an hour, stopping to inspect paintings hanging on the walls, the woman approached Velázquez's *The Toilet of Venus*. Two security guards were seated nearby on red plush seats. An attendant was standing at the doorway. The woman took out her sketchbook and began making a drawing of the famous seventeenth-century painting.

Commonly known as the "*Rokeby Venus*," the Velázquez masterpiece was among the best-known works of art in Britain. It had been brought to England by the nation's great military hero, the Duke of Wellington, who defeated Napoleon at the Battle of Waterloo. The work's acquisition by the National Gallery, for the colossal sum of £45,000 in 1906, had caused a sensation. The exquisitely sensual painting depicts the naked goddess of love reclining with her back to the viewer while gazing languorously at her own image in a mirror held up by Cupid.

At noon on that March morning, one of the security guards got up and left the room. The other guard relaxed and read a newspaper. With security less vigilant at the lunch hour, the woman holding the sketchbook could now act. She reached into her left coat sleeve and pulled out a small hatchet that resembled a meat cleaver. With a hard blow, she smashed the glass protecting the painting. Then she began slashing the canvas, cutting wide gashes on the naked goddess's shoulder just below the neck.

Alarmed by the sound of smashed glass, the attendant at the doorway rushed over to stop the woman, but he slipped on the polished floor and fell. This gave

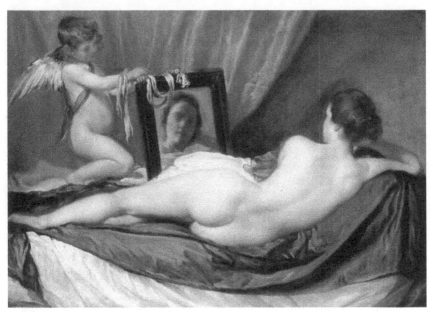

Diego Velázquez's *Rokeby Venus*.

the assailant extra time to attack the painting. More blows rained down on the canvas, slicing through Venus's curvy hips and fleshy buttocks.

The other security guard, still clutching his newspaper, rushed to the painting and seized hold of the woman, struggling with her to grab the hatchet. Visitors in the gallery joined in, tackling her to the floor. When police arrived, she put up no resistance.

The next day, the *Manchester Guardian* reported that the *Rokeby Venus* had been attacked and seriously damaged by a member of the suffragist Women's Social and Political Union.[1] Her name was Mary Richardson. She was a young Canadian woman raised in the small town of Belleville, on Lake Ontario, before moving to England. She had spent some time in Paris and Italy before settling in London. In 1914, Richardson was already known to London police. Sometimes known by her alias "Polly Dick," she was a radical suffragette who had been imprisoned for numerous acts of violence including arson.

"Yes, I'm a suffragette," admitted Richardson after her arrest. She added enigmatically, "You can get another picture, but you cannot get a life, as they are killing Mrs. Pankhurst."[2]

The reference to Emmeline Pankhurst made her motive obvious. Pankhurst was the founder of the suffragist movement, which recently had been resorting to violent tactics against the British establishment to bring public attention to

the issue of women's voting rights. Mary Richardson had joined the suffragist movement after hearing Emmeline Pankhurst speak at London's Albert Hall. She later compared her embrace of the suffragist cause to enlisting in a "holy crusade."[3] On the day Richardson mutilated the *Rokeby Venus*, Emmeline Pankhurst had just been arrested and incarcerated in Glasgow. Richardson's attack on the Velázquez painting was a public protest against the suffragist leader's imprisonment.

Following Richardson's arrest, reaction in the press reflected public incomprehension at an act that seemed utterly senseless. Most British newspapers described Richardson as mentally unstable. *The Times* expressed astonishment that "any person outside a lunatic asylum could conceive that such an act could advance any cause, political or otherwise."[4] Other papers dubbed her "Slasher Mary," an image that evoked the Jack the Ripper murders a few decades earlier. Her frenzied attack on the Velázquez painting was described like the fatal stabbing of a human being. One paper observed that her hatchet blows had caused a "ragged bruised injury" to Venus, as if the blade had cut into the flesh of the goddess. *The Times* took the same anatomical interest in the trauma inflicted on the painting, noting that "the most serious blow has caused a cruel wound in the neck."[5]

Richardson's motive for attacking the *Rokeby Venus* has been analyzed over the past century, a task rendered difficult by her complex personality and inconsistencies in her own accounts. Immediately following her arrest, she put out a prepared statement published in *The Times*. "I have tried to destroy the picture of the most beautiful woman in mythological history, as a protest against the government for destroying Mrs. Pankhurst, who is the most beautiful character in modern history," she stated.[6] Richardson's rationale, it seemed, was based on a comparison between the iconic image of a pagan goddess, Venus, and a living woman, Emmeline Pankhurst. By mutilating the painting, Richardson's message was that justice for living people was more important than the preservation of art.

A less enigmatic explanation for Richardson's actions could be discovered in the wider backdrop of the suffragist cause in Britain before the First World War. Emmeline Pankhurst's movement, founded in 1903, had turned away from a gentle persuasion approach of lobbying for legislative reforms. The suffragettes were now committing more radical acts of civil disobedience. A major turning point was the infamous Black Friday riot on November 10, 1910, when some 300 suffragists marched on parliament in London. As tensions mounted, violence erupted and suffragettes clashed with police and male bystanders. Newspapers published photos of suffragettes being manhandled and thrown to the ground.

Following the Black Friday incident, suffragists stepped up their campaign of violence. Pankhurst's daughters, Christabel and Sylvia, took leadership roles

alongside their mother.[7] The Pankhursts orchestrated attacks on symbols of the British establishment. They bombed Westminster Abbey and committed acts of arson of castles, railway stations, and sports pavilions. The frequency of suffragette attacks was astonishing. In 1913, they struck a total of 232 times, or on average 21 times a month.[8]

As the suffragette campaign accelerated and radicalized, even the monarchy was not spared. The king, George V, was a symbol who, if targeted, guaranteed to stir panic at the very highest levels of British society. George V personally had no sympathy for the suffragist movement. His wife, Queen Mary, referred to them as "those horrid suffragettes" after they burned down a tea house in Kew Gardens. "There seems no end to their iniquities," the queen added.[9]

In June 1913, suffragette Emily Davison fatally threw herself in front of George V's horse at the Epsom Races. In the autumn that year, suffragettes protested at the royal wedding of Princess Alexandra, a niece of George V, at St. James's Palace in London. In December, they disrupted a gala performance of the play *Joan of Arc* in Covent Garden attended by the king. A royal command performance of *Joan of Arc* was a perfect target. The figure of Joan of Arc was an icon of rebellion. Many suffragette rallies featured a woman dressed as Joan of Arc on horseback. At Emily Davison's funeral in 1913, suffragette Elsie Howey rode in costume as Joan of Arc in the procession.[10]

Mary Richardson's attack on the Velázquez masterpiece was inscribed in this pattern of suffragette violence. Her assault on the painting was meticulously planned with the Pankhursts as part of a campaign against highly visible targets. The suffragists targeted famous artworks because they were fetishized by the elites in British society. The *Rokeby Venus* was particularly celebrated following its acquisition by the National Gallery in 1906. King Edward VII was a great admirer of the painting and contributed financially to the purchase. In the eyes of the suffragettes, the *Rokeby Venus* was a cherished possession of the British establishment which put too much value on property. As Emmeline Pankhurst stated: "There is something governments care for more than human life, and that is the security of property. And so it is through property that we shall strike the enemy."[11]

Mary Richardson, as a well-informed student of art, was undoubtedly aware of similar attacks against national art collections in Europe. Three years earlier in 1911, a psychologically unstable man in the Netherlands had stabbed the Rembrandt painting *The Night Watch* in the Amsterdam's Rijksmuseum. He claimed that he had selected *The Night Watch* because of its high visibility and financial value. While attacks on famous works of art were often attributed to mental disorders, Richardson's mutilation of the *Rokeby Venus* was not an irrational act of desperation. She was not mentally ill, criminally insane, or driven to violence by divine revelations. She did not target a "forbidden image" considered blasphemous or obscene. The Velázquez painting of the naked Venus was sensual,

even erotic, but it was not especially shocking to public morality in Edwardian England. *The Times* described the painting as "neither idealistic nor passionate, but absolutely natural, and absolutely pure."[12]

Richardson's attack on the painting was iconoclasm as political discourse. Defacing the *Rokeby Venus* was an act of violence against the institutions that she believed oppressed women. In his book *Images at Work*, David Morgan suggests a way of understanding Richardson's actions. She was not acting alone. She was operating in a well-organized system of "networked action" in the suffragist movement. For the suffragettes, the powerful British establishment was in the thrall of fetishized idols of public enchantment and displayed them in prestigious institutions. By attacking the *Rokeby Venus*, Richardson was smashing one of the false idols venerated by the establishment. "Destroying them becomes a way of disabling their distortion of reality," observes Morgan. "To express this in terms of networks, we can say that breaking or compromising the idols of a particular worldview counts as action against the networks they mediate."[13] Mutilating the Velázquez painting was a strike against the male-dominated ruling class whose values dictated tastes in Britain.[14]

The *Rokeby Venus* incident triggered a flurry of copycat suffragette acts against other works of art. Fourteen more paintings were attacked over the next few months in 1914. Suffragette Grace Marcon returned to the National Gallery in May and damaged five paintings, including Giovanni Bellini's *The Agony in the Garden*. Another suffragette, Mary Wood, walked into the Royal Gallery with a meat cleaver and slashed John Singer Sargent's portrait of novelist Henry James while shouting, "Votes for women!" Wood, who was a 55-year-old grandmother, stated: "I have tried to destroy a valuable picture because I wish to show the public that they have no security for their property, nor for their art treasures, until women are given political freedom."[15]

Following an unsuccessful march on Buckingham Palace in May 1914 to present a petition to George V, suffragette Maude Edwards slashed a portrait of the monarch hanging in the Royal Scottish Academy in Edinburgh. She struck the portrait of George V on the left breast where his medals were dangling. Her hatchet attack on the image of a reigning monarch was the closest the suffragettes came to symbolic regicide. As art historian Helen Scott observes, "Maude Edwards assault on the king's portrait was among the most vehement protests that she could have committed without overstepping the line into actual bloodletting."[16] Edwards was sentenced to three months in prison. In total, eight suffragettes were arrested for the attacks on works of art. Like Edwards, most were given short prison sentences and released early, sometimes following hunger strikes and forced feeding. Mary Richardson, for her part, received a six-month sentence but was released after a few weeks.

The suffragist movement faded following the First World War, largely because women were accorded voting rights in 1918. Mary Richardson was suddenly a rebel without a cause, but she kept busy. She published a novel and a few volumes of poetry, then jumped into parliamentary politics as a Labour candidate in the London district of Acton. She won 26% of the vote in the 1922 elections but lost, followed by two more defeats in 1924 and 1931.

In the early 1930s, Richardson's life took an unexpected turn: she became a fascist. She was one of the first women to join Oswald Mosley's blackshirt movement in Britain. Richardson was not the only ex-suffragette to find a political home in the British Union of Fascists. Several suffragettes embraced fascism out of disillusionment with post-war politics.[17] Mosley's fascist party was, much like Emmeline Pankhurst's suffragette movement, a highly disciplined organization on the margins of British politics.

"I was first attracted to the Blackshirts," said Richardson in an interview in 1934, "because I saw in them the courage, the action, the loyalty, the gift of service, and the ability to serve which I had known in the suffragette movement."[18]

Later in her life, Richardson erased her fascist interlude from the persona she constructed in her autobiography published in 1953. Of the three main phases of her career trajectory—suffragette, socialist, fascist—she airbrushed the last one from her book. The self-erasure was perhaps understandable in the years following the defeat of Nazism, but it also cast some doubt on Richardson's honesty about her own past.[19] This had some relevance for understanding the infamous *Rokeby Venus* incident in 1914. In interviews that Richardson granted toward the end of her life, she provided explanations for her actions that contradicted earlier versions. In 1952, she stated that she had attacked the Velázquez painting because she "didn't like the way men visitors gaped at it all day long."[20] This appeared to suggest that her motive for mutilating the painting was not political, but moral outrage, perhaps an expression of feminist indignation toward erotic representations of female nudes to satisfy male gazes.

Art historian David Freedberg, in his book *The Power of Images*, described Richardson's violent reaction to the painting as "political motivation" coupled with "fear of the senses."[21] Freedberg compared Richardson's attack on the *Rokeby Venus* to Louis d'Orléans's knife assault on Correggio's painting *Leda and the Swan* inspired by the ancient Greek myth about Zeus raping Leda in the guise of a swan. Richardson, like Louis d'Orléans, was seized by paradoxical emotions of repulsion and attraction.[22] There is one important difference, though. Louis d'Orléans attacked Correggio's *Leda and the Swan* in his own private residence. He had no political motive for his gesture. Mary Richardson, on the other hand, attacked a Velázquez masterpiece on public display in the National Gallery. Her motives were clearly political. She was unequivocal about this in her public statements immediately after the incident.

Richardson's motives were undoubtedly complex. She may have had personal opinions about the *Rokeby Venus*, perhaps even repressed sexual feelings. Later in life, she described her strictly puritanical upbringing by her grandparents in small-town Canada, mentioning that it had instilled in her an admiration for Oliver Cromwell. The credibility of her own recollections decades after the incident were suspect, however, given her selective attitude to memory.[23] Moreover, it doesn't seem likely that she had spent hours in the National Gallery watching men "gape" at the painting. Even if she had been outraged by the male gaze at the nude Venus, she did not give this reason following her arrest or in subsequent years. She supplied this justification decades later in the 1950s, possibly because that rationale was more likely to resonate in the moral climate at the time.[24]

Mary Richardson died in obscurity in 1961 in the town of Hastings on the English Channel. She left behind a puzzling legacy as the suffragette-turned-fascist who had attacked the *Rokeby Venus* with a hatchet.

In 2014, on the hundredth anniversary of the infamous incident, the Tate Gallery in London launched an exhibition titled "Art Under Attack." It showcased examples suffragette iconoclasm, including photos of the gashed Velázquez painting.

The term *bohemian* today suggests a free-spirited, anti-conformist, slightly rebellious lifestyle. In recent years, the "boho" look has been fashionably in vogue.

Today's bohemians, whether they know it or not, owe a great deal to a nineteenth-century Parisian subculture known as "*bohème*." The look and lifestyle of its members were part fashion statement, part aesthetic movement. More importantly, the bohemian movement was a revolt.

Parisian bohemians took their name from the Romani gypsies, called "Bohemians" because it was believed they came from that region of Europe. The gypsies lived in lower-class areas of the French capital, which young artists began inhabiting as part of their rebellion against bourgeois values and tastes. Bohemian men wore their hair long under wide-brimmed hats and dressed in vividly colored redingotes and duffle coats with tapered trousers to cultivate a *désenchanté* appearance.[25] The spirit of Parisian bohemian culture was romanticized in a popular 1845 collection of stories by Henri Murger titled *Scènes de la vie bohème*. The book, which described bohemian life in the Latin Quarter, later inspired Puccini's famous opera, *La Bohème*.

Besides sartorial eccentricity, the bohemian movement was at its core a revolt against all forms of tradition. Bohemians embraced a revolutionary individuality that marked a radical rupture with conventional values and lifestyles. French philosopher Luc Ferry constructed a typology of Parisian bohemian

culture in his book, *L'Invention de la vie bohème*, which framed the era historically between 1830 and 1900.[26]

The first characteristic of the bohemian spirit, observed Ferry, was a *tabula rasa* ideology seeking a complete break with the past. Second, bohemians used derision as a modernist form of revolt, hence their satires and burlesques in Parisian cabarets such as the Chat Noir. Third, bohemians cultivated a spirit of "revolutionary individualism" inspired by the Romantic movement. Fourth, they embraced the aesthetics of avant-gardism. Fifth, they practiced sexual liberty and advocated the active role of women in their moral emancipation from repressed bourgeois social codes. Sixth, bohemians embraced a cult of youth and hatred of older generations regarded as calcified embodiments of rigid tradition. Seventh, bohemians accessed hallucinatory "artificial paradises" through alcohol and drugs, including absinthe and hashish. Eighth, bohemians elevated the "*fête*" into a cult, frequenting cabarets, taverns, and theaters as places of bacchanalian indulgence in the senses.

The common theme among these different aspects of bohemian culture was revolt against the bourgeoisie. Bohemians not only rejected bourgeois values but also sought to deconstruct and demolish them by breaking the chains of conventionality and smashing the idols of tradition. Bohemian culture was, in a word, profoundly iconoclastic.

The height of the bohemian movement corresponded to a period of enormous political upheaval in France. In 1848, French king Louis-Philippe was overthrown and the Second Republic was proclaimed in a climate of revolutionary exultation. The Second Republic was short-lived, but the bohemian spirit thrived throughout the Belle Époque until the end of the century. An early literary figure in the movement was Victor Hugo, whose romantic plays broke the rules of classical drama. Arthur Rimbaud and Paul Verlaine, while considered "symbolist" poets, were both associated with the bohemian spirit. Rimbaud even wrote a poem titled "My Bohemian Life." Others influenced by the movement were composer Erik Satie and painter Toulouse-Lautrec. Edouard Manet's famous painting, *Déjeuner sur l'herbe*, completed in 1863, depicted two bohemian students enjoying a sexually suggestive picnic in the woods with two undressed women. Manet's painting shocked the Parisian bourgeoisie and was refused by the official Salon exhibition. In bohemian fashion, Manet took his painting for display at the edgy Salon des Refusés devoted to works rejected by the establishment.

The Parisian bohemian aesthetic spread to Britain and America, where it was embraced by writers and artist keen to copy Parisian fashions and lifestyles. George Du Maurier's novel *Trilby*, about three English art students in Paris, made the bohemian lifestyle popular among young people in both Britain and America. A vibrant bohemian scene emerged in priggish Boston in the 1880s. It

was largely inspired by gothic revivalism, Pre-Raphaelite aesthetics, and the Arts and Crafts movement.[27] The connection between iconoclasm and bohemianism was consummated in San Francisco, where a Boston-born bohemian named Gelett Burgess pulled down a towering cast-iron statue of a prominent local temperance figure. The statue of Dr. Henry Cogswell in Market Street featured a water fountain to encourage the city's citizens to refrain from drinking alcohol. In January 1894, Burgess enlisted the complicity of three fellow bohemians to knock down the statue, which they regarded as a moralizing monument to Philistinism. Burgess, a dandy who was a great admirer of Oscar Wilde, lost his job as a drawing instructor at Berkeley College after the incident. He later travelled to Paris, where he wrote about the early Cubist movement led by Picasso, Matisse, and Georges Braque.[28]

It is not a coincidence that bohemians claimed philosophical inspiration from Arthur Schopenhauer and Friedrich Nietzsche. Schopenhauer's ideas were essentially iconoclastic because they broke with traditional German philosophy and posed new existential questions outside of the traditions of his time. It is intriguing that the book that made Schopenhauer famous in English, published in 1853, was titled *Iconoclasm in German Philosophy*.[29] Schopenhauer's pessimism appealed to the bohemian ethos because it asserted that life is essentially pain, suffering, and sorrow. The only escape from the servitude of strife and struggle is the aesthetic experience of art. Schopenhauer elevated aesthetics to a new form of religion. This philosophy was tremendously attractive to bohemians proclaiming their disenchantment with bourgeois values. Nietzsche, who was profoundly inspired by Schopenhauer, advocated breaking the shackles of traditional values imposed by Christianity.[30] The title of Nietzsche's 1889 book, *The Twilight of the Idols*, was explicitly iconoclastic. So was its subtitle: *How to Philosophize with a Hammer*. Nietzsche was the philosopher who declared, "I am dynamite!"[31]

The bohemian movement was not without paradoxes. While rebelling against tradition, bohemian aesthetics often flattered bourgeois sensibilities. Over time, members of the bourgeoisie began mixing socially with bohemians. Today we see the same ambiguity in the French term *bobo*—a contraction of "bourgeois-bohemian"—describing a subculture of well-to-do urban professionals who affect a bohemian lifestyle while living in gentrified neighborhoods. They are bohemian in spirit, but enjoy the material advantages of the bourgeoisie.

Another paradox resided in the bohemian attitude toward art. While the movement was essentially aesthetic, it was resolutely opposed to art as objects. Art was bourgeois culture. Consequently, art was not to be created; it was to be destroyed. For bohemians, aesthetic self-destruction was not only a social statement but also a new form of avant-garde expression. The bohemians declared war on art. Or rather, their art declared war on itself.

Iconoclastic posturing toward art was a recurrent theme in Parisian bohemian culture. A familiar rhetorical flourish was the declaration that the Louvre should be set ablaze and burned to the ground. "If I had had some matches," wrote French art critic Louis Edmond-Duranty in 1856, "I would have set fire to that catacomb with the intimate conviction that I was serving the art of the future."[32] The painter Gustave Courbet was infamous for his iconoclasm, figuratively and literally. Courbet is known today for his controversial 1866 painting, *L'Origine du monde*, showing a close-up of a reclining woman's hairy vagina. Courbet also gained notoriety in the political sphere during the Paris Commune insurrection. As president of the radical commune's "Artists' Commission," Courbet masterminded the toppling of Napoleon's statue in Place Vendôme. He argued that the monument was "antipathetic to the genius of our modern civilization and the ideals of universal fraternity."[33]

Courbet initially proposed that the Vendôme Column and Napoleon's statue be dismantled. In April 1871, the commune voted in favor of Courbet's idea but took his plan a step further. The Vendôme Column wouldn't be dismantled; it would be pulled down. The following month, the column came crashing down in a ceremony presided over by National Guard battalions and a band playing "La Marseillaise." More iconoclastic violence was to come. The insurrectionists targeted public buildings with high symbolic value. Communard soldiers stationed at the Tuileries Palace, ancestral home of the French monarchy, set the building on fire. When the flames subsided, the palace was a charred ruin. Next was the Hôtel de Ville. It, too, was set on fire as part of the Communards' scorched-earth campaign. Murals by Delacroix and Ingres went up in flames. Courbet, meanwhile, was arrested for sedition for his role in the vandalism. Before his trial, ladies in the streets of Paris struck him with their umbrellas. He was convicted and sentenced to six months in prison. Courbet didn't appeal the sentence, instead he fled into self-imposed exile in Switzerland. His paintings and personal assets were seized to pay for the cost of the damage to the Vendôme Column.[34]

By the end of the century, Parisian bohemians had split into different subculture movements. The "Hydropathes" and "Incohérents" made satirical avant-garde works of "anti-art" to mock the establishment. An "Incohérents" exhibition in 1886 featured an image of the "Husband of the Venus de Milo," showing the famous Greek sculpture as a man with a beard. The image was an iconoclastic statement through irreverence. These rebellious gestures inspired aesthetic revolts against authority, beginning with Alfred Jarry's absurdist play *Ubu Roi*, which premiered in Paris in 1896. *Ubu Roi* was a precursor of the Dada movement which used iconoclasm as an artistic principle. In the years just before the First World War, avant-garde artists were performing in Zurich at the Cabaret Voltaire—known as the "birthplace of Dada"—founded by Hugo Ball

and Emmy Hennings. The Dada movement was born in Switzerland, a neutral country in the First World War, as a protest against the nationalist and bourgeois values that had led inexorably to war. The Dadaist used theater of nonsense and avant-garde "anti-art" as expressions of revolt against rationality and traditional aesthetics. Ball's iconoclasm was greatly influenced by sixteenth-century *Bildersturm* theologians such as Thomas Müntzer. Ball, who kept an engraving of Müntzer above his desk, admired the German theologian's revolutionary iconoclasm and "religious anarchy." For Ball, *Bildersturm* and Dada iconoclasm shared a "conflict with orthodoxy."[35]

Dada artists, like bohemians, were iconoclastic in their rejection of the past, especially in the aftershock of the First World War. Cubists, Expressionists, and Surrealists carried forward the ethos of the pre-war avant-garde movement with distorted and fractured visions of reality. Artistic deconstruction was essentially iconoclastic because it destroyed conventional systems of representation. Artists and poets were not only in revolt against the bourgeoisie but also questioning the values of the civilization that had produced the apocalypse of war. T. S. Eliot's "The Waste Land" and William Butler Yeats's apocalyptic "The Second Coming," both published in the immediate post-war years, were poetic expressions of this prevailing zeitgeist of despair.

Dada artist Marcel Duchamp, famous for his urinal signed "R Mutt," was deeply engaged in this aesthetic rupture with the past. He once suggested that a Rembrandt should be "used as an ironing board."[36] Duchamp produced "ready-made" works that desacralized art, including one of the Mona Lisa with a moustache. He irreverently titled it "L.H.O.O.Q"—in French, sounding like "*elle a chaud au cul*" (roughly translated, "her ass is hot"). Duchamp greatly admired American society, he said, because of its relentless destruction of old buildings to construct new ones, constantly turned toward the future. "The dead should not be permitted to be so much stronger than the living," he said in 1915. "We must learn to forget the past, to live our own lives in our own times."[37] These ideas took off with the Futurist movement that emerged notably in Italy. The Futurist leader, poet Filippo Tommaso Marinetti, called on fellow artists to set fire to libraries and flood museums. "Oh, the joy of seeing the glorious old canvases bobbing adrift on those waters, discolored and shredded," he wrote. "Take up your pickaxes, your axes and hammers and wreck, wreck, the venerable cities, pitilessly!"[38]

The Dada idea of art as destruction culminated with Man Ray's work *Object to Be Destroyed*. The object was a metronome. The viewer was asked to attach to the pendulum the photo of a loved one's eye. Man Ray made the original in 1923, but he destroyed it himself. He later made a copy in the 1930s, attaching detailed instructions for the object's destruction. "With a hammer well-aimed," he wrote, "try to destroy the whole at a single blow." When *Object to Be*

Destroyed was displayed at a Paris gallery in 1957, students from the nearby École des Beaux Arts stormed the exhibition, tossed handbills denouncing Dada and Surrealism, then ran off with two of Man Ray's works, including *Object to Be Destroyed* and *Boardwalk*. Man Ray was in the gallery and gave chase. He managed to recuperate *Boardwalk*, which the students had shot with a gun, but *Object to Be Destroyed* was never recovered. The anti-Dada students doubtless had taken him at his word and destroyed the work. When Man Ray reproduced the same metronome artwork a year later in 1958, he named it *Indestructible Object*.[39]

After the Second World War, the Beat generation embraced the bohemian spirit of hedonism, rejection of material values, sexual liberty, and experimentation with drugs. The term *beat* was usually interpreted as musical rhythm, though Beat writers such as Jack Kerouac claimed it was connected spiritually to the notion of "beatitude." In the visual arts, meanwhile, styles such as Abstract Expressionism, Neo-Dadaism, and early pop art were transforming the cultural iconography in the post-war period. In 1953, artist Robert Rauschenberg produced his famous work, *Erased de Kooning*, which took a real painting by Willem de Kooning and erased it. The finished work was a blank paper canvas with a gilded frame. Only traces of the original De Kooning painting were visible. It wasn't an object to be destroyed, in the Dada tradition of Man Ray. It was an object to be erased.

At the height of the Cold War, the fear of nuclear annihilation gave birth to another movement called Auto-Destructive Art. It was largely inspired by Dada—indeed, its acronym "ADA" formed part of the word "Dada." In a manifesto in 1960, artist Gustave Metzger wrote: "Auto-destructive art re-enacts the obsession with destruction, the pummeling to which individuals and masses are subjected." Metzger's interest in auto-destructive art was shaped by his experience during the war in Nazi Germany, where his parents had perished in the Holocaust. The auto-destructive art movement was, in Metzger's words, a "desperate, last-minute subversive political weapon against capitalism and consumerism."[40] Metzger used destructive techniques —spraying acid onto sheets of nylon—as part of the creative process. One Metzger piece, called *Skoob Tower Ceremonies*, consisted of stacks of books (*skoob* was *books* spelled backward) that were set on fire. Metzger's movement influenced performance artist Yoko Ono and rock stars such as The Who's Peter Townshend, who was famous for smashing his guitars on stage.

In the hippie counter-culture of the 1960s, bohemianism was reinvented yet again. Hippies threw themselves into the spirit of revolutionary individualism, sexual liberty, drugs as artificial paradise, and rebellion against middle-class values. Philosophically, the counter-culture of the 1960s was in tune with the postmodernist ethos of romanticized subjectivity inspired by Friedrich Nietzsche. His championing of individualism resonated with the "do your own thing"

youth culture in the 1960s. Postmodernist philosophers such as Michel Foucault took Nietzsche's thinking one step further by advocating the dismantling of established power structures which could be found in everything from images to ideas and language.

The pop art movement in the 1960s took a different direction. Artists such as Andy Warhol appropriated the symbols of consumer culture and turned them into icons. Warhol's synthetic paintings of Campbell's soup cans were emblematic of this postmodernist trend. He did the same with iconic portraits of celebrities, including Marilyn Monroe, depicting them in mass-produced series like consumer products. Warhol's icons were partly ironic, and perhaps even derisive, much like bohemian aesthetics and Dada art. His works nonetheless became fetish objects in America's celebrity culture. To further complicate the irony, Warhol himself joined the celebrity stratosphere and became a cultural icon himself. Pop art idolatry brought the bohemian revolt full circle. It was flattering the sensibilities of the bourgeoisie that it had once rejected. Bohemians were now respectable members of the establishment.

This paradox was addressed in the last category of Luc Ferry's typology of bohemian ideology. Ferry described the final bohemian phase as "disillusionment." Bohemians inevitably achieve social success and become *arrivistes* in the bourgeoisie that was once the target of their revolt. Dada founder Hugo Ball, who opened the Cabaret Voltaire in Zurich in 1916, came to this disillusioned realization. Ball, the author of the "Dada Manifesto," eventually abandoned the movement that he created. "All Expressionism, Dadaism, and other -isms," he lamented, "are the worst kind of bourgeoisie."[41]

Art was no longer iconoclastic; it had become idolatrous. It was no longer going under the artist's hammer to be destroyed; it was going under the auctioneer's hammer to be sold.

Aesthetic self-destruction has been making a comeback in recent years. The zeitgeist of our times is reconnecting with the original bohemian spirit of revolt.

In the 1990s, Chinese artist Ai Weiwei produced his photographic performance art piece in which he dropped and smashed a Han dynasty ceramic urn. The images of him breaking the urn seemed shocking. But Ai's point was that they were of little value. Han Dynasty urns could be purchased cheaply. Smashing them was a form of protest against China's lack of concern for its own cultural heritage. Ai called the urns "ready-made," the same concept used by Marcel Duchamp to describe his objects transformed into art. When he encountered outrage against his act of destruction, Ai countered: "Chairman Mao used to tell us that we can only build a new world if we destroy the old one."[42]

Two decades later in New York, activists demanded that artist Dana Schutz's oil painting, *Open Casket*, be destroyed because it represented White power. The abstract work depicted the battered face of 14-year-old Emmett Till lying in his open coffin. Emmett Till was the African American teenager in Mississippi who was lynched in 1955 after being accused of flirting with a White girl. Following his murder, his mother, Mamie Till-Mobley, insisted that her son's face be visible in an open casket. "Let the people see what they did to my boy," she said.[43]

Dana Schutz said she painted *Open Casket* to create awareness of police brutality toward African Americans. At the Whitney Biennial in 2017, however, activists denounced the work as a "White gaze" on a Black death. African American artist Parker Bright protested by standing in front of the painting wearing a gray T-shirt emblazoned with the words "Black Death Spectacle." British artist Hannah Black fired off a petition to the Whitney museum demanding that the painting "be destroyed and not entered into any market or museum."

"It's not acceptable for a white person to transmute Black suffering into profit and fun," wrote Black in her petition.[44] She added that "contemporary art is a fundamentally white supremacist institution."[45]

The protest against *Open Casket* was not based on aesthetic objections. The style of the work was abstract. The painting moreover had been exhibited in Berlin the previous year to no controversy. It offended because the artist was White and, moreover, it was exhibited at the Whitney Museum—both regarded as structures of power and privilege. This was suffragette Mary Richardson's motive, in a different historical context, for mutilating the *Rokeby Venus*. The Velázquez painting was a symbol of powerful institutions that oppressed women. Richardson didn't launch a petition. She attacked the work with a meat cleaver.

In the end, calls to have *Open Casket* destroyed produced the opposite outcome. Instead of being erased from memory, the painting became highly publicized and debated. The painting was not destroyed, though artist Dana Schutz promised never to put it up for sale.[46]

The most dramatic act of aesthetic destruction in recent years was Banksy's painting *Girl with a Balloon*. On October 5, 2018, the painting was sold at a Sotheby's auction in London. The winning bid was $1.4 million. When the hammer came down on the sale, an alarm suddenly sounded inside the painting's frame. To the consternation of the auctioneer and assembled bidders, the work began to self-destruct before their eyes. The picture of the girl holding up a red heart-shaped balloon slowly slipped through its frame, self-shredding as it slid downward.[47] As onlookers watched the painting consume itself, two Sotheby employees rushed to the canvas and frantically carried it away. The shredder malfunctioned and stopped, leaving the top portion of the painting intact.

This astonishing act of aesthetic self-destruction was watched around the world in viral videos on social media. Banksy himself posted a video on Insta-

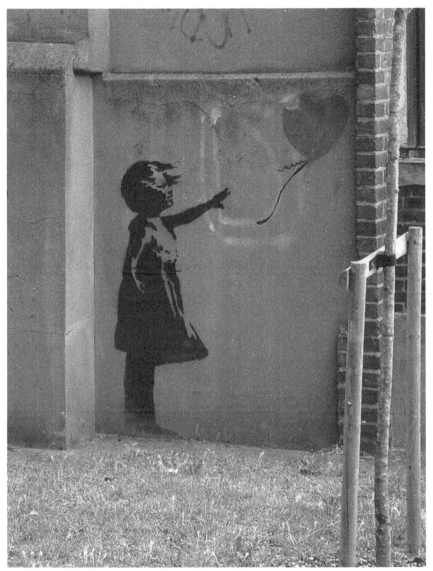

Mural version of Banksy's *Girl With a Balloon*. *Wikimedia Creative Commons*.

gram, confirming that he had orchestrated the self-destruction of his own work. Like the Man Ray work a century earlier, *Girl with a Balloon* was an object to be destroyed. Banksy explained his prank with a quote from Picasso: "The urge to destroy is also a creative urge."[48]

Banksy was not new to guerilla tactics of art and destruction. Many of his works were wall murals in cities that had either been vandalized or destroyed. In London, a Banksy mural inspired by the film *Pulp Fiction*—showing Samuel L. Jackson and John Travolta holding bananas instead of guns—was painted over by London Transport in 2007. A spokesman for the city said the mural created a "general atmosphere of neglect and social decay which in turn encourages crime."[49] The mural was estimated to be worth about $300,000, but now it was gone forever.

In 2012, Banksy made another mural in London called *Slave Labour*, showing a boy crouching and making Union Jack flags on a sewing machine. The mural was Banksy's protest against sweatshop exploitation to make memorabilia for the London Olympics in 2012. The following year, the *Slave Labour* mural was removed under mysterious circumstances and put up for auction. Following protests over its sale, the mural was eventually bought by American artist Ron English, who paid $730,000 for it. He vowed to destroy *Slave Labour* as a protest against the commercialization of street art. Banksy himself wrote on his website, citing the French painter Henri Matisse: "I was very embarrassed when my canvases began to fetch high prices, I saw myself condemned to a future of painting nothing but masterpieces."[50]

The fate of *Slave Labour* might have influenced Banksy's decision to make a work that would self-destruct if ever put up for auction. His prank with the self-destroying *Girl with a Balloon* was an iconoclastic comment on art as commercial commodity. Auto-destroying art was a defiant rebellion against the mercantile values of bourgeois capitalism with a bohemian touch of humor and derision.[51]

Ironically, the self-destruction of *Girl with a Balloon* only increased its value. The wealthy woman who made the successful $1.4 million bid for the painting concluded the purchase without hesitation. "When the hammer came down last week and the work was shredded, I was at first shocked," she said. "But gradually I began to realize that I would end up with my own piece of art history."[52] She was right, but it seems she was unsentimental about her world-famous acquisition. Renamed *Love Is in the Bin*, the painting was put back on the market in the autumn of 2021. It fetched more than $25.4 million at auction—eighteen times the original price.[53]

In the final analysis, Banksy had not destroyed a work of art; he had created one. He proved that, just as iconoclasm inevitably becomes idolatry, an act of aesthetic self-destruction is inescapably an act of artistic creation.

CHAPTER 13

Statue Mania

In the statue-toppling frenzy through the summer of 2020, one of the first monuments pulled down was a bronze statue of Williams Carter Wickham.

Wickham's statue had stood in the Virginia state capital's Munroe Park since 1891. The ten-foot-high granite pedestal was inscribed, "Soldier Statesman, Patriot, Friend." Wickham was a classic Virginia patrician. Born in 1820 into a plantation-owning family, he was descended from the first families of Virginia. His maternal great-grandfather had been a signatory of the Declaration of Independence. Wickham's mother was a first-cousin of Confederate general Robert E. Lee. His paternal grandfather was a prominent lawyer and slave-owner. Wickham himself was elected to the Virginia assembly. During the Civil War, he served in the Confederate Army as a cavalry general. Following the war, he consolidated his fortune through investments in the railroad and coal industries. Wickham embodied the antebellum values of White supremacy in the South.

On June 6, 2020, Black Lives Matter activists used rope to pull the Wickham statue off its pedestal. After it hit the ground to a burst of cheers, protestors covered Wickham in paint—orange on his beard, red splashed on his torso. They also defaced the pedestal with graffiti: "BLM" and "history's dustbin." One protestor urinated on the toppled statue.

Protestors likely targeted Wickham's pedestrian statue because it was relatively low to the ground and could easily be pulled down. About a mile from the Wickham monument, the bronze equestrian statue of Robert E. Lee on a sixty-foot marble column was too massive to be toppled. Towering over the city, the Lee monument was located on the city's tree-lined Monument Avenue, home to other bronze statues of Confederate heroes. Protestors could only deface the Lee monument. They were more successful with a nearby statue of Confederacy leader Jefferson Davis. After it was knocked down, a crowd cheered as a truck hauled it away.

Statues in some American cities were dismantled and removed by local authorities, but in most cases protestors attacked, defaced, and toppled monuments in spontaneous bursts of rage. On television news and social media, videos showed angry crowds assailing and mutilating statue after statue. The iconoclastic fury quickly spread beyond the United States around the world, as protestors in other countries attacked statues regarded as symbols of racism and oppression. In England, a viral video showed Edward Colston's bronze statue being toppled and tossed into Bristol harbor. The world suddenly learned the name of one of Britain's wealthiest slave traders in the seventeenth century.

These attacks on statues were acts of symbolic violence that rejected the past and made claims on historical memory. BLM activists were not revolutionaries determined to overthrow a political order, usurp power, or impose a new political program. Knocking down monuments was a belligerent form of political discourse. It was speech by other means. It was violence that exacted historical vengeance. It was physical destruction that disempowered the symbolic authority of the figures represented in the targeted monuments. It was Nietzsche's "critical" history in action.

Some denounced the statue-smashing violence as irrational and utterly senseless vandalism. They were outraged to see statues of revered figures in American history, including George Washington and Thomas Jefferson, toppled along with those of Confederate generals. Washington and Jefferson statues were apparently targeted because both men owned slaves in Virginia. In other instances, the motive was more puzzling. In Wisconsin, a statue of Hans Christian Heg at the Madison state capital was decapitated and thrown into a lake—even though Heg was an abolitionist and anti-slavery activist who fought and died in the Union army during the Civil War. A statue of Abraham Lincoln in Portland, Oregon, was also knocked off its pedestal and spray-painted. Lincoln was the venerated American president who ended slavery and issued the Emancipation Proclamation. During the Civil Rights era in the 1960s, Martin Luther King made his famous "I have a dream" speech in front of the Lincoln Memorial in Washington, DC. For many anti-racist activists, however, Lincoln was the president who authorized the execution by hanging of thirty-eight Dakota Native Americans in 1862. In an uprising in southwest Minnesota, Dakota Sioux natives killed hundreds of settlers and U.S. soldiers before the rebellion was put down. More than 300 Dakota men were sentenced to death. President Lincoln reviewed the case and approved the executions of only 39 men, though one was later reprieved. On the pedestal of his toppled statue in Portland, a protestor spray-painted "Dakota 38" as a reminder.

The outburst of violence against statues in 2020 was not new. In the United States, attacks against Confederate monuments and colonialists stretched back years, even decades. In the five years before George Floyd's death, some 54 stat-

ues had been taken down in the United States. Resentment toward these statues had been simmering for generations. Floyd's murder in late May 2020 was a flashpoint that ignited a volcanic eruption of rage and revolt.

Most of the toppled statues did not date to the era of slavery. They were erected after slavery had been abolished in America and Britain. This presents an intriguing paradox. Why did societies that had abolished slavery choose to erect reverential monuments to men associated with it?

The answer can be found in the complex social and political dynamics of the nineteenth century, when "great men" statues were accorded pride of place in the public squares of America, Britain, and other countries. This period is frequently described as the era of "statue mania." It peaked at the end of the nineteenth century and continued to thrive until the 1930s. Statue mania was a civic expression of Nietzsche's "monumental" history: statues of revered figures were erected in public squares to glorify, galvanize, and inspire.[1]

The second half of the nineteenth century was an era of industrialization, technological progress, and bold national purpose. Following the wave of revolutions that swept through Europe in 1848, new nations such as Germany and Italy were forged in a political climate of surging nationalist fervor. In France, the Third Republic emerged from the humiliation of the country's defeat in the Franco-Prussian war in 1871. At the same time, Britain was at the apogee of "rule Britannia" imperial glory. European leaders were looking for nation-building myths and symbols to forge collective identity and boost patriotic emotions. Ornate monuments and statues of heroic figures sprang up in public squares as symbols of national pride. Statue mania promoted a civic cult of the "great man."

In Britain, statues of colonial rulers, mercantilists, and inventors went up in cities throughout the century. The death of British prime minister Sir Robert Peel—who gave us the word *Bobbies* for London policemen—is considered to be the starting point for statue mania in Britain. After Peel's death in 1850, statues of him were raised everywhere. Peel's monumental glorification sparked a flurry of statues honoring other statesmen and civic leaders. Many statues were mounted on victory columns and pedestals and embellished with allegorical figures representing "Victory" and "Britannia." Statue mania was fit-for-purpose in the Victorian culture of *horror vacui*, or fear of empty spaces. Statues and monuments took the nineteenth-century preference for dense ornamentation to public squares throughout Britain.

Paris was at the center of the statue mania phenomenon. Following the collapse of Napoleon III's Second Empire, the Third Republic was searching for heroic figures who embodied France's universalist values. In Paris, thirty-four "great man" statues appeared in the 1870s, followed by dozens more in the next few decades. By the end of the Belle Époque, there were more than 150 heroic

statues in Paris. Foreign dignitaries visiting the city were so impressed by the French capital's extravagant public statuary that, when they returned to their home countries, they commissioned similar monuments for their own cities. Equestrian statues began appearing in Cairo, Alexandria, Damascus, Haifa, and Istanbul.[2] The French obsession with statues reached such extravagant excesses that, in 1911, the city of Paris imposed a ten-year moratorium on the erection of monuments "no matter what may be the claims to immortality of the candidates for honors."[3] Many of the statues erected under the Third Republic were later demolished by the Nazis during the Occupation in the early 1940s. The Nazis had no patience for the French Republic's cult of great men.

Statue mania spread to the Americas, where civic leaders in the nineteenth century were keen to absorb influences from Europe.[4] Public statuary in the United States borrowed heavily from European influences such as allegorical figuration. Thousands of oversized statues and monuments appeared in the squares and parks of American cities as symbols of nation-building. Along with "great man" statues of George Washington and Christopher Columbus, frontier towns in America adorned their public squares with monuments to explorers and pioneers. In the South, statue mania took a different turn in the post-bellum period by glorifying Confederate figures such as Robert E. Lee.

Understanding the statue mania phenomenon and its social usages offers insights into why public statues proliferated during this era—and, more importantly, why many of these same monuments were toppled by protestors more than a century later.

In Bristol, the bronze statue of English mercantilist Edward Colston was a classic symbol of Victorian statue mania.

Colston was not, ironically, a figure from the Victorian Age. He lived two centuries earlier. When Colston was born in Bristol in 1636, Charles I was king of England and William Shakespeare had been dead for only twenty years. Colston made a colossal fortune in the slave trade and later became a Tory member of parliament. In the 1680s, he was active in the Royal African Company set up under Charles II. The company held a monopoly on the African trade in ivory and slaves. It transported about 84,000 men, women, and children between West Africa and the Americas between 1672 and 1689.[5] Colston died in 1721 at the grand age of eighty-four. In Bristol, he was remembered for his great philanthropy, including the endowment of almshouses, schools, and hospitals.

The statue of Colston was unveiled by Bristol's lord mayor in 1895, nearly two centuries after the rich mercantilist's death. It depicted Colston as a man of his own time, wearing a wig and dressed in a waistcoat and knee breeches. At the base, one of the relief panels showed Colston distributing alms to widows and orphans.

Why did the civic leaders of Bristol in 1895—more than a half century after slavery was abolished in the British Empire—unveil a statue honoring a rich slave trader? The answer lies in the cultural zeitgeist and collective psyche of the late Victorian era.

In the early nineteenth century, several decades before the Colston statue was unveiled, the anti-slavery movement in Britain had political momentum. Public statues were erected in honor of prominent abolitionists—Charles James Fox, Thomas Fowell Buxton, and Zachary Macaulay. The slave trade was made illegal in 1807, though plantations still existed in British colonies. Finally, the Slavery Abolition Act was adopted in 1833. Slavery in British territories was made illegal three decades before the American Civil War.

In the latter half of the "Rule Britannia" century, however, surging industrialization created a different moral climate among British elites. For the laboring classes, the effects of industrialization brought horrendous inequalities and misery. A workers movement sprang up and called for reforms. In 1888, teenage girls at the Bryant and May match factory in east London walked out to protest deplorable work conditions, including fourteen-hour workdays and health risks from working with phosphorous. The so-called "match girls" strike—which was supported by Karl Marx's daughter Eleanor—was a highly publicized event in London. It was said that, during the strike, one of the match girls attacked a statue of prime minister William Gladstone at nearby Bow Church.

The port city of Bristol was hit by similar worker militancy and labor strikes. Thousands of dockers and women working in cotton mills protested for better wages and conditions. In December 1892, a "March of the Workers" was held two days before Christmas to support women working in the Sanders Sweet Factory. Their working conditions were so poor that the women were dubbed "Sanders' White Slaves." At a demonstration, two hundred mounted police broke up the protest. Fifty-one demonstrators and fifty-seven police were injured.[6]

This was the turbulent backdrop to the unveiling of the Edward Colston statue in Bristol. With rising social unrest, British civic leaders felt an urgent need to reinvent an imagined tradition that evoked the past grandeur of British achievements by great men. They turned to accomplished figures from previous epochs such as Edward Colston. The fact that Colston was a slave trader was conveniently overlooked. As a wealthy mercantilist-turned-philanthropist, Colston was glorified as the embodiment of the industrious spirit that had built the British empire.

The civic mythology created around Edward Colston took many forms beginning in the eighteenth century with the establishment of charitable societies—the Grateful, the Dolphin, and the Anchor—dedicated to furthering his benevolence. Local buildings in Bristol were named after Colston, and public ceremonies were held in his honor. An annual "Colston Day" on November 13

was celebrated to mark the date on which he had received his royal charter for his merchant company. On Colston Day, local Bristol elites raised money for the poor and sweet "Colston buns" were distributed to children. The cult of Colston became so important to the city's identity that, in 1843, civic leaders had his body disinterred in search of relics to venerate. According to legend, his cadaver was found to be immaculately preserved. Cuttings of his hair and nails were conserved and worshipped like sacred objects. Colston was revered as both "merchant prince" and "moral saint."[7]

The bronze statue was unveiled on Colston Day in 1895. The inscription on the base read: "Erected by citizens of Bristol as a memorial of one of the most virtuous and wise sons of their city." The statue's purpose was to promote social cohesion and civic pride around the values of British industry and empire. Edward Colston belonged to another epoch in history, but his statuary presence in Bristol sent a proud civic message to Victorian-era residents of the city at a time of social unrest.

Not long after Colston's statue was unveiled, a bronze statue of Robert Clive appeared in London in 1912. Like Colston, Clive was a figure from another epoch. Born in 1724, he worked for the colonialist East India Company and laid the foundations for British rule of India, where he became governor of Bengal. He looted the Bengali economy and was responsible for the local famine of 1770. Through his various defalcations, Clive became one of the richest men in Britain. Though ennobled, he was vilified in his own day. He faced a corruption trial before parliament amid calls to have him stripped of his peerage. When he committed suicide in 1771, he was one of the most hated men in England and was buried in an unmarked grave. The great man of letters Samuel Johnson observed that Clive "had acquired his fortune by such crimes that his consciousness of them impelled him to cut his own throat."[8] Yet in 1912, a bronze statue of Robert Clive was unveiled at the heart of British government just behind the prime minister's residence in Downing Street. Some in the British establishment believed the statue was needlessly provocative, but the unveiling went ahead. At a time when Britain was at the pinnacle of its imperial glory, Clive's crimes were forgiven and forgotten.[9]

In the United States, heroic public statuary was rare in the early nineteenth century, partly due to a reluctance to follow European aristocratic habits. In the latter half of the century, however, Americans were actively embracing influences from Europe. The statue mania trend was one of them. The collective trauma of the American Civil War, and the military heroes it produced on both sides, gave purpose to statue fetishism. It also explains why, in the decades after the Civil War, the proliferation of statues and monuments had an overwhelmingly militaristic theme.[10] From the 1860s, the American urban landscape was transformed by a flourishing of military statues and memorials.

The fusion between war and monument had been inaugurated by Abraham Lincoln in his famous Gettysburg Address in 1863, when he consecrated the battlefield as a sacred shrine. After the war, so-called "Standing Soldier" statues appeared in cemeteries and public spaces from Maine to Alabama. Mass-produced bronze figures, they depicted both Union and Confederate soldiers, usually standing high on a pedestal in "parade rest" posture, hands gripping the end of a musket, head leaning down as if mourning the loss of battlefield comrades. In the after-shock of the Civil War, demand for these statues was high because most towns and villages counted fallen soldiers.[11] The Standing Soldier was a uniquely American public symbol. In contrast to "great man" statues in Europe, the Standing Soldier memorialized the common man. Neither triumphant nor defeated, he was depicted as a noble and brave citizen contemplating the sacrifices of war.

Some "great man" statues joined the proliferation of American war monuments. George Washington statues moved from official buildings into public spaces to propagate a cult of the country's founding father. A notable statue, erected in 1892, was on the Washington Square Arch in Manhattan. Christopher Columbus was another superstar of the American statue mania period. Columbus monuments—statues, busts, fountains—appeared in many American cities. In New York City, the Columbus Circle statue was erected in 1894. The Columbus Fountain inauguration at Washington, DC's Union Station in 1912 attracted a turnout of more than 150,000 and featured a parade with 15,000 soldiers, 50,000 Knights of Columbus, and floats providing a visual narrative of his life story.[12]

The quintessential "great man" figure of the statue mania era in America was Abraham Lincoln. Many Lincoln statues appeared after the Civil War, notably the marble monument erected in 1868 outside the old District of Columbia City Hall, several blocks from where he was assassinated at Ford's Theater. The unveiling was attended by the assassinated president's successor, Andrew Johnson, as well as Union generals Ulysses S. Grant and William Tecumseh Sherman. Another famous statue was the "Lincoln Standing" monument erected in Chicago in 1887. Widely praised as a great achievement in public sculpture, the 12-foot bronze statue depicted Lincoln on his feet, having just risen from a chair behind him, preparing to give a speech. A crowd of 10,000 attended the unveiling ceremony, including Lincoln's grandson, Abraham Lincoln II. Today there are more statues of Abraham Lincoln in the United States than of any other figure—in total, 193 Lincoln statues, followed by George Washington at 171, and Christopher Columbus with 149 monuments.[13]

Statue mania in northern American states forged a collective ideology of national unity. This was an important goal at a time of industrialization and immigration to the United States. With a rapidly diversifying population, heroic

statuary of figures such as Christopher Columbus articulated a coherent national narrative around Manifest Destiny and America as a promised land.

Some monuments in northern states memorialized African Americans. In 1888, a statue of Crispus Attucks was erected on the Boston Common to commemorate the first Black man killed during the Revolutionary War. In 1899, a bronze statue of African American social reformer Frederick Douglass appeared in Rochester, New York, where he had lived and worked as an anti-slavery newspaper publisher. African Americans were sometimes uncomfortable with monuments that specifically depicted them in a different category of patriotism. When a group in Rochester started a subscription in 1894 to fund a monument to African-American soldiers who had fallen in the Civil War, some members of the Black community opposed it on the grounds that a Standing Soldier monument represented all the war dead. This raised the issue of racial characteristics of soldier statues, which were generically depicted as young White males, usually with a moustache.

In the South, the social function of public monuments was different. The post-war era of Reconstruction was traumatic in southern states, as they absorbed the cultural shock of military defeat. The victorious Union army could have crushed the South and eradicated every vestige of its patrician culture of racism. But the South was spared the indignity of total humiliation. The North opted for a more pragmatic approach. Instead of destroying the South's culture, the North left the old Confederacy largely free to maintain its social structures and racist ideology. This was achieved through the construction of a cultural myth known as the "Lost Cause of the Confederacy."[14]

The Lost Cause myth provided southerners with a noble narrative about honor and chivalry that made the trauma of defeat more bearable. For the victorious North, the Lost Cause bargain facilitated national reconciliation by allowing the South to preserve its antebellum culture while integrating into the Union on its own terms. The Confederacy had lost the war on the battlefield, but won the war for official memory.

Southern elites crafted a revisionist history of the Civil War. Its template was supplied by Edward A. Pollard, a journalist for the *Richmond Examiner.* In 1866, Pollard's book *The Lost Cause: A New Southern History of the War of the Confederates* provided a narrative guidebook on how southerners should remember the war.[15] The book framed the conflict as a war of Northern aggression in which southerners were defending their cherished values. They were not defending slavery; they were simply protecting the constitutional principle of "states' rights."[16]

Statue mania played an important role in promoting collective memory around the Lost Cause narrative. Starting in the 1880s, as southern states began adopting Jim Crow laws to disenfranchise freed African slaves, an ambitious

rollout of Confederate statues added monumental symbolism to a reassertion of White supremacy. The earliest monuments went up in cemeteries, but soon heroic statues of Civil War generals were dominating public spaces. Their function was to militarize memory of the Confederacy. One of the first "commander" monuments was the massive Robert E. Lee equestrian statue unveiled in Richmond in 1890.[17] Confederate statues were often erected outside courthouses, thus establishing symbolic proximity between monumental and institutional power. Their inauguration was frequently accompanied by official ceremonies, public parades, and society balls. At the height of the statue mania period between 1885 and 1915, some 500 Confederate statues and monuments were erected in the South.[18]

Patrician White women in the South were a driving force behind statue mania campaigns. Influential groups such as the United Daughters of the Confederacy actively sponsored the financing of public monuments. The UDC, as it was known, was founded by thirty women in 1894. Its leaders were usually blue-blooded daughters or granddaughters of Confederate generals and politicians. They exerted influence on everything from shaping the narratives in history schoolbooks and placing portraits of Confederate leaders in classrooms to erecting statues in public places.[19] In Richmond, the Ladies Lee Monument Committee played a leading role in financing the Robert E. Lee statue. A massive crowd of 100,000 attended the Lee statue's inauguration.

The UDC also solicited sculptor Gutzon Borglum to carve a Confederate memorial sculpture on Stone Mountain in Georgia. Stone Mountain was a sacred Ku Klux Klan site where annual cross-burning ceremonies took place every Labor Day. Borglum, an Idaho-born Mormon of Danish origin, was a KKK member and held strong xenophobic "nativist" attitudes forged by his belief in Anglo-Saxon superiority. The Stone Mountain monument was a dress rehearsal for Borglum's next big project: Mount Rushmore. At Stone Mountain, Borglum sculpted a massive bas relief statue of three Confederate leaders—Jefferson Davis, Robert E. Lee, Stonewall Jackson—into the granite on the mountain's north face.[20]

African Americans contested Confederate monuments almost from the outset. In 1905, the African American newspaper *Chicago Defender* declared: "Every Confederate monument standing under the Stars and Stripes should be torn down and ground into pebbles."[21] Another contentious issue was the erection of statues of Black Americans. At the end of the nineteenth century, slaves were sentimentalized for their faithful servility during the Civil War.[22] In 1927, a so-called "good darky" statue was unveiled in Natchitoches, Louisiana, in honor of a dutiful family servant known as "Uncle Jack." The bronze statue, showing Uncle Jack deferentially tipping his hat, was inscribed: "Erected by the City of

Natchitoches in Grateful Recognition of the Arduous and Faithful Service of the Good Darkies of Louisiana." During the Civil Rights era in the 1960s, Black activists vandalized the Uncle Jack statue. The mayor of Natchitoches had the statue removed, and it was put into storage. In 1974, it found a home at the Louisiana State Rural Life Museum in Baton Rouge, though its presence there has not been uncontroversial.[23]

As pressures to remove Confederate monuments increased, some cities sought compromise solutions by embellishing public squares with "counter monuments" of African Americans. In Richmond, a statue of Black tennis star Arthur Ashe was erected in 1996 on Monument Avenue near the Robert E. Lee monument. Ashe, who was from Richmond, won the Wimbledon and U.S. Open tournaments before his early death in 1993. The twelve-foot bronze statue depicted Ashe holding up a tennis racket and a book while cheered by a circle of children—thus emphasizing the importance of education and sports.

Two decades later in June 2015, a mass shooting of African Americans by a White supremacist in Charleston, South Carolina, provoked calls for the removal of Confederate flags and statues in the South. In Virginia, the Charlottesville city council voted in early 2017 to remove the equestrian statue of Robert E. Lee from a park and rename it "Emancipation Park." But the Sons of Confederate Veterans challenged the decision in the Virginia courts and sought injunctions against the statue's removal. A few months later in August, neo-Nazis held a "Unite the Right" rally in Charlottesville to defend the same statue. They were confronted by anti-racist protestors including Black Lives Matter activists. When the two sides clashed, a White supremacist drove his car into a group of protestors and killed 22-year-old protestor Heather Heyer.

In the aftermath of these tragic events, families of Confederate generals pleaded with authorities to have statues of their controversial ancestors removed. The wheels of bureaucracy were slow, however, and the statues remained standing. There were also legal obstacles. As the Sons of Confederate Veterans court challenges demonstrated, even when city councils voted to have statues removed, judges ruled in favor of those who were seeking to have them left unmolested. In Virginia, the courts prohibited the removal of war memorials by citing a law on heritage protection.

Statues with no symbolic connection with the Confederacy were also vandalized in 2017. In New York City, protestors defaced a statue of Christopher Columbus in Central Park. They covered one hand with red paint and inscribed "hate will not be tolerated" and "#somethingscoming" on the pedestal. Anticipating further violence, New York mayor Bill de Blasio announced that the Columbus Circle statue in Manhattan may have to be removed. The monument, a classic of the statue mania era, was erected in 1892 to commemorate the 400th anniversary of Columbus's discovery of America. The mayor's announcement

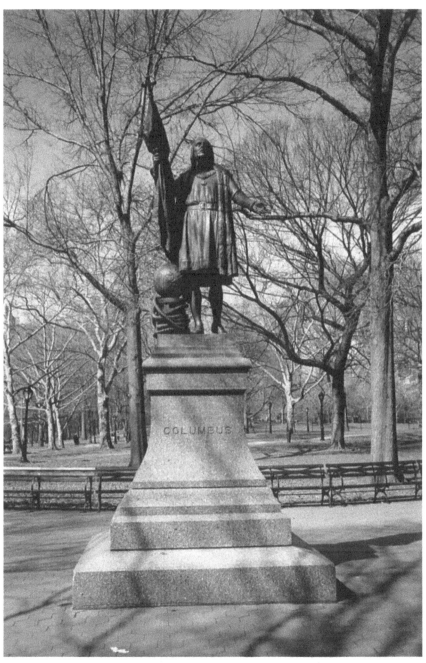

Statue of Christopher Columbus in Central Park, New York City. *Photo by Karl Doringer, Wikimedia Creative Commons.*

provoked outrage in New York's Italian community, for whom Columbus was an iconic figure of civic pride.[24] The Columbus mythology provided immigrant Italian Americans with a legitimate claim to citizenship in their new homeland in the early twentieth century when they often faced negative discrimination.

Three years later in 2020, following the statue-smashing fury ignited by George Floyd's murder, New York state governor Andrew Cuomo ordered police protection for the 76-foot Columbus Circle monument. It was also added to New York's register of protected historic monuments. In New York City, Christopher Columbus statues were now safe.[25]

"I understand the feelings about Christopher Columbus and some of his acts, which nobody would support," Cuomo told the press. "But the statue has come to represent and signify appreciation for the Italian-American contribution to New York."[26]

The Columbus mythology in America was fabricated long before the first wave of Italian immigrants arrived in New York in the late nineteenth century. The first iconography behind the Columbus myth portrayed him as a symbol of American nationhood. Statues of the legendary explorer represented him as a classical female deity named "Columbia," who resembled the Roman goddess of wisdom, Minerva. The allegorical "Columbia" was, following the tradition of gendering nations as female, the equivalent of the female "Marianne" figure in the French Republic. Naming places and institutions "Columbia" signified liberty and progress. In 1784, King's College in New York City was renamed Columbia—or today's Columbia University.[27] George III was out, Christopher Columbus was in. Two years later, South Carolina named its capital Columbia. The nation's capital—Washington, District of Columbia—combined the names of two mythic figures in America's foundation narrative.

In the nineteenth century, the Columbus myth followed America's western expansion. Columbus was no longer a female allegorical figure; he was now a masculine symbol of rugged exploration and Manifest Destiny. Cities in Ohio, Arkansas, Missouri, Wisconsin, Indiana, and other states were named after Columbus. In 1828, author Washington Irving boosted the cult of Columbus with a multivolume *A History of the Life and Voyages of Christopher Columbus*. It was so successful that it enjoyed thirty-nine printings and was translated into eight languages. The image of Columbus appeared throughout the country in public statues, paintings, and historical murals. By the end of the century, twenty-eight Columbus monuments had been erected in American cities. In 1893, Chicago held the World Columbian Exposition to celebrate the 400th anniversary of Columbus's discovery of America.

The third incarnation of the Columbus mythology was related specifically to the collective identity of Italian Americans—and immigrant patriotism more generally.[28] As Italian immigrants poured into the United States, they embraced

Columbus as their unofficial patron saint. In 1892, President Benjamin Harrison declared "Columbus Day" as a one-time national holiday, perhaps to heal the wounds from a year earlier when eleven Italian Americans were lynched in New Orleans. The first Columbus Day celebration, in fact, had been held in New York a century earlier in 1792, sponsored by the local Columbian Order (Tammany Hall) to celebrate the 300th anniversary of America's discovery. By the 1860s, annual Columbus Day parades were held in New York with both Italian and American flags. In 1876, Italian Americans in Philadelphia erected a 22-foot Columbus statue at the city's fair site. By 1910, Columbus Day was a holiday in fifteen states; by the late 1930s, it was celebrated by thirty-four states. In 1937, President Franklin Roosevelt declared Columbus Day a national holiday under pressure from the Catholic fraternal organization Knights of Columbus. Finally, in 1964 it was made a statutory holiday every October 12.

The cult of Christopher Columbus has since become highly divisive in American society. Columbus is a revered figure for many Americans, but his legacy is fiercely contested in the indigenous population and by the college-age generation.[29] In 1992, which marked the 500th anniversary of Columbus's discovery of America, the city of Berkeley, California, became the first local jurisdiction to drop Columbus Day. Berkeley replaced it with "Indigenous People's Day." Today, more than 70 cities in the United States celebrate "Indigenous People's Day." The statue of Columbus erected in Philadelphia in 1876, like many other Columbus statues, has been the object of controversy. Following the murder of George Floyd in 2020, city officials moved to dismantle the statue and put it in storage. After a legal dispute, a judge blocked the statue's removal as illegal. The city surrounded the statue with plywood, and its fate remained uncertain.[30]

When the iconoclastic fury through the last half of 2020 subsided, nearly one hundred monuments had been removed throughout the United States— some by democratic vote, others toppled in spontaneous acts of violence. That was roughly twice as many as the number of statues pulled down over the previous four years.[31]

In the South, meanwhile, an estimated 800 monuments commemorating the Confederacy are still standing today.[32] Most will remain standing for the foreseeable future—unless a dramatic event triggers another iconoclastic explosion of rage.

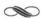

In Bristol, the stone plinth on which the Edward Colston statue stood did not remain vacant long.

A few weeks later, a statue of a Black woman with her pumped fist raised in the air appeared on the pedestal. It was the work of artist Marc Quinn, who

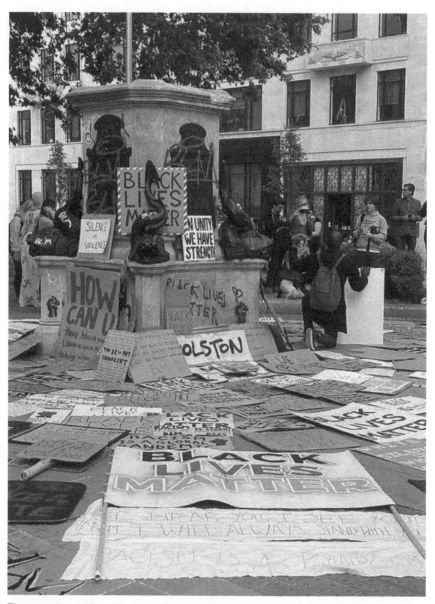

The empty pedestal of the Edward Colston statue in Bristol the day after protesters toppled and tossed it into the harbor. *Photo by Caitlin Hobbs, Wikimedia Creative Commons.*

made the resin-and-steel sculpture named "Surge of Power." Quinn installed the statue on the empty plinth in a stealth operation at five o'clock in the morning.[33]

Bristol's mayor, Marvis Rees, was quick to state publicly that the new statue was not authorized. While he was careful to say that he regarded the toppling of the Colston statue as a "piece of historical poetry," the mayor said he was opposed to the replacement statue on the Colston plinth. Praised by some, criticized by others as a PR stunt, the unauthorized statue was taken down within twenty-four hours.[34]

The toppled Colston statue, meanwhile, was fished from its watery grave in the Bristol harbor and placed in storage. A year later in June 2021, it reappeared in public at Bristol's M Shed museum. The city also set up a "We Are Bristol History" commission to decide the statue's long-term future. "The display is not a comprehensive exhibition about Colston or transatlantic slavery in Bristol," said commission chair Tim Cole. "But it is intended to be a departure point for continuing conversations about our shared history."[35]

Four protestors arrested and charged for pulling down the Colston statue— called the "Colston Four"—were acquitted in a Bristol court in January 2022. Their lawyers successfully argued that their actions were not criminal because they were "on the right side of history." Britain's Tory government, which had been pushing for stiffer penalties for vandalizing statues, vowed to close a loophole to ensure that statue-topplers don't go unpunished. The publicity surrounding the Colston statue, meanwhile, hugely increased its value as a sculpture. Following the acquittal of the "Colston Four," the statue's value was estimated at $400,000—more than fifty times than before it was toppled.[36]

At Oxford University, meanwhile, students were renewing protests for the removal of a Cecil Rhodes statue at Oriel College. Rhodes was a nineteenth-century British imperialist in South Africa, where he pushed Africans off their lands to expand his diamond concessions. In 2015, a "Rhodes Must Fall" campaign was launched at universities in South Africa. The same year, graffiti activists attacked and defaced the Rhodes Memorial in Cape Town, slicing off his bronze nose.[37] Five years later, Rhodes's bronze head was decapitated, but later recovered and reattached. The "Rhodes Must Fall" campaign spread to Oxford, where his name was famous for the Rhodes Scholarship. Oriel College refused to remove the Rhodes statue despite the protests, citing the potential loss of $135 million in gifts.

In the wake of the Black Lives Matter statue-smashing protests in 2020, there were fresh calls for the Rhodes statue to be removed. But Oriel College once again refused. The college said it would instead work on the "contextualization" of its relationship with Rhodes. Activists called the decision a "slap in the face." A few months later, the college added an explanatory plaque to the statue describing Rhodes as a "committed British colonialist" who obtained his

fortune through the "exploitation of minerals, lands, and peoples." While activists claimed the description was too gentle, some argued that the plaque was unbalanced because it didn't describe Rhodes's virtues as well as his vices.[38] In the end, few were happy with the result.

In the United States, the monument of Confederate general A.P. Hill in Richmond presented a uniquely ghoulish challenge. General Hill, from a slave-owning family in Virginia, was killed in battle fighting the Union army in April 1865, a week before the South surrendered. In 1892, his remains were exhumed from a Richmond cemetery and interred under a monument erected in his honor in the city's north end. At the unveiling, General Hill was praised as "a worthy comrade of that bright galaxy of leaders which made the name and fame of the Southern Confederacy immortal forever." [39] More than a century later in 2021, plans to remove the statue standing at the center of a traffic circle presented a delicate issue. The monument was also a burial site. Dismantling the statue required the exhumation of A. P. Hill's body for a second time. In early 2022, the city finally voted to remove the monument and General Hill's remains at a cost of $1.5 million.[40] A. P. Hill was to be buried, for a third time, at a cemetery in the Virginia town where he was born, Culpeper.

Digging up the remains of Confederate generals recalled the gruesome aspects of damnatio memoriae sentences in Renaissance Italy, when corpses of disgraced figures were exhumed and buried outside the city limits. This was the dilemma faced by local authorities in Memphis, Tennessee, after calls for the removal of yet another combined monument and burial site of a Confederate general. In this case, the military figure was Nathan Bedford Forrest. For more than a century, a Forrest statue had towered over a Memphis park named after him. Forrest was not only a Confederate general, he was also a slave trader and Grand Wizard of the Ku Klux Klan. His statue and burial site had long been contentious in Memphis, and the city's Black residents demanded the removal of both statue and gravesite.

The Forrest monument was finally taken down in 2017, but the Confederate general's remains were left undisturbed. The Sons of Confederate Veterans threatened lawsuits for violating a gravesite if anyone attempted to have General Forrest exhumed. The matter was made more delicate by an additional complication: Forrest's wife Mary was also buried under the monument. In June 2021, the Sons of Confederate Veterans agreed to a compromise. The two coffins would be disinterred and moved to the National Confederate Museum in Columbia, Tennessee. The exhumation did not go without incident, however. At the gravesite during the disinterment, Black Lives Matter protestors traded insults with Sons of Confederate Veterans members.[41]

The massive equestrian statue of Robert E. Lee in Richmond was the most controversial. The Lee monument, too massive to pull down, was defaced and

Equestrian statue of Robert E. Lee in Richmond, Virginia, covered in graffiti. *Wikimedia Creative Commons.*

covered with graffiti to deprive the statue of its symbolic authority. Protesters spray-painted epithets on the monument ("Stop killing us") and left their paint canisters for others to add new layers of messages. The letters *BLM* were emblazoned on Lee's horse, and images of George Floyd and abolitionist Harriet Tubman were projected onto the massive pedestal.

The area surrounding the Robert E. Lee monument quickly took on a festive ambiance as local residents turned the square into a community space with food stands, voter registration tents, basketball hoops, and even a pop-up library. The statue served as a backdrop for everything from photo shoots and kaleidoscope projections to gospel sermons and ballerina performances.[42] The monument's defacement by local residents was a form of modification that transformed the statue's meaning. The site even became a place of pilgrimage. Its protest iconography gave a tourism boost to the city of Richmond.

The question of what to do with the Robert E. Lee statue was unresolved, however. Despite the social transformation of the site, the Confederate general remained atop his horse with a commanding view of Richmond's tree-lined Monument Avenue. In the short term, the city-owned monument was protected by court injunctions, but its fate was finally settled after state Supreme Court rulings cleared the way for its removal. In early September 2021, cranes lifted the enormous 12-ton statue from its pedestal. A crowd of onlookers cheered as the bronze statue came off its plinth for the first time since 1890. After being carefully lowered to the ground, it was cut into pieces before being hauled off to a secure facility while awaiting a permanent home.

Robert E. Lee's presence in Richmond hadn't vanished entirely. The monument's enormous marble base was left intact. Local Richmond officials said the pedestal would remain in place until the entire Monument Avenue area was "reimagined" with new narratives expressed by different kinds of public art.[43] In nearby Charlottesville, that town's Robert E. Lee statue was removed in 2021 and melted down to be transformed into public art as part of a project called "Swords into Plowshares." The project's stated goal was to "transform a national symbol of White supremacy into a new work of art that will reflect racial justice and inclusion."[44]

The removal of these Robert E. Lee statues marked a symbolic rupture with the statue mania culture that had erected Confederate monuments throughout the South. Many Confederate statues remained standing in southern states, but the Lost Cause ideology was now officially dismantled.

And yet, as with all iconoclastic legacies, it won't likely be a final ending. It could well be a new beginning, perhaps even the start of another cycle of struggles over collective memory and historical narratives. If iconoclasm has one enduring lesson, it's that the destruction of venerated statues invariably leads to new and unexpected forms of idol veneration.

CHAPTER 14

Memorial Mania

On a June morning in 1920, John Robinson's traveling circus rolled into the town of Duluth, Minnesota, for a one-day stop.

Self-advertised as "America's first and foremost circus," it boasted dens of wild beasts including performing elephants, camels, and a baby hippopotamus named Congo. In the morning, a local parade celebrated the circus's arrival in town before the big top opened after lunch. Performances continued all day from 2 p.m. till 8 o'clock.

After the show that evening, a local teenaged boy named Jimmie Sullivan went behind the main circus tent with his girlfriend, Irene Tusken. Sullivan later told police that he and Irene were attacked by six Black men. He claimed that they held him at gunpoint while they raped Irene.

The police immediately rounded up several Black circus employees and put them in a lineup. Tusken and Sullivan found it difficult to identify their alleged attackers. But police charged six of the Black men with the crime and put them in jail.

In small-town Duluth, word that a local White girl had been gang-raped by Black men spread quickly. The next day, a mob of nearly 10,000—about one-tenth of the town's population—gathered outside the police station where the accused Black men were being held. Wielding bricks and timbers, the mob stormed the building and overpowered the guards. Three of the Black men— Elias Clayton, Elmer Jackson, and Isaac McGhie—were pulled from their jail cells. All three were "roustabout" laborers traveling with the circus. The mob dragged them into the streets, beat them, then lynched them on an electric light pole. Following the lynching, locals posed for photographs, standing beside the bodies like hunters with their trophy kills.

The public lynching of Black men in America—called a "necktie party" or a "Negro barbecue"—was a widespread form of racist violence throughout the

United States from the 1880s to the 1930s. Lynchings frequently were treated as macabre rituals that attracted entire families who came to view hanged bodies in a carnival spirit that included picnics.[1] Photos of limp bodies of lynching victims were printed on postcards and distributed widely to strike fear into the hearts of African Americans. Criminal investigations into these crimes were rare. Following the lynching in Duluth, three White men were tried and convicted, but not for murder. They were charged with "rioting." Each served a sentence of less than fifteen months in prison.

In October 2003, eight decades after the incident, a monument was unveiled in Duluth to memorialize the three victims of the lynching. Located across the street from the spot where the lynching occurred, the monument features life-size statues of Elias Clayton, Elmer Jackson, and Isaac McGhie. The pavement is inscribed with three words: *respect, compassion, atonement.* Surrounding the statues, a quote in large letters cites the philosopher Edmund Burke: "An event has happened upon which it is difficult to speak and impossible to remain silent."

The inauguration of the Clayton Jackson McGhie Memorial was attended by three thousand residents of Duluth. One of the descendants of the lynch mob in 1920 delivered a speech of apology. "True shame is not in the discovery of a terrible event such as this, but in the refusal to acknowledge and learn from that event," said Warren Read, whose great-grandfather Louis Dondino, a local businessman, was charged and jailed for organizing the riots before the lynching. "I stand here as a representative of my great-grandfather's legacy, and I willingly place that responsibility upon my shoulders."[2]

The memorial in Duluth could never have been erected in the years following the event. America in the 1920s was a deeply segregationist society. Public memory of the Duluth lynching was kept alive over the decades, however, in popular culture. Bob Dylan, who was born in Duluth, referred to the lynching in his 1965 song "Desolation Row." A few decades later in the 1990s, a new culture of collective memory was taking root in America. The lynching in 1920 was a stain on collective memory that evoked emotions of shame. A book about the lynching was published in 2000, followed by a surge of community activism that led to the construction of the memorial.[3] The monument was the first large-scale public memorial in the United States commemorating a lynching.

Today, memorials are omnipresent in American public spaces. They commemorate every conceivable injustice—from the lynching of African Americans and executions of witches to victims of mass shootings and terrorism. Like the Duluth memorial, these monuments are physical expressions of public feelings that make emotional claims on social justice and seek to shape new narratives of shared memory.

Obsession with memorialization is a defining trait of our age. Our culture is consumed with collective memory and the emotions it evokes. In the past,

statues and monuments played a vital role in forging identity around shared memory. Today, however, the nature of public memory has fundamentally changed. We have shifted from a culture of "statue mania" and its glorification of civic and military heroism to a new culture of memory aptly described as "memorial mania."

Statue mania, as we saw in the previous chapter, provided the monumental adornments of nineteenth-century nation-building and its civic cult of "great men." Statue mania was an expression of Nietzsche's "monumental" history: erecting symbols of "mythic fiction" meant to glorify and inspire. Memorial mania, by contrast, corresponds to Nietzsche's category of "critical" history. It is, observed Nietzsche, history for those who are "suffering and in need of emancipation."[4] Critical history brings the past before a tribunal to judge and condemn it. Memorial mania constitutes an iconoclastic rejection of statue mania's underlying values and symbols. Whereas statue mania venerates heroic figures from history's grand narratives, memorial mania commemorates identity groups in specific social categories. Statue mania glorifies history's victors; memorial mania commemorates its victims.

Historian Erika Doss describes memorial mania in the United States as "an obsession with issues of memory and history and an urgent desire to express and claim those issues in visibly public contexts." Many public memorials today are visual symbols that make demands for recognition and respect. "Driven by heated struggles over self-definition, national purpose, and the politics of representation," observes Doss, "memorial mania is especially shaped by the affective conditions of public life in America today: by the fevered pitch of public feelings such as grief, gratitude, fear, shame, and anger."[5]

While pervasive in the United States, memorial mania is neither new nor uniquely American. Public memorials have been erected for centuries. Every great military conflict has been followed by a proliferation of monuments commemorating those who fell on the battlefield. After the American Civil War, the country was covered in "Standing Soldier" statues to memorialize the dead. In Paris, a "Communards' Wall" memorial can be found in Père Lachaise cemetery, where, in May 1871, 147 insurrectionists were lined up and executed by firing squad. In London, the Cenotaph was erected in Whitehall in 1920 to memorialize those killed in the First World War, like the eternal flame and Tomb of the Unknown Soldier at the Arc de Triomphe in Paris.

Memorials are sometimes monumental projects erected at great public expense, such as the reflecting pools at New York's World Trade Center commemorating the victims of the 9/11 terrorist attacks. Sometimes memorials are spontaneous and ephemeral, impromptu shrines designed as symbols of collective grief. Following the Columbine High School shooting tragedy in Colorado, for example, local residents transformed a nearby park into a shrine covered with

flowers, balloons, soccer balls, sneakers, and offerings of all kinds. In some cases, existing monuments are appropriated to serve as memorials for tragic events that have no association with the monument. This happened after Princess Diana's tragic death in an underpass tunnel in Paris. Following the accident, mourners transformed a nearby statue of a gold flame at Place de l'Alma into a shrine, leaving candles, messages, and photos of Princess Diana. Today the flame statue still serves as a Princess Diana memorial that attracts tourists every day. The flame statue had been standing in Place de l'Alma for a decade before the tragic accident. A replica of the Statue of Liberty's torch flame, it was a gift to Paris from the *International Herald Tribune* newspaper in 1987 as a symbol of Franco-American friendship. To this day, tourists who visit the site believe the flame was erected as a memorial to Princess Diana.

The obsession with collective memory today marks a "cultural turn" toward much more intense forms of public feelings that seek expression in memorials.[6] Memorial mania is moreover unique in its wide range of emotions that make demands for recognition in public monuments. In the past, collective mourning and gratitude animated public memorialization to promote social cohesion around shared experience and common values. Today's memorials, by contrast, are emotionally volatile and often hostile to the past. Memorials today are not always meant to inspire reverence and respect. They are emotional calls for social change, moral accountability, and correction of perceived injustices.

The wide range of emotions that drive memorial mania—grief, gratitude, fear, shame, anger—explains the proliferation of monuments in recent years. Monuments are erected to satisfy a great diversity of social demands seeking publicly visible recognition. In Washington, DC, alone, the capital has been transformed into an urban gallery of memorials of every conceivable kind. A Victims of Communism memorial, featuring a bronze "Goddess of Democracy" holding a torch aloft, can be found a few blocks from the Capitol building. There is also a Black Revolutionary War Patriots memorial, a Victims of the Ukrainian Famine-Genocide memorial, and an American Veterans Disabled for Life memorial. In the 1980s, there were so many memorials in the U.S. capital that Congress passed a Commemorative Works Act to restrict their number. If the 1986 law limited to some degree the mania for new monuments in the capital, memorials have continued to proliferate throughout the United States.

In the United Kingdom, too, statues have mushroomed everywhere over the past few decades. In 2004, the term *statue mania* was revived to describe the explosion of monuments in Britain—not a return of Victorian statues featuring allegorical figures and great men on horseback, but a proliferation of outlandishly new kinds of public art closely allied with the values of memorial mania.

Why so much new public art in Britain? According to *The Economist*, the British elite was "promoting public art in an attempt to plug the hole in public

life."[7] If a community group proposed an idea for a statue, it was approved, created, and unveiled. In the 1970s, some eighty-four public artworks and statues appeared in Britain. In the 1980s, the number jumped to 185. In the 1990s, it soared to 659 new public works of art. The statue mania revival in Britain shared with its Victorian version a cultural *horror vacui*—or fear of empty spaces.

"Public artworks are springing up everywhere in Britain's towns and cities," wrote Josie Appleton in 2004. "Victorian statues of royalty, local philanthropists and military heroes have had the rule of public places for over 100 years. Now they are fighting for space with modern sculptures."[8]

Fifteen years later in 2019, *The Economist* magazine took another look and concluded that Britain was in the midst of a "Victorian-style statue mania." Despite the comparison with nineteenth-century monuments, public sculptures in Britain today bear little resemblance to the Victorian era's penchant for heroic figures in public squares.[9] Many are contested for their poor aesthetic quality, and their diversity of design and purpose frequently sparks disputes. When a statue of eighteenth-century feminist Mary Wollstonecraft went up in a London park in 2020, many were outraged by the tiny figure of a nude woman perched atop a large mass of silver. It bore no resemblance to the author of *A Vindication for the Rights of Women*. The statue was so contested by locals that a crowd-funder was launched to have an alternative erected.[10] A statue of former British prime minister Margaret Thatcher was controversial for different reasons. The 10-foot bronze statue, commissioned after Thatcher's death in 2013, was intended for a spot in Parliament Square. But the local Westminster Council turned down the statue, fearing it would become the target of vandals. Thatcher's hometown of Grantham finally agreed to take it. But that plan, too, met with local resistance. Six years after it was created, the statue remained in limbo without a home.[11]

Unlike public monuments of the statue mania era, memorial mania does not seek to forge a broad civic identity around shared memory. Memorials today represent the feelings and emotional claims of specific segments of society. They are not symbols of unity, but of division. They don't forge a consensus around shared values; they create tensions between opposing values. As reactions to the Margaret Thatcher statue demonstrated, they can even trigger iconoclastic resentment.

Memorialization, in that respect, is ideologically aligned with iconoclasm. An illustration of this fusion between iconoclasm and memorialization is the Custer Battlefield Monument in Montana. It commemorates the famous "Custer's Last Stand" battle in 1876 against the Cheyenne, Arapaho, and Lakota natives. The obelisk at the battlefield site, erected in 1879, memorialized the legendary U.S. cavalry commander George Custer. In reality, as history records, Custer lost the battle. The natives under chiefs Sitting Bull and Crazy Horse defeated the U.S. cavalry. Custer was shot in the chest and killed in the battle.

The victorious native warriors slaughtered and ritually mutilated some 270 of his men. And yet the "Custer's Last Stand" myth persisted in American historical legend glorifying the heroic U.S. cavalry in their wars against the menacing Native Americans.

In the 1970s as the centenary of the battle approached, Native American groups began protesting for a monument commemorating their fallen dead in the battle they had won. In 1976, native protestors disrupted the battle's 100th anniversary commemoration at which George Armstrong Custer III laid a wreath at the spot where his famous ancestor was killed.[12] Twelve years later in 1988, native activists dug a hole near the monument, filled it with cement, and laid a plaque inscribed: "In honor of our Indian Patriots who fought and defeated the U.S. Cavalry."[13] Native American iconoclastic anger at the old Custer memorial changed the historical narrative. In 1991, the name of the Custer Battlefield monument was finally changed to "Little Bighorn." Custer's Last Stand was henceforth called the Battle of Little Bighorn.

Meanwhile, a massive monument to the battle's victor, Crazy Horse, was being sculpted on a massive rock in the Black Hills of South Dakota. The Crazy Horse Monument, commissioned by Lakota chief Henry Standing Bear in 1948, remains incomplete. If the work is ever finished, it will show Crazy Horse on horseback with one outstretched arm making a claim on his ancestral lands. The monument is described as the Native American answer to Mount Rushmore carved into the granite face of a nearby Black Hills mountain. The close proximity of Crazy Horse and Mount Rushmore demonstrates that idolatry doesn't always provoke iconoclastic destruction. It inspires rivalrous idolatry.[14]

In New York City, a bronze statue of Medusa holding the severed head of Perseus offers a jarring illustration of how monuments can be culturally appropriated to express powerful emotions in the name of social justice. The statue, unveiled in 2020, depicted a seven-foot naked Medusa holding a sword in one hand and a severed male head in the other—an allusion to the Greek myth, but reversing the narrative. In the ancient myth, the hero Perseus decapitates the gorgon Medusa. The statue switched the roles to make Medusa the victor. The visual reversal of fortunes brought the myth into a modern setting to make a bold and dramatic feminist statement. The Medusa statue's location, in Collect Pond Park across from the New York courthouse, was unmistakably symbolic. The disgraced Hollywood movie mogul Harvey Weinstein was being tried for sexual assault in one of the building's courtrooms. For most people who contemplated the statue, Medusa was a #MeToo symbol of feminist frustration, anger, and revenge against male sexual predators.

The Medusa statue was the work of Argentine sculptor Luciano Garbati and erected as part of New York City's "Art in the Parks" program. Garbati had created the resin-and-fiberglass statue more than a decade earlier in 2008. At

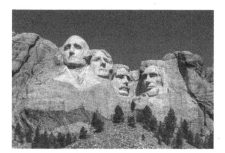

Mount Rushmore. *Photo by Thomas Wolf, Wikimedia Creative Commons.*

The Crazy Horse Monument in the Black Hills, South Dakota. *Wikimedia Creative Commons.*

that time, his Medusa was not meant to symbolize feminist vindication. He was reversing the Medusa myth with specific allusion to Cellini's sixteenth-century sculpture in Florence's Piazza della Signoria. Cellini's bronze sculpture, faithful to the Greek myth, shows Perseus stepping on the body of Medusa while holding her severed head aloft in a gesture of victory over the gorgon. A decade after Garbati created his statue, its meaning was unexpectedly politicized in a viral internet meme. The meme showed his Medusa with the caption, "Be grateful we only want equality and not payback."[15] Online virality gave the statue a second life and new meaning.

When the Medusa statue appeared in Lower Manhattan, it was reimagined as a feminist #MeToo memorial to victims of sexual assault. The triumphant Medusa was a symbol of feminist anger and catharsis.[16] Some criticized the Medusa because the modern-looking female figure looked like a naked fashion model. They claimed that the sexualization of Medusa was an invitation for the "male gaze"—precisely the opposite of a feminist message. Most viewers, however, regarded the Medusa as an emotionally charged feminist icon with a mythologically implied threat of violence to male sexual predators. The sculpture's installation in Lower Manhattan was only temporary, however, and was removed in April 2021. But the controversy it provoked demonstrated how statues can take on new meaning when appropriated and reinterpreted in different contexts.

Not far away in Manhattan's Union Square, an installation of three busts standing ten feet high appeared in the autumn of 2021. The gold busts made of precision-cut wood were the heads of George Floyd, Breonna Taylor, and John Lewis. Lewis was the legendary civil rights figure and Congressman, and both

George Floyd and Breonna Taylor were victims of police violence. Sponsored by the Confront Art project aimed at "connecting artists to social justice," the installation was called *See Injustices*. The installation was positioned directly in front of an equestrian statue of George Washington erected in 1856. The juxtaposition contrasted two fundamentally different kinds of public statuary: on the ground, the emotionality of contemporary memorial mania in the three busts; and hovering above, the historic heroism of nineteenth-century statue mania in the figure of George Washington. Two days after the installation's inauguration, the George Floyd bust was defaced with gray paint. It had previously been put on public display in Brooklyn, where it was defaced with black paint.[17]

The vengeful Medusa and *See Injustices* installation in Manhattan demonstrated that memorial mania isn't simply a new aesthetic approach to public statuary. It's a cultural ideology whose values about monuments are shaped by public feelings and emotional claims on social justice.

If memorial mania marked a "cultural turn" in values about public monuments, it must be possible to pinpoint the beginning of this movement and trace its origins.

The statue mania era was largely over by the 1930s. Following the Second World War, monuments in many countries were focused on memorialization of those who had served in both world wars. In Allied nations, they promoted social cohesion and collective memory around the shared values that had defeated fascism and tyranny in the name of democracy and freedom.[18]

By the 1960s, younger generations were actively contesting traditional values, aesthetics, and institutions. The revolt against the past had begun with new artistic movements such as Abstract Expressionism and the Beat Generation, and followed in the 1960s with pop art, rock 'n' roll music, and the counterculture hippies. This generation was not interested in memorializing war; they were anti-war—especially the Vietnam War. Against this backdrop of anti-establishment revolt, traditional forms of statuary were declared officially dead. New movements in art were radically transforming the aesthetics of public spaces.

In the mid-1970s, photographer Lee Friedlander produced a book, *The American Monument*, featuring a series of photos of old statues on the country's urban landscape. Friedlander photographed dozens of bronze statues—for example, Father Francis Duffy in New York's Times Square—standing forlornly in new urban settings, hiding in plain sight, present but strangely invisible against a backdrop of neon signs, shopping malls, high-rise buildings, and Coca Cola billboards. Friedlander's camera captured statue mania monuments in a way that both paid tribute and eulogized. These statues from another epoch were ignored and neglected in the postmodern world.

The postmodern ethos of the 1970s shaped the wider zeitgeist that spread through the entire culture in the last few decades of the twentieth century. Attitudes toward statues and public art did not escape these influences. The postmodernist impact on memorial mania was powerful. It was driven by two factors: first, a revolt against rationalist Enlightenment values and the "grand narratives" of the past; and second, a deeply held belief in the primacy of personal identity and subjective feelings as a source of knowledge and truth.

The postmodernist movement regarded the Enlightenment with suspicion as a bourgeois European power structure whose legacy was capitalism and colonialism. Postmodernism was a revolt against the "modern" world and its universal values of reason and objective truth inspired by Enlightenment values. Postmodernists also contested—and sought to "deconstruct"—the narrative frameworks of the Enlightenment that shaped our understanding of history. The revolt found its origins in the ideas of Friedrich Nietzsche, who advocated breaking the shackles of grand narratives and traditional morality in favor of an assertive cult of individual fulfillment. It was also an expression of Nietzsche's "critical" history that sits in judgment of the past. These ideas were passionately embraced in the counterculture era of the 1960s and 1970s, when "do your own thing" was the slogan of youth rebellion.

The values underpinning statue mania represented everything that postmodernists were revolting against. The heroic monuments erected in the statue mania period were classic Enlightenment symbols. The Statue of Liberty in New York—an allegorical representation of Liberty as a symbol of universal values—was a quintessentially Enlightenment-inspired monument. It's no accident that statues of illustrious Enlightenment figures—such as Voltaire and Thomas Jefferson—have been targeted by activists in recent years. They are "great men" figures of "monumental" history that activists believe should be judged and condemned. In 2021, a seven-foot statue of Thomas Jefferson was removed from the council chambers of New York's city hall on the pretext that he owned slaves. Jefferson personally found slavery repugnant. In his first draft of the *Declaration of Independence*, he described slavery as an "execrable commerce" that "violated the most sacred rights of life and liberties."[19] But Jefferson, like George Washington, owned slaves who lived and worked on his Monticello estate. In today's cultural ideology profoundly hostile to Enlightenment values, statues of Jefferson, Voltaire, and other revered figures of that epoch are seen as tributes to White patricians of the colonial and racist past. They are regarded as embodiments of the grand narratives of monumental history that must be dismantled.

The postmodern movement was also a revolt against rationalism and objective truths. Postmodernist thinkers argued that all truths are individual and subjective. Nietzsche's championing of subjective truths laid the cornerstones of the movement's "deconstructionist" philosophy whose leading figures included French philosophers Michel Foucault and Jacques Derrida. Postmodernist

culture advocated emotion over rationality, subjectivity over objectivity, Dionysian passions over Apollonian reason. These ideas had a profound influence on the wider cultural zeitgeist that animated memorial mania and its emotional claims on public memory.

In keeping with the rebellious spirit of the 1960s and 1970s and the era's cultural bias in favor of experimentation, new ideas for public art flourished. In the last three decades of the twentieth century, a "public art" movement emerged and quickly filled urban spaces with innovative artworks and monuments. Artist Claes Oldenburg, for example, turned everyday objects—clothespin, plug, garden tool, lipstick—into public sculptures that challenged conventional ideas about public spaces. These sculptures also challenged modernism's insistence on the grand narratives of historical movements. Pop art was post-historical. There was no longer any distinction between art and objects from everyday life.

In urban landscapes cluttered with new-fangled objects, calls for social responsibility in public art became a new trend. Public art needed to stand for something. It needed gravitas. It could be omnipresent and outlandishly different, but it needed to have a message. This cultural proviso added a whole new dimension to public monuments. Interest groups, associations, and activists now regarded public places as extensions of their particular causes. They had emotional messages for the world, and now they could use public art to communicate them in innovate ways. Citizens groups began competing for claims on public spaces as spheres of visibility for their own values and interests.

On a practical level, the proliferation of public art was facilitated by technology. Statues and monuments were easier to produce with new materials. In the past, erecting an equestrian statue of a revered "great man" figure involved a lengthy process, sometimes taking years from conception to unveiling. Today, statues can go up spontaneously. In England, the pedestal of the toppled Edward Colston statue was vacant for only one week until the resin-and-steel *Surge of Power* statue of a Black female activist appeared on the plinth.

The internet also facilitates and accelerates the flourishing of public memorials. It is easy for citizen groups to use online petitions to mobilize support for new monuments. In 2016, British feminist Caroline Criado Perez was jogging with her dog in London's Parliament Square when she noticed that the statues were all men: Winston Churchill, Robert Peel, Benjamin Disraeli, Lord Palmerston, and so on. Criado Perez, who had already successfully lobbied to have novelist Jane Austen put on a British ten-pound bank note, pulled out her smartphone and created an online petition to have a statue of suffragist Millicent Fawcett unveiled among the men. Only two years later, a bronze statue of Fawcett—showing her holding up a banner that reads "Courage calls to courage everywhere"—was unveiled in April 2018.[20] The Millicent Fawcett statue was a perfect example of memorial mania culture. Public statues no longer glorify

history's winners—men like Winston Churchill and Lord Palmerston—they memorialize society's marginalized victims.

There is also a demographic component to the explosion of public art and memorials. Unlike in previous generations, today many competing groups are jostling for public recognition. By the 1980s, many countries had experienced a massive demographic explosion. The arrival of new immigrants created an ethnic and racial diversity that brought new demands for political participation. Diversity also brought pressures for new forms of recognition and memorialization. In Washington, DC, a National Japanese American Memorial was erected in 2000. In Newark, New Jersey, a 16-foot granite monument called "Ironbound Immigrants Memorial" was unveiled in 2018. It depicts fourteen men, women, and children waiting in line at Ellis Island as new arrivals to the United States from different countries. Monuments are the visible symbols of public recognition for ethnic groups who, once marginalized, are now accorded representation in public spaces.

The postmodernist ethos of subjective feelings and emotions brought other influences that germinated in academia before spreading into the wider culture. One was the academic discipline of "memory studies." Launched in the 1980s, a veritable "memory industry" has since flourished on American university campuses, where professors advocate new interpretations of "cultural history" through the remaking of historical imagination.[21] In the 1990s, cultural critic Andreas Huyssen observed a "memory boom" sweeping through the culture. "The notion of the monument as memorial or commemorative public event has witnessed a triumphal return," he observed.[22]

This cult of memory was promoted in opposition to history. History is suspect as a construct that emphasizes those who dominated the past. In short, the winners of the grand narratives—or Nietzsche's "monumental" history. Memory, by contrast, is a subjective sphere for personal feelings and emotions—and hence more authentic and closer to the "truth." The space of memory is inhabited by real people, often marginalized and disempowered, with genuine feelings and emotions that need to be recognized. History is a construct that is studied and interpreted; memory is a feeling that is "experienced" emotionally. The remaking of historical memory requires a critical "deconstruction" of the past and its values.

In the 1990s, so-called "affect theory" joined "memory studies" as an intellectual trend that swept through university campuses. Affect theory—from the Latin *affectus* for feelings—emphasizes the importance of emotions in personal, social, and political interactions. The fashionable term *affective turn* has become influential in a wide variety of academic disciplines from psychology and sociology to literary criticism.[23] Affect theory puts a postmodern spin on the ideas of seventeenth-century philosopher Baruch Spinoza, who established three

categories of affect: desire/appetite (*cupiditas*), pleasure/joy (*laetitia*), and pain/ sorrow (*tristitia*). While diverse in its applications across several fields, affect theory explores the sphere of feelings, passions, fears, dreams, religions, gender, sexuality, and identity. In the political arena, it attempts to explain the rise of emotionally charged populism, irrational conspiracy theories, and overheated debates in the boiling cauldron of social media.

By the first decade of the new century, two generations of university students had been steeped in these "critical" approaches and the cult of memory. As their influence spread, these ideas grew into a cultural ideology making claims in the political sphere through different forms of identity-based activism fueled by subjective feelings, collective memory, and grievances for past injustices. The influence spread into the creative arts and even journalism, where some argued that journalists should be skeptical about "objective" facts and instead be more "emotional" in their approach to news reporting.[24] The cultural obsession with memory and emotion has undoubtedly uncovered new ways of understanding the forces that shape the world, but it has many critics.[25] They point to its ideological character, arguing that it elevates collective memory of "marginalized" groups as authentic and hence above criticism. Memory creates new archives of public emotions that, unlike traditional historiography, will not tolerate dispute because they are considered exempt from contradiction. Also, if history is a mere construct, the same can be said of collective memory. Memory, like emotion, is often unreliable. Memory can also be fabricated. It can even be an illusion.

As this new cultural ideology moved out of university lecture halls and into the public sphere, it influenced ideas about how urban spaces should be conceived and used. The emphasis shifted away from public spaces as *historical* spheres devoted to civic heroes and national mythologies. The new trend was toward public spaces conceived as *cultural* spheres that give expression to citizen rights, shared memory, and public recognition for specific social categories. This shift reinforced memorial mania's obsession with public feelings. Public spaces today are conceived as arenas for passions, emotions, subjective identities, and collective memory.

This shift has not been without consequences. In a culture where public artworks, statues, and monuments evoke emotions, they inevitably provoke emotional reactions. They touch off strong feelings. They are sometimes found to be offensive. They can become objects of outrage, protest, defacement, and vandalism.

It was perhaps predictable that a memorial to Abraham Lincoln unveiled in Virginia's capital city would be controversial.

Richmond was, after all, the capital of the Confederacy. Lincoln's assassin, John Wilkes Booth, was a member of the local militia, known as the Richmond

Grays. More recently, Richmond was home to the contested equestrian statue of Confederate general Robert E. Lee.

The idea for a Lincoln memorial in Richmond was inspired by his second inaugural address in March 1865. Lincoln had won a second term, and the North had just defeated the South. His speech could have been triumphant, but it was remarkably conciliatory. Lincoln refrained from sounding like a victor in war. His inaugural address called on the nation to heal its wounds.

"With malice toward none, with charity for all," declared Lincoln, "with firmness in the right as God gives us to see the right, let us strive on to finish the work we are in, to bind up the nation's wounds, to care for him who shall have borne the battle, and for his widow and his orphan, to do all which may achieve and cherish a just and lasting peace among ourselves and with all nations."[26]

The bronze statue in Richmond, erected in April 2003 by the U.S. Historical Society, depicted a fatherly Lincoln seated on a bench with one arm around his twelve-year-old son, Tad. A granite wall behind them was inscribed, "To Bind Up the Nation's Wounds." The date of the unveiling in April was tied to the anniversary of Lincoln's historic "healing visit" to Richmond in 1865, shortly after his second inaugural address. Lincoln and his son Tad arrived in Richmond to discover a town devastated by war. Smoke was still rising from the ruins of battle

Lincoln Emancipation Memorial in Washington, DC. *Wikimedia Creative Commons.*

following the South's surrender. The southern army had burned the town to the ground rather than hand it over to Union troops.

Lincoln was instantly recognized in Richmond due to his tall height and top hat. Many freed Black residents rushed to greet him. One Black woman dropped to her knees and declared: "I know that I am free, for I have seen Father Abraham." Lincoln replied to the woman: "Don't kneel to me. That is not right. You must kneel to God only, and thank Him for the liberty you will enjoy hereafter." Scenes of ecstatic joy followed as other slaves freed from bondage approached Lincoln to touch him and shake his hand. Many White residents of Richmond remained indoors or looked on from their porches.[27]

Ten days after Lincoln's visit to Richmond, assassin John Wilkes Booth shot him in the back of the head in Ford's Theater in Washington, DC.

The unveiling of an Abraham Lincoln memorial in Richmond was meant as a symbol of reconciliation, but inevitably it opened old wounds. Rebel yells of protest rose up against the memorial. Confederate sympathizers denounced Lincoln as a "war criminal." They compared him to Saddam Hussein, Obama bin Laden, and Adolf Hitler. Some 3,000 Richmond residents signed an online petition against the statue. "Build a John Wilkes Booth statue instead," one of them wrote. A member of the White supremacist League of the South described the memorial as "whole-hog capitulation to the Lincoln fable."[28] When the Lincoln statue was unveiled, a hundred members of the Sons of Confederate Veterans defiantly held a vigil at Confederate president Jefferson Davis's gravesite in the city.

"They have no concept of history and how it might be the wrong place to put the statue," said Bragdon Bowling, the Virginia division commander of the Sons of Confederate Veterans. "As a Southerner, I'm offended. You wouldn't put a statue of Winston Churchill in downtown Berlin, would you?"[29]

During the unveiling ceremony, a small plane flew overhead dragging a large red banner inscribed with Virginia's state motto: "*Sic semper tyrannis*"—Latin for "thus always to tyrants." The banner was a deliberate provocation with an unmistakable allusion. John Wilkes Booth shouted those three words immediately after shooting Lincoln in his box at Ford's Theater. Following the Lincoln memorial inauguration, security cameras were installed around the monument to provide round-the-clock surveillance.

Another Lincoln statue has long been controversial for different reasons. The Emancipation Memorial in Washington, DC, was erected in 1876 during the early phase of statue mania in America. The bronze statue depicted Lincoln holding a copy of his Emancipation Proclamation in one hand while reassuringly holding out his other hand over a Black man crouched at his feet. The prostrate African American's fists are clenched and shackles around his wrists are broken, a sign that he has been freed from bondage. The memorial's unveiling in 1876 was attended by President Ulysses S. Grant, members of his cabinet, Congress-

men, and Supreme Court justices. The keynote speaker was Black abolitionist Frederick Douglass.

While the Emancipation Memorial was not controversial in 1876, in subsequent years the figure of the Black man crouched at Lincoln's feet was interpreted as offensively subservient. Frederick Douglass, though he spoke at the unveiling, was later critical of that aspect of the monument. "The negro here, though rising, is still on his knees and nude," he wrote. "What I want to see before I die is a monument representing the negro, not couchant on his knees like a four-footed animal, but erect on his feet like a man."[30]

During the explosion of violence against statues in the aftermath of George Floyd's murder in 2020, there were calls to have the Emancipation Memorial taken down. The memorial's supporters argued that the enslaved Black man, though on his knees, is rising up and looking into the distance. Others found the depiction of the Black man degrading. In Congress, Democrat representative Eleanor Holmes Norton led a push to have the memorial removed. "The statue fails to note in any way how enslaved African-Americans pushed for their own emancipation," said Norton. "It is time it was placed in a museum."[31] Later that year, a replica of the Emancipation Memorial in downtown Boston was taken down following an online petition. Launched by Black artist Tory Bullock, the petition collected more than 12,000 signatures. "I've been watching this man on his knees since I was a kid," said Bullock. "It's supposed to represent freedom but instead represents us still beneath someone else. I would always ask myself: 'If he's free why is he still on his knees?' No kid should have to ask themselves that question anymore."[32]

In New York City, the American Museum of Natural History removed a statue of Theodore Roosevelt from its front steps for similar reasons. The bronze equestrian statue of Teddy Roosevelt, unveiled in 1940, depicted the former president on horseback with a Native American beneath him on one side and an African American on the other. While some claimed the Native American and African American figures were Roosevelt's "guides," for many their position beneath him signified their subordination. Roosevelt's great-grandson, Theodore Roosevelt IV, supported the statue's removal, saying it did not reflect his illustrious ancestor's legacy. In January 2022, the statue was unbolted and lifted from the museum steps with a crane. It found a new home in the Theodore Roosevelt Presidential Library in North Dakota.[33]

A monument in Washington, DC, to another American president named Roosevelt was controversial for different reasons. The construction of the Franklin Delano Roosevelt memorial demonstrated the complexities and sensitivities that can plague public monuments before and after their unveiling. In 1955, an FDR Memorial Commission selected a design for a Roosevelt monument to be unveiled in 1965 on the twentieth anniversary of the wartime president's

death. But the Roosevelt family disapproved of the chosen design—described as "Stonehenge"—and consequently the project was postponed. The delays lasted not years, but decades.

The FDR Memorial was finally unveiled by President Bill Clinton in May 1997. A vast red granite monument stretching over several acres, it was completed at a cost of $48 million.[34] It featured a waterfall, still pool, quotes from FDR, a wall with tactile braille writing for the blind, and various scenes evoking Franklin Roosevelt's legacy. There was also a statue of First Lady Eleanor Roosevelt and one of FDR seated next to his beloved dog, Fala.

Controversy surrounded the memorial even before its unveiling. Anti-fur groups insisted that Eleanor Roosevelt not be depicted wearing one of her fox fur or mink coats. Anti-smoking advocates lobbied to ensure that the FDR statue did not show him smoking with his trademark cigarette holder. After the statue was unveiled, an association for the visually impaired complained that the spacing of the braille dots made them unreadable. Disability groups protested because Roosevelt wasn't seated in a wheelchair like he was in real life due to his polio paralysis. The FDR Memorial Commission had decided to portray Roosevelt seated, but not in a wheelchair, because that was how the American public knew him from photographs.[35] The controversy over the representation of FDR's disability became so heated that, four years later, the National Organization on Disability raised funds to have a second statue of FDR added to the memorial. It showed Roosevelt clearly seated in a wheelchair.

Washington Post columnist Charles Krauthammer wrote that he hated the FDR Memorial because it transformed Roosevelt into a figure of the 1990s, when the monument was unveiled, instead of presenting him as a man of his own era during the Great Depression and Second World War. "FDR revived a nation, reconceived its government, bequeathed a social safety net and then vanquished the most radical evil of this century," wrote Krauthammer. "You would think the memorializers would be satisfied with so prodigious a legacy. They weren't. They felt compelled to make him an environmentalist anti-war champion of civil rights too."[36]

Krauthammer was undoubtedly right. But most statues reflect the values of the present day when they are unveiled. The Confederate statues that went up in the late nineteenth century reflected the Lost Cause ideology, just as the bronze statue of Edward Colston in Bristol revealed more about Victorian England than it did about seventeenth-century colonialism and slave trading. In that respect, memorial mania is similar to statue mania. Both share the vice of narcissistic attachment to present-day values, biases, and obsessions. The one difference, however, is that statue mania reveres the past, whereas memorial mania contests it.

Statues today, as previously noted, are no longer symbols of social cohesion; they are physical reminders of social divisions. Our statuary culture reflects a

splintered mosaic of competing interests, each making claims on recognition and respect, often at the expense of others. Memorial mania validates social fractures produced by the rival claims of competing identity groups. As historian Erika Doss observes, memorial mania "is shaped by individual impulses and factional grievances, by special interest claims for esteem and recognition, and by efforts to symbolize and enshrine the particular issues and aspirations of diverse and often stratified publics."[37] Public spaces for memorials have become a political battlefield on which protest and belligerence are accepted rules of engagement.

Perhaps the best way to understand memorial mania is to examine how we describe it. Like *statue mania*, it contains the word *mania*. That word connotes feverish psychology, excessive fixation, even addictive behavior. Our mania for memorialization has created a statuary culture that is emotionally fraught, irrational, and turned toward the past with grievance and animosity. It is a symptom of our culture's obsession with collective memory and its claims on social justice. We have elevated memory to the status of a cult that transforms remembrance into an ideology of identity construction. The legacy of memorial mania is both aesthetically and socially polarizing.

The cult of memory is a burden that condemns the present to the ceaseless torment of remembrance and claims on retribution. It is a collective form of *hyperthymesia*, a psychological condition that facilitates precise memory of absolutely everything that happened in the past. The cult of memory leads to Nietzsche's "critical" model of history that compels us to drag the past before moral tribunals and sit in judgment of its alleged crimes. But if the past is not left in peace, argued Nietzsche, it risks becoming the "gravedigger of the present."[38] If we live obsessively in the past, history will bury us in the present. Or we will be condemned to live like the tragic character Ireneo Funes in Jorge Luis Borges's short story "Funes the Memorious." After falling from a horse, Funes suffers the curse of remembering absolutely everything in the past. He is incapable of thinking in general ideas or abstractions. Everything in his brain is filled with particular memories. His mind is so consumed with memory that he cannot sleep.[39]

Perhaps we need to reflect more deeply on the political uses and abuses of memory. Many reasonably believe that remembering the past is a moral duty. Except for authoritarian regimes, few would argue in favor of collective amnesia regarding the past. It can nonetheless be asked whether obsession with collective memory can sometimes do more harm than good. As David Rieff argues in his book *In Praise of Forgetting*, throughout history memory has enflamed the volatile emotions that triggered disputes, wars, and atrocities. "Collective memory deployed by communities, peoples and nations has led to war rather than peace, rancor rather than reconciliation, revenge rather than forgiveness," observes Rieff, adding that "historical memory serves to accentuate differences rather than bridge them." Rieff further notes that, like history, collective memory is not

always a truthful account of the past, but a manufactured reconstruction that imagines the past through the filter of remembrance. If forgetting does injustice to the past, remembering does an injustice to the present.[40]

When today's struggles over collective memory have become past, we will leave the legacy of our monumental battles to future generations to inspect with different eyes. It is not inconceivable that they will repudiate the excesses of memorial mania, perhaps even violently, just as we have turned against monuments of the past.

CHAPTER 15

Street Art, Graffiti, and Memes

In the English seaside town of Clacton-on-Sea, local residents awoke one morning to discover a startling image on a public wall.

It was a drawing of five gray pigeons on a clothesline. The birds were holding angry placards directed at a small African swallow perched nearby. One sign read, "Migrants Not Welcome." Another was inscribed, "Go back to Africa." More amusingly, a placard read, "Keep Off Our Worms."

Offended by the image, several residents complained to the town council. They claimed the drawing was "racist." The local council agreed. The mural was immediately erased clean. A spokesman for the district council said: "The site was inspected by staff who agreed that it could be seen as offensive and it was removed this morning in line with our policy to remove this type of material within 48 hours."[1]

Local officials in Clacton-on-Sea were unaware that the artist behind the drawing was Banksy, the world's most famous street artist. Banksy's other murals at the time, in the autumn of 2014, were being stolen and fetching staggering prices. His *Slave Labour* mural in London had been removed two years earlier and sold for $730,000.

When Banksy revealed himself as the artist behind the *Anti-Immigration Birds* mural in Clacton-on-Sea, some local residents criticized the council for its blunder in having the mural erased. But it was too late; Banksy's gift to the town was gone. The wall now had no artistic value.

Banksy's mural was not "racist." It was, on the contrary, an anti-racist message to the local voters in Clacton-on-Sea. The town had a reputation for its anti-immigration attitudes, possibly shaped by its location on the coast looking across a stretch of sea to the European continent. When Banksy stealthily stenciled the anti-immigration pigeons on a wall in town, voters were going to the polls in a local by-election after a Conservative member of parliament had defected to the

far-right UK Independence Party. Known as UKIP, the party was resolutely anti-immigration. Banksy's "racist" birds were a satirical reminder to Clacton-on-Sea voters that bigotry and racism had infected British politics.

British art critic Jonathan Jones praised the *Anti-Immigration Birds* mural. "This is the best Banksy I have never seen: a clever and succinct satire on some currents of feeling in contemporary Britain, terrified of 'migrants', menaced by otherness," observed Jones in *The Guardian*. "Far from being by any stretch of the imagination 'racist', it is—was—a witty putdown of the drab, dour vision of Britain touted by those who would push down diversity and hold back the tide of modern human movement."[2]

Banksy's message to Clacton-on-Sea had no influence on the outcome of the election. The local voters, as expected, elected the far-right UKIP candidate, Douglas Carswell, who won handily with 60% of the vote. Carswell went on to launch the "Vote Leave" movement that campaigned in the Brexit referendum for the Britain to leave the European Union.

The result of the Clacton-on-Sea election probably didn't surprise Banksy. He had produced another stenciled street mural in central London showing a rat under a slogan splashed in vibrant red: "If graffiti changed anything, it would be illegal." It appeared to be an allusion to American anarchist Emma Goldman's comment, "If voting changed anything, they'd make it illegal." Banksy was slyly mocking his own powerlessness to change the course of events. But he was also making a comment about street art and graffiti as political statements in public spaces.

Street art emerged from the graffiti movement in the 1970s. It added images to tags and symbols to create a new style of urban discourse through iconography. In the 1960s, pop artists such as Andy Warhol had moved everyday objects—Campbell's soup cans, Brillo Boxes—into art galleries as postmodernist statements that collapsed the distinction between daily life and curated art. A decade later, graffiti and street artists pushed art in the opposite direction: they took it out of galleries and integrated it back into the fabric of street life. Street artists put art into its social context by imprinting it directly onto everyday experience—literally stenciling it on walls and pavements. It wasn't art created and later placed in out-door settings, like Claes Oldenburg's sculptures of clothespins, spoons, and plugs. Street art was physically created in the streets, using the texture of urban settings as material. The street was internal to the meaning of the art.[3] The work could not be removed without destroying it—unless, of course, it was carved out of a wall and carted off. Street art was ephemeral, subject to vagaries of daily life, cruelties of the weather, and bureaucratic decisions to have it erased.

The paradox of street art is that it is both iconic and iconoclastic. Like Dada art, it breaks many things, first among them conventional notions of art as works to be displayed in galleries. Street art also revolutionizes values about public

spaces. It shatters the traditional practice in both statue mania and memorial mania of erecting monuments in places designated to produce cultural meaning. Statue mania sought to forge social cohesion around grand narratives of civic and military heroism. Memorial mania fractured that consensus by filling public spaces with monuments that emotionally commemorated specific identity groups and their claims on public recognition. Street art challenges both. It rejects both glorification and memorialization. It defies the logic of designated locations for public iconography. It appears anywhere, without authorization, often illegally. Its practices are transgressive and its goals are subversive. Street artists don't ask for permission to stencil their works in public places. And when their art suddenly appears in the streets, it frequently offends the authorities whose permission was required.

Street art's subversive message is often delivered with humor and irony. Banksy's *Anti-Immigration Birds* provides a good illustration of street art irony as political discourse. In that respect, street art borrows from Dada's aesthetic revolt, revived today by activist groups such as Extinction Rebellion. While Dada was iconoclastic through performative aesthetic statements, street art is iconoclastic through guerilla iconography. Like Dada, it shatters expectations about what art is supposed to be.

In Richmond, Virginia, the graffiti-caked Robert E. Lee statue brought street art to a contested public monument in an unexpected way. Since the Lee monument was too massive to pull down, activists spray-painted and covered it with graffiti to neutralize its symbolic power. The letters *BLM* were projected onto Lee's horse. The visual transformation of the Lee monument showed how the communalization of street art could superimpose a new iconography on a contested statue. Thanks to its graffiti makeover, the monument was transformed into a powerful work of street art. In October 2020, the *New York Times* named the Robert E. Lee monument the "most influential work of American protest art since World War II."

"Activists have transformed the base of the sculpture, covering the marble and granite with the names of victims of police violence, protest chants, calls for compassion, revolutionary symbols and anti-police slogans in dozens of colors," noted the *New York Times*. "New phrases continually appear, adding to the kaleidoscopic display of communal, collective action. People who once avoided the statue now make pilgrimages to see what has become an emblem of the Black Lives Matter movement as well as a newly diverse public gathering space."[4]

The spontaneous embellishment of the Robert E. Lee monument turned an act of iconoclastic violence into an innovative form of protest idolatry that reimagined the statue with new layers of meaning.

Graffiti has a long history stretching back thousands of years. Archeologists have discovered graffiti while excavating the ruins of virtually every ancient civilization. The earliest examples of Christian imagery, before the proliferation of Christ's iconography starting in the fourth century, took the form of graffiti.[5]

The Roman emperor Nero, infamous for persecuting Christians, was the subject of many vile rumors and anonymous graffiti about his depraved behavior. The ancient historian Suetonius tell us that, when the hatred of Romans turned against Nero, "there was no form of insult to which he was not subjected."[6] Some allegations against the emperor, including the murder of his wife and mother, were scrawled on public walls. This took tremendous courage, for the slightest murmur of gossip about the emperor could be punished by execution. Graffitied slanders about the emperor were public expressions of protest that nobody dared utter. Graffitied insults about Nero called him a "*matricide*." Some brave Romans hung mocking objects on public statues of the emperor.[7] Not all graffiti about Nero was negative, however. The eccentric emperor had many fans. Some messages inscribed on Pompeii's walls praised him, for example, with the words "*Neroni Feliciter*," which roughly translates as "Long Live Nero."

Roman graffiti touched on many subjects beyond slandering and praising emperors. Graffiti was pervasive and diverse. Romans inscribed messages on public façades and in vestibules, atria, latrines, kitchens, tablina, and peristyles. Based on thousands of graffiti samples preserved on the walls of Pompei, modern archeologists have pieced together a detailed understanding of daily life in ancient Rome. Romans used graffiti—sometimes including drawings—to express the same banalities, desires, and personality impulses that are all-too-familiar to us two thousand years later. Many messages scratched on walls were, like today's public billboards, for advertising purposes. Romans also scrawled messages to make satirical barbs, pun-filled commentary, professions of love ("Rufus loves Cornelia"), and naughty sexual remarks. They sometimes used graffiti to write clever poems and express admiration for handsome gladiators. Some made boasts of their sexual abilities, like this one: *Narcissus fellator maximus*—or "Narcissus, supreme cocksucker."[8] There is evidence that some Romans, like many people today, found the proliferation of graffiti irritating. One epigram discovered on a wall in Pompeii reads: "I'm amazed, O wall, that you have not fallen in ruins, you who support the tediousness of so many writers."[9]

Graffiti in ancient Rome, as the examples above suggest, had a social function. Romans wrote on walls as a gesture of public engagement. Graffiti was not always anonymous. Romans were keen to include their names with their messages—except, of course, when insulting the emperor. For most Roman graffiti artists, a public mural inscription was a form of identity affirmation and, more trivially, attention seeking. It was not unlike today's posts and comments on

Facebook, Instagram, and Twitter. Writing on a wall in ancient Rome was a form of social media engagement.[10]

In Renaissance Rome, so-called *pasquinades* were public inscriptions whose function was protest. *Pasquinades* were bits of written satire and caricature that Romans attached to a famous statue known as "Pasquino." Unearthed in Rome in the fifteenth century, the statue was of the ancient Greek king Menelaus, husband of Helen of Troy. After its installation in a Roman square, the statue was named after a legendary local character named Pasquino famous for his epigrammatic barbs against corrupt prelates, cardinals, and even the pope. In keeping with Pasquino's reputation for castigating officials, the battered Greek bust served as a "talking statue."[11] Romans attached notes to the statue to make anonymous statements expressing their dissatisfaction with public officials. The scribbled *pasquinades*, as the notes were called, put protest statements in the mouth of the statue.

Pasquino was not the only "talking statue" in Rome. Statues with the same function appeared in the city's other squares. Such was their visibility and influence that popes became irritated by the anonymous criticisms posted on them. In the early 1520s, Pope Adrian VI came close to ordering the Pasquino statue removed and tossed in the Tiber River. In 1522, the poet Pietro Aretino attempted to manipulate the election for Pope Adrian's successor by posting sonnet-style *pasquinades* with stinging criticisms of all the candidates—except one, his own patron, Giulio de Medici. The following year, Giulio de Medici was elected pontiff as Clement VII. Romans are still posting *pasquinades* today, though they are not allowed to stick messages directly on Pasquino, which is still standing after five centuries. Locals post their notes on a sideboard installed for that purpose. In 2011, when media mogul Silvio Berlusconi was Italy's playboy prime minister, *pasquinades* appeared on the statue with messages including, "Italy is not a brothel."[12]

Today's graffiti artists, armed with spray-paint canisters and graphic stencils, operate in the *pasquinades* tradition of protest. We tend to regard street art and graffiti as transgressive, even illegal, because it uses the surfaces of public and private property. Most graffiti in modern cities is invasive and aggressive. Like *pasquinades*, it's an expression of frustration and anger. The sight of graffiti in urban settings is frequently denounced as defacement and vandalism. This explains why most modern graffiti—unlike in ancient Rome—is anonymous or coded with "tags." Street artists use pseudonyms to avoid prosecution. In some cases, graffiti appears in streets to make spontaneous statements of revolt against injustices. In the aftermath of George Floyd's death, for example, graffiti messages were scrawled on the streets of Minneapolis where he was killed. For example, the words "my cries are 4 humanity" were spray-painted on a wall.[13]

Pasquino statue in Rome. *Photo by Remi Jouan, Wikimedia Creative Commons.*

Historians of modern street art and graffiti trace their early origins to the United States. In the 1930s, the U.S. government sponsored artists to travel across the country and make public artworks as part of President Roosevelt's "New Deal" program.[14] A government-funded Federal Art Project paid hundreds of artists to produce paintings, murals, and sculptures for government buildings, schools, and hospitals around the country. It wasn't exactly an edgy street art movement, but it gave impetus to important trends in modern American art. Some of America's emerging Abstract Expressionist painters—including Jackson Pollock, Willem de Kooning and Mark Rothko—got their start working for this New Deal program.

Many of the murals produced in the 1930s were inspired by the work of celebrated Mexican artist Diego Rivera. In 1931, Rivera had been treated to a highly successful solo exhibition at New York's Museum of Modern Art. The wealthy Rockefeller family were great admirers of Rivera, who was married to artist Frida Kahlo. Abby Rockefeller, wife of John D. Rockefeller Jr., acquired forty-five Rivera watercolors. Abby's son, Nelson Rockefeller, commissioned Rivera to create the ground-floor murals for the new Rockefeller Center in Manhattan. Rivera came up with a "New Frontiers" concept for the murals. When he started working on the project, Nelson Rockefeller was alarmed by what he saw. Rivera had included images of Vladimir Lenin and a hammer-and-sickle—communist symbols on the walls at a citadel of capitalism. Rockefeller demanded that Rivera replace Lenin with an unrecognizable figure. Rivera proposed to keep Lenin but add Abraham Lincoln. Rockefeller eventually fired him, and the mural was demolished in a storm of protests decrying its destruction as "vandalism."[15] Rockefeller hired another artist, José Maria Sert, to create an alternative mural titled "American Progress," an allegorical scene illustrating the history of America over three centuries. It is that mural visitors can see in the Rockefeller Center lobby today.

While French street artist Gérard Zlotykamien was spray-painting ghost-like figures on Parisian walls in the 1960s, the graffiti movement was taking off in the United States. In the early 1970s, American artists were moving their work into the gritty urban streets, especially in New York City. New York was an urban dystopia in the 1970s. The city was heading toward bankruptcy, its infrastructure was rotted, its streets overrun with criminal gangs. Against this grim backdrop, a graffiti movement took off in the low-income Bronx area, where early hip-hop artists were performing in the streets with their boom boxes. This graffiti art was, in many respects, a visual extension of the subversive, angry beat of the city's rap scene. Graffiti artists—such as Fab 5 Freddy, Taki 183, Jean-Michel Basquiat, and Al Diaz—were soon marking up New York's public spaces with tags and bubble letters. Many were dispossessed youths spray-painting their tags on urban walls and subway cars as a way of asserting ownership of public property in

a world that scarcely recognized their existence. Graffiti was an affirmation of identity through tags.

Many New Yorkers despised graffiti as a symptom of the ills plaguing the city in the 1970s. New York mayor Ed Koch declared that something had to be done about urban graffiti culture. "Pickpocketing and shoplifting and graffiti defacing our public and private walls," said Koch. "They're all in the same area of destroying our lifestyle and making it difficult to enjoy life." In his war on graffiti, Koch enlisted the help of celebrities in a public relations campaign to stigmatize street art. Prize-fighter boxers got behind the campaign with the slogan, "Take it from the champs, graffiti is for chumps."[16]

Banksy once irreverently remarked, "People say graffiti is ugly, irresponsible and childish—but that's only if it's done properly." In truth, the New York graffiti scene was not merely playful and egocentric, it was driven by a fierce socio-political dynamic of revolt. Its insurrectional dimension was picked up by French philosopher Jean Baudrillard, whose essay, "*Kool Killer ou l'insurrection par les signes*," analyzed graffiti as a postmodern revolt against the established symbolic order.[17] In that spirit of protest, artist Jean-Michel Basquiat was tagging the streets of New York in the late 1970s with his "SAMO©" (for "Same Old Crap") tags and graffitied statements ("SAMO© as an alternative to mass-produced individuality").[18]

At the same time, Keith Haring was covering New York's subway trains with his figurative chalkboard style of graffiti art to subvert advertising posters. Haring also created playful public art for schools, daycare centers, and hospitals—echoing the New Deal public art of the 1930s. In the early 1980s, Haring was the first graffiti artist to produce an entire mural on a New York City wall—later known as the "Bowery Mural"—in the Lower East Side of Manhattan. The same 70-foot-long wall in Houston Street was used by many New York street artists throughout the 1980s. Banksy produced a mural on the Bowery Wall in 2018 to protest the imprisonment in Turkey of artist Zehra Dogan, who was jailed for her painting of a pummeled Kurdish town with Turkish flags flying over the rubble.[19]

The paradox of graffiti was the same as the fate of rap music, breakdancing, and hip hop culture: it became respectably mainstream. Once graffiti achieved legitimacy as an art form, it was commercialized. Graffiti art went upmarket and its artists soon achieved wealth and fame. The commercialization of the movement had already been happening in the early 1980s. In 1981, the pop group Blondie released a chart-topping song "Rapture" with a rap beat and graffitied wall as urban backdrop. Jean-Michel Basquiat appeared in the Blondie videoclip as a DJ. He was soon being lionized as an international celebrity, dating pop star Madonna and hanging out with Andy Warhol. Both Basquiat and Keith Haring were treated to high-profile exhibitions before their early deaths. Basquiat died from a heroin overdose in 1988. Haring died of AIDS in 1990.

Keith Haring's *We the Youth* mural in Philadelphia. *Wikimedia Creative Commons.*

Graffiti art moved back into galleries just in time. The city of New York's war on crime and urban decay included systematic erasure of graffiti on subway trains. In the 1990s, New York's mayor Rudy Giuliani set up an Anti-Graffiti Task Force with a mandate to end "graffiti vandalism." The initiative even had a rhyming slogan: "Graffiti-Free NYC." In some cases, urban graffiti was destroyed to make way for new housing projects. The famous "5 Pointz" graffiti mecca in New York's Queens borough was demolished in 2014 and converted into condominiums. Its murals had been iconic in the New York underground scene and appeared as backdrops in Hollywood movies such as *Now You See Me*. After the building was razed, the graffiti artists who had worked in 5 Pointz sued the owner for damages. In 2018, a New York judge ordered the building's owner to pay twenty-one graffiti artists $6.7 million in compensation for their destroyed art. The court ruling established—perhaps with some irony—that graffiti was in fact art with significant commercial value.[20]

As graffiti art went mainstream, it lost its spirit of revolt. In an article about its "gentrification" in New York, *The New Republic* magazine described graffiti as "an art form that has increasingly been defanged, coopted, and commodified."[21] High prices paid for graffiti works on canvases provided another measure of how respectable it had become. Following Basquiat's death in 1988, his work was given a retrospective at the Whitney Museum, and his canvases began selling for astounding prices. His 1982 painting, *Untitled*, fetched $110.5 million at a Sotheby's auction in 2017. A Keith Haring work, also called *Untitled*, was auctioned by Sotheby's for $6.5 million. Basquiat and Haring were both dead,

so we cannot know if they would have felt the disillusionment of Dada founder Hugo Ball, who, a century earlier, abandoned the movement he founded because it had been appropriated by the "bourgeoisie."[22]

In London, meanwhile, the Tate Modern Gallery commissioned graffiti artists—including Blu from Italy and JR from France—to produce work on its façades on the Thames river. French street artist JR also created a vast *trompe l'oeil* mural for the French embassy in Rome's historic Palazzo Farnese. The mural turned the building inside out so the viewer from the piazza outside could see the interior.[23] With these kinds of commissioned projects, an art form that had started in a spirit of subversive revolt was now enjoying the official stamp of approval from establishment institutions.[24]

Today graffiti as protest has resurfaced in Britain as "guerrilla art." Its most famous proponent is Banksy who has transformed street art into a unique style of subversive visual satire. Like Basquiat and Haring canvases, Banksy's work has commanded eye-popping prices at auction—even against his own wishes. His London street mural *Slave Labour* was literally carved out of the wall and sold. In Paris, Banksy's drawing of a rat wearing a face mask was stolen from the back of a road sign near the Pompidou Center. The same year in the French capital, someone stole a Banksy image of a mournful woman on a fire-exit door at the Bataclan Theater, where more than a hundred people had been killed in the terrorist attacks on the city in 2015. The art thieves ripped out the entire door. It was found a year later in a farmhouse in Italy.[25]

Banksy's self-destructing *Girl with a Balloon* was his personal statement against the commercialization of art, but it didn't prevent the painting's value from soaring even after it was sold to the highest bidder. *Girl with a Balloon* took Banksy's iconography from the streets and put it into the auction houses as a fetishized commodity for the super-rich. It also synchronized street art with the virtual sphere of social media. Banksy made sure the world witnessed the self-shredding of *Girl with a Balloon* by having the work's self-destruction filmed and posted on Instagram, where it clocked nearly 15 million views.

Social media networks have provided a powerful new platform for the display of icons. In the past, public squares gave physical permanency to the symbolic authority of statues, while museums conferred legitimacy on art with the official imprimatur of established institutions. Street art rebels, for their part, used tags and stenciled images to proclaim the ephemeral quality of their subversive messages. The digital sphere has provided a virtual space for that ephemerality. As Banksy dramatically demonstrated with his *Girl with a Balloon* video, social media platforms empower revolt against establishment institutions, including the prestige auction houses that put art under the hammer.

The street art rebellion today is taking place on the virtual walls of social media, where hashtags, gifs, and memes are the new icons of revolt. Social networks such as Instagram, Twitter, TikTok, and YouTube provide a digital sphere for a

new form of iconography that is transforming the definition of public spaces and their potential for defiance and rebellion.

What's in a meme? A great deal, apparently. In some countries, a meme can land you in jail.

In January 2021, a 25-year-old Algerian called Walid Kechida was sentenced to three years in prison for posting on Facebook three memes that mocked the country's president. Kechida belonged to the "Hirak" protest movement opposed to the Algerian regime. He managed a satirical "Hirak Memes" page on Facebook. For Kechida, his memes were merely humorous. But he was arrested in April 2020 and accused not only of "offending" the country's president, but also of "attacking the precepts" of Islam.[26]

"I am not a murderer and I have never been charged with any crime," said Kechida, who served nine months of his three-year prison sentence. "I am however the first creator of memes to have been imprisoned in the history of Algeria."[27]

Political protest in many countries has embraced the language of meme iconography on web platforms—Instagram, TikTok, YouTube, Twitter. The "memeification" of protest demonstrates how activism has moved online with an entirely new vocabulary—not words, but icons. In liberal democracies, targets of protest memes doubtless find them irritating, but they are generally regarded as amusing forms of mockery and satire. But authoritarian states treat meme protests as subversive behavior.

Walid Kechida's prison sentence wasn't the first prosecution for activist memes. In Russia, 24-year-old Maria Motuznaya was arrested in 2018 and charged with posting satirical memes on the country's Facebook-style network called VKontakte. One of the memes showed a group of nuns smoking cigarettes with the caption, "Quick, while God isn't looking!" Motuznaya was charged with hate speech and offending religious feelings, both of which were criminalized in Russia.[28] While she was awaiting trial, the Russian government classified her as an "extremist." Motuznaya initially fled the country for Ukraine, but returned to Russia when the case against her was dropped.

Another flurry of protest memes appeared online in Russia after a court imprisoned opposition leader Alexei Navalny in early 2021. The memes were satirically tagged "Aquadisco" in reference to Vladimir Putin's luxurious residence—or "Putin's palace," as it is known. Other memes show Putin holding a "golden toilet brush."[29] Putin, not surprisingly, is a regular target of memes in Russia. As one observer of Russian politics notes,

> In a country where police brutality and institutional injustice have
> been normalized for decades, the language of memes can be an entry

point to finally challenge them. Memes can be endlessly empowering because they are often too fluid to be censored, and because they bring unity among those who understand them and their often coded language and references.[30]

The word *meme* is derived from *memetics*, whose Greek origin means "imitate." Memes are formally defined as images that are circulated, imitated, or transformed in participatory networks as units of shared cultural experience. The diffusion of memes, formally speaking, is transmission of knowledge through iconography. Creating a meme involves the reappropriation of images and words to produce new meaning, usually through parody, pastiche, or protest.[31]

"You can express yourself with one picture of a meme better than a whole page of text," says Alan Schaaf, the CEO of the image-hosting site Imgur. "They're easy to create, reuse, and remix. And what makes them work so well is that they're so relatable. They make us laugh but have the ability to connect us around a common feeling."[32]

Early memes, like the famous "grumpy cat," were relatively innocent image-suggested humor. They quickly evolved, however, into more sophisticated forms of public discourse and political protest. When used politically, a meme seeks to create impressions, spread ideas, and influence public opinion. Some argue that memes are simple-minded substitutes for serious political discourse. Memes may be amusing, they claim, but they won't bring serious changes to society. Still, their satirical edge gives them tremendous potential for subversion. Memes are digital age *pasquinades*, but instead of scribbled notes, they are posted images that mock and criticize figures of authority. The familiar phrase "a picture is worth a thousand words" sums up the political power of memes. The power of memes consecrates the long-predicted triumph of the image over the word.[33] If graffiti was the logo-centric language of protest for the Gen X, memes are the iconic language of protest for Gen Z.

Like graffiti and street art, memes reverse the status of the icon. In meme culture, the icon perpetrates the symbolic violence. The meme icon shatters the image of the figure targeted for lampooning and satire. In the United States, memes took off as icons of mockery under the presidency of Donald Trump. Anti-Trump memes filled the internet to spoof the grotesque aspects of Trump and his entire family.[34] In Britain, viral Twitter memes created by the artist known as Cold War Steve use allusions to famous paintings to satirize the government with devastating effect. Thanks to the simplicity of their cultural iconography, memes can be politically appropriated for different purposes depending on the context. A good illustration of this is the "Pepe the Frog" meme, originally from the *Boy's Club* comic. In the United States, the Pepe the Frog meme was appropriated by White supremacists. In Hong Kong, however, the

same green anthropomorphic frog wearing a helmet went viral as a symbol of resistance to China's authoritarian state.[35]

Memes are difficult to regulate or censor because, unlike traditional media, their creation and dissemination are participatory and populist. Memes have no single creator or point of creation. The internet counts millions of creators and curators who are appropriating images to fabricate new icons. Unlike statues and monuments, memes are intangible. They destabilize the very logic of representation. Memes operate in the sphere of pure representation, with no reference to anything real. They are appropriations of representations.

The distinction between reality and representation has been examined by philosophers stretching back to Plato's ideas about forms. For Plato, a representation of reality is a faithful reproduction—for example, a statue of George III. The entire history of iconoclastic violence has been driven by a conflation of *real* and *representation*. Those who attack statues and images make no distinction between the person depicted and its representation. Assaulting and toppling a statue of George III or Robert E. Lee was tantamount to a physical attack on those two historical figures. Iconoclasm blurs the distinction between person and symbol.

The digital sphere pushes our senses into new modes of perception concerning reality and representation. Today many people spend much of their lives online interacting not with the real world, but with representations of reality. Virtual reality has become their reality. The philosopher Jean Baudrillard used the term *simulacrum*—from Latin for "likeness" or "semblance"—to analyze the impact of living in a world of representations. In pre-industrial eras, the simulacrum was taken as a representation of the real. This Platonic distinction between real and representation endured for many centuries. It broke down, however, after technologies of mass production made unlimited copies possible. In the postmodern world, the line between real and copy disappeared altogether. The simulacrum took on its own reality—or what Baudrillard called "hyperreality."[36] Baudrillard cited illustrations of hyperreality in cultural spaces such as Disneyland, where the imaginary becomes its own form of reality. The same phenomenon could be found in the iconography of celebrity culture. The millions of fans who venerate celebrities make no distinction between image and reality. Celebrity iconography operates in its own sphere of reality. Mass adulation of celebrities is idol worship. The idolized pop star is a fetishized icon that is more real than the actual person behind the image.

Virtual reality makes possible radically new forms of hyperreality. Social networks such as Instagram and TikTok are powerful platforms for simulacrum effects in which the image produces its own reality. On Instagram and TikTok, hundreds of millions of people interact only with simulacrum images that exercise tremendous powers of enchantment on their senses. Sexual and romantic

desires are satisfied in these virtual spaces, sometimes with no connection to the exigencies of the real world. It is possible to fall in love and maintain romantic relationships in the virtual sphere. Such is the power of digital hyperreality that, when we exit it to interact socially, it's called "IRL"—for "in real life." It's like exiting Plato's famous cave to enter the sunlight of the real world. But for the millions of people who spend most of their time interacting with images in the virtual sphere, the real world is merely an option.

Some celebrities behind Instagram iconography are not even real. Instagram star Lil Miquela, for example, is a computer-generated pop star. Miquela does not exist, yet she has more than 3 million followers on Instagram. She also releases songs, gets involved in activist causes, and endorses brands including Calvin Klein and Prada. Miquela is not the only celebrity who exists only virtually. In Japan, pop diva Hatsune Miku is pure virtual reality. Miku does not exist; she is a hologram. Her YouTube channel has millions of subscribers, and she counts more than 2 million followers on Facebook. The obsession with *anime* cartoons and videogames in Japan has created a culture of romance divorced from the real world. Japanese men are falling in love with *anime* characters and turning their backs on real-world emotional attachments. In 2018, the media reported the case of the 35-year-old Japanese man, Akihiko Kondo, who "married" an *anime* celebrity named Hatsune Miku. He lives with Miku in his small Tokyo apartment, where she takes the form of a hologram. The company that made Miku reported that it had issued 3,700 "marriage certificates" to young men like Akihiko Kondo who prefer to have relationships with virtual wives.[37]

Holograms have moved beyond the world of Japanese *anime* characters. They have become visual weapons of protest against authorities. In 2015, the New York artist-activist collective known as "the Illuminator" created a hologram of Edward Snowden and projected it in a Brooklyn park. The hologram appeared on the spot where authorities had removed a pop-up statue of Snowden, an iconic figure for protest groups after his subversive leaking of classified information about the U.S. government.[38] A year earlier, the same artist collective projected "light graffiti" images on the façade of the Metropolitan Museum of Art to protest against billionaire donor David H. Koch, an outspoken climate change denier who made his fortune in fossil fuels.[39] The projected image read: "Koch = Climate Chaos." In 2013, members of the Illuminator collective were arrested after projecting images of a ballot box stuffed with dollar bills on the façade of New York mayor Michael Bloomberg's residence in Manhattan.[40]

Today rock stars have also been transformed into holograms. Some have even been digitally resurrected from their graves. Five years after his death, Michael Jackson performed as a hologram in a gold jacket, white T-shirt, and brick red trousers at the 2014 Billboard Music Awards. The virtual revival of deceased pop stars began two years earlier when rapper Tupac Shakur made an appear-

ance as a 3-D image with Snoop Dogg at the Coachella festival. Sometimes pop stars are not digitally brought back to life, Lazarus-like, they are restored to their youth. In 2021, the hit pop group ABBA announced the release of a new album and tour. The band members would be performing not in the flesh, however, but as holograms representing their youthful images from the 1970s when they were at the height of their fame. The simulated images of the four ABBA members were called "Abba-tars," a wordplay on *avatars*.[41]

The simulation of iconic figures, it seems, has rendered their presence in physical reality obsolete. The copy has become an acceptable substitute for the real. Performers who have been dead for decades—from Maria Callas and Billie Holiday to Elvis Presley and the Beatles—can now be exhumed and brought back to the stage as simulations that, for fans, make no distinction between the real and represented. As the *New York Times* put it: "Old musicians never die. They just become holograms."[42] If pop stars can be resurrected as holograms, it doesn't take a great leap of imagination to predict that figures from history will similarly return from the dead. Perhaps even the emperor Nero, once sentenced to damnatio memoriae, will make a comeback after two thousand years.

The emergence of hyperreality could have profound consequence for public spaces and the statues that inhabit them. The digital world has created new possibilities for idolatry that could make traditional forms of iconoclasm irrelevant. While it may seem that we are living at a time of tumultuous iconoclastic violence, we are also embracing a radically new culture of virtual idolatry. The virtual sphere also allows us to fabricate icons and memes that themselves can be used as weapons of iconoclastic destruction.

We undoubtedly will continue to spend much of our time on the internet interacting with virtual symbols—memes, emojis, and gifs. It's not likely, however, that we will abandon entirely the real world of public squares and boulevards. What will change is how we conceive of public spaces and interact with them. It is not impossible to imagine that virtual reality, like the holograms on concert hall stages, will increasingly encroach on public settings. An early sign of this was the virtual Bamiyan Buddhas that were briefly projected on the empty cave temples of Afghanistan. The intangible Buddhas appeared on a physical space, merging the virtual and real.

If the Buddhas of Bamiyan can return to their original location through virtual reality, any toppled statue or monument from the past could similarly make a spectacular comeback, glowing with life in the same public squares where they had once stood before being violently knocked down. Statues that once incited revolts and ignited revolutions could one day return to be venerated like sacred relics.

If this happens, it will demonstrate, yet again, that fallen idols and smashed icons never vanish, but inevitably return, resurrected, as objects of veneration.

Conclusion

This book began with an attack on a Christopher Columbus statue in San José. In March 2001, a Native American activist walked into the town's City Hall and smashed a life-sized Columbus with a sledgehammer while shouting, "Murderer!"

The hammer blows broke off one arm and then shattered the legs of the marble Columbus. Following the attack, the statue was meticulously repaired and restored to its place in the City Hall lobby. That wasn't the end of the story, however.

Nearly two decades later, activists were still assailing the statue, not with a hammer but with paint. In 2018, San José's council finally voted to remove the Columbus statue for good.[1] Two years later when George Floyd's murder ignited an explosion of statue-smashing violence across the country, San José town councilors must have felt relieved knowing the Columbus statue was no longer on display in the City Hall lobby.

On the other side of the country in Virginia, the controversial Robert E. Lee monument in Richmond met a similar fate. In September 2021, the massive equestrian statue, caked with graffiti and protest art, was finally lifted from its pedestal, cut into pieces, and hauled away. Like the Columbus statue in San José, the Robert E. Lee statue was removed not by spontaneous violence. The Lee monument's dismantling followed due legal process and a court ruling.

Once a statue comes down, whether toppled by crowds or removed by authorities, there remains the inescapable question of what to do with it. The fate of contested statues, as we observed at the outset of this book, is often framed as a dilemma: should they be preserved, destroyed, or modified?

In San José, the Columbus statue found a new home in the hall of the local Italian American Heritage Foundation. In Richmond, the Robert E. Lee monument was stored in a secured facility while awaiting a permanent home. In early

2022, it was announced that the statue had been acquired by the city's Black History Museum. "Now it will be up to our thoughtful museums, informed by the people of Virginia, to determine the future of these artifacts," said Virginia's governor, Ralph Northam.[2]

The preserve-destroy-modify dilemma is usually focused on a specific kind of public monument, notably the "great man" statues of the nineteenth century that today are contested as symbols of colonialism, racism, and social injustice. Debates about the fate of these statues undoubtedly will continue so long as they remain standing. The chapters in this book have attempted to find answers to questions about our relationship with many different kinds of statues and images from ancient civilizations to the present day. The book has examined our motivations for erecting monuments in public places, why we look on them with strong emotions, and how they become the targets of iconoclastic violence. We proposed three categories—*religion, revolution, revolt*—to frame analysis of the different patterns of iconoclastic violence throughout history.

As the many examples evoked in these pages have illustrated, those who inflict violence on statues are rarely insane or medieval "barbarians." Motives for attacking statues and monuments are diverse and complex. Statue-smashing is sometimes the work of deranged fanatics. But most iconoclastic violence is inscribed in a clear logic of action, driven by religious dogma, political ideology, or social protest. Religious iconoclasts are commanded by scripture and faith. Political revolutionaries are motivated by an ideological program of regime change and symbolic erasure. Protestors attack statues in revolts against social injustice that make claims on collective memory. That has been the broad underlying argument of this book.

More specifically, we have proposed that one way of understanding the status and fate of statues is to see them as symbols of *power*. We confer tremendous power on statues as symbols that inspire feelings of identity and belonging. Those who smash statues are attempting to neutralize their symbolic power; and yet, at the same time, acts of destruction paradoxically acknowledge the power they exercise. Second, we argued that the dynamic of *time* helps understand why we erect and attack statues. Monuments are symbols erected to transcend the constraints of time, and those who attack them are frequently engaged in acts of violence against the past and its values. The destruction of statues is violence that makes claims on historical narratives and how the past should be remembered. Third, we attempted to demonstrate that iconoclastic acts can be understood as a form of discourse. If statues are expressions of ideology and propaganda, so are acts of violence against them.

Iconoclastic destruction, as many examples in this book have illustrated, often produces unintended consequences. Attempts to erase memory are rarely successful. The symbolic power of toppled statues endures in the minds of

those who venerated them. Even after they are smashed or melted down, they can make surprising comebacks. The French revolutionaries who toppled the statue of king Henri IV in Paris could not have imagined that, only a generation later, a replica of the same statue would reappear at the same spot on the Pont Neuf—and still stands today, more than two centuries later. History is not a linear narrative, constantly moving forward; it is a ceaseless cycle of tensions between past and present.

Grasping the complexity of iconoclastic impulses renders the familiar preserve-destroy-modify dilemma difficult to resolve. At best, proposed solutions—preserve? destroy? modify?—determine the fate of monuments only in the short term. Yet the "what to do" question continues to be treated with great urgency. Many feel that the fate of statues must be settled now, according to the present moral and political climate. The present, it is argued, has the right to judge the past.

There is no need to dwell here, in these concluding observations, on the *destroy* option. The chapters in this book have been largely devoted to the destruction of statues and monuments. As noted above, the symbolic power of destroyed statues rarely vanishes into the mists of time. Their fragments become fetishized like sacred relics. They reappear in replica and reassert symbolic authority restored by the values of new generations. Iconoclasm begets idolatry.

Many argue that we have a duty to *preserve* the legacy of the past, however contestable statues and monuments may seem in the present. Preserving contested statues involves doing nothing except letting them remain where they have long stood. Preservation rejects the clamor to destroy statues, even monuments of detested figures accused of horrendous crimes. We have not razed the Roman Colosseum because of the horrific cruelty that occurred there; nor are there calls to have all statues of Julius Caesar pulled down because of the atrocities his armies committed during the conquest of Gaul. We must confront and integrate the past, not erase it from our historical memory. But preservation risks provoking the indignation of those who resent monuments for the values they symbolize. Some insist that, if they must be preserved, contested statues should be "contextualized" with explanatory narratives inscribed on plaques.

Others argue that controversial statues be removed from public squares and placed in museums to be studied as historical artifacts. That was the fate of the Edward Colston statue after its toppling in Bristol. The statue of the slave trader was placed in a Bristol museum—where, interestingly, its value as a museum object soared to more than $400,000, or fifty times its original cost.[3] Like a self-destructing Banksy painting, a toppled statue can become a fetishized object with an inflated commercial value that defies the protests of those who despise it.

The museum solution is rejected by many curators who argue that, while well intended, this solution is based on a misunderstanding of the museum's purpose. Museums must not serve as warehouses for unwanted artifacts that some believe should be hidden from public view. Even if controversial statues were "recontextualized" in museums, they are institutions often associated with authority. This was precisely the reason that, in the early twentieth century, suffragettes attacked works of art in Britain's public art galleries. They were striking a blow not at the targeted paintings but at the establishment institutions of authority that exhibited them. Putting contested statues in museums could be interpreted as a form of re-sacralization that encourages new kinds of idolatry.

A variation on the museum solution is the statue graveyard concept based on Budapest's Memento Park and the Fallen Monument Park in Moscow. The public can stroll around these open-air statue cemeteries and gaze upon the vestiges of monuments consigned there in perpetuity. In both Budapest and Moscow, statues are from the Soviet communist era. In the United States, Confederate monuments could, in like manner, be dismantled and assembled in statue cemeteries operated as revenue-generating theme parks. But as with the museum solution, that could produce the unintended consequence of creating new kinds of idol veneration. Collected monuments of Confederate heroes could become fetishized, turning statue graveyards into pilgrimage destinations.

Another solution is melting down and repurposing dismantled statues. This happened to the 50-foot equestrian statue of Iraqi dictator Saddam Hussein after it was toppled during his overthrow in 2003. The enormous statue was melted down and repurposed at a U.S. Army base in Texas as a memorial to the 81 soldiers in the 4th Infantry Division who had fought and died in Iraq. Will bronze statues of Confederate generals be melted down to make statues of abolitionists Harriet Tubman and Frederick Douglass? Perhaps, but as we have seen throughout this book, melted-down statues can reappear in replicas and be restored to their original place. In Paris, four different statues of Napoleon were removed and replaced on the Vendôme Column throughout the nineteenth century. One generation's verdict about a monument is rarely final.

Some argue that public statues, however controversial, should be left in place but *modified.* They can be "reimagined" through embellishments that encourage new layers of interpretation and meaning. Banksy sketched a possible modification of the Edward Colston statue in Bristol, adding figures of protestors pulling it down with ropes.[4] This approach would reconnect with the ancient Roman practice of giving statues makeovers. When an ex-emperor fell out of favor, his head was removed and a more popular emperor's head was attached to the torso.

By reimagining statues, iconoclasm could be elevated to a new form of artistic creation. That was the fleeting status of the equestrian Robert E. Lee statue in

Richmond before it was removed by authorities. Local residents appropriated the monument and turned it into a vibrant piece of urban street art. By projecting new interpretations on the statue, its symbolic power was transformed through creative reimagining. A similar approach was taken with Mussolini's fascist Victory Monument in the Italian town of Bolzano. Instead of tearing down the monument, local authorities reimagined it by constructing a museum in a crypt and embellishing the bas-relief with an illuminated quote from Hannah Arendt: "Nobody has the right to obey."[5] The monument was recontextualized and its fascist symbolism neutralized. This approach could have been endorsed for the Robert E. Lee monument in Richmond, but authorities opted to dismantle the statue and haul it away. Some local residents opposed its removal as an unwelcome act of government-ordered iconoclasm. Those who had once called for its destruction had grown accustomed to the statue and were satisfied with its creative transformation.[6]

Yet another solution is for pedestals of toppled statues to be left vacant. If the plinth remains empty, the contested monument has not entirely disappeared. The symbol has vanished, but memory lingers through the presence of the pedestal. Empty plinths can be used as temporary platforms for artists to create new works, such as the *Surge of Power* statue that briefly appeared on Edward Colston's pedestal in Bristol. This concept is already practiced in London's Trafalgar Square, where new sculptures are displayed on the "fourth plinth." The pedestal had originally been intended for an equestrian statue of king William IV to be erected in 1841, but funds could not be raised, and the pedestal remained vacant for 150 years.[7] Today, the "fourth plinth" is used for new works of publicly displayed art. Some of them are mocked and criticized for their aesthetic qualities, but they are generally accepted by the public, albeit grudgingly, perhaps in the knowledge that they are temporary.

Should all public monuments be granted only a temporary status in public places? It has been cleverly suggested that a "statue of limitations" should be adopted to give towns and cities the authority to review all monuments—say, every fifty years—and vote on their removal or continued presence in public squares.[8] This concept may have democratic appeal, though it puts the fate of statues in the hands of politicians and bureaucracies. It also assumes that each generation is the best judge of what statues from the past should remain or be removed. We know from history that the passions of politics can be ill-advised, even recklessly destructive. Some periods in history—such as Savonarola's fanatical theocracy in Florence—fall into collective hysteria. Should any one generation be authorized to lay waste to an entire cultural legacy of monuments stretching back centuries? It might reasonably be argued that each generation should be permitted to erect the monuments of their own choosing, but not to destroy those inherited from the past. Even that solution would be of little practical value in the face of a

sudden explosion of iconoclastic fury triggered by religious fanaticism, political revolution, or social upheaval.

In the meantime, our conception of what monuments are, and our relationship with them, could be radically transformed by new technologies. New forms of digital idolatry elicit the same strong emotions as statues did in the past. Icons and idols today are dematerialized as holograms. Long-dead figures whose likeness was once sculpted in marble could return, resurrected as virtual replicas, venerated by future generations in hyper-reality. The day could come when passionate debates about the fate of bronze statues in public squares seem oddly antiquated.

For those who prefer to live in the material world, the fate of contested statues presents difficult questions about our obligations to previous generations. As we observed at the outset of this book, the present generation understandably wishes to assert the right to decide what kind of monuments it wishes to see embellishing public spaces. It could also be argued, however, that citizens must be mindful of a duty of care to preserve the monuments left by past generations. We are, like them, only fleeting occupants of this world. Our statues and public artworks, like theirs, will outlive the emotions that animate our passionate debates about these questions today.

As we suggested in preceding chapters, perhaps we need to reassess our cultural obsession with memory and the claims that it makes. If we have a moral duty to remember the past, we also have an obligation to live in the present. The cult of memory condemns a society to constant strife and torment over the past. As we observed at the outset of this book, we need to reflect on how much the past is responsible for the present, and how much the present is responsible for the past. While few would advocate collective amnesia, excessive obsession with the past brings many dangers. As the lessons of history have demonstrated, when societies in upheaval have declared war on the past—Jacobins in France, Bolsheviks in Russia, Maoists in China—the result has been a spiral of violence, terror, and atrocity. It may be wiser to make peace with the past, consign its torments to the status of history, and use its lessons as the foundation for the commitments we make in the present. Failing to do so risks falling into the trap that Nietzsche warned against. If we feel compelled to sit constantly in judgment of the past and its alleged crimes, history will become the gravedigger of the present. Fixating constantly on the past is no way to live in the present.

It is not impossible, and may even be inevitable, that our descendants will look on our cultural obsessions and moral certitudes with the same bewilderment, and perhaps even outrage, with which we judge previous epochs that once erected proud statues with their own unwavering convictions. The prospect that our cherished monuments and icons could one day become vandalized objects of

scorn should motivate us to look on the statues we have inherited from the past with humility and forbearance.

Just as we cast judgments on past generations for their vices, we will unavoidably be judged by future generations for our own sins.

Notes

Preface

1. For edited volumes offering international perspectives and case studies, see Laura Macaluso, ed., *Monumental Culture: International Perspectives on the Future of Monuments in a Changing World* (Lanham, MD: Rowman & Littlefield, 2019). Also see Rachel Stapleton and Antonio Viselli, eds., *Iconoclasm: The Breaking and Making of Images* (Montreal: McGill-Queen's University Press, 2019); and Stacy Boldrick, Leslie Brubaker, and Richard Clay, eds., *Striking Images: Iconoclasm, Past and Present* (Aldershot, UK: Ashgate, 2013).

2. For a discussion of the semantics of *iconoclasm, vandalism,* and other terms, see the following sources: Dario Gamboni, *The Destruction of Art: Iconoclasm and Vandalism since the French Revolution* (London: Reaktion Books, 1997); Stacy Boldrick and Richard Clay, eds., *Iconoclasm: Contested Objects, Contested Terms* (Aldershot, UK: Ashgate, 2007); Kristine Kolrud and Marina Prusac, eds., *Iconoclasm from Antiquity to Modernity* (Aldershot, UK: Ashgate, 2014); Bruno Latour, "What Is Iconoclash?" in *Beyond the Image-Wars in Science, Religion and Art*, ed. Peter Weibel and Bruno Latour (Cambridge: MIT Press, 2002); and Alexander Adams, *Iconoclasm, Identity Politics, and the Erasure of History* (Luton, Bedfordshire, UK: Imprint Academic, 2020).

Introduction

1. "Columbus Statue Smashed in San José," *SF Gate,* March 10, 2001; and Erika Doss, *Memorial Mania: Public Feeling in America* (Chicago: University of Chicago Press, 2010), 323.

2. See "What a Previous Iconoclastic Period Reveals about the Present One," *The Economist,* January 8, 2022, www.economist.com/britain/2022/01/08/what-a-previous-

iconoclastic-period-reveals-about-the-present-one; and Sebastian Payne, "Why the Tory 'War on Woke' Doesn't Travel," *Financial Times,* October 5, 2021.

3. David Freedberg, *The Power of Images* (Chicago: University of Chicago Press, 1989), 1.

4. Friedrich Nietzsche, "The Use and Abuse of History," trans. Adrian Collins (New York: The Liberal Arts Press, 1957), 14.

5. Nietzsche, "The Use and Abuse of History," quoted in Breazeale, "Nietzsche, Critical History and 'Das Pathos der Richtertum,' *Revue Internationale de Philosophie* 54, no. 211 (March 2000): 64.

6. The quote is from George Orwell, *1984* (London: Secker & Warburg, 1949), www. abhafoundation.org/assets/books/html/1984/162.html.

Chapter 1

1. Nasir Behzad and Daud Qarizadah, "The Man Who Helped Blow up the Bamiyan Buddhas," *BBC News,* March 12, 2015.

2. Barry Bearak, "Over World Protests, Taliban Are Destroying Ancient Buddhas," *New York Times,* March 10, 2001, www.nytimes.com/2001/03/04/world/over-world -protests-taliban-are-destroying-ancient-buddhas.html.

3. Kate Clark, "Taleban 'Destroy' Priceless Art," *BBC,* February 12, 2001, http:// news.bbc.co.uk/1/hi/world/south_asia/1165983.stm. On the pejorative language used to describe the Taliban, see the introduction in James Simpson, *Under the Hammer: Iconoclasm in the Anglo-American Tradition* (Oxford: Oxford University Press, 2010).

4. See Jalal Atai, "The Destruction of Buddhas: Dissonant Heritage, Religious or Political Iconoclasm?" *Tourism, Culture & Communication* 19 (2019): 303–12.

5. See Michael Falser, "The Bamiyan Buddhas: Performative Iconoclasm and the Image of Heritage," in *The Image of Heritage: Changing Perception, Permanent Responsibilities,* ed. Andrzej Tomaszewski and Simone Giometti (Florence: Edizioni Polistampa, 2009).

6. See Finbarr Barry Flood, "Idol-Breaking as Image-Making in the 'Islamic State,'" *Religion and Society: Advances in Research* 7 (2016): 116–38.

7. Bearak, "Over World Protests."

8. David Freedberg, "The Power of Wood and Stone," *Washington Post,* March 25, 2001, www.washingtonpost.com/archive/opinions/2001/03/25/the-power-of-wood -and-stone/4ffe0955-4cc4-45ea-bfd3-a5b10f546fc2.

9. Pierre Lafrance, "Témoignage: Comment les bouddhas de Bamiyan n'ont pas été sauvés," *Critique internationale* (July 2001): 19.

10. See Pierre Centlivres, "The Controversy over the Buddhas of Bamiyan," *South Asia Multidisciplinary Journal* 2 (2008), https://journals.openedition.org/samaj/992.

11. Plato discusses images in books 3 and 10 of *The Republic.* See Pierre Destrée and Radcliffe G. Edmonds III, eds., *Plato and the Power of Images* (Leiden, Netherlands: Brill,

2017). See also Chapter 1 in Alain Besançon, *The Forbidden Image: An Intellectual History of Iconoclasm* (Chicago: University of Chicago Press, 2000).

12. See James Hoffmeier, *Akhenaten and the Origins of Monotheism* (New York: Oxford University Press, 2015).

13. The gold cherubim reference can be found in Exodus 25:18; the brass serpent in Numbers 21:8; and its destruction by Hezekiah in 2 Kings 18:4.

14. See Exodus 20:2: https://www.biblegateway.com/passage/?search=Exodus+20&version=KJV.

15. The golden calf story is recounted in Exodus 32: https://www.bible.com/bible/114/EXO.32.NKJV.

16. See Deuteronomy 12:3: https://biblehub.com/deuteronomy/12-3.htm.

17. See Samuel 5:2: https://biblehub.com/1_samuel/5-2.htm.

18. See John 1:1: https://www.biblegateway.com/passage/?search=John%201&version=KJV.

19. See Kristy Campion, "Blast through the Past: Terrorist Attacks on Art and Antiquities as a Reconquest of the Modern Jihadi Identity," *Perspectives on Terrorism* 11, no. 1 (February 2017): 26–39; and Finbarr Barry Flood, "Between Cult and Culture: Bamiyan, Islamic Iconoclasm, and the Museum," *The Art Bulletin* 84, no. 4 (December 2002): 641–59.

20. For a dating of the Buddhas, see Catharina Blänsdorf, Marie-Josée Nadeau, Pieter M. Grootes, C. Matthias Hüls, Stephanie Pfeffer, and Laura Thiemann, "Dating of the Buddha Statues—AMS 14C Dating of Organic Materials," *Monuments and Sites* 19 (2009).

21. S. H. Wriggins, *Xuanzang: A Buddhist Pilgrim on the Silk Road* (Boulder: Westview Press, 1966).

22. See Llewelyn Morgan, *The Buddhas of Bamiyan* (Cambridge: Harvard University Press, 2015).

23. See Flood, "Between Cult and Culture: Bamiyan, Islamic Iconoclasm, and the Museum," *The Art Bulletin* 84, no. 4 (December 2002): 647.

24. See the chapter "Jihad" in Johan Elverskog, *Buddhism and Islam on the Silk Road* (Philadelphia: University of Pennsylvania Press, 2010).

25. Neil McMullin, *Buddhism and the State in Sixteenth Century Japan* (Princeton: Princeton University Press, 1985), 81.

26. McMullin, *Buddhism and the State in Sixteenth Century Japan*, 93.

27. For the wording of the second *fatwā*, see World Islamic Front, Jihad Against Jews and Crusaders: https://fas.org/irp/world/para/docs/980223-fatwa.htm.

28. Andreas Huyssen, "Twin Memories: Afterimages of Nine/Eleven," *Grey Room* 7 (Spring 2002): 12.

29. See Jason Farago, "One World Trade Center: How New York Tried to Rebuild Its Soul," *The Guardian*, September 8, 2014.

30. See Edward Delman, "Afghanistan's Buddhas Rise Again," *The Atlantic*, June 10, 2015.

Chapter 2

1. See John Pollini, "Christian Desecration and Mutilation of the Parthenon," *Mitteilungen des Deutschen Archäologischen Instituts Athenische Abteilung* 122 (2007): 207–28.

2. See the introduction to Catherine Nixey's *The Darkening Age: The Christian Destruction of the Classical World* (London: Macmillan, 2017), 19.

3. On early Christian book burnings, see Dirk Rohmann, *Christianity, Book Burning and Censorship in Late Antiquity* (Berlin: De Gruyter, 2016).

4. For a largely positive review, see Cambridge professor Tim Whitmarsh, "*The Darkening Age: The Christian Destruction of the Classical World* by Catherine Nixey," *The Guardian*, December 28, 2017, https://www.theguardian.com/books/2017/dec/28/the-darkening-age-the-christian-destruction-of-the-classical-world-by-catherine-nixey. For a largely negative review of the book, see Oxford professor Averil Cameron, "Blame the Christians," *The Tablet*, September 21, 2017, https://www.thetablet.co.uk/books/10/11298/blame-the-christians.

5. See chapter 28 in Edward Gibbon, *The Decline and Fall of the Roman Empire* (London: Penguin Classics, 2000), https://www.ccel.org/g/gibbon/decline/volume1/chap28.htm.

6. See book 15:44 in Tacitus, *The Annals of Imperial Rome* (London: Penguin, 1996).

7. See Suetonius's Twelve Caesars, the chapter on Nero: http://penelope.uchicago.edu/Thayer/E/Roman/Texts/Suetonius/12Caesars/Nero*.html#ref158.

8. See Tacitus, *Annals*, book XV, http://penelope.uchicago.edu/Thayer/E/Roman/Texts/Tacitus/Annals/15B*.html.

9. See Tacitus, *Annals*, book XV, http://penelope.uchicago.edu/Thayer/E/Roman/Texts/Tacitus/Annals/15B*.html.

10. See G. E. M. de Ste. Croix, "Why Were the Early Christians Persecuted?" *Past & Present*, no. 26 (November 1963): 25.

11. de Ste. Croix, "Why Were the Early Christians Persecuted?"

12. See Bradley M. Peper and Mark DelCogliano, "The Pliny and Trajan Correspondence," in *The Historical Jesus in Context*, ed. Amy-Jill Levine, Dale C. Allison Jr., and John Dominic Crossan (Princeton: Princeton University Press, 2006), 370.

13. For the exchange of letters between Pliny and Trajan, see https://faculty.georgetown.edu/jod/texts/pliny.html.

14. See Paul Middleton, "Early Christian Voluntary Martyrdom: A Statement for the Defence," *The Journal of Theological Studies* 64, no. 2 (October 2013): 558.

15. See Jaś Elsner, "Iconoclasm as Discourse: From Antiquity to Byzantium," *The Art Bulletin* 94, no. 3 (September 2012): 368–94.

16. See Eberhard Sauer, "Disabling Demonic Images: Regional Diversity in Ancient Iconoclasts' Motives and Targets," in *Iconoclasm from Antiquity to Modernity*, ed. Kristine Kolrud and Marina Prusac, 15–40 (London: Routledge, 2014).

17. T. C. G. Thornton, "The Destruction of Idols—Sinful or Meritorious?" *The Journal of Theological Studies* 37, no. 1 (April 1986): 122.

18. See David Freedberg, "The Fear of Art: How Censorship Becomes Iconoclasm," *Social Research* 81, no. 1 (Spring 2016), http://www.columbia.edu/cu/arthistory/faculty/Freedberg/The-Fear-of-Art.pdf.

19. In his paper on Christian desecration of the Parthenon, John Pollini observes: "There is both literary and archaeological evidence from various parts of the Empire for such destructive raids on temples, as well as for assaults on the sacred objects of polytheists." See John Pollini, "Christian Desecration and Mutilation of the Parthenon,"*Mitteilungen des Deutschen Archäologischen Instituts Athenische Abteilung* 122 (2007): 210.

20. See Jeremy Swist, "Pagan Altars and Monarchic Discourse in Libanius *Declamation* 22," *Phoenix* 70, nos. 1–2 (Spring–Summer 2016): 170–89.

21. For a text of Libanius's *Pro Templis,* see https://www.tertullian.org/fathers/libanius_pro_templis_02_trans.htm#9.

22. See Ramsay MacMullen, *Christianizing the Roman Empire* (New Haven: Yale University Press, 1984), 85.

23. See Rodney Stark, *The Rise of Christianity: How the Obscure, Marginal Jesus Movement Became the Dominant Religious Force in the Western World in a Few Centuries* (Princeton: Princeton University Press, 1996); and Tim Whitmarsh, *Battling the Gods: Atheism in the Ancient World* (London: Faber and Faber, 2015).

24. See Gibbon, *The History of the Decline and Fall of the Roman Empire,* chapter XXVIII, https://sourcebooks.fordham.edu/source/gibbon-decline28.asp.

25. The main contemporary account of the attack on the Serapeum comes from the Christian monk and historian Rufinus in book XI of *Ecclesiastical History.* See *The Church History of Rufinus* (Oxford: Oxford University Press, 1997). Also see Johannes Hahn, "The Conversion of the Cult Statues: The Destruction of the Serapeum 392 AD and the Transformation of Alexandria into the 'Christ-Loving' City," in *From Temple to Church: Destruction and Renewal of Local Cultic Topography in Late Antiquity,* ed. Johannes Hahn, Stephen Emmel, and Ulrich Gotter, 336–67 (Leiden/Boston: Brill, 2008).

26. Soraya Field Fiorio, "The Killing of Hypatia," *Lapham's Quarterly,* January 16, 2019. Accounts of Hypatia's death vary according to the source. For a contemporary account, see Socrates Scholasticus in *Ecclesiastical History,* book VI, chapter XV, https://sourcebooks.fordham.edu/source/hypatia.asp.

27. See Hahn, "The Conversion of the Cult Statues."

28. See notably Michele Renee Salzman, Marianne Sághy, and Rita Lizzi Testa, eds., *Pagans and Christians in Late Antique Rome: Conflict, Competition and Coexistence in the Fourth Century* (Cambridge: Cambridge University Press, 2016); Alan Cameron, *The Last Pagans of Rome* (Oxford: Oxford University Press, 2011); and Averil Cameron and Peter Garnsey, eds., *The Cambridge Ancient History XIII: The Late Empire, AD 337–425* (Cambridge: Cambridge University Press, 1998).

29. See John 14:9, https://biblehub.com/kjv/john/14-9.htm.

30. See F. E. Peters, *The Voice, the Word, the Books: The Sacred Scripture of the Jews, Christians, and Muslims* (Princeton: Princeton University Press, 2007), 229.

31. Alain Besançon, *The Forbidden Image: An Intellectual History of Iconoclasm* (Chicago: University of Chicago Press, 2000), 3.

32. See Thomas Mathews nuances the "Emperor Mystique" theory in his book, *Clash of the Gods: A Reinterpretation of Early Christian Art* (Princeton: Princeton University Press, 1993).

33. See Benjamin Anderson, "The Disappearing Imperial Statue: Toward a Social Approach," in *The Afterlife of Greek and Roman Sculpture*, ed. Troels Myrup Kristensen and Lea Stirling (Ann Arbor: University of Michigan Press, 2016).

34. For an image of the disfigured Germanicus bust, see the British Museum website: https://www.britishmuseum.org/collection/object/G_1872-0605-1.

35. See Amelia Brown, "Crosses, Noses, Walls, and Wells: Christianity and the Fate of Sculpture in Late Antique Corinth," and Nadin Burkhardt, "The Reuse of Ancient Sculpture in the Urban Spaces of Late Antique Athens," in *The Afterlife of Greek and Roman Sculpture*, ed. Troels Myrup Kristensen and Lea Stirling (Ann Arbor: University of Michigan Press, 2016).

36. See Leslie Brubaker and John Haldon, *Byzantium in the Iconoclast Era* (Cambridge: Cambridge University Press, 2011).

37. This quote is from Pope Gregory the Great in the seventh century. See Besançon, *The Forbidden Image*, 187.

38. See Pollini, "Christian Desecration and Mutilation of the Parthenon."

39. "Acropolis Museum Cuts Film after Church's Protest," *Reuters*, July 26, 2009, www.reuters.com/article/uk-greece-acropolis/acropolis-museum-cuts-film-after-churchs-protest-idUKTRE56P1LJ20090726. Also see Melena Ryzik, "Museum Decides Not to Edit Costa Gavras," *New York Times*, August 5, 2009.

40. "Seven Arrests as Barclays Windows Are Smashed during Extinction Rebellion Protest in London," *Evening Standard*, April 7, 2021, www.standard.co.uk/news/uk/extinction-rebellion-protest-barclays-london-broken-windows-b928215.html.

41. For one example of the term *cult*, see Dominic Lawson's column, "Behind the Science, Extinction Rebellion Is a Doomsday Cult," *Sunday Times*, October 13, 2019.

42. Stefan Skrimshire, "Extinction Rebellion and the New Visibility of Religious Protest," *OpenDemocracy*, May 12, 2019, www.opendemocracy.net/en/transformation/extinction-rebellion-and-new-visibility-religious-protest.

43. Skrimshire, "Extinction Rebellion."

44. Cullan Joyce, "Responses to Apocalypse: Early Christianity and Extinction Rebellion," *Religions* 11, no. 8 (2020): abstract.

45. W. C. Campbell-Jack, "Extinction Rebellion—the New Religion with Greta as Its Saint," *The Conservative Woman*, October 13, 2019, www.conservativewoman.co.uk/extinction-rebellion-the-new-religion-with-greta-as-its-saint.

46. See Tim Adams, "QAnon and On: Why the Fight against Extremist Conspiracies Is Far from Over," *The Guardian*, June 20, 2021; and Giovannie Russonnello, "QAnon Now as Popular in U.S. as Some Major Religions, Poll Suggests," *New York Times*, May 27, 2021.

47. See Michael Luo, "The Wasting of the Evangelical Mind," *New Yorker*, March 4, 2021, www.newyorker.com/news/daily-comment/the-wasting-of-the-evangelical-mind.

Chapter 3

1. See Pliny the Elder's *The Natural History*, chapter 21, www.perseus.tufts.edu/hopper/text?doc=Perseus%3Atext%3A1999.02.0137%3Abook%3D36%3Achapter%3D21.

2. See Lynn R. LiDonnici, "The Images of Artemis Ephesia and Greco-Roman Worship: A Reconsideration," *The Harvard Theological Review* 85, no. 4 (October 1992): 389–415.

3. See Ross Poole, "Enacting Oblivion," *International Journal of Politics, Culture, and Society* 22, no. 2, Special Issue: Memory and Media Space (June 2009): 149–57.

4. "Erostrate" appeared in Sartre's collection of stories, *Le Mur* (Paris: Gallimard, 1939); see also Walter Redfern, "Erostrate: Sartre's Crazy Mixed-Up Hero," *Sartre Studies International* 2, no. 1 (1996): 77–89.

5. See Albert Borowitz, *Terrorism for Self-Glorification: The Herostratos Syndrome* (Kent, OH: Kent State University Press, 2005). The spelling of his name is alternatively given as "Herostratus" and "Herostratos"; we have adopted for the former.

6. Pierre Centlivres, "The Controversy over the Buddhas of Bamiyan," *South Asia Multidisciplinary Academic Journal* 2 (2008), http://journals.openedition.org/samaj/992.

7. See Acts 19:23: www.biblegateway.com/passage/?search=Acts%2019&version=NIV.

8. See Acts of John, *The Apocryphal New Testament* (Oxford: Clarendon Press, 1924), http://gnosis.org/library/actjohn.htm.

9. See "Bloodbath at Luxor," *The Economist*, November 20, 1997; and Douglas Jehl, "70 Die in Attack at Egypt Temple," *New York Times*, November 18, 1997.

10. The term *damnatio memoriae* was not used in the ancient world; it dates to the seventeenth century and is used in modern scholarship to designate sanctions against memory throughout history.

11. See Catharine Roehrig, *Hatshepsut: From Queen to Pharaoh* (New Haven: Yale University Press, 2005); also see Vanessa Davies, "Hatshepsut's Use of Tuthmosis III in Her Program of Legitimation," *Journal of the American Research Center in Egypt* 41 (2004): 55–66.

12. See Peter Schjeldahl, "Rule Like an Egyptian: Hatshepsut, the King and Queen," *New Yorker*, March 26, 2006.

13. See Jan Assmann, *From Akhenaten to Moses: Ancient Egypt and Religious Change* (Cairo: American University in Cairo Press, 2014).

14. See James K. Hoffmeier, *Akhenaten and the Origins of Monotheism* (Oxford: Oxford University Press, 2015).

15. See Peter Brand, "Secondary Restorations in the Post-Amarna Period," *Journal of the American Research Center in Egypt* 36 (1999): 113–34.

16. See Erik Hornung, "The Rediscovery of Akhenaten and His Place in Religion," *Journal of the American Research Center in Egypt* 29 (1992): 43–49.

17. See Thucydides, *History of the Peloponnesian War*, book VI, www.loebclassics.com/view/thucydides-history_peloponnesian_war/1919/pb_LCL110.231.xml?readMode=recto.

18. See Rachel Kousser, "The Mutilation of the Herms: Violence toward Images in the Late 5th Century BC," in *Autopsy in Athens: Recent Archaeological Research on Athens and Attica*, ed. Margaret Miles (Oxford: Oxbow Books, 2015).

19. See chapter 2, "Did the Greeks Have Memory Sanctions?" in Harriet Flower, *The Art of Forgetting: Disgrace and Oblivion in Roman Political Culture* (Chapel Hill: University of North Carolina Press, 2006).

20. See Anthony J. Podlecki, "The Political Significance of the Athenian 'Tyrannicide' Cult," *Historia: Zeitschrift für Alte Geschichte* 15, no. 2 (April 1966): 129–41; and Mabel Lang, "The Murder of Hipparchus," *Historia: Zeitschrift für Alte Geschichte* 3, no. 4 (1955): 395–407.

21. See Vincent Azoulay, *The Tyrant Slayers of Ancient Athens: A Tale of Two Statues* (Oxford: Oxford University Press, 2017).

22. See Rachel Kousser, "Destruction and Memory on the Athenian Acropolis," *The Art Bulletin* 91, no. 3 (September 2009): 263–82. For the reference to Lycurgus, see *Against Leocrates*, www.perseus.tufts.edu/hopper/text?doc=Perseus%3Atext%3A1999.01 .0152%3Aspeech%3D1%3Asection%3D81.

23. See Plutarch's "Life of Alexander" in *Parallel Lives*, https://penelope.uchicago.edu/ Thayer/E/Roman/Texts/Plutarch/Lives/Alexander*/5.html.

24. See Jennifer Finn, "Alexander's Return of the Tyrannicide Statues to Athens," *Historia: Zeitschrift für Alte Geschichte* 63, no. 4 (2014): 385–403.

25. See Leslie Brubaker, "Making and Breaking Images and Meaning in Byzantium and Early Islam," in *Striking Images: Iconoclasm, Past and Present*, ed. Stacy Boldrick, Leslie Brubaker, and Richard Clay (Aldershot: Ashgate, 2013).

26. See Maureen Carroll, "Memoria and Damnatio Memoriae: Preserving and Erasing Identities in Roman Funerary Commemoration," in Maureen Carroll and Jane Rempel, *Living Through the Dead: Burial and Commemoration in the Classical World* (Oxford: Oxbow Books, 2011).

27. See chapter 3, "The Origins of Memory Sanctions in Roman Political Culture," in Flower, *The Art of Forgetting*.

28. See Dario Calomino, "Erasing Memory to Assert Loyalty and Identity in the Roman Empire," in *Negotiating Memory from the Romans to the Twenty-First Century*, ed. Øivind Fuglerud, Kjersti Larsen, and Marina Prusac-Lindhagen (New York: Routledge, 2021); and Eric R. Varner, *Mutilation and Transformation: Damnatio Memoriae and Roman Imperial Portraiture* (Leiden: Brill, 2004).

29. Pliny the Younger, *Panegyricus*, 52, 4–5 (Cambridge: Loeb Classics, Harvard University Press, 1969).

30. See Tracy Robey, "'Damnatio Memoriae': The Rebirth of Condemnation of Memory in Renaissance Florence," *Renaissance and Reformation* 36, no. 3 (Summer 2013): 5–32.

31. See Fabien Faugeron, "L'art du compromis politique: Venise au lendemain de la conjuration Tiepolo-Querini (1310)," *Journal des savants* 2 (2004): 357–421; and Dennis Romano, "Popular Protests and Alternative Visions of the Venetian Polity, c. 1260 to 1423," in *Popular Politics in an Aristocratic Republic: Political Conflict and Social Contestation in Late Medieval and Early Modern Venice*, ed. Maartje van Gelder and Claire Judde de Larivière (London: Routledge, 2020).

32. See Melinda Hegarty, "Laurentian Patronage in the Palazzo Vecchio: The Frescoes of the Sala dei Gigli," *The Art Bulletin* 78, no. 2 (June 1996): 264–85.

33. See Robey, "'Damnatio Memoriae.'"

34. See chapter 2 of Niccolò Machiavelli's *Florentine Histories*, www.gutenberg.org/files/2464/2464-h/2464-h.htm.

35. See Jordan Runtagh, "When John Lennon's 'More Popular Than Jesus' Controversy Turned Ugly," *Rolling Stone*, July 29, 2016, www.rollingstone.com/feature/when-john-lennons-more-popular-than-jesus-controversy-turned-ugly-106430.

36. See Mark Murrmann, "Burn Your Beatles Records!" *Mother Jones*, August 12, 2014.

37. For the original John Lennon interview with the *Evening Standard* in 1966, see Maureen Cleave, "How Does a Beatle Live? John Lennon Lives Like This," *London Evening Standard*, 1996, www.beatlesinterviews.org/db1966.0304-beatles-john-lennon-were-more-popular-than-jesus-now-maureen-cleave.html.

38. On the illiberal influence of the Puritans in America, see two books by James Simpson: *Under the Hammer: Iconoclasm in the Anglo American Tradition* (New York: Oxford University Press, 2010) and *Burning to Read: English Fundamentalism and Its Reformation Opponents* (Cambridge: Harvard University Press, 2007).

39. Christopher Schelin, "Cancel Culture Looks a Lot Like Old-Fashion Religion," *The Conversation*, April 28, 2021, https://theconversation.com/cancel-culture-looks-a-lot-like-old-fashioned-church-discipline-158685.

40. Schelin, "Cancel Culture Looks a Lot Like Old-Fashion Religion."

41. "Nick Cave Compares Cancel Culture to Bad Religion," *BBC News*, August 13, 2020, www.bbc.com/news/entertainment-arts-53768254.

42. The classic work on commodity fetishism is the Frankfurt School analysis of the cultural industry by Max Horkheimer and Theodor Adorno in *Dialectic of Enlightenment* (Stanford: Stanford University Press, 2002). See also David Morgan's discussion of the allure and aura of cultural icons in chapter 5 of his book *Images at Work: The Material Culture of Enchantment* (New York: Oxford University Press, 2018).

43. See Simpson, *Under the Hammer*, 12.

44. Emma Nolan, "Who Shot John Lennon and Why? Mark David Chapman's Motive for Killing Beatles Icon," *Newsweek*, December 8, 2020, www.newsweek.com/john-lennon-death-mark-david-chapman-motive-killing-40-anniversary-1553156.

45. Craig Unger, "John Lennon's Killer: The Nowhere Man," *New York Magazine*, June 22, 1981.

46. "John Lennon's Killer Wants to Spread the Word of God after Forty Years of Protective Custody," *The Mirror*, December 5, 2020.

Chapter 4

1. See Abigail Cain, "A Look at Botticelli's 'The Birth of Venus' in Pop Culture," *Artsy*, July 26, 2018, www.artsy.net/article/artsy-editorial-botticellis-birth-venus-pop-culture.

2. See chapter 11, "The Savonarolan Moment: King Christ," in Lauro Martines, *Scourge and Fire: Savonarola and Renaissance Italy* (London: Jonathan Cape, 2006); and Patrick Macey, "The Lauda and the Cult of Savonarola," *Renaissance Quarterly* 45, no. 3 (Autumn 1992): 439–83.

3. Quoted in Alain Besançon, *The Forbidden Image: An Intellectual History of Iconoclasm* (Chicago: University of Chicago Press, 2000): 172.

4. See Alexander Nagel, *The Controversy of Renaissance Art* (Chicago: University of Chicago, 2011), 37.

5. See Joseph Leo Koerner, *The Reformation of the Image* (Chicago: University of Chicago Press, 2008), 136.

6. See chapter 18, "Burning the Vanities" in Donald Weinstein, *Savonarola: The Rise and Fall of a Renaissance Prophet* (New Haven: Yale University Press, 2011).

7. See Vasari's *Lives of the Most Eminent Painters, Sculptors and Architects,* www.trav elingintuscany.com/art/giorgiovasari/lives.pdf. A different translation is quoted in David Freedberg, *The Power of Images* (Chicago: University of Chicago Press, 1989), 348.

8. See Exodus 20:2, www.biblegateway.com/passage/?search=Exodus+20&version= KJV.

9. For Exodus 32:35, see https://biblehub.com/exodus/32-35.htm. Also see David Freedberg, *The Power of Images* (Chicago: University of Chicago Press, 1989), 379–80.

10. See Ovid, *Metamorphoses* Book 10, www.theoi.com/Text/OvidMetamorphoses 10.html.

11. The negative reactions to Michelangelo's work on the Sistine Chapel is recounted by Vasari in his *Lives of the Artists,* http://employees.oneonta.edu/farberas/arth/arth213/ michelangelo_vasari.html. See also Bernadine Barnes, "Aretino, the Public, and the Censorship of Michelangelo's Last Judgment," in Elizabeth Childs, *Suspended License: Censorship and the Visual Arts* (Seattle: University of Washington Press, 1997).

12. See Mark Twain, *A Tramp Abroad* (1880), https://twain.thefreelibrary.com/ Tramp-Abroad/0-50.

13. See Egon Verheyen, "Correggio's Amori di Giove," *Journal of the Warburg and Courtauld Institutes* 29 (1966): 160–92.

14. See the *Souvenirs de la Marquise de Crequy,* vol. 3, https://gallica.bnf.fr/ ark:/12148/bpt6k2049670.image; and "Sur la vie et mort de très haut, très puissant, et très sérénissime prince, Monseigneur Louis d'Orléans," http://penelope.uchicago.edu/ crequy/vie_orleans.html.

15. See "Omaha's Shocking Nineteenth Century Art," *History Nebraska,* https://his tory.nebraska.gov/blog/omaha%E2%80%99s-shocking-nineteenth-century-art.

16. See David Scobey, "Nymphs and Satyrs: Sex and the Bourgeois Public Sphere in Victorian New York," *Winterthur Portfolio* 37, no. 1 (Spring 2002): 51.

17. See Stephen Gillers, "A Tendency to Deprave and Corrupt: The Transformation of American Obscenity Law from *Hicklin* to *Ulysses,*" *Washington University Law Review* 85, no. 2 (2007): 218.

18. Cherry Wilson, "Man Held after Poussin Painting Is Vandalized in National Gallery," *The Guardian,* July 17, 2011.

19. "Painting Is Slashed by Vandal in London," *New York Times,* April 4, 1978, www .nytimes.com/1978/04/04/archives/painting-is-slashed-by-vandal-in-london.html.

20. See David Freedberg, *Iconoclasm* (Chicago: University of Chicago, 2021), 144–45.

21. See Vasari's life of Michelangelo, http://employees.oneonta.edu/farberas/arth/ arth213/michelangelo_vasari.html.

22. See Dario Gamboni, *The Destruction of Art: Iconoclasm and Vandalism Since the French Revolution* (London: Reaktion Books, 1997), 247–49.

23. See John J. Teunissen and Evelyn J. Hinz, "The Attack on the *Pietà*: An Archetypal Analysis," *The Journal of Aesthetics and Art Criticism* 33, no. 1 (Autumn 1974): 43–50.

24. Robert Hughes, "Can Italy Be Saved from Itself?" *Time* (5 June 1972), http:// content.time.com/time/subscriber/article/0,33009,905967,00.html.

25. See Richard Burt, "Iconoclasm and Ambivalence," in *Censorship: A World Encyclopedia*, ed. Derek Jones (London: Routledge, 2001), 1145; and David Freedberg, *Iconoclasts and Their Motives*, Gerson Lecture, October 7, 1983 (The Hague: SDU Publishers, 1985), 11.

26. "Rembrandt's 'The Night Watch' Slashed," *New York Times*, 15 September 1975.

27. See Dario Gamboni, *The Destruction of Art: Iconoclasm and Vandalism Since the French Revolution* (London: Reaktion Books, 1997): 183.

28. See Michael Pennington, *An Angel for a Martyr—Jacob Epstein's Tomb for Oscar Wilde* (Reading: Whitenights Press, 1987).

29. See Dario Gamboni, *The Destruction of Art: Iconoclasm and Vandalism since the French Revolution* (London: Reaktion Books, 1997), 188.

30. Stuart Jeffries, "Scarlet Kisses of Death for Oscar's Tomb," *The Guardian*, October 29, 2000, www.theguardian.com/world/2000/oct/29/books.booksnews.

Chapter 5

1. Some accounts give the date of the attack on the statue as late December 1997, while other sources indicate early January 1998.

2. See chapter 2 in David Weber, *The Spanish Frontier in North America* (New Haven: Yale University Press, 1992), 48.

3. See James Brooke, "Conquistador Statue Stirs Hispanic Pride and Indian Rage," *New York Times*, February 9, 1998.

4. Oñate's biographer is Marc Simmons, *The Last Conquistador: Juan de Oñate and the Settling of the Far Southwest* (Norman: University of Oklahoma Press, 1991).

5. See Michael Trujillo, "Onate's Foot: Remembering and Dismembering in Northern New Mexico," *Aztlan: A Journal of Chicano Studies* 33, no. 2 (Fall 2008): 91–119.

6. See David Weber and William DeBuys, "Acoma," in *First Impressions: A Reader's Journey to Iconic Places of the American Southwest* (New Haven: Yale University Press, 2017).

7. See Erin Vanderhoof, "New Mexico Rethinks Its Conquistador Iconography One Monument at a Time," *Vanity Fair*, June 18, 2020; and Samuel Gilbert, "Protests Target Spanish Colonial Statues That 'Celebrate Genocide' in the US West," *The Guardian*, June 24, 2020.

8. See chapter 6 in Erika Doss, *Memorial Mania: Public Feeling in America* (Chicago: University of Chicago Press, 2010), 313.

9. See James Brooke, "Conquistador Statue Stirs Hispanic Pride and Indian Rage," *New York Times*, February 9, 1998.

10. See Weber and DeBuys, "Acoma," 22.

11. See Frank Perez and Carlos Ortega, "Mediated Debate, Historical Framing, and Public Art: The Juan de Oñate Controversy in El Paso," *Aztlán* 33, no. 2 (December 2008): 121–40.

12. See Perez and Ortega, "Mediated Debate"; and Weber and DeBuys, "Acoma."

13. See "El Paso City Council Renames Onate Statue," *Albuquerque Journal*, November 6, 2003.

14. The historical veracity of the amputated feet story is debated. See, for example, David Weber and William DeBuys, who note that Oñate's order that twenty-four Acoma have their feet cut off "may or may not have been executed fully." See Weber and DeBuys, "Acoma," 21.

15. Ginger Thompson, "As a Sculpture Takes Shape in Mexico, Opposition Takes Shape in the U.S.," *New York Times*, January 17, 2002, www.nytimes.com/2002/01/17/world/as-a-sculpture-takes-shape-in-mexico-opposition-takes-shape-in-the-us.html.

16. See Dario Gamboni, *The Destruction of Art: Iconoclasm and Vandalism Since the French Revolution* (London: Reaktion Books, 1997), 37.

17. Francisco López de Gómara, a contemporary of Cortés, is considered a biased source but provided a full account of the Spanish conquest. See chapter 13, "Cortés Cast Down the Idols of Cozumel" in his book *Cortés: The Life of the Conqueror by His Secretary Francisco López de Gómara* (Berkeley: University of California Press, 1964).

18. See Carlos M. N. Eire, *War Against the Idols: The Reformation of Worship from Erasmus to Calvin* (Cambridge: Cambridge University Press, 1986), 5.

19. See Alan Knight, *Mexico: From the Beginning to the Spanish Conquest* (New York: Cambridge University Press, 2002), 155; and Caroline Dodds Pennock, "Mass Murder or Religious Homicide? Rethinking Human Sacrifice and Interpersonal Violence in Aztec Society," *Historical Social Research* 37, no. 3 (2012): 276–302.

20. See Farah Mohammed, "Who Was La Malinche?" *JStor Daily*, March 1, 2019, https://daily.jstor.org/who-was-la-malinche. See also Cordelia Candelaria, "La Malinche: Feminist Prototype," *Frontiers: A Journal of Women Studies* 5, no. 2 (Summer 1980): 1–6.

21. See chapter 1 in Donald Chipman, *Moctezuma's Children: Aztec Royalty Under Spanish Rule, 1520–1700* (Austin: University of Texas Press, 2005).

22. See chapter 2 in Weber, *The Spanish Frontier in North America*, 25.

23. See chapter 2 in Chipman, *Moctezuma's Children*.

24. See David Weber, *The Spanish Frontier in North America: The Brief Edition* (New Haven: Yale University Press, 2009), 8.

25. See Todd Hartch, "A Brief History of Christianity in Mexico," in *Understanding World Christianity: Mexico* (Minneapolis: Augsburg Fortress, 2019), 8.

26. See W. H. Holmes, "Examples of Iconoclasm by the Conquerors of Mexico," *The American Naturalist* 19, no. 11 (November 1885): 1031–37.

27. See "A Lesson from Mexico: How to Forgive Historical Wrongs to Do Right in the Present," *National Geographic*, January 29, 2018.

28. Raphael Minder and Elizabeth Malkin, "Mexican Call for Conquest Apology Ruffles Feathers in Spain. And in Mexico," *New York Times*, March 27, 2019, www.nytimes.com/2019/03/27/world/americas/mexico-spain-apology.html.

29. Isis Davis-Marks, "Mexico Seeks Apology for Catholic Church's Role in Spanish Conquest," *Smithsonian Magazine*, November 2, 2020, www.smithsonianmag.com/smart-news/mexico-asks-vatican-return-indigenous-objects-180976178.

30. Tod Robberson, "Pope Uses Ceremony at Ancient Mayan Site to Reach out to American Indians," *Washington Post*, August 12, 1993.

31. Ben Hoyle, "Mexico Demands Apology from Spain for the Conquistadores," *The Times*, March 27, 2019, www.thetimes.co.uk/article/mexico-demands-apology-from-spain-for-the-conquistadores-c7hgvnd0t.

32. Sam Jones, "500 Years Later, Cortés Still Looms Large on Both Sides of Atlantic," *The Guardian*, December 31, 2019.

33. John Burnett, "Statues of Conquistador Juan de Onate Come Down as New Mexico Wrestles with History," *National Public Radio*, July 13, 2020, www.npr.org/2020/07/13/890122729/statues-of-conquistador-juan-de-o-ate-come-down-as-new-mexico-wrestles-with-hist.

34. Wyatte Grantham-Philips, "Indigenous Activists Protest Spanish Conquistadors," *USA Today*, June 29, 2020.

35. Samuel Gilbert, "Protests Target Spanish Colonial Statues That 'Celebrate Genocide' in US West," *The Guardian*, June 24, 2020, www.theguardian.com/environment/2020/jun/24/protests-target-spanish-colonial-statues-new-mexico.

36. "Colombian Anti-Government Protesters Topple Columbus Statue," *BBC*, June 20, 2021, www.bbc.com/news/world-latin-america-57651833; and "Indigenous Colombians Topple Conquistador Statue in Capital," *France 24*, May 7, 2021.

37. Anatoly Kurmanaev and Oscar Lopez, "Mexico City Replaces a Statue of Columbus with One of an Indigenous Woman," *New York Times*, October 14, 2021.

38. Anna Della Subin, "How to Kill a God. The Myth of Captain Cook Shows How the Heroes of Empire Will Fall," *The Guardian*, January 18, 2022.

39. "Investigation Opened on Vandalized Cook Monument," *Big Island Now*, January 3, 2022, https://bigislandnow.com/2022/01/03/investigation-open-on-vandalized-captain-cook-monument.

40. Ian Austin, "Residential Schools Show Canada's Grim Legacy of Cultural Erasure," *New York Times*, July 5, 2021.

41. "Statues of Queen Victoria and Queen Elizabeth II Torn Down in Canada," *BBC*, July 3, 2021.

42. Leyland Cecco, "Burned Churches Stir Deep Indigenous Ambivalence over Faith of Forefathers," *The Guardian*, July 4, 2021, www.theguardian.com/world/2021/jul/04/canada-burned-churches-indigenous-catholicism.

43. See Benjamin Soloway, "Pope Francis Apologizes for Church's Colonial Sins," *Foreign Policy*, July 15, 2015, https://foreignpolicy.com/2015/07/10/pope-francis-apologizes-for-churchs-colonial-sins.

Chapter 6

1. For Charles I's final words, see the British royal website biography: www.royal.uk/charles-i.

2. See Robert Wilcher, "What Was the King's Book For? The Evolution of 'Eikon Basilike,'" *The Yearbook of English Studies* 21, Special Number, Politics, Patronage and Literature in England 1558–1658 (1991): 218–28.

3. On the role of *Eikon Basilike* in transforming Charles I into a royal "celebrity," see Elizabeth Skerpan-Wheeler, "The First 'Royal': Charles I as Celebrity," *PMLA* 126, no. 4 (October 2011): 912–34. Also Kevin Sharpe, "'So Hard a Text'? Images of Charles I, 1612–1700," *The Historical Journal* 43, no. 2 (June 2000): 383–405.

4. See Margaret Aston, *England's Iconoclasts*, vol. 1 (Oxford: Clarendon Press, 1988), 62.

5. On the competing interpretations of the English Reformation, see Peter Marshall, "(Re)defining the English Reformation," *Journal of British Studies* 48, no. 3 (July 2009): 564–86.

6. See Aston, *England's Iconoclasts*, vol. 1, 256.

7. See "The 95 Theses, or Disputation for Clarifying the Power of Indulgences, 1517," in *The Annotated Luther: The Roots of Reform*, ed. Timothy Wengert, Hans Hillerbrand, and Kirsi Stjerna (Minneapolis: Augsburg Fortress, 2015).

8. See Lucy Beckett, "Smash and Grab," *Times Literary Supplement*, June 20, 2008, 22. Also see G. W. Bernard, "The Dissolution of the Monasteries," *History* 96, no. 4 (324; October 2011): 390–409; and more recently, James Clark, *The Dissolution of the Monasteries: A New History* (London: Yale University Press, 2021).

9. See Peter Marshall, *Heretics and Believers: A History of the English Reformation* (New Haven: Yale University Press, 2017), 261.

10. For the text of the injunction, see *The Second Royal Injunctions of Henry VIII, 1538*, www.henryviiithereign.co.uk/1538-second-injunctions.html.

11. See Keith Thomas, "Art and Iconoclasm in Early Modern England," in *Religious Politics in Post-Reformation England*, ed. Kenneth Fincham and Peter Lake (Rochester: Boydell Press, 2006).

12. See Stanford E. Lehmberg, "Henry VIII, the Reformation and the Cathedrals," *Huntington Library Quarterly* 49, no. 3, Tudor History Issue (Summer 1986): 261–70; and Robert Scully, "The Unmaking of a Saint: Thomas Becket and the English Reformation," *The Catholic Historical Review* 86, no. 4 (October 2000): 579–602.

13. See Bernard, "The Dissolution of the Monasteries."

14. See chapter 1, "The Call to Destroy," in Margaret Aston, *Broken Idols of the English Reformation* (Cambridge: University of Cambridge Press, 2015).

15. See the chapter "Iconoclasm" in Susan Juster, *Sacred Violence in Early America* (Philadelphia: University of Pennsylvania Press, 2016), 206.

16. See Roy Strong, "Edward VI and the Pope," *Journal of the Warburg and Courtauld Institutes* 23, no. 3/4 (July–December 1960): 311–13.

17. See *Homily Against Peril of Idolatry and Superfluous Decking of Churches*, www.anglicanlibrary.org/homilies/bk2hom02.htm.

18. Julie Spraggon, *Puritan Iconoclasm during the English Civil War* (Woodbridge: Boydell Press, 2003), xiii.

19. See Thomas, "Art and Iconoclasm in Early Modern England."

20. See Thomas, "Art and Iconoclasm in Early Modern England."

21. On crosses and crucifixes, see Margaret Aston, "Cross and Crucifix in the English Reformation," *Historische Zeitschrift. Beihefte* 33, New Series (2002): 253–72.

22. "What a Previous Iconoclastic Period Reveals about the Present One," *The Economist*, January 8, 2022.

23. Spraggon, *Puritan Iconoclasm during the English Civil War*, 159.

24. See Simon Chidley's *Bells Founder Confounded*, 1659, https://quod.lib.umich.edu/e/eebo2/A79486.0001.001?rgn=main;view=fulltext.

25. Spraggon, *Puritan Iconoclasm during the English Civil War*, 85.

26. See Adam Swann, "Twilight of the Idle, or How to Historicize with a Hammer: Milton, Nietzsche, and the Iconoclasm of English Identity," in *Iconoclasm: The Breaking and Making of Images*, ed. Rachel F. Stapleton and Antonio Viselli (Montreal: McGill-Queen's University Press, 2019), 147–67. Also see an account on the Peterborough Cathedral website: www.peterborough-cathedral.org.uk/history.aspx.

27. See Susan Juster, *Sacred Violence in Early America* (Philadelphia: University of Pennsylvania Press, 2016), 210.

28. On William Dowsing, see chapters 4 and 7 in Spraggon, *Puritan Iconoclasm During the English Civil War*; also James Simpson, *Under the Hammer: Iconoclasm in the Anglo-American Tradition* (Oxford: Oxford University Press, 2011).

29. The term *sacrament of forgetfulness* is from historian Eamon Duffy in *The Stripping of the Altars* (New Haven: Yale University Press, 1992), 480. It's quoted in Spraggon, *Puritan Iconoclasm during the English Civil War*, 1.

30. See "Cromwell, a Kill Joy Regime?" in Margerette Lincoln, *London and the Seventeenth Century: The Making of the World's Greatest City* (New Haven: Yale University Press, 2021).

31. See the chapter "The Restoration Regime and Historical Reconstructions of the Civil War and Interregnum" in Matthew Neufeld, *The Civil Wars After 1660: Public Remembering in Late Stuart England* (Woodbridge: Boydell and Brewer, 2013). For the text of the 1660 law, *An Act of Free and General Pardon Indemnity and Oblivion*, see www.british-history.ac.uk/statutes-realm/vol5/pp226-234.

32. See Lincoln, *London and the Seventeenth Century*, 183.

33. See "Restoration and a Licentious Court" in Lincoln, *London and the Seventeenth Century*, 184.

Chapter 7

1. On liberty poles, see Wendy Bellion, "Mast Trees, Liberty Poles, and the Politics of Scale in Late Colonial New York," in *Scale*, ed. Jennifer Roberts (Chicago: University of Chicago Press, 2016).

2. For a text of the Declaration of Independence, see www.archives.gov/founding -docs/declaration-transcript.

3. See Arthur Marks, "The Statue of King George III in New York and the Iconology of Regicide," *The American Art Journal* 13, no. 3 (Summer 1981): 65–66.

4. See Edward Gray and Jane Kamensky, eds., *The Oxford Handbook of the American Revolution* (New York: Oxford University Press, 2013), 503.

5. See Wendy Bellion, "Pitt on a Pedestal: Sculpture and Slavery in Late-Eighteenth-Century Charleston," *European Journal of American Studies* 14, no. 4, (2019), http://journals.openedition.org/ejas/15410.

6. See Arthur Marks, "The Statue of King George III in New York and the Iconology of Regicide," *The American Art Journal* 13, no. 3 (Summer 1981): 61–82.

7. See Wendy Bellion, *Iconoclasm in New York: Revolution to Reenactment* (University Park: Pennsylvania State University Press, 2019), 110–13.

8. See James Spalding, "Loyalist as Royalist, Patriot as Puritan: The American Revolution as a Repetition of the English Civil Wars," *Church History* 45, no. 3 (September 1976): 329–40.

9. See the chapter "Pilgrims and Puritans and the Myth of the Promised Land," in Heike Paul, *The Myths that Made America* (Bielefeld: Transcript Verlag, 2014).

10. Benjamin Rush, "A Plan of a Peace Office for the United States," in *Essays, Literary, Moral and Philosophical* (Philadelphia: Thomas and William Bradford, 1806), 183–88.

11. See "The Correspondence of Benjamin Rush and Granville Sharp 1773-1809," *Journal of American Studies* 1, no. 1 (April 1967): 9.

12. See Susan Juster, *Sacred Violence in Early America* (Philadelphia: University of Pennsylvania Press, 2016), 216.

13. See chapter 2, "War with America" in Jeremy Black, *George III: America's Last King* (New Haven: Yale University Press, 2009), 224.

14. Abigail Adams to John Adams, July 21, 1776, https://founders.archives.gov/documents/Adams/04-02-02-0033.

15. See Thomas J. McGuire, *Battle of Paoli* (Mechanicsburg, PA: Stackpole Books, 2000).

16. See the introduction in Kirk Savage, *Monument Wars: Public Monuments in Changing Societies* (Berkeley: University of California Press, 2011).

17. See Wendy Bellion, *Iconoclasm in New York: Revolution to Reenactment* (University Park: Pennsylvania State University Press, 2019).

18. See Ryan Cole, "Nathaniel Macon as Dr. No," *National Review*, February 22, 2015, www.nationalreview.com/2015/02/nathaniel-macon-dr-no-ryan-l-cole. See also the introduction in Savage, *Monument Wars*.

19. John Quincy Adams, *Memoirs of John Quincy Adams, Comprising Portions of His Diary from 1795 to 1848*, ed. Charles Francis Adams (Philadelphia: J.B. Lippencott and Co., 1876), 8, 433.

20. *The Letters of Thomas Jefferson*, April 1803, www.let.rug.nl/usa/presidents/thomas-jefferson/letters-of-thomas-jefferson/jefl154.php.

21. See Brian Christopher Jones, *Constitutional Idolatry and Democracy: Challenging the Infatuation with Writtenness* (Cheltenham: Edward Elgar, 2020).

22. The classic work on taste and bourgeois "distinction" is Pierre Bourdieu's *La Distinction: Critique sociale du jugement* (Paris: Les Éditions de minuit, 1979).

23. For an insightful analysis of Enlightenment values and iconoclasm, see the chapter "Iconoclasm and the Enlightenment" in James Simpson, *Under the Hammer: Iconoclasm in the Anglo-American Tradition* (Oxford: Oxford University Press, 2011).

24. See Maurie McInnis, "George Washington: Cincinnatus or Marcus Aurelius?" in *Thomas Jefferson, the Classical World, and Early America*, ed. Peter Onuf and Nicholas Cole (Charlottesville: University of Virginia Press, 2011), 139.

25. "George Washington to Marquis de Lafayette, November 8, 1785," *The Writings of George Washington, 1748-1799*, 14 vols., ed. Worthington C. Ford (New York: G.P. Putnam's Sons, 1893), vol. 10, p. 502.

26. See Phoebe Lloyd Jacobs, "John James Barralet and the Apotheosis of George Washington," *Winterthur Portfolio* 12 (1977): 115–37. For the image of the work, see the Metropolitan Museum of Art, www.metmuseum.org/art/collection/search/365795.

27. For the Walt Whitman poem on the Washington Monument, see https://whitmanarchive.org/published/LG/1891/clusters/333.

28. See Maurice Agulhon, "La 'statuomanie' et l'histoire," *Ethnologie Française* 8, nos. 2/3 (1978): 145–72.

29. Nietzsche's "monumental" philosophy of history can be found in his essay, "On the Uses and Abuses of History for Life" (1874). See Daniel Breazeale, ed., *Nietzsche: Untimely Medications* (Cambridge: Cambridge University Press, 1997): 57–124.

30. Simpson, *Under the Hammer*, 85.

31. See Yasmin Sabina Kahn, *Enlightening the World: The Creation of the Statue of Liberty* (Ithaca: Cornell University Press, 2010), 181–82.

32. See James McConnell, "Royal Statues and Monuments in the United States of America, 1770-2010," in David Gleeson, *English Ethnicity and Culture in North America* (Columbia: University of South Carolina Press, 2017).

33. See Stephen Tuffnell, "'Uncle Sam Is to Be Sacrificed': Anglophobia in Late Nineteenth-Century Politics and Culture," *American Nineteenth Century History* 12, no. 1 (March 2011): 77–99.

34. See McConnell, "Royal Statues and Monuments," 163.

35. See "Charging Bull Sculptor Says New York's Fearless Girl Statue Violates His Rights," *The Guardian*, April 12, 2017.

36. See Wendy Bellion, *Iconoclasm in New York: Revolution to Reenactment* (Philadelphia: University of Pennsylvania Press, 2019), 116.

37. Quoted in Holger Hoock, *Empire of the Imagination: Politics, War and the Arts in the British World* (London: Profile Books, 2010), 53.

38. See Len Buckwalter, "Treasure Hunting: A Regal Reward," *New York Times*, February 4, 1972.

39. See New York Historical Society, www.nyhistory.org/exhibit/fragment-equestrian-statue-king-george-iii-tail.

40. See chapter 4 in Wendy Bellion's *Iconoclasm in New York: Revolution to Reenactment* (Philadelphia: University of Pennsylvania Press, 2019).

41. David Dunlap, "Long-Toppled Statue of King George III to Ride Again, from a Brooklyn Studio," *New York Times*, October 20, 2016.

Chapter 8

1. See Richard Clay, "Re-Making French Revolutionary Iconoclasm," *Perspective*, January 2012, http://journals.openedition.org/perspective/633; and Richard Wrigley, "Breaking the Code: Interpreting French Revolutionary Iconoclasm," in *Reflections of Revolution*, ed. Alison Yarrington and Kevin Everest (London: Routledge, 1993), 182–95.

2. On the connection between iconoclasm and state building in revolutionary France, see chapter 3 in James Noyes, *The Politics of Iconoclasm: Religion, Violence, and the Culture of Image-Breaking in Christianity and Islam* (London: I.B. Tauris, 2013). Noyes makes a connection between Calvinist and Jacobin iconoclasm.

3. On the use of the term *iconoclasm* to describe French revolutionary violence, see Clay, "Re-Making French Revolutionary Iconoclasm."

4. For a detailed description of the damage inflicted on churches, monasteries, aristocratic residences, and royal symbols, see François Souchal, *Le Vandalisme de la Révolution* (Paris: Nouvelles Éditions Latines, 1993).

5. On revolutionary engravings, see Erika Naginski, "The Object of Contempt," *Yale French Studies*, no. 101, Fragments of Revolution (2001): 32–53.

6. See Robert Darnton, "What Was Revolutionary about the French Revolution?" *New York Review of Books*, January 19, 1989.

7. See Richard Clay, *Iconoclasm in Revolutionary Paris: The Transformation of Signs* (Oxford: Voltaire Foundation, 2012).

8. See Andrew McClellan, "The Life and Death of a Royal Monument: Bouchardon's Louis XV," *Oxford Art Journal* 23, no. 2 (2000): 1–27.

9. See Richard Clay, "Bouchardon's Statue of Louis XV: Iconoclasm and the Transformation of Signs," in *Iconoclasm: Contested Objects, Contested Terms*, ed. Stacy Boldrick and Richard Clay (Aldershot, UK: Ashgate, 2007).

10. See Victoria Thompson, "The Creation, Destruction and Recreation of Henri IV: Seeing Popular Sovereignty in the Statue of a King," *History and Memory* 24, no. 2 (Fall/Winter 2012): 5–40.

11. See Stanley Idzerda, "Iconoclasm during the French Revolution," *The American Historical Review* 60, no. 1 (October 1954): 16.

12. See Idzerda, "Iconoclasm during the French Revolution," 17.

13. See Maurice Agulhon, "Marianne, réflexions sur une histoire," *Annales historiques de la Révolution française*, no. 289 (1992): 313–22.

14. Bertrand Barère, quoted in Gabrièle Sprigath, "Sur le vandalisme révolutionnaire 1792–94," *Annales historique de la Révolution française*, no. 242 (October–December 1980): 512.

15. See Idzerda, "Iconoclasm during the French Revolution," 21.

16. Jean-Louis David quoted in Idzerda, "Iconoclasm during the French Revolution," 21.

17. See Idzerda, "Iconoclasm during the French Revolution," 22.

18. See the chapter "Iconoclasm and the Enlightenment" in James Simpson, *Under the Hammer: Iconoclasm in the Anglo-American Tradition* (Oxford: Oxford University Press, 2011).

19. "Convention nationale: Suite de la séance du mercredi, 31 juillet," *Le Moniteur Universel*, August 2, 1793, 914.

20. See Suzanne Glover Lindsay, "The Revolutionary Exhumations at St-Denis, 1793," in *Conversations: An Online Journal of the Center for the Study of Material and Visual Cultures of Religion* (2014), https://mavcor.yale.edu/conversations/essays/revolutionary-exhumations-st-denis-1793.

21. On revolutionary festivals, see Mona Ozouf, *Festivals and the French Revolution* (Cambridge: Harvard University Press, 1988).

22. Jean Joseph François Poujoulat, *Histoire de la Révolution Française* (Tours: A. Mame et Cie, 1848): 2, 87. For a detailed account of the royal crypt desecrations by a witness to the events, see Alexandre Lenoir, "Notes historiques sur les exhumations faites en 1793 dans l'abbaye de Saint Denis," Musée des monuments français (Paris: Imprimerie d'Hacquart, 1801). Also see Max Billard, *Les Tombeaux des rois sous la Terreur* (Paris: Perrin, 1907).

23. See Kevin Smith, "Victor Hugo and the Vendôme Column," *French Forum* 21, no. 2 (May 1996): 149–64.

24. See Karl Marx, *The Eighteenth Brumaire of Louis Bonaparte*, www.marxists.org/archive/marx/works/1852/18th-brumaire/preface.htm.

25. Quoted in Jonathan Beechers, *Writers and Revolution: Intellectuals and the French Revolution of 1848* (Cambridge: Cambridge University Press), 118.

26. Quoted in Ting Chang, "Rewriting Courbet: Silvestre, Courbet, and the Bruyas Collection after the Paris Commune," *Oxford Art Journal* 21, no. 1 (1998): 109.

27. See Robert Solé, *Le Grand Voyage de l'obélisque* (Paris: Seuil, 2004), 139.

28. "Paris Statues of Voltaire and Colonial-Era General Splashed with Red Paint," *France 24*, June 6, 2020.

29. On the defacing and toppling of statues in France, including the Victor Schœlcher statue, see Jacqueline Lalouette, *Les statues de la discorde* (Paris: Passés Composés, 2021).

30. For an anti-Voltaire opinion in the wake of the controversy over his statue, see Nabila Ramdani, "Voltaire Spread Darkness, Not Enlightenment. France Should Stop Worshipping Him," *Foreign Policy*, August 31, 2020.

31. "Macron Says France Won't Remove Statues, Erase History," *Reuters*, June 14, 2020, www.reuters.com/article/us-health-coronavirus-france-macron-stat/macron-says-france-wont-remove-statues-erase-history-idUSKBN23L0QP.

32. See Kim Willsher, "Où est Voltaire? Mystery of Parisian Statue Solved," *The Guardian*, February 20, 2022.

Chapter 9

1. For the influence of French historical figures on the Bolsheviks, see Jay Bergman, *The Revolutionary Tradition in Russian and Soviet Politics* (Oxford: Oxford University Press, 2019); and John Keep, "1917: The Tyranny of Paris Over Petrograd," *Soviet Studies* 20, no. 1 (July 1968): 22–35.

2. See the prologue in David Jordan, *The Revolutionary Career of Maximilien Robespierre* (Chicago: University of Chicago Press, 1985). For a comparison between

Lenin and Robespierre, see chapter 4, "Lenin: The Russian Robespierre," in Jay Bergman, *The Revolutionary Tradition in Russian and Soviet Politics* (Oxford: Oxford University Press, 2019); and Robert Mayer, "Lenin and the Jacobin Identity in Russia," *Studies in East European Thought* 51, no. 2 (June 1999): 127–54.

3. See "Memorandum from the Visual Arts Section of the People's Commissariat for Enlightenment to the Soviet of People's Commissars: Project for the Organization of Competitions for Monuments to Distinguished Persons (1918)," *Design Issues* 1, no. 2 (Autumn 1984): 70–74.

4. See chapter 3, "The Politics of Meaning and Style," in James von Geldern, *Bolshevik Festivals 1917–1920* (Berkeley: University of California Press, 1993), http://ark .cdlib.org/ark:/13030/ft467nb2w4.

5. The original title of Gustave Le Bon's book was *Psychologie des foules*, published in 1895. For an English version, see, *The Crowd: A Study of the Popular Mind* (New York: Viking, 1960).

6. Le Bon, *The Crowd*, 20.

7. Natalia Murray, *Art for the Workers: Proletarian Art and Festive Decorations of Petrograd 1917–20* (Leiden: Brill, 2018), 7.

8. See footnote 53 to chapter 3, "The Politics of Meaning and Style," in von Geldern, *Bolshevik Festivals*.

9. See James Billington, *Fire in the Minds of Men: Origins of the Revolutionary Faith* (New York, Basic Books, 1980); and Jay Bergman, "The Perils of Historical Analogy: Leon Trotsky on the French Revolution," *Journal of the History of Ideas* 48, no. 1 (January–March 1987): 73–98.

10. For the Lenin quote, see V. I. Lenin, "Socialism and Religion," www.marxists .org/archive/lenin/works/1905/dec/03.htm; also see chapter 6, "Religion," in Arno Mayer, *The Furies: Violence and Terror in the French and Russian Revolutions* (Princeton, NJ: Princeton University Press, 2000), 161.

11. See Arno Mayer, *The Furies: Violence and Terror in the French and Russian Revolutions* (Princeton, NJ: Princeton University Press, 2000), 465.

12. See V. I. Lenin, "Draft Programme of the R.C.P.," www.marxists.org/archive/ lenin/works/1919/mar/x02.htm.

13. See chapter 12, "Engaging the Russian Orthodox Church," in Mayer, *The Furies*, 472.

14. See Richard Stites, "Russian Revolution: Destroying and Preserving the Past," in *Bolshevik Culture: Experiment and Order in the Russian Revolution*, ed. Abbott Gleason (Bloomington: Indiana University Press, 1985).

15. See M. J. O'Mahony, "Bringing Down the Tsar: 'Deconstructing' the Monument to Tsar Aleksandr III in Sergei Eisenstein's *October*," *Sculpture Journal* 15, no. 2 (2006): 272–78.

16. On the limited demolition policy under the Bolsheviks, see Aaron J. Cohen, "The Limits of Iconoclasm: The Fate of Tsarist Monuments in Revolutionary Moscow and Petrograd, 1917–1918," *City* 24, nos. 3–4 (July 2020): 616–26.

17. See "Decree of the Soviet of People's Commissars, 'On Monuments of the Republic,'" April 12, 1918, www.marxists.org/subject/mayday/soviet/decree.html.

18. See Alexei Yurchak, "Bodies of Lenin: The Hidden Science of Communist Sovereignty," *Representations* 129, no. 1 (2015): 116–57.

19. John Maynard Keynes, "A Short View of Russia" (1925), in Keynes, *Essays in Persuasion* (New York: Rupert Hart-Davis, 1965), http://pombo.free.fr/krussia.pdf.

20. See Dario Gamboni, *The Destruction of Art: Iconoclasm and Vandalism Since the French Revolution* (London: Reaktion Books, 1997), 69.

21. See chapter 1, "The Religious Front," in Victoria Smolkin, *A Sacred Space Is Never Empty: A History of Soviet Atheism* (Princeton: Princeton University Press, 2018).

22. Lee Hockstader, "From a Ruler's Embrace to a Life in Disgrace," *Washington Post*, March 10, 1995.

23. See Anita Pisch, "The Phenomenon of the Personality Cult—a Historical Perspective," in *The Personality Cult of Stalin in Soviet Posters, 1929–1953* (Canberra: ANU Press, 2016), 79.

24. See Pisch, "The Phenomenon of the Personality Cult."

25. Isabella Kwai, "Turkmenistan's President Gives His Favorite Dog a Golden Treat," *New York Times*, November 12, 2020.

26. See Alexander Adams, "Iconoclasm and the Erasing of History," *Aero*, April 11, 2019, https://areomagazine.com/2019/04/11/iconoclasm-and-the-erasing-of-history.

27. On Mao's Cultural Revolution and the Red Guards, see Roderick MacFarquhar and Michael Schoenhals, *Mao's Last Revolution* (Cambridge, MA: Belknap Press, 2006).

28. See Wang Liang, "The Confucius Temple Tragedy of the Cultural Revolution," in *On Sacred Grounds: Culture, Society, Politics, and the Formation of the Cult of Confucius*, ed. Thomas Wilson (Cambridge: Harvard University Asia Center, 2002).

29. See Ian Johnson, "China's Memory Manipulators," *The Guardian*, June 8, 2016.

30. Kathy Long, "Zhao Ziyang, a Reformer China's Communist Party Wants to Forget," *BBC News*, January 17, 2019, www.bbc.com/news/blogs-china-blog-46901248.

31. Chun Han Wong, "China Guards Its Historical Heroes with New Law," *Wall Street Journal*, April 27, 2018.

32. Pamela Kyle Crossley, "Xi's China Is Streamrolling Its Own History," *Foreign Policy*, January 29, 2019.

33. Louisa Lim and Ilaria Maria Sala, "China Wants to Forget the Horrors of Tiananmen as It Rewrites Its History," *The Guardian*, May 19, 2019; and "Pillar of Shame: Hong Kong's Tiananmen Square Statue Removed," *BBC News*, December 23, 2021.

34. Jamil Anderlini, "The Return of Mao: A New Threat to China's Politics," *Financial Times Magazine*, September 29, 2016.

35. See Julia Murray, "'Idols' in the Temple: Icons and the Cult of Confucius," *Journal of Asian Studies* 68, no. 2 (May 2009): 371–411.

36. See Rachelle Peterson, "American Universities Are Welcoming China's Trojan Horse," *Foreign Policy*, May 9, 2017.

37. See Sanford Levinson, *Written in Stone: Public Monuments in Changing Societies* (Durham, NC: Duke University Press, 2018), 10.

38. Steven Lee Myers, "Russia Rebukes Estonia for Moving Soviet Statue," *New York Times*, April 27, 2007.

39. See Tom Parfitt, "Russia Not Amused at Red Army Statue Reinvented as Super-man and Friends," *The Guardian*, June 22, 2011; and Martin Dimitrov, "Sofia's Red Army Monument: Canvas for Artists and Vandals," *Balkan Insight*, October 26, 2018.

40. See Benjamin Forest and Juliet Johnson, "Unraveling the Threads of History: Soviet-Era Monuments and Post-Soviet National Identity in Moscow," *Annals of the Association of American Geographers* 92, no. 3 (September 2002): 524–47.

41. See Benjamin Forest and Juliet Johnson, "Unraveling the Threads of History: Soviet-Era Monuments and Post-Soviet National Identity in Moscow," *Annals of the Association of American Geographers* 92, no. 3 (September 2002): 524–47.

42. "Russia's First Monument to Ivan the Terrible Inaugurated," *The Guardian*, October 14, 2016.

43. "Putin Unveils Controversial Statue of Saint Vladimir by Kremlin," *Agence France-Presse*, November 4, 2016.

44. See Lucian Kim, "Amid 'Quiet Rehabilitation of Stalin,' Some Russians Honor the Memory of His Victims," *NPR*, July 8, 2019.

45. Shaun Walker, "Ukraine Protestors Topple Lenin Statue in Kiev," *The Guardian*, December 8, 2013.

46. Jordan Teicher, "What Happened to Ukraine's 5,500 Lenin Statues?" *New York Times*, July 17, 2017.

47. "Looking for Lenin: The Ukraine Banned the Statues—but Where Did They Go?" *The Guardian*, April 11, 2016; and Sebastien Gobert, "Lenin's Tumble: The Iconoclasm of Ukraine's Decommunization," *The Odessa Review*, February 6, 2017.

48. See chapter 3, "The Fall of Communist Monuments" in Dario Gamboni, *The Destruction of Art: Iconoclasm and Vandalism Since the French Revolution* (London: Reaktion Books, 1997).

49. See Kate Connolly, "First Lenin Statue in Western Germany to Be Erected after Heated Battle," *The Guardian*, March 6, 2020.

50. See "Controversial Lenin Statue Unveiled in Germany's Gelsenkirchen," *DW*, June 20, 2020, www.dw.com/en/controversial-lenin-statue-unveiled-in-germanys-gelsenkirchen/a-53880002.

51. "Karl Marx: Monument Vandalised for Second Time in Two Weeks," *BBC News*, February 16, 2019.

52. Elian Peltier, "With Cameras Monitoring His Grave, Karl Marx Still Can't Escape Surveillance," *New York Times*, February 9, 2020, www.nytimes.com/2020/02/09/world/europe/karl-marx-grave-london.html.

Chapter 10

1. On the Nazi "brand," see Nicholas O'Shaughnessy, "Selling Hitler: Propaganda and the Nazi Brand," *Journal of Public Affairs* 9 (2009): 55–76.

2. See chapter 1, "Deconstructing Modernism," in Michael Kater, *Culture in Nazi Germany* (New Haven: Yale University Press, 2019).

3. Christoph Hasselbach, "When Books Were Burned in Germany," *DW*, May 10, 2018, www.dw.com/en/when-books-were-burned-in-germany/a-43725960; and J. M.

Ritchie, "The Nazi Book-Burning," *The Modern Language Review* 83, no. 3 (July 1988): 627–43.

4. The Heinrich Heine quote is from his 1821 play, *Almansor,* a tragic love story about a Moroccan woman forced to convert to Christianity. The play features a Christian book burning of the Quran.

5. Olivier Faye, "Le Sénat dissimule dans ses cave un buste d'Hitler et un drapeau nazi depuis soixante-quinze ans," *Le Monde,* September 3, 2019.

6. See the chapter "Pre-War Nazi Culture," in Kater, *Culture in Nazi Germany.*

7. Adolf Hitler, "Art and Its Commitment to Truth" (1934), in Anson Rabinbach and Sander L. Gilman, *The Third Reich Sourcebook* (Berkeley: University of California Press, 2013), 490.

8. Joseph Goebbels, "Ban on Art Criticism," first published as "Anordnung des Reichsministers für Volksaufklärung und Propaganda über Kunstkritik vom 27. 11. 1936," in *Völkischer Beogachter,* November 28, 1936, in Rabinbach and Gilman, *The Third Reich Sourcebook.*

9. See Neil Levi, "'Judge for Yourselves!' The 'Degenerate Art' Exhibition as Political Spectacle," *October* 85 (Summer 1998): 41–64.

10. See Frederick Spotts, *Hitler and the Power of Aesthetics* (London: Hutchinson Press, 2001).

11. Lucy Burns, "Degenerate Art: Why Hitler Hated Modernism," *BBC World Service,* November 6, 2013.

12. See Mary-Margaret Goggin, "'Decent' vs. 'Degenerate' Art: The National Socialist Case," *Art Journal* 50, no. 4, Censorship II (Winter 1991): 84–92.

13. See Dirk Rupnow, "The Invisible Crime: Nazi Politics of Memory and Postwar Representation of the Holocaust," in *The Holocaust and Historical Methodology,* ed. Dan Stone (New York: Berghahn Books, 2012).

14. Quoted in Katherina von Kellenbach, "Guilt and the Transformation of Christian-Jewish Relations," *SCJR* 15, no. 1 (2020): 11.

15. See Janet Jacobs, "Memorializing the Sacred: Kristallnacht in German National Memory," *Journal for the Scientific Study of Religion* 47, no. 3 (September 2008): 485–98.

16. See Karen Fiss, *Grand Illusion: The Third Reich, the Paris Exposition, and the Cultural Seduction of France* (Chicago: University of Chicago Press, 2009).

17. See Danilo Udovički-Selb, "Facing Hitler's Pavilion: The Uses of Modernity in the Soviet Pavilion at the 1937 Paris International Exhibition," *Journal of Contemporary History* 47, no. 1 (January 2012): 13–47.

18. See Dario Gamboni, *The Destruction of Art: Iconoclasm and Vandalism since the French Revolution* (London: Reaktion Books, 1997), 277; and Jean Adhémar, "Les statues parisiennes de grands hommes," *Gazette des Beaux Arts* 6, no. 83 (March 1974): 149–52.

19. See Maurice Agulhon, *Marianne into Battle: Republican Imagery and Symbolism 1789-1880* (New York: Cambridge, 1981); also Maurice Agulhon, *Marianne au pouvoir: L'imagerie et la symbolique républicaines de 1880 à 1914* (Paris: Flammarion, 1989).

20. See chapter 6, "Endangered Local Patrimony: Bronze Statues in Paris, Chambéry, and Nantes," in Elizabeth Campbell Karlsgodt, *Defending National Treasures: French Art and Heritage under Vichy* (Palo Alto: Stanford University Press, 2011).

21. See chapter 7, "Recycling French Heroes" in Karlsgodt, *Defending National Treasures.*

22. See Emmanuelle Polack, *Le Marché de l'art sous l'Occupation 1940–1944* (Paris: Tallandier, 2019); and Jonathan Petropoulos, *Goering's Man in Paris: The Story of a Nazi Art Plunderer and His World* (New Haven, CT: Yale University Press, 2021).

23. See chapter 7, "Recycling French Heroes," in Karlsgodt, *Defending National Treasures.*

24. See Elmer Plischke, "De-Nazifying the Reich," *The Review of Politics* 9, no. 2 (April 1947): 153–72.

25. Mark Landler, "'Hitler's Favorite Sculptor' Is Back, Hitting Raw Nerve," *New York Times,* July 24, 2006, www.nytimes.com/2006/07/24/world/europe/24germany .html; and Stuart Jeffries, "Hitler's Favourite Artists: Why Do Nazi Statues Still Stand in Germany?" *The Guardian,* September 7, 2021.

26. See Alison Smale and Jesse Coburn, "Sleuth Work Leads to Discovery of Art Beloved by Hitler," *New York Times,* June 25, 2015; and Konstantin von Hammerstein, "The Quest for Hitler's Lost Treasures," *Der Spiegel International,* May 26, 2015.

27. Carlo Invernizzi-Accetti, "A Small Italian Town Can Teach the World How to Defuse Controversial Monuments," *The Guardian,* December 6, 2017.

28. Alex Sakalis, "What Happens to Fascist Architecture after Fascism," *BBC Culture,* January 18, 2022, https://architexturez.net/pst/az-cf-223962-1640674869.

29. Sam Jones, "'Spain Is Fulfilling Its Duty to Itself': Franco's Remains Exhumed," *The Guardian,* October 24, 2019; and "Franco: Mililla Enclave Removes Last Statue of Fascist Dictator on Spanish Soil," *BBC News,* February 24, 2021.

30. Katie Mettler, "We Live in Crazy Times: Neo-Nazis Have Declared New Balance the 'Official Shoes of White People,'" *Washington Post,* November 15, 2016.

31. See Morgan Harries, "How New Balance Shoes Got Co-Opted by Neo-Nazis," *Vice,* November 15, 2016.

32. See Carla Bleiker, "Lonsdale Shows Love for the Left," Deutsche Welle, March 6, 2014, www.dw.com/en/lonsdale-shows-love-for-the-left/a-17476089.

33. Eileen Kinsella, "Maurizio Cattelan's Hitler Sculpture Leads Christie's $78 Million Sale," *Artnet News,* May 8, 2016.

34. Elizabeth Grenier, "Holocaust Memorial Outside AfD Leader's Home Provokes Accusations of 'Blackmail,'" *DW,* November 23, 2017.

35. See David Shim, "Memorials' Politics: Exploring the Material Rhetoric of the *Statue of Peace,*" *Memory Studies* (2021), https://journals.sagepub.com/ doi/10.1177/17506980211024328.

36. Philip Oltermann, "Holocaust Memorial Replica Stunt Shines Light on Right-wing Radicalism in Germany," *The Guardian,* April 7, 2019.

37. "In a Stadium Once Filled Not with Denim but Nazi Drab, Bob Dylan Makes His Judgment at Nuremberg: He Plays It," *People,* July 17, 1978.

38. See Tony Paterson, "Nuremberg: Germany's Dilemma over the Nazis' Field of Dreams," *The Independent,* January 1, 2016.

39. See Tom Batchelor, "Neo-Nazis Filmed Marching with Torches at Hitler's Nuremberg Rally Area," *The Independent,* February 27, 2019.

40. See Brigit Katz, "Nuremberg Decides to Conserve Nazi Rally Grounds," *Smithsonian Magazine,* May 21, 2019, www.smithsonianmag.com/smart-news/nuremberg -decides-conserve-nazi-rally-grounds-180972244.

Chapter 11

1. See Judith Pollmann, "Iconoclasts Anonymous," *Low Countries Historical Review* 131, no. 1 (2016): 155–76.

2. See Peter Arnade, *Beggars, Iconoclasts, and Civic Patriots* (Ithaca: Cornell University Press, 2008), 166.

3. See the introduction in Arnade's *Beggars, Iconoclasts, and Civic Patriots*, 2.

4. See chapter 4, "*Vivent les gueux!* Iconoclasm, Inversion and the Problem of Authority," in Arnade, *Beggars, Iconoclasts, and Civic Patriots*, 114.

5. See Herman van der Wee, "The Economy as a Factor in the Start of the Revolt of the Netherlands," *Acta Historiae Neerlandica* 5 (1971): 52–67.

6. See Violet Soen, "Between Dissent and Peacemaking: The Dutch Nobility on the Eve of the Revolt (1564–1567)," *Revue belge de philologie et d'histoire* 86, nos. 3–4 (2008): 735–58.

7. See Anne-Laure Van Bruaene, Koenraad Jonckheere, and Ruben Suykerbuyk, "Introduction: Beeldenstorm: Iconoclasm in the Sixteenth-Century Low Countries," *Low Countries Historical Review* 131, no. 1 (2016): 3–14.

8. See Arnade's *Beggars, Iconoclasts, and Civic Patriots*, 152.

9. On the profile and motivations of the rioters, see notably Solange Deyon and Alain Lottin, *Les "Casseurs" de l'été 1566: L'iconoclasme dans le Nord de la France* (Paris: Hachette, 1981).

10. For a study of the profile and influence of the Calvinist hedge-preachers, see Phyllis Mack Crew, *Calvinist Preaching and Iconoclasm in the Netherlands, 1544–1569* (Cambridge: Cambridge University Press, 1978).

11. For a contemporary account of the local reactions to the Spanish military, see Marcus Van Vaernewijck, quoted in Arnade, *Beggars, Iconoclasts, and Civic Patriots*, 177.

12. See Arnade, *Beggars, Iconoclasts, and Civic Patriots*, 182.

13. See the chapter "Le Châtiment," in Deyon and Lottin, *Les "Casseurs" de l'été 1566*.

14. See Soen, "Between Dissent and Peacemaking."

15. Tom Kertscher, "Is Black Lives Matter a Marxist Movement?" *Politifact*, Poynter Institute, July 21, 2020, www.politifact.com/article/2020/jul/21/black-lives-matter -marxist-movement.

16. For BLM leader Patrisse Cullor's statement that she was inspired by Karl Marx, see "Black Lives Matter Co-Founder Patrisse Cullors on Her Memoir, Her Life and What's Next for the Movement," *Time*, February 26, 2018, https://time.com/5171270/ black-lives-matter-patrisse-cullors. For Trump calling BLM a "Marxist group," see "Trump Slams Black Lives Matter Organization as 'Marxist Group,'" *New York Post*, August 5, 2020, https://nypost.com/2020/08/05/trump-slams-black-lives-matter-orga nization-as-marxist-group.

17. See "Evangelical Seminary Condemns Black Lives Matter Movement, 'Wokeness' Ideology," *Christian Post*, August 20, 2020, www.christianpost.com/news/evangelical -seminary-condemns-black-lives-matter-movement-wokeness-ideology.html.

18. See Marx's "Critique of Hegel's Philosophy of Right" in Part IV of John Raines, ed., *Marx on Religion* (Philadelphia: Temple University Press, 2002), 171; and Peter

Thompson, "Karl Marx, Part 1, Religion, the Wrong Answer to the Right Question," *The Guardian,* April 4, 2011.

19. See Hebah Farrag and Ann Gleig, "Far from Being Anti-Religious, Faith and Spirituality Run Deep in Black Lives Matter," *The Conversation,* September 14, 2020, https://theconversation.com/far-from-being-anti-religious-faith-and-spirituality-run -deep-in-black-lives-matter-145610.

20. See Hebah Farrag, "The Role of the Spirit in the #BlackLivesMatter Movement," June 24, 2015, Center for Religion and Civic Culture, University of Southern California, https://crcc.usc.edu/the-role-of-the-spirit-in-blacklivesmatter-movement.

21. James Simpson compares the Taliban to sixteenth-century evangelical iconoclasts in the introduction of his book, *Under the Hammer: Iconoclasm in the Anglo-American Tradition* (Oxford: Oxford University Press, 2011). See also the introduction in James Noyes, *The Politics of Iconoclasm: Religion, Violence, and the Culture of Image-Breaking in Christianity and Islam* (London: I.B. Tauris, 2013).

22. "Salafism: Politics and the Puritanical," *The Economist,* June 25, 2015. See also Gilles Kepel, *Jihad: The Trail of Political Islam* (Cambridge: Harvard University Press, 2003); and "Gilles Kepel: 'Le salafisme est l'arrière-plan culturel du djihadisme,'" *Revue des deux mondes,* April 22, 2016.

23. Scott Pham, "Police Arrested More Than 11,000 People at Protests across the US," *BuzzFeed News,* June 2, 2020, www.buzzfeednews.com/article/scottpham/floyd -protests-number-of-police-arrests.

24. On the Pacification of Ghent and "oblivion," see Pollmann, "Iconoclasts Anonymous."

25. See the chapter "The Restoration Regime and Historical Reconstructions of the Civil War and Interregnum," in Matthew Neufeld, *The Civil Wars after 1660: Public Remembering in Late Stuart England* (Woodbridge: Boydell and Brewer, 2013). For the text of the 1660 law, *An Act of Free and General Pardon Indemnity and Oblivion,* see www. british-history.ac.uk/statutes-realm/vol5/pp226-234.

26. See Ross Poole, "Enacting Oblivion," *International Journal of Politics, Culture, and Society* 22, no. 2 (June 2009): 149–57. On the Spanish "Pact of Forgetting," see Alex Sakalis, "What Happens to Fascist Architecture after Fascism," *BBC Culture,* January 18, 2022; and Andrew Rigby, "Amnesty and Amnesia in Spain," *Peace Review* 12, no. 1 (2000): 73–79.

27. Friedrich Nietzsche, "On the Uses and Abuses of History for Life" (1874). See Daniel Breazeale, ed., *Nietzsche: Untimely Medications* (Cambridge: Cambridge University Press, 1997), 57–124.

28. The quote is from Ernest Renan's "What Is a Nation?" from his conference at the Sorbonne in 1882. See Ernest Renan, *Qu'est-ce qu'une nation?* (Paris: Presses-Pocket, 1992).

29. See Dominique Allart, Christina Currie, and Steven Saverwyns, "Une copie qui fait honneur à son modèle: Le Massacre des innocents de Pierre Brueghel le Jeune (Sibiu, Muzeul National Brukenthal)," *Bulletin de l'Institut royal du Patrimoine artistique* 33 (2013): 133–52.

30. For the version in the British royal collection, see "Massacre of the Innocents, c. 1565-67," The Royal Collection, www.rct.uk/collection/405787/massacre-of-the -innocents.

Chapter 12

1. "*Rokeby Venus* Slashed with a Chopper. Sequel to Mrs. Pankhurst's Re-Arrest," *Manchester Guardian*, March 11, 1914.

2. See the chapter "The Injustice of Velázquez," in Daniel Cottom, *The Unhuman Culture* (Philadelphia: University of Pennsylvania Press, 2006), 78; and Derek Jones, *Censorship: A World Encyclopedia* (London: Routledge, 2002), 1145.

3. Mary Richardson, *Laugh a Defiance* (London: Weidenfeld & Nicholson, 1953), 96.

4. "The Damaged Venus," *The Times*, March 13, 1914, cited by Helen Scott, "'The Campaign of Wanton Attacks': Suffragette Iconoclasm in British Museums and Galleries during 1914," *The Museum Review* 1, no. 1 (2016), https://themuseumreviewjournal.wordpress.com/2016/12/12/vol1no1scott.

5. See Gridley McKim-Smith, "The Rhetoric of Rape, the Language of Vandalism," *Woman's Art Journal* 23, no. 1 (Spring–Summer 2002): 29–36; and "National Gallery Outrage: The *Rokeby Venus*, Suffragist Prisoner in Court. Extent of the Damage. Miss Richardson's Statement," *The Times*, March 11, 1914, www.heretical.com/suffrage/1914tms2.html.

6. Richardson gave a prepared statement to the Women's Social and Political Union that was published by *The Times* (London): "National Gallery Outrage: The *Rokeby Venus*, Suffragist Prisoner in Court. Extent of the Damage. Miss Richardson's Statement," *The Times*, March 11, 1914, www.heretical.com/suffrage/1914tms2.html.

7. Dario Gamboni cites Sylvia Pankhurst's written account of suffragist violence in Gamboni, *The Destruction of Art: Iconoclasm and Vandalism Since the French Revolution* (London: Reaktion Books, 1997), 117.

8. See C. J. Bearman, "An Examination of Suffragette Violence," *The English Historical Review* 120, no. 486 (April 2005): 365–97.

9. Queen Mary's remarks, written in a letter in 1913, cited in Anne Edwards, *Matriarch: Queen Mary and the House of Windsor* (Lanham, MD: Rowman & Littlefield, 1984), 257.

10. See Yvonne Seale, "How Joan of Arc Inspired Women Suffragists," *The Public Medievalist*, September 10, 2020.

11. See the chapter "The Injustice of Velázquez," in Cottom, *The Unhuman Culture*, 87.

12. "National Gallery Outrage."

13. See David Morgan, *Images at Work: The Material Culture of Enchantment* (New York: Oxford University Press, 2018), 83.

14. See notably Rowena Fowler, "Why Did Suffragettes Attack Works of Art?" *Journal of Women's History* 2, no. 3 (1991): 109–25; and Lena Mohamed, "Suffragettes: The Political Value of Iconoclastic Acts," in *Art Under Attack*, ed. Tabitha Barber and Stacy Boldrick, 114–25 (London: Tate, 2013).

15. See Helena Bonett, "'Deeds Not Words': Suffragettes and the Summer Exhibition," *Royal Academy*, June 19, 2018, www.royalacademy.org.uk/article/deeds-not-words-suffragettes-and.

16. See Scott, "'Their Campaign of Wanton Attacks.'"

17. See Julie Gottlieb, *Feminine Fascism. Women in Britain's Fascist Movement 1923–1945* (London: I.B. Tauris, 2000).

18. See Martin Pugh, "Why Former Suffragettes Flocked to British Fascism," *Slate*, April 14, 2017, https://slate.com/news-and-politics/2017/04/why-the-british-union-fascist-movement-appealed-to-so-many-women.html.

19. See Hilda Kean, "Some Problems of Constructing and Reconstructing a Suffragette's Life: Mary Richardson, Suffragette, Socialist and Fascist," *Women's History Review* 7, no. 4 (1998): 475–93.

20. Quoted in Gamboni, *The Destruction of Art*, 95.

21. David Freedberg, *The Power of Images* (Chicago: University of Chicago Press, 1989), 410.

22. Freedberg, *The Power of Images*, 410–12.

23. Richardson's autobiography was published in 1953; see Richardson, *Laugh a Defiance*. On Richardson's selective memory, see Kean, "Some Problems of Constructing and Reconstructing a Suffragette's Life."

24. On Richardson's motivations, see Scott, "'Their Campaign of Wanton Attacks'"; and Gamboni, *The Destruction of Art*, 97.

25. For drawings of the Parisian bohemian look circa 1850, see Luc Ferry, *L'Invention de la vie de Bohème 1830–1900* (Paris: Éditions cercle de l'art, 2012), 50–51.

26. See Ferry, *L'Invention de la vie de Bohème 1830-1900*, 171–221.

27. See Jan M. Ziolkowski, "The Boston Bohemians," in *The Juggler of Notre Dame and the Medievalizing of Modernity*, vol. 3 (Cambridge: Open Book Publishers, 2018).

28. See Marvin Nathan, "San Francisco's Fin-de-Siècle Bohemian Renaissance," *California History* 61, no. 3 (Fall 1982): 196–209.

29. The book in English on Schopenhauer was by John Oxenford, *Iconoclasm in German Philosophy* (1853), www.schopenhauer.fr/oeuvres/iconoclasm-in-german-philosophy.html.

30. For the connection between the Bohemian movement and Schopenhauer and Nietzsche, see Ferry, *L'Invention de la vie de Bohème 1830–1900*, 13.

31. The title of Sue Prideaux's biography of Nietzsche, *I Am Dynamite*, evokes the same iconoclastic idea. See Sue Prideaux, *I Am Dynamite: A Life of Nietzsche* (New York: Tim Duggan Books, 2018).

32. See Linda Nochlin, "Museums and Radicals: A History of Emergencies," *Art in America*, 59, no. 4 (1971): 32.

33. See Alda Cannon and Frank Anderson Trapp, "A Plea for a Dead Friend. Gustave Courbet and the Destruction of the Vendome Column," *The Massachusetts Review* 12, no. 3 (Summer 1971): 502. On Courbet's radical politics, see Linda Nochlin, "The Invention of the Avant-Garde, France 1830-1880," *ArtNews Annual*, 1968.

34. Oliver Larkin, "Courbet in the Commune," *Science & Society* 5, no. 3 (Summer 1941): 255–59; and Alda Cannon and Frank Anderson Trapp, "Castagnary's: 'A Plea for a Dead Friend' (1882) Gustave Courbet and the Destruction of the Vendome Column," *The Massachusetts Review* 12, no. 3 (Summer 1971): 498–512.

35. See Debbie Lewer, "Hugo Ball, Iconoclasm and the Origins of Dada in Zurich," *Oxford Art Journal* 32, no. 1 (2009).

36. Thomas Girst, "Marcel Duchamp: A Riotous A to Z of His Secret Life," *The Guardian,* April 7, 2014, www.theguardian.com/artanddesign/2014/apr/07/marcel-duchamp-artist-a-z-dictionary.

37. Duchamp quoted in Gamboni, *The Destruction of Art,* 318.

38. See Lewer, "Hugo Ball," 20.

39. On Man Ray's *Object to Be Destroyed,* see Gamboni, *The Destruction of Art,* 345.

40. "Gustav Metzger, 'Auto-Destructive' Artist Who Inspired Pete Townshend to Smash His Guitars, Dies at 90," *Los Angeles Times,* March 3, 2017, www.latimes.com/local/obituaries/la-me-gustav-metzger-20170303-story.html.

41. See Lewer, "Hugo Ball," 19.

42. See "Ai Weiwei, Dropping a Han Dynasty Urn, 1995," *Guggenheim Bilbao,* www.guggenheim-bilbao.eus/en/learn/schools/teachers-guides/ai-weiwei-dropping-han-dynasty-urn-1995.

43. Maureen Corrigan, "'Let the People See': It Took Courage to Keep Emmett Till's Memory Alive," *NPR,* October 30, 2018, https://wamu.org/story/18/10/30/let-the-people-see-it-took-courage-to-keep-emmett-tills-memory-alive.

44. "Dana Schutz's Painting of Emmett Till at Whitney Biennial Sparks Protest," *Artnet News,* March 21, 2017.

45. "White Artist's Painting of Emmett Till at Whitney Biennial Draws Protests," *New York Times,* March 21, 2017, www.nytimes.com/2017/03/21/arts/design/painting-of-emmett-till-at-whitney-biennial-draws-protests.html.

46. See Peter Schjeldahl, "Dana Schutz's Paintings Wring Beauty from Worldwide Calamity," *The New Yorker,* January 21, 2019.

47. "Banksy Painting Self-Destructs after Fetching $1.4 million at Sotheby's," *New York Times,* October 6, 2018.

48. "Banksy Explains Why and How He Destroyed Artwork That Had Just Been Sold for £1m," *The Independent,* October 8, 2018, www.independent.co.uk/arts-entertainment/art/news/banksy-explains-prank-shredded-girl-with-balloon-sothebys-auction-a8572956.html.

49. "Iconic Banksy Image Painted Over," *BBC News,* April 20, 2007, http://news.bbc.co.uk/2/hi/uk_news/6575345.stm.

50. "Now Bring Back Banksy Boy: Slave Labour Mural Withdrawn from Auction at Last Minute," *Evening Standard,* February 25, 2013, www.standard.co.uk/news/london/now-bring-back-banksy-boy-slave-labour-mural-withdrawn-from-auction-at-last-minute-8508403.html.

51. See Darran Anderson, "The Anarchy, Piety and Celebrity of Banksy's Auto-Destructive Prank," *Frieze,* October 22, 2018; and Gareth Harris, "Banksy's £1m Self-Destructing Painting Goes Back to Auction—and Could Sell for Six Times the Price," *The Art Newspaper,* September 3, 2021.

52. "Woman Who Bought Shredded Banksy Artwork Will Go through with Purchase," *The Guardian,* October 11, 2018, www.theguardian.com/artanddesign/2018/oct/11/woman-who-bought-shredded-banksy-artwork-will-go-through-with-sale.

53. Julia Halperin, "Banksy's Famed Shredded Artwork, 'Love Is in the Bin,' Sells for a Record $25.4 Million at Sotheby's—18 Times the Non-Shredded Price," *Artnet,* October 14, 2021.

Chapter 13

1. On "monumental" history, see Friedrich Nietzsche, "On the Uses and Abuses of History for Life" (1874). See Daniel Breazeale, ed., *Nietzsche: Untimely Medications* (Cambridge: Cambridge University Press, 1997), 57–124.

2. See Klaus Kreiser, "Public Monuments in Turkey and Egypt, 1840–1916," *Muqarnas* 14 (1997): 103–17.

3. See "To Stop Statue Mania. No More Such Monuments May Be Erected in Paris for Ten Years," *New York Times*, July 23, 1911, www.nytimes.com/1911/07/23/archives/to-stop-statue-mania-no-more-such-monuments-may-be-erected-in-paris.html. Also see Jean Adhémar, "Les statues parisiennes de grands hommes," *Gazette des Beaux Arts* 6, no. 83 (March 1974): 149–52.

4. See Rebecca Senior, "Britain's Monument Culture Obscures a Violent History of White Supremacy and Colonial Violence," *The Conversation*, June 10, 2020; and "To Stop Statue Mania. No More Such Monuments May Be Erected in Paris for Ten Years," *New York Times*, July 23, 1911.

5. Pamela Parkes, "Who Was Edward Colston and Why Is Bristol Divided by His Legacy?" *BBC News*, June 8, 2020.

6. See Matthew Sweet, "Did Colston Deserve His Watery Grave?" *UnHerd*, June 8, 2020, https://unherd.com/2020/06/did-colston-deserve-his-watery-grave; and Madge Dresser, "Monumental Folly: What Colston's Statue Says about Victorian Bristol," *Apollo*, June 8, 2020, www.apollo-magazine.com/colston-statue-victorian-bristol.

7. See Roger Ball, "Edward Colston and That Statue," *Bristol Radical History Group*, October 14, 2018, www.brh.org.uk/site/articles/myths-within-myths; and Spencer Jordan, "The Myth of Edward Colston: Bristol Docks, the 'Merchant' Elite and the Legitimisation of Authority 1860–1880," in *A City Built upon the Water: Maritime Bristol 1750–1900*, ed. S. Poole (Bristol: Redcliffe/Regional History Centre UWE, 2013).

8. See William Dalrymple, "The East India Company: The Original Corporate Raiders," *The Guardian*, March 4, 2015, www.theguardian.com/world/2015/mar/04/east-india-company-original-corporate-raiders.

9. See William Dalrymple, "Robert Clive Was a Vicious Asset Stripper. His Statue Has No Place on Whitehall," *The Guardian*, June 11, 2020.

10. See Thomas J. Brown, *Civil War Monuments and the Militarization of America* (Chapel Hill: University of North Caroline Press, 2019).

11. See chapter 6, "Common Soldiers," in Kirk Savage, *Standing Soldiers, Kneeling Slaves: Race, War, and Monument in Nineteenth-Century America* (Princeton: Princeton University Press, 1997).

12. See chapter 1, "Statue Mania to Memorial Mania," in Erika Doss, *Memorial Mania: Public Feeling in America* (Chicago: University of Chicago Press, 2010).

13. In October 2021, the top 5 ranking for most public monuments in America were Abraham Lincoln (193), George Washington (171), Christopher Columbus (149), Martin Luther King Jr. (86), and Saint Francis of Assisi (73). There were 59 Robert E. Lee monuments. See *National Monument Report*, Monument Lab, 2021, https://monumentlab.com/audit.

14. See John A. Simpson, "The Cult of the Lost Cause," *Tennessee Historical Quarterly* 34, no. 4 (Winter 1975): 350–61; and Modupe Labode, "Confronting Confederate Monuments in the Twenty-First Century," in David B. Allison, *Controversial Monuments and Memorials: A Guide for Community Leaders* (Lanham, MD: Rowman & Littlefield, 2018).

15. See Jack P. Maddex Jr., "Pollard's The Lost Cause Regained: A Mask for Southern Accommodation," *The Journal of Southern History* 40, no. 4 (November 1974): 595–612.

16. See Eric Herschthal, "The Fate of Confederate Monuments Should Be Clear," *New Republic*, August 9, 2021; and chapter 1 of Karen L. Cox, *No Common Ground: Confederate Monuments and the Ongoing Fight for Racial Justice* (Chapel Hill: University of North Carolina Press, 2021).

17. See chapter 3 in Brown, *Civil War Monuments*.

18. See Cox, *No Common Ground*, 28–29; and Sarah Churchwell, "White Lies Matter," *Prospect*, August/September 2020.

19. See Fred Arthur Bailey, "The Textbooks of the 'Lost Cause': Censorship and the Creation of Southern State Histories," *The Georgia Historical Quarterly* 75, no. 3 (Fall 1991): 507–33.

20. See Matthew Glass, "Patriotic Inspiration at Mount Rushmore," *Journal of the American Academy of Religion* 62, no. 2 (Summer 1994): 265–83; and Matthew Shaer, "The Sordid History of Mount Rushmore," *Smithsonian Magazine*, October 2016, www .smithsonianmag.com/history/sordid-history-mount-rushmore-180960446.

21. See Karen L. Cox, "Why Honor Them," *Lapham's Quarterly*, April 12, 2021, www.bunkhistory.org/resources/8006.

22. See *Confederate Veteran*, Nashville, Tennessee, January 1894, https://archive.org/ details/confederateveter02conf/page/336/mode/2up?view=theater.

23. See Ellen Daugherty, "The Rise and Fall of a Racist Monument: The *Good Darky, National Geographic Magazine*, and Civil Rights Activism," *Nineteenth-Century Contexts* 41, no. 5 (2019): 631–49.

24. Edward Helmore, "New York Mayor Considers Christopher Columbus Statue Removal," *The Guardian*, August 25, 2017.

25. See Peter Szekely, "New York's Cuomo Defends Columbus Statues for Symbolism to Italian Americans," *Reuters*, June 11, 2020, https://headtopics.com/us/new-york -s-cuomo-defends-columbus-statues-for-symbolism-to-italian-americans-13616369.

26. See Szekely, "New York's Cuomo."

27. See Thomas J. Schlereth, "Columbia, Columbus, Columbianism," *The Journal of American History* 79, no. 3 (December 1992): 939.

28. See Schlereth, "Columbia, Columbus, Columbianism."

29. Opinion polls in 2019 on attitudes toward Columbus found that 56% of American adults said that Columbus Day should continue to be honored, with only 26% opposed. However, 69% of college students rejected Columbus Day. See Kriston Capps, "Why There Are Still 149 Statues of Christopher Columbus in the U.S." *Bloomberg*, October 9, 2021.

30. Jason Laughlin and Allison Steele, "After a Day of Wrangling, South Philly Columbus Statue to Stay Covered—for Now, Court Rules," *Philadelphia Inquirer*, October 10, 2021.

31. See Herschthal, "The Fate of Confederate Monuments."

32. See "Whose Heritage? Public Symbols of the Confederacy," *Southern Poverty Law Center*, February 1, 2019, www.splcenter.org/20190201/whose-heritage-public-symbols -confederacy#executive-summary.

33. Archie Bland, "Edward Colston Statue Replaced by Sculpture of Black Lives Matter Protester Jen Reid," *The Guardian*, July 15, 2020.

34. Steven Morris, "Bristol Mayor: Colston Statue Removal Was 'Act of Historical Poetry,'" *The Guardian*, June 13, 2020.

35. "Edward Colston Statue on Display int Bristol Exhibition," *BBC News*, June 4, 2021, www.bbc.com/news/uk-england-bristol-57350650.

36. Aubrey Allegretti, "Minister Vows to Close 'Loophole' after Court Clears Colston Statue Topplers," *The Guardian*, January 6, 2022; and Dan Whitehead, "Edward Colston Statue: Toppled Artwork 'Now Worth £300,000'—50 Times Its Original Value," *Sky News*, January 6, 2022.

37. See Hedley Twidle, "To Spite His Face: What Happened to Cecil Rhodes's Nose?" *Harper's*, December 2021.

38. Michael Race, "Cecil Rhodes: Refusal to Remove Oxford Statue a 'Slap in the Face,'" *The Guardian*, May 20, 2021; and James Grierson and Damien Gayle, "Oxford College Installs Plaque Calling Cecil Rhodes a 'Committed Colonialist,'" *The Guardian*, October 11, 2021.

39. "Opening Dedication Speech for the Unveiling of the A.P. Hill Monument, Richmond, VA, May 30, 1892," www.battlefields.org/learn/primary-sources/opening -dedication-speech-unveiling-ap-hill-monument-richmond-va.

40. Zoe Strozewski, "Final Richmond Monument Removal of Confederate Gen. A.P. Hill's Statue, His Remains Set," *Newsweek*, January 6, 2022.

41. Maria Cramer, "Tensions Rise in Memphis as Slave Trader's Remains Are Removed," *New York Times*, June 5, 2021.

42. Sarah McCammon, "In Richmond, Va., Protesters Transform a Confederate Statue," *National Public Radio*, June 12, 2020; and Ezra Marcus, "Will the Last Confederate Statue Standing Turn Off the Lights?" *New York Times*, June 23, 2020.

43. "Robert E. Lee statue: Virginia Removes Contentious Memorial as Crowds Cheer," *BBC News*, September 9, 2021; and Leah Small, "Richmond's Confederate Statues Are Gone. What Should Replace Them?" *The Guardian*, September 26, 2021.

44. Eduardo Medina, "Charlottesville's Statue of Robert E. Lee Will Be Melted Down," *New York Times*, December 7, 2021, www.nytimes.com/2021/12/07/us/robert -e-lee-statue-melt-charlottesville.html.

Chapter 14

1. "A Lynching Memorial Unveiled in Duluth," *New York Times*, December 5, 2003.

2. See Warren Read's memoir *The Lyncher in Me: A Search for Redemption in the Face of History* (St. Paul, MN: Borealis Books, 2008), 129–31.

3. See Erika Doss, "Public Art, Public Response: Negotiating Civic Shame in Duluth, Minnesota," *Indiana Magazine of History* 110, no. 1, Special Issue—Art, Race, Space (March 2014): 40–46.

4. Friedrich Nietzsche, "On the Uses and Abuses of History for Life" (1874), quoted in Daniel Breazeale, "Nietzsche, Critical History and 'Das Pathos der Richtertum,'" *Revue Internationale de Philosophie* 54, no. 211 (March 2000): 64.

5. See Erika Doss, *Memorial Mania: Public Feeling in America* (Chicago: University of Chicago Press, 2010), 2.

6. See Erika Doss, "War, Memory, and the Public Mediation of Affect: The National World War II Memorial and American Imperialism," *Memory Stories* 1, no. 2 (2008): 227–50.

7. Josie Appleton, "The Return of Statuemania," *Spiked*, September 23, 2004, www.spiked-online.com/2004/09/23/the-return-of-statuemania.

8. Appleton, "The Return of Statuemania."

9. "Britain Is in the Midst of a Victorian-Style Statue Mania," *The Economist*, March 23, 2019, www.economist.com/books-and-arts/2019/03/21/britain-is-in-the-midst-of-a-victorian-style-statue-mania.

10. Mark Brown, "Mary Wollstonecraft Statue Becomes One of 2020's Most Polarising Artworks," *The Guardian*, December 25, 2020.

11. "The Sorry Tale of Margaret Thatcher's Statue," *The Economist*, January 8, 2022.

12. See chapter 9, "The Custer Chronicles," in Karen Coody Cooper, *Spirited Encounters: American Indians Protest Museum Policies and Practices* (Plymouth: Altamira Press, 2008).

13. "Activists Plaque at Little Bighorn Honors 'Patriots' Who Beat Custer," *Los Angeles Times*, June 4, 1988, www.latimes.com/archives/la-xpm-1988-07-04-mn-3871-story.html.

14. See Brooke Jarvis, "Who Speaks for Crazy Horse?" *New Yorker*, September 16, 2019.

15. Livia Gershon, "Why a New Statue of Medusa Is So Controversial," *Smithsonian Magazine*, October 13, 2020, www.smithsonianmag.com/smart-news/controversial-metoo-medusa-statue-unveiled-180976048.

16. Julia Jacobs, "How a Medusa Sculpture from a Decade Ago Became #MeToo Art," *New York Times*, October 13, 2020.

17. Precious Fondren, "George Floyd Statue Vandalized in Union Square," *New York Times*, October 2, 2021; and "George Floyd Sculpture in New York Defaced for a Second Time," *BBC News*, October 4, 2021.

18. On Second World War memorials in America, see Doss, "War, Memory, and the Public Mediation of Affect."

19. For Thomas Jefferson's first draft of the *Declaration of Independence*, see the U.S. Library of Congress website: www.loc.gov/exhibits/declara/ruffdrft.html.

20. Nicci Gerrard, "Caroline Criado Perez: How I Put a Suffragist in Parliament Square," *The Guardian*, April 15, 2018.

21. See Kerwin Lee Klein, "On the Emergence of Memory in Historical Discourse," *Representations*, no. 69, Special Issue: Grounds for Remembering (Winter 2000): 127–50.

22. See Andreas Huyssen, "Monumental Seduction," *New German Critique*, no. 69 (Autumn 1996): 181–200.

23. See Patricia Clough, "The Affective Turn: Theorizing the Social," in *The Affective Turn: Theorizing the Social*, ed. Patricia Clough (Durham: Duke University Press, 2007).

24. See Brent Cunningham, "Rethinking Objectivity," *Columbia Journalism Review*, July–August 2003; and Lene Bech Sillesen, Chris Ip, and David Uberti, "Journalism and the Power of Emotions," *Columbia Journalism Review*, May–June 2015.

25. See Susanne von Falkenhausen, "The Trouble with Affect Theory in Our Age of Outrage," *Frieze*, June 6, 2019.

26. For Lincoln's second inaugural address, see www.nps.gov/linc/learn/historycul ture/lincoln-second-inaugural.htm.

27. See Ronald D. White Jr., "Lincoln in Richmond: Worth Setting in Stone," *Washington Post*, March 30, 2003, www.washingtonpost.com/archive/opinions/2003/03/30/ lincoln-in-richmond-worth-setting-in-stone/ca4e2e9b-412b-4295-9fe0-77191b1f87d4.

28. See Bob Moser, "Conflicts Arise over Lincoln Statue in Richmond Va. Cemetery," *Southern Poverty Law Center*, August 15, 2003, www.splcenter.org/fighting-hate/intelli gence-report/2003/conflicts-arise-over-lincoln-statue-richmond-va-cemetery.

29. "Lincoln Statue Is Unveiled, and Protestors Come Out," *New York Times*, April 6, 2003, A19.

30. See Ted Mann, "How a Lincoln-Douglass Debate Led to Historic Discovery," *Wall Street Journal*, July 4, 2020, www.wsj.com/articles/how-a-lincoln-douglass-debate -led-to-historic-discovery-11593869400.

31. "Activists Push for Removal of Statue of Freed Slave Kneeling Before Lincoln," *New York Times*, June 27, 2020, www.nytimes.com/2020/06/27/us/politics/lincoln -slave-statue-emancipation.html.

32. "Boston Removes Statue of Formerly Enslaved Man Kneeling Before Lincoln," *New York Times*, December 29, 2020, www.nytimes.com/2020/12/29/us/boston-abra ham-lincoln-statue.html.

33. Meredith Deliso, "Problematic Roosevelt Statue at American Museum of Natural History Finds a New Home," *ABC News*, November 20, 2021; and Jennifer Calfas, "Theodore Roosevelt Statue Is Removed from New York's Natural History Museum," *Wall Street Journal*, January 20, 2022.

34. "Clinton Dedicates Memorial, Urges Americans to Emulate FDR," *Washington Post*, May 3, 1997.

35. See John Parsons, "The Public Struggle to Erect the Franklin Delano Roosevelt Memorial," *Landscape Journal* 31, nos. 1/2 (2012): 145–59.

36. Charles Krauthammer, "The FDR Memorial Scam," *Washington Post*, May 9, 1997, www.washingtonpost.com/archive/opinions/1997/05/09/the-fdr-memorial -scam/5a9bd5cc-4722-4a9d-909d-c6ae0a3d7712.

37. See Doss, *Memorial Mania*, 37.

38. Nietzsche, "On the Uses and Abuses of History for Life," quoted in Daniel Breazeale, ed., *Nietzsche: Untimely Medications* (Cambridge: Cambridge University Press, 1997), 57–124.

39. For a text of Jorge Luis Borges's "Funes the Memorious," see the *Paris Review*, www.theparisreview.org/fiction/4604/funes-the-memorious-jorge-luis-borges.

40. See David Rieff, *In Praise of Forgetting: Historical Memory and Its Ironies* (New Haven, CT: Yale University Press, 2016), 65 and 121. See also David Rieff, "The Cult of Memory: When History Does More Harm Than Good," *The Guardian*, March 2, 2016.

Chapter 15

1. Chris Johnston, "Council Removes Banksy Artwork after Complaints of Racism," *The Guardian*, October 1, 2014, www.theguardian.com/artanddesign/2014/oct/01/banksy-mural-clacton-racist.

2. Jonathan Jones, "Banksy Wanted Clacton-on-Sea to Confront Racism—Instead It Confronted Him," *The Guardian*, October 2, 2014, www.theguardian.com/commentisfree/2014/oct/02/bansky-clacton-on-sea-racism-tendring-district-council-destroyed-immigration.

3. See Nicholas Alden, "Street Art: The Transfiguration of the Commonplaces," *The Journal of Aesthetics and Art Criticism* 68, no. 3 (Summer 2010): 243–57; and Andrea Baldini, "Street Art: A Reply to Riggle," *The Journal of Aesthetics and Art Criticism* 74, no. 2 (Spring 2016): 187–91.

4. "The 25 Most Influential Works of American Protest Art Since World War II," *New York Times*, October 15, 2020, www.nytimes.com/2020/10/15/t-magazine/most-influential-protest-art.html.

5. Alain Besançon, *The Forbidden Image: An Intellectual History of Iconoclasm* (Chicago: University of Chicago Press, 2000), 3.

6. See Suetonius's *Life of Nero*, 45:2, https://penelope.uchicago.edu/Thayer/E/Roman/Texts/Suetonius/12Caesars/Nero*.html#ref135.

7. Along with Suetonius, see also the account of ancient historian Dio Cassius in *Roman History*, 16.2, https://penelope.uchicago.edu/Thayer/e/roman/texts/cassius_dio/62*.html.

8. See Kristina Milnor, *Graffiti and the Literary Landscape in Rome Pompeii* (Oxford: Oxford University Press, 2014), 124.

9. See the introduction in J. A. Baird and Claire Taylor, *Ancient Graffiti in Context* (London: Routledge, 2011).

10. See Kristina Milnor, *Graffiti and the Literary Landscape in Rome Pompeii* (Oxford: Oxford University Press, 2014), 51; and chapter 2 in Tom Standage, *Writing on the Wall* (London: Bloomsbury, 2013).

11. See Christopher Gilbert, "If This Statue Could Talk: Statuary Satire in the Pasquinade Tradition," *Rhetoric and Public Affairs* 18, no. 1 (Spring 2015): 79–112.

12. See Alison C. Meier, "The Talking Statues of Rome," *JSTOR Daily*, June 18, 2018, https://daily.jstor.org/the-talking-statues-of-rome.

13. Heather Shirley and David Todd Lawrence, "Documenting a Global Uprising through Protest Art in the Streets," *Monument Lab*, September 29, 2021, https://monumentlab.com/bulletin/documenting-a-global-uprising-through-protest-art-in-the-streets.

14. Jerry Adler, "The Art of the New Deal," *Smithsonian Magazine*, June 2009.

15. See "Lenin in New York," in Dario Gamboni, *The Destruction of Art: Iconoclasm and Vandalism Since the French Revolution*, 172–77 (London: Reaktion Books, 1997).

16. Daisy Alioto, "How Graffiti Became Gentrified," *The New Republic*, June 19, 2019, https://newrepublic.com/article/154220/graffiti-became-gentrified; and David Diallo, "From the Street to Art Galleries: How Graffiti Became a Legitimate Art Form," *Revue de la recherche en civilisation américaine* 2 (2014), https://journals.openedition.org/rrca/601.

17. See Jean Baudrillard, *Kool Killer ou l'insurrection par les signes. L'échange symbolique et la mort* (Paris: Gallimard, 1976).

18. Philip Faflick, "Jean-Michel Basquiat and the Birth of SAMO," *Village Voice*, March 20, 2019, www.villagevoice.com/2019/03/20/jean-michel-basquiat-and-the-birth-of-samo.

19. Andrew Chow, "New Banksy Mural in New York Protests Turkish Artist's Imprisonment," *New York Times*, March 15, 2018.

20. Alan Feuer, "Graffiti Artists Awarded $6.7 Million for Destroyed 5Pointz Murals," *New York Times*, February 12, 2018; and Enrico Bonadio, "How 21 Artists Graffitied One Man's Property, Made It Famous, Sued Him When He Knocked It Down and Won $6.7m," *The Conversation*, February 16, 2018.

21. Alioto, "How Graffiti Became Gentrified."

22. See Debbie Lewer, "Hugo Ball, Iconoclasm and the Origins of Dada in Zurich," *Oxford Art Journal* 32, no. 1 (2009): 17–35.

23. Jason Horowitz, "A Trick of the Eye Turns a Luxurious Embassy Inside Out," *New York Times*, July 27, 2021.

24. See Cinzia Bianchi and Silvia Vita, "Street Art: Iconoclasm and Institutionalization," *Ocula* 18, no. 18 (September 2017): 1–6.

25. "Banksy Artwork Stolen from Central Paris," *BBC News*, September 3, 2019; and "Banksy Artwork Stolen from the Bataclan in Paris Found in Italy," *BBC News*, June 10, 2020.

26. "Algerian Jailed for 3 Years for Political Protest Memes," *France 24*, January 4, 2021, www.france24.com/en/live-news/20210104-algerian-jailed-for-3-years-for-political-protest-memes.

27. "Walid Kechida, en Algérie, brandit le même comme étendard politique," *Courrier International*, May 5, 2021, www.courrierinternational.com/article/la-personne-suivre-walid-kechida-en-algerie-brandit-le-meme-comme-etendard-politique.

28. Olga Robinson, "The Memes That Might Get You Jailed in Russia," *BBC News*, August 23, 2018, www.bbc.com/news/blogs-trending-45247879.

29. Matthew Sweet, "The Throne Behind the Power: From Putin's Toilet Brush to Trump's Golden Bowl," *The Economist, 1843 Magazine*, February 4, 2021, www.economist.com/1843/2021/02/04/the-throne-behind-the-power-from-putins-toilet-brush-to-trumps-golden-bowl.

30. Anastasiia Federova, "The Memeification of Russian Politics: How Opposition Protests Are Drawing Strength from Online Jokes," *Russia Z*, February 10, 2021, www.calvertjournal.com/features/show/12514/memefication-of-russian-politics-russia-z.

31. See Alice Marwick, "Memes," *Contexts* 12, no. 4 (Fall 2013): 12–13; and Limor Shifman, *Memes in Digital Culture* (Cambridge: MIT Press, 2014).

32. Sage Lazzaro, "Memes Are Our Generation's Protest Art," *Vice*, March 1, 2019, www.vice.com/en/article/mbzxa3/memes-are-our-generations-protest-art.

33. See Chris Tenove, "The Meme-ification of Politics: Politicians and Their 'Lit' Memes," *The Conversation*, February 4, 2019.

34. See An Xiao Mina, *Memes to Movements: How the World's Most Viral Media Is Changing Social Protest and Power* (Boston: Beacon Press, 2019).

35. Emma Grey Ellis, "Pepe the Frog Means Something Different in Hong Kong— Right?" *Wired*, August 23, 2019.

36. Jean Baudrillard published *Simulacres et Simulation* in French in 1981. For an English translation, see Baudrillard, *Simulacra and Simulation* (Ann Arbor: University of Michigan Press, 1994).

37. Emiko Jozuka, "Beyond Dimensions: The Man Who Married a Hologram," *CNN*, December 29, 2019; and "Why I Married a Cartoon Character," *BBC News*, August 17, 2019.

38. Jim Dwyer, "A Removed Snowden Sculpture Inspires a Hologram in Its Place," *New York Times*, April 7, 2015.

39. "David Koch Was the Ultimate Climate Change Denier," *New York Times*, August 23, 2019.

40. Ben Davis, "NYPD Detains Activists for Anti-Koch Light Graffiti at the Met," *ArtNet*, September 11, 2014. For website of the Illuminator activist collective, see http://theilluminator.org.

41. Mark Savage, "Abba Tease Major Announcement Ahead of New Music," *BBC News*, August 26, 2021.

42. Mark Binelli, "Old Musicians Never Die. They Just Become Holograms," *New York Times*, January 7, 2020, www.nytimes.com/2020/01/07/magazine/hologram -musicians.html.

Conclusion

1. "San José Council Votes to Remove Columbus Statue," *The Hill*, January 31, 2018.

2. Tessa Solomon, "Richmond's Controversial Robert E. Lee Statue May Head to the City's Black History Museum," *ARTNews*, January 4, 2022, www.artnews.com/art-news/news/robert-e-lee-monument-richmond-black-history-museum-1234614890.

3. Dan Whitehead, "Edward Colston Statue: Toppled Artwork Now Worth £300,000—Fifty Times Its Original Value," *Sky News*, January 6, 2022.

4. "Banksy Reveals Suggestion to Replace Edward Colston Statue Toppled by Protesters in Bristol," *Sky News*, June 9, 2020.

5. Carlo Invernizzi-Accetti, "A Small Italian Town Can Teach the World How to Defuse Controversial Monuments," *The Guardian*, December 6, 2017.

6. Leah Small, "Richmond's Confederate Statues Are Gone. What Should Replace Them?" *The Guardian*, September 26, 2021.

7. Hazel Shearing, "Black Lives Matter: Statues Are Falling but What Should Replace Them?" *BBC News*, June 20, 2020.

8. Yasmeen Serhan, "A Case for a Statue of Limitations," *The Atlantic*, June 25, 2020.

Index

Note: Page numbers in *italics* refer to photos.